CARL BECKER

MEDIEVAL &
RENAISSANCE ART

KUNST DES MITTELALTERS
UND SCHÄTZE DER RENAISSANCE

L'ART DU MOYEN ÂGE
ET LES TRÉSORS DE LA RENAISSANCE

The Complete Plates

Edited by / Herausgegeben von / Publié sous la direction de
CARSTEN-PETER WARNCKE

The copy used for printing belongs to the
Der Druck erfolgte nach dem Exemplar von
L'impression a été effectuée d'après l'exemplaire de la
WÜRTTEMBERGISCHE LANDESBIBLIOTHEK,
STUTTGART

TASCHEN
Bibliotheca Universalis

Contents
Inhaltsverzeichnis
Sommaire

"Art in the Picture"

Hefner-Alteneck and Becker's presentation of the artworks of the Middle Ages and Renaissance

CARSTEN-PETER WARNCKE

Leafing through the illustrated plates accompanying *Kunstwerke und Geräthschaften des Mittelalters und der Renaissance* (Artworks and Artefacts of the Middle Ages and the Renaissance), we are greeted by the spirit of another age. The illustrations are lovingly drawn, with meticulous attention paid even to the tiniest detail, and are hand-coloured in a discreet manner that avoids excessive colouristic effects. Only rarely polychrome, and sometimes almost monochrome, the colouring is never monotonous and in each case endeavours to capture a true – but nonetheless artistic – likeness of its object. No photographic reproductions of the kind we are accustomed to seeing in modern-day art books; no glossy pages that make delicate watercolours gleam like oil paintings and sparkle like magnificent goblets. There were technical reasons for this, of course: in the mid-19th century, illustrating art books by means of photography – itself developed only a few decades earlier – did not yet exist. The invention of the colour photograph was a long way off and lithographic printing techniques were still in their infancy. The decision to illustrate *Kunstwerke und Geräthschaften* in such a labour-intensive manner was nevertheless taken for a specific reason and with a deliberate aim in mind, as one of the two editors, Jakob Heinrich von Hefner-Alteneck (ill. 1), would later explain. Twenty-seven years after the first appearance of *Kunstwerke und Geräthschaften*, Hefner-Alteneck published a second edition, which combined the *Kunstwerke und Geräthschaften* with another anthology that he had begun at an earlier date. In the introduction to this new, joint edition, he wrote: "The illustrations in the two works now united here consist of copper and steel engravings, which in the case of the hand-painted edition were executed by skilled colourists on the basis of originals provided by myself. At that time, I still hesitated to use colour printing, since the sharpness and definition of the drawing – which remains the most important thing – would thereby have suffered too much. Only with the

ILL. 1
Jakob Heinrich von Hefner-Alteneck
Franz Hanfstaengel, Portrait

7

advances of more recent times has it become possible to combine copper engraving with colour printing in such a way that the former retains its full effect and the latter, in the full clarity of its colours, reproduces the character of a watercolour painting." For the ambitious author Hefner-Alteneck, it was not simply a matter of reproduction, of replicating images, but of preserving the particular character of the originals. In their own way, the plates in *Kunstwerke und Geräthschaften* are in fact works of art in their own right. While it is true that they deny the objects that they present their distinctive material properties, they do so without adding other effects. Aware of their technical limitations and fully cognizant of the dialectic of all imitation, which can never attain identity and which, for all its similarity, is only ever a reflection of the original, they content themselves with being hand-coloured drawings. They are the products not of a camera mechanism but of an observant eye and an intelligently deployed, trained hand – they are works of art in the original sense, in other words. They are thereby also analogous to the designs that artists in the pre-modern era submitted to potential patrons, hoping to win their custom – designs such as those also forming the basis of plates in the present work (ills. 5, 6 and ills. pp. 204, 211, 585).

The production process as a whole, starting with the design drawings and followed by the printing and finally hand-colouring of the plates, was extremely time-consuming and the resulting publication was correspondingly expensive. A system had been in place since the late 18th century that made it possible to finance projects of this kind: books were not published in complete sets but in individual volumes, issued at successive intervals and purchased separately. *Kunstwerke und Geräthschaften* was thus published over an extended period of time, with intervals of five and six years between the appearance of each part. Thus the first volume is dated 1852, the second 1857, and the third and final volume 1863.

Funding was not the only reason why publication took so long, however. The reader's eye is struck not only by the artistic quality but also by the heterogeneous nature of the illustrations, which bring together some 400 objects on 216 plates. The eleven years separating the first and last volume gave the editors time to assemble illustrations of the most wide-ranging objects from the most varied locations.

Cupboards destined for use in aristocratic households appear alongside exclusive objects fashioned by master goldsmiths, and wrought-iron fixtures alongside wood and ivory reliefs (ills. 2, 3 and ills. pp. 143, 385); secular drinking vessels are followed by liturgical items such as censers and containers for holy water, and insignia of office, such as bishop's crosiers, find their counterparts in ceremonial swords worn by princes. Church seats are found alongside rings and necklaces, and knives and spoons are juxtaposed with reliquaries attesting to the veneration of the saints. Only the often outstanding beauty of the objects, and the subtle mastery of their craftsmanship, prevents their profusion from becoming a confusion of odds and ends in book form. There is clearly no obvious system to their presentation, nor do they follow any logical chronological order: ivory reliefs from the 11th century incorporated into book covers are accompanied, for example, by hand towels from the early 16th century, while a magnificent comb from the Early and High Middle Ages is followed by a design drawing for a portable organ from the mid-16th century, which is succeeded, in turn, by carved chess pieces from the 14th century (ills. pp. 203–07). In order to understand why

Hefner-Alteneck and Becker included such a wide range of artefacts in their publication, and presented each work as equal in value to all the rest, it is necessary to take a look at the state of art-historical knowledge in their day.

Public museums enjoyed immense importance in the mid-19th century. Their very existence marked a new chapter in cultural history, as the art collections assembled by Europe's princes and major noble dynasties were gradually transformed into institutions accessible to the general public. What had begun in the form of individual initiatives taken by enlightened rulers developed, in the wake of the French Revolution, into national policy. It took decades, however, before the public museums we take for granted today were established. The British Museum in London was founded by an act of parliament in 1753; it was followed in 1793 by the Muséum Français in the Louvre. Not until 1891, however, and after long years of planning, did the Kunsthistorisches Museum in Vienna finally open its doors.

These public museums were also understood as educational institutions and needed knowledgeable experts who could supply information about the objects in their collections. At this early stage, however, no systematic programmes of academic study in the field of art history were yet available. The first professorships of art history had been created purely in order to complement other areas of study. Responsibility for publicizing the history of art in many cases lay in the hands of art lovers and collectors. Carl Schnaase, for example, the author of a five-volume history of the fine arts and an influential figure within the young discipline, was not an expert in the strict sense, but a lawyer who was only able to devote himself to the full-time study of art history after his retirement in 1857. At the other end of the scale was Franz Kugler, head of the department of artistic affairs at the Prussian Ministry of Culture from 1843 and full professor of art history at the University of Berlin from 1844. Kugler had already published his *Handbuch der Geschichte der Malerei* (Guide to the History of Painting) in 1837 and his *Handbuch der Kunstgeschichte* (Guide to the History of Art) in 1842. The two scholars represented different universalistic positions, albeit in each case informed by their reading of Hegel's idealistic philosophy of art, and thereby placed a clear emphasis upon architecture, painting and sculpture, the genres considered to embody "high" art.

This limited focus was perceived as a shortcoming by the editors of *Kunstwerke und Geräthschaften des Mittelalters und der Renaissance*. As they declare in programmatic fashion in their introduction to Volume I: "The primary aim of the editors of this work is to present a comprehensible series of largely unknown artworks from the past, ranging from the earliest Christian epoch up to the start of the 16th century, which – whether they be everyday or luxury items, for ecclesiastical or secular purposes – provide a yardstick of the development of culture and civilization in the various centuries [...] the modestly sized works that are presented [here] in faithful illustrations, and which proclaim the artistic sensibilities and trends in taste of the various epochs, were created in response to practical needs or for the adornment of churches, palaces or middle-class homes. In addition to exhibiting the finest taste and the most skilled craftsmanship, they at the same time bear witness to the principle pursued in the past of lending such works, so intimately connected with the architecture and painting of their day, a form appropriate to the style of the epoch. While large-scale works of architecture, sculpture and painting have been objects of avid research and

scholarship in more recent times, little study has been made up to now of the smaller art objects with which we are surrounded."

Today, we categorize such objects under the heading of artefacts, a term that presupposes a fundamental qualitative distinction between art and handicraft. Such a differentiation is relatively modern, however: unknown in medieval times, it started to take root only during the 16th century and did not become firmly established until the 18th century. How little it corresponds with historical reality is demonstrated by the objects reproduced in Hefner-Alteneck's plates. The works produced by the important Late Gothic sculptor Tilman Riemenschneider (*c.* 1460–1531) included not just his famous carved altarpieces and monumental statues, such as the *Virgin and Child on the Crescent Moon* (ill. 4 and ill. p. 177), but also a table for Würzburg's city council (ill. p. 161). Riemenschneider was indeed a councillor himself and in 1520/21 even served as mayor of Würzburg. In those days, crafting a practical object was no less highly regarded than carving a sculpture – a fact of which most people, significantly, are no longer aware.

The mirror cases (ill. 3 and ill. pp. 229, 317, 385), too, represent superlative examples of ivory carving, whereby the preciousness of the material alone sufficed to make them prized objects. Great pains were taken to craft not only works of art, but also what from today's perspective seem to be trivial objects, such as a compact mirror. A rare material that was hard to procure, ivory was reserved for those who could afford it, namely members of the highest echelons of society. Rather like the two sides of a mirror, this aristocracy wanted to see not only master craftsmanship of the most virtuoso kind, but also – reflected in the ivory decoration – the ideals and conventions of their exclusive lifestyle. Compact mirrors were toiletry items used by high-ranking ladies, who took pleasure in their carved scenes of courtly love. For noblewomen in the Middle Ages, the relationship between the sexes was romantically idealized in a world of chivalry, one that did not extend, however, to the reality of their lives. These mirror cases are thus first-hand documents of medieval cultural history: they show how the themes, legends and motifs of chivalric literature were brought to life in art. Even more than this, they testify to the pervasive influence of such romantic imagery – which greeted the user every time she picked up the mirror – upon everyday life.

Similar decoration was frequently employed for larger wall-mounted mirrors (ill. p. 495) and combs, practical toiletry articles, even if these latter were not made of precious ivory but of cheaper boxwood. Their carving might thus show scenes from classic works of chivalric literature, such as the story of Tristan and Iseult (ill. p. 429). A sense of the daily lives and intellectual world of bygone eras, and of the people who lived in them, can be conveyed only by the full spectrum of material, both tangible and intangible, that has come down to us – and not by a one-sided fixation upon "high" art alone.

The legends and stories composed and performed by the medieval troubadours ultimately found their way not only into the decoration of practical requisites, but also onto the walls of rooms, though not as murals and panel paintings – the draughty and poorly heated interiors of castles and palaces were furnished in the first instance with tapestries.

These offered the combined advantage of fulfilling both a decorative and a practical function, insofar as they provided a degree of insulation against the cold – and in places the damp – of the

Ill. 2
Relief of the Entombment / Relief mit Darstellung der Grablegung Christi /
Relief représentant la mise au tombeau du Christ
Hans Schwarz, Augsburg, 1516. Pearwood, 28.5 x 20 cm / 11 ⅛ x 7 ⅞ in.
Staatliche Museen zu Berlin, Bode-Museum

walls, and at the same time brightened up the room with their attractive designs. These might include scenes from the Old French epic, also familiar in the German-speaking sphere, recounting the romance of Willehalm and Amelie (ills. pp. 401–07). The ideals, convictions and conventions of social life, and the world view underlying them, were present at every level of daily life.

It comes as no surprise, therefore, that the artistic decoration of secular objects should also bear witness to contemporary religiosity and the Christian faith (ill. 14 and ill. p. 267). Combs correspondingly offered artistically carved representations of scenes from the Bible, such as the Annunciation and the Adoration of the Magi (ill. p. 473). This is interesting because it shows us the fundamental importance assumed by decoration in the Middle Ages and the Renaissance. Decoration was inseparably linked with the concept of decorum and implied not just ornamentation but also stylistic propriety. It was logical that the two spheres of life, the sacred and the secular, should permeate one another at the level of art and consequently also at the level of the design and decoration of functional objects. What was true of secular items was all the more so of objects employed in a religious context. The containers that were used to house the blessed sacraments, for example, assumed a special significance during Mass, when they became *Vasa sacra*, holy vessels. It is not surprising that this should also be reflected in their designs, which combined practical handling with a decoration that made visual allusion – however limited the space available, and by restricting itself to a few salient motifs – to the most important themes of faith, whether in medallions of angels, saints and prophets (ill. p. 501), or in reliefs of the Crucifixion and the Virgin and Child (ill. p. 189).

In the Late Middle Ages, the principle of visual reinforcement led to the display of the consecrated Host in a specially designed container during Mass, when – according to Catholic belief – the Eucharistic bread is transformed, or transubstantiated, into the body of Christ. This container was purely a display vessel and incorporated the figures of Christ and saints within its architectural housing (ill. p. 575). The same principle also extended to the design of other liturgical containers: the full significance of what looks like a miniature fortress to the impartial modern observer can be fully understood and appreciated only when we remember that the Christian faith and its institution on earth, the Church, were metaphorically understood as a fortress whose appearance is based on that of the Heavenly Jerusalem (ill. p. 301).

This desire to render Christian concepts visible and tangible also extended to Romanesque candelabra, whose dragons and demons in subservient roles embody the victory of the Light, as a symbol of the triumph of Good over Evil ("Ego sum lux mundi": "I am the light of the world," John 8:12) and the victory of God over the Devil (ill. p. 551). Even the hand bell rung during Mass to introduce the next section of the liturgy was decorated with the symbols of the Evangelists (ill. p. 217). It almost goes without saying that the robes worn by church dignitaries (ill. 10 and ill. p. 227) and the insignia of ecclesiastical office were adorned with ornament that embedded the particular status of their bearer in the foundations of the Church. The artistry with which the objects are crafted, whether carved out of ivory (ills. pp. 243, 345) or skilfully wrought in copper (ills. pp. 395, 465), underlines the important function they served, which was always twofold. The crooks of the crosiers not only proclaim the bishop's rank but legitimize his office, insofar as they

show representations of the Annunciation (ill. p. 465), the Crucifixion (ill. p. 243), the Coronation of the Virgin (ill. p. 345), and Christian sacrifice in the example of the martyrs (ill. p. 395).

Witnesses to the Christian faith distinguished by their lives and acts were traditionally held in particular veneration. This found its most intense expression in the cult of relics, which saw the corporeal remains of saints preserved in reliquaries that not uncommonly assumed lavish forms. It was only natural that sumptuous decoration should be employed for such reliquaries, which were "tangible" in the truest sense of the word. They were attributed with the power to work miracles and pilgrimage routes frequently led to the places where they were housed. The reliquaries that have come down to us present a host of different faces as individual as the fates of the saints themselves, subject to changes in form and style but always designed to "speak". They include chests and caskets (ill. p. 427), whole shrines (ill. pp. 324/25), busts (ill. p. 455), and statuettes (ill. p. 557). The sign of the Christian faith, the crucifix, did not just serve a symbol but also as a container for precious relics (ills. pp. 383, 461, 553). Reliquary decoration and design thereby ranged from conventional representations of stations in the Life of Christ (ills. pp. 324/25, 427), which set the relics in their broader Christian context, via objects shaped as body parts or whole figures that immediately proclaim the nature of their contents (ills. pp. 455, 557), to complex objects that combine different histories and symbols (ills. pp. 479, 481).

The spirit of the Middle Ages and the Renaissance, so very different from that of our own age, also permitted transference processes that today seem odd. Just as sacred themes could be applied to secular objects, which involved religious motifs being depicted on objects of everyday household use, so it was also perfectly possible for a support bearing secular imagery to change its function. A case that strikes us as particularly unusual is that of the famous "Aschaffenburg Board Game" (ill. 11 and ills. pp. 367–75).

The board was namely transformed from a board game into a reliquary, whereby the lateral compartments originally designed to hold the tokens were now used to house holy relics. The pictorial decoration allowed this change of function, for just as dragons and light symbolism were associated in Romanesque candlesticks (ill. p. 551), it was possible to read the fabulous beasts in the squares as demons. In this way, a meaningful link was established between the decoration and the relics, enabling the now sacred object to illustrate the victory of Good over Evil. This principle of transferability also extended to the use of earlier works of art in new context, as for example when a Fatimid cup became part of a Christian chalice (ill. 8 and ill. p. 417). Christian works of art from previous centuries, too, were frequently incorporated into new sacred artefacts at a later point in time. Such instances of "recycling" are regularly encountered in the luxury bindings given to precious manuscripts (ill. 7 and ill. p. 103). Thus the front cover of a Gospel book could incorporate at its centre the middle panel of a three-part ivory relief, or triptych, whose subject was entirely in keeping with a codex containing the texts of the four Gospels (ill. p. 137). In some cases, the earlier work was physically modified to fit its new context, for example, by removing sections or borders that were considered unnecessary (ill. p. 91).

The close of the Middle Ages spelled no fundamental changes either in the approach to artworks of the past or the way in which objects were designed and decorated. In the Renaissance, Mannerist

Ill. 3
Mirror case / Spiegelkapsel / Valve de miroir
Paris, mid-14th century. Ivory, 12.3 x 12.2 cm / 4 ⅞ x 4 ¾ in.
Darmstadt, Hessisches Landesmuseum

and Early Baroque periods, too, items of everyday use continued to be adorned with "speaking" decoration. Bowls in which confectionery was served thereby delivered a hidden joke in scenes from antiquity executed by specially commissioned, highly paid enamel painters on their inner faces (ills. pp. 577–579). This lay in their witty combination of action and intellect: only as the bowls were emptied did the pictures in their interior become visible, and even then their subjects could be understood only by those with a classical education. It is easy to imagine such serving bowls providing a form of entertainment around the table during banquets. The marriage of the

practical and the entertaining was characteristic of the Early Modern Era and found linguistic expression in the Latin maxim *prodesse et delectare* ("useful and delightful"), derived from Horace. Even door knockers were designed as ingenious miniature works of art concealing a second layer of meaning, insofar as they invoked members of the Roman pantheon as allegories of the prosperity of their wealthy owners (ill. p. 547). Members of the nobility in the 16th century wished to reinforce their chivalrous image no less than in medieval times, and had even their armour and saddles decorated with scenes from antique history that harboured barely concealed allusions to key events of the present day (ills. pp. 157, 159, 378/79).

It would be erroneous, however, to think that the rank of the patron exerted a direct influence upon the choice of subjects represented and their design. While it is certainly true that social position had a bearing on the lavishness of the decoration and the monetary value of the materials employed, the principles of design – adapted to the budget available – remained fundamentally the same in almost every case. We thus find virtually the same themes and motifs on works created for members of the nobility as on those for the middle classes. A magnificent goblet that was probably created as an imperial commission, and which stands out both for its sheer size and for the sophistication and technical mastery of its craftsmanship (ill. p. 107), is decorated with the same champion of knightly virtue, St George, as a covered beaker of approximately the same date that belonged to the Ingolstadt municipal treasury (ill. p. 503). Such commissions by their very nature placed exacting demands on those who are today sometimes dismissively referred to as "artisans". The guilds made sure that the standard of training was extremely high, especially in cities famed and admired throughout Europe for their artistic products, so that ambitious standards of production could be achieved (ill. 13 and ill. p. 225). A cup has come down to us that formerly belonged to the Nuremberg Goldsmiths Corporation, who used it as one of the set pieces for their demanding guild examination (ill. 12 and ills. pp. 269–71). Its design presupposes not only supreme technical virtuosity but also a thorough familiarity with the topics of a classical education, and demonstrates just what apprentices had to be capable of before they could become masters.

Although the bourgeoisie and the nobility were strictly divided in terms of status, the two classes regularly converged within the political and economic domain, fuelling a constant exchange that sparked the same transference processes as taking place between the sacred and the secular spheres. Objects having the same function were created alike even if they were commissioned by members of different social echelons. This is clearly apparent in corporate and official insignia. What was true of the above-mentioned goblets was true of ceremonial shields and chains, of which perhaps the most lavish example is the ceremonial chain of the Munich Fraternity of Crossbowmen and Arbalestiers, whose shields were variously presented by Bavarian dukes and Munich patricians (ills. pp. 359–63). Yet a village confraternity in the Lower Rhine boasted a chain almost equally as splendid, fashioned in parcel-gilt silver and adorned with figures (ill. p. 365). It was only natural that the guilds themselves should attach importance to the fitting design of their own ceremonial items, even when these were made not of precious silver but of tin (ill. pp. 474/75). The material from which an item was fashioned was certainly not without significance, since it provided an immediate clue to the object's status, but the choice of material ultimately imposed no restrictions

on the decoration. Thus an earthenware flask might be lovingly decorated with scenes from the Bible and Roman history (ill. p. 113), and famous masters depicted elaborate religious cycles on their clay jugs (ill. p. 133).

The ambitious editors of *Kunstwerke und Geräthschaften des Mittelalters und der Renaissance* provide an entire panorama, in their illustrated plates, of applied-arts production in the pre-modern era. Costly items of jewellery such as necklaces, pendants, amulets and finger rings incorporating representations of the Virgin and the saints were intended to demonstrate the fervent faith of their wearers (ills. pp. 283, 333, 441). Exquisite toiletry items, richly carved cupboards, tiled stoves decorated with coats of arms, soldiers and saints as true fortresses of programmatic art (ill. p. 415) and outstanding examples of goldsmithery, together with the reliquaries, monstrances, chalices, candelabra and other items of religious worship – all are monuments to a lost world.

The presentation of these objects was a pioneering act of scholarship in the 19th century, when art-historical research was still in its infancy, and the publication rapidly rose to become a standard work. A second edition was soon prepared, in which *Kunstwerke und Geräthschaften* was combined with the three-volume *Trachten des christlichen Mittelalters* (Costumes of the Christian Middle Ages), which Hefner-Alteneck had been compiling and publishing since 1840. The new edition, which appeared in instalments between 1879 and 1889, fused the two works, introduced further examples of decorative art from the 17th and 18th centuries, and presented the individual objects in chronological order, so that the evolution of art production could be retraced step by step. In this revised and updated form, the anthology – which had now swelled to ten volumes – would continue to serve as a work of reference until well into the 20th century. It represented a veritable treasure trove whose virtue was to present art as the document of a past culture. In his memoirs, Hefner-Alteneck explained: "Once the first work [*Costumes*] was progressing well, I perceived that it would be most useful if, in addition to this latter, which treats man's immediate environment, i.e. costumes, arms, jewellery etc., a second one were to appear that went a step further and faithfully reproduced man's broader environment, in other words utensils of all kinds, both for everyday use and for luxury purposes, in different centuries. It was given the title: *Artworks and Artefacts of the Middle Ages and the Renaissance.*"

In deliberately choosing to focus upon objects understood to belong to everyday life, Hefner-Alteneck was not proceeding from the distanced perspective of the historian, however. Rather, the editor was anxious that the witnesses of the past should pollinate the art of the present. By the mid-19th century, human sensibility no less than social reality was feeling the impact of the rapid advance of the industrial revolution. The general atmosphere of radical change brought with it a profound sense of insecurity, which extended to the arts. "In what style shall we build?" ran the highly revealing

Ill. 4
**Virgin and Child on the Crescent Moon / Muttergottes auf der Mondsichel /
La Mère de Dieu sur le croissant de lune**
Tilman Riemenschneider, Würzburg, c. 1516–1522. Sandstone, 156.5 x c. 56 x 23 cm / 61 ½ x c. 22 x 9 in.
Frankfurt am Main, Liebieghaus Skulpturensammlung

title of numerous articles published in architectural journals. A widespread solution was to look back to the monuments of the past, which now became models for the architecture of the present. It was the heyday of historicism: new churches, palaces, public buildings and private residences sprang up in the Gothic and Baroque styles, and historicist forms were even invoked, paradoxically, in the design of brand-new types of building. Thus libraries, museums and even railway stations appeared in the guise of Greek temples or clad in Renaissance dress.

A major factor motivating this return to the past was the recognition that craft and design skills were being lost with the rise of industrialization, and consequently that product quality was diminishing. Like architecture, therefore, the decorative arts of the past also became a model for the present. Historicist artists purchased earlier works of art as inspiration for their own œuvre, in some cases building up a substantial private library of such visual resources. One such was the French architect Hippolyte Destailleur (1822–1893), whose comprehensive collection of woodcuts, etchings and engravings, incorporating designs from the Late Gothic, Renaissance, Baroque and Rococo eras, was acquired for the Berlin Museum in 1879 and laid the foundation for the largest collection of ornamental engravings in the world. From the middle of the 19th century onwards, state initiatives led to the creation of museums devoted specifically to the decorative arts and design, in which contemporary artists could study the handcrafted masterpieces of earlier epochs. The very first of these was the South Kensington Museum (today the Victoria and Albert Museum) in London, founded in 1852. Next came the Museum für Kunst und Industrie in Vienna in 1871, followed by a rapid succession of similar institutions in Berlin, Leipzig and Hamburg.

One exponent of this view that the works of the past could serve as models for the present was the joint editor of *Kunstwerke und Geräthschaften*, Jakob Heinrich von Hefner-Alteneck. He was born in 1811 in Aschaffenburg, into a prosperous middle-class family with extensive branches in the Rheingau and what was then the Electorate of Kurmainz. His great-grandfather, grandfather and father (the latter ennobled in 1814) were all lawyers, whereas his mother was the owner of a publishing house based in Bamberg and Würzburg, whose catalogue included Hegel's *Phenomenology of Mind*. The Hefner home was renowned for its hospitality and its substantial collection of art. Despite the fact that Jakob Heinrich lost his right arm in a riding accident as a child, he did not let this discourage him and took intensive private tuition in order to develop his exceptional gift for drawing. He was able even as a youth to make copies of the miniatures in the *Hallesches Heiltum* in Aschaffenburg palace library and later went on to draw most of the outstanding illustrations for his own books, including those in *Kunstwerke und Geräthschaften*. His interest in art and its history was awakened early on and was broadened by the many trips that he made with his father to visit collections in Vienna, Innsbruck, Munich, Nuremberg and Regensburg. When his father became part owner of an earthenware factory in 1832, Jakob Heinrich

ILL. 5
Armchair / Armsessel / Fauteuil à accoudoirs
Peter Flötner, Nuremberg, 1535. Pen and India ink on paper, 19 x 15.5 cm / 7 ½ x 6 in.
Staatliche Museen zu Berlin, Kupferstichkabinett

took over as its artistic director. He also taught drawing in his spare time and, in 1836, was awarded the title of professor. His real interest, however, lay in the history of art and its documentation. In 1838 he published the first of his portfolios, *Beitrag zur Geschichte der deutschen Goldschmiedekunst, besonders des XVI. Jahrhunderts* (On the History of German Goldsmithery, Particularly of the 16th Century), with which he obtained his doctorate at the University of Giessen in 1840. Wishing to devote himself entirely to his publications, he left the factory that same year and started work on *Trachten des christlichen Mittelalters*. He then conceived the idea of publishing *Kunstwerke und Geräthschaften* in tandem with this first title. As he wrote in his memoirs: "My time and energy, like those of my publisher, were so consumed by the first work, which was still in the process of publication, that I had to look around for another publisher and another editor. I found the first in Heinrich Keller in Frankfurt am Main, the second in Karl Becker, who, although an expert on antiques, was not a draughtsman. He arranged for skilled artists to make drawings of the old originals for me, whereby the large part of the work fell to myself." From the signatures on the plates, it is evident that Hefner-Alteneck indeed executed the majority of the originals himself.

Born in 1794, Karl (spelled "Carl" on the title pages) Becker reached Paris as a soldier with the allied troops after the victory over Napoleon in 1814. There, he was introduced to connoisseurs of art and was later active in his home in Würzburg as an art expert and collector. In 1840 he wrote the first monograph on Tilman Riemenschneider, an artist at that time still largely forgotten, whose *Virgin and Child* (ill. 4 and ill. p. 177) Becker himself owned. In 1852 Becker made efforts to locate works by the important Late Gothic artist for the newly founded Germanisches Nationalmuseum in Nuremberg. He died in 1859 and thus did not see the completion of *Kunstwerke und Geräthschaften*. It is thanks to him, however, that many objects from Würzburg found their way into its pages.

Even if Hefner-Alteneck, adopting an alphabetical order in the title, allowed the name of Carl Becker to precede his own, *Kunstwerke und Geräthschaften* was undoubtedly primarily his own achievement – something of which his contemporaries were also aware. When Hefner-Alteneck moved to Munich in 1852, he was elected a member of the Bavarian Academy of Sciences and one year later was placed in charge of the Combined Royal Collections. In 1861 he took over as head of the royal cabinet of prints and drawings. In 1868 King Ludwig II appointed him general director of the monuments and antiquities of Bavaria and a few months later Hefner-Alteneck was made director of the Bayerisches Nationalmuseum. His activities there were not uncontroversial, as he pursued a rigorous acquisitions and display policy that focused upon the collection of works from earlier epochs as models for the applied arts of his own day. He redesigned the exhibition galleries laid out by his predecessor, Baron Karl Maria Freiherr von Aretin, director of the museum since its foundation, bought non-Bavarian objects for the collection and broadened the museum's focus to include German art in general, while continuing to publish further anthologies. The hostility aroused by his actions led him to become increasingly bitter. His application for retirement was turned down because there were still curators to be trained, and not until 1885 was he able to resign from office. He died in 1903 at the age of ninety-two.

Hefner was undoubtedly quite a character. It was typical of him that he should apply, in 1854, for an extension to his name. Even though his father's ennoblement meant that the middle-class

ILL. 6
Positive Organ / Tischorgel / Orgue de table
Peter Flötner, Nuremberg, 1527. Pen and India ink on paper, 21.2 x 17.9 cm / 8⅜ x 7 in.
Staatliche Museen zu Berlin, Kupferstichkabinett

Ill. 7
Front cover of the Gospels of St Kilian / Buchdeckel des Kilian-Evangeliars /
Couverture de l'évangéliaire de saint Kilian
Würzburg and Bamberg, mid-15th century and c. 1090
Frame 24.5 x 19 cm / 9⅔ x 7½ in. Relief 15 x 9.5 cm / 5⅞ x 3¾ in.
Würzburg, Universitätsbibliothek, Sign. M. p. th. q. 1a

"Hefner" was now preceded by the aristocratic "von," Jackob Heinrich still considered his surname to lack distinction. There was, moreover, another person by the name of Josef von Hefner active in the field of art history. To avoid confusion, Hefner proposed adding "Alteneck" – "old corner" – to his surname. It was an abbreviated reference to his job: having no books upon which to draw when it came to researching his own publications, he was obliged to hunt out his historical material in nooks and crannies, i.e. to track down the "old" in "corners." It was indeed true that no body of scholarly literature yet existed that might have provided him with pertinent information, and thus Hefner-Alteneck was obliged to travel extensively in his search for the objects of his interest. Some he found in the recently opened museums; he discovered the greater number, however, in churches, libraries and princely collections, and in the hands of art dealers and private individuals. At the end of the 1840s, he recalls in his memoirs, he was invited to Mainberg Castle near Schweinfurt, then owned by the manufacturer Wilhelm Sattler and his wife. The wealthy couple showed him their magnificent private collection and he was able to make drawings of several fine pieces (ills. pp. 111, 117, 213).

He undoubtedly incurred considerable expense in the course of his research, but he was regularly compensated by the discovery of rare, curious and beautiful works of art. The high regard in which he was held by the owners of such collections is demonstrated by his visit to Weimar, where he had gone to look at a Netherlandish nautilus cup in the grand-ducal collections. The Grand Duchess lent him the valuable and fragile cup on the spot, so that he could take it back to his apartment and draw it in peace. When it came to illustrating the cup in *Kunstwerke und Geräthschaften*, however, he and his co-editor, Becker, opted for a drawing by Friedrich Preller (1804–1878), at that time a highly regarded painter and the head of the Weimar Academy of Drawing (ill. p. 221). Why they chose Preller's original over Hefner-Alteneck's, we do not know; perhaps Hefner-Alteneck wished to pay homage to the Grand Duke, under whom Preller held a post similar to that of court artist. It was not a good decision, for the Weimar artist placed too much emphasis on painterly and compositional effects.

A reassuring contrast is offered by the very precise representation of the large covered goblet in Wiener Neustadt, which strives for documentary accuracy (ill. p. 107). The original for this plate was executed by Georg Christian Wilder (1797–1855), a Nuremberg draughtsman and etcher renowned for his highly detailed watercolours and pen, ink and sepia drawings of art objects, rendered with reliable precision in a palette both harmonious and accurate. The illustrations of the nautilus cup and the covered goblet demonstrate the stylistic breadth spanned by the plates of *Kunstwerke und Geräthschaften*.

By comparison with modern art-historical research, which values and respects the monuments of the past both as witnesses to their epoch and as works of art in their own right, scholars in the 19th century – the age of historicism – got somewhat carried away by their own enthusiasm. They proceeded in the conviction that they understood the course of history; from their position of hindsight, they felt armed with an overview that allowed them to correct flaws and defects in traditional styles. Just as architects, in their neo-Gothic, neo-Renaissance and neo-Baroque designs, invoked the typical forms of the style in question more systematically than the buildings

serving as their models, and in this very way created something new and original bearing only an external resemblance to the past, so too the documentation of art history was approached with greater self-confidence and independence. For this reason, the plates in *Kunstwerke und Geräthschaften* show us not simply pictorial copies of originals, but reproductions and reconstructions. The editor had no scruples about reorganizing views of objects (ills. 15–16 and ills. pp. 89, 99–101), adding new ones (ill. p. 73), and cosmetically enhancing partly damaged objects (ills. pp. 73, 177, 345–49, 413, 443, 485).

The fact that Hefner-Alteneck and Becker themselves collected art on a substantial scale and compiled the material for their publication from their position as connoisseurs was also characteristic of the day. Hefner-Alteneck recalls some of his more interesting and important acquisitions in his memoirs. In 1846, for example, he was offered a roll of paintings on parchment by the Bamberg antiques dealer Leo Kronacher. Having bought them, Hefner-Alteneck not only managed to identify them as works by the Munich court artist Hans Mielich (1516–1573), but was also able to recognize amongst their miniatures jewels and treasures belonging to the Duke of Bavaria, Albert V, and his wife, Anne of Austria. The objects painted by Mielich represent masterpieces of 16th-century goldsmithery and Hefner-Alteneck copied the most remarkable of them for inclusion in his *Kunstwerke und Geräthschaften* (ills. pp. 85, 89, 99–101). The chain and pendant comprising the item of a necklace (ill. p. 89) are not only reproduced in the miniatures owned by Hefner-Alteneck, but are also illustrated in the *Kleinodienbuch der Herzogin Anna* (The Duchess Anne's Book of Jewels) painted by Hans Mielich and today housed in the Munich Staatsbibliothek (Cod. Icon 429), where they appear on separate plates (ills. 15, 16). Along with paintings on parchment, the editor also purchased design drawings (ills. pp. 123–25). Above all he collected originals. The editor's passion for collecting embraced the full spectrum of the applied arts. He acquired old prayer books in the leather bags in which they were carried (ill. p. 565), elaborate book covers (ill. p. 393), ivory mirror cases (ill. p. 229), a magnificent goblet (ills. pp. 559–63), numerous items of jewellery (ills. pp. 257–259, 283, 307–309, 559) and even nail heads (ill. p. 191), hand towels (ills. pp. 172–73) and tablecloths (ill. p. 299). Becker was just the same. Along with outstanding sculptures, such as Riemenschneider's *Virgin and Child on the Crescent Moon* (ill. 4 and ill. p. 177), other pieces from Becker's private collection reproduced in *Kunstwerke und Geräthschaften* include pots and caskets (ills. pp. 93, 141), jewellery (ill. p. 283), a tablecloth (ill. p. 165), spoons and design drawings for spoons (ill. p. 115). Even more important, however, for the compilation of the anthology were the contacts cultivated with other collectors and connoisseurs of art. The editors acted as the hub of a veritable network, whereby Becker's primary task lay in gathering information and advice about works and then commissioning artists to make drawings of the originals, which served, in turn, as the basis of the engravings. The fact that *Kunstwerke und Geräthschaften* was shaped largely by individual knowledge and personal contacts means that the objects we find on its pages are sourced primarily from German, above all south German, collections, alongside a smaller number of pieces from Italy, France and the Netherlands.

Years went by before publication of the work, which was organized into three volumes of seventy-two plates each, was finally complete. Fortunately, its progress was not disrupted by any

noteworthy external factors and was probably facilitated, too, by Hefner-Alteneck's appointment as head of the Combined Royal Collections in Munich a year after the appearance of the first volume. By contrast, the publication of *Trachten des christlichen Mittelalters* had been beset with difficulties: planned from 1839 and issued from 1840, the project became caught up in the whirlpool of historical events. The publisher, Heinrich Hoff in Mannheim, was involved in the 1848 revolution and had to flee to America, leaving his publishing house to go bankrupt. A successor was found in Heinrich Keller in Frankfurt am Main, who subsequently also published *Kunstwerke und Geräthschaften* and later the new, joint edition of the two works, issued between 1879 and 1889.

These were decades of great political upheaval. In 1848 a national assembly was convened and then dissolved. In 1864 Prussia and Austria joined forces to defeat Denmark, thereby winning the duchies of Schleswig, Holstein and Lauenburg, but in 1866 took up arms against each other. Prussia's victory resulted in the abolition of the German Confederation and the formulation of the "Lesser German Solution", which proposed a unification of Germany's Protestant-dominated northern states that excluded Catholic Austria. Another Prussian victory in the Franco-Prussian War led in 1871 to the proclamation of the King of Prussia as German Emperor and so to the founding of the German Empire.

Thus the Bavarian public official Hefner-Alteneck, an ardent supporter of German nationalism, found himself part of a new leading European power. Politics, the economy and the arts proceeded to flourish during the years up to his death – years characterized above all by one thing: change. Collections were reorganized and combined, museums were founded, and princely and private art collections alike assumed different faces. Works of art were bought and sold and it became hard to keep track of their provenance. In the new, joint edition published under the title of *Trachten, Kunstwerke und Geräthschaften* (Costumes, Artworks and Artefacts), the editor updated ownership details wherever he could, but all too frequently had to confess his ignorance and resort to phrases such as "formerly in the possession of."

This is still the position in which we find ourselves today. *Kunstwerken und Geräthschaften* bears witness to the enduring fact that change is the sole constant in human life. Two world wars and the devastation thereby wreaked upon cities, the establishment of different political systems and the redrawing of national and geographic boundaries all left their mark and had adverse consequences for the protection and preservation of artworks. Many of the objects illustrated on the plates have been lost forever. More than ten documented objects and groups of objects from the Berlin museums have been missing since 1945 (ills. pp. 209, 245, 253, 257–59, 277, 307–09, 313, 333, 411, 540/41, 569–73), while others suffered wartime damage (ills. 18 and ills. pp. 207, 237). The damage to Würzburg's cathedral treasury was hardly less great: two reliquary caskets and a ewer (ills. pp. 183, 199, 223) were lost in the war, whereby an accompanying basin, missed in an inventory drawn up in 1915, subsequently came to light in a cupboard (ill. p. 199). Riemenschneider's table for Würzburg council was saved – but with the loss of its original top (ill. p. 161). A reliquary shrine belonging to the city of Nuremberg and today housed in the Germanisches Nationalmuseum is now also lacking several of its parts (ill. pp. 324/25). But not everything was destroyed. Important pieces in the Quedlinburg cathedral treasury disappeared in 1945 because – as it later transpired –

they had been stolen. They were restored to the treasury only in 1992 (ills. 17, 22 and ills. pp. 203, 215). Perhaps the famous Rupertsberg Codex, missing from the Hessische Landesbibliothek in Wiesbaden since 1945, suffered a similar fate (ill. p. 195).

War and destruction represent just one facet of the historical process, however; economic crises and changing interests make up two more, and did not spare even the collections of famous noble houses. In 1928 the Hohenzollern art collection from Sigmaringen palace was sold at auction in Frankfurt. Parts of the collection thereby passed into public ownership (ills. pp. 303, 401–07), while others disappeared from view (ill. p. 453). And although the important collection of art assembled by the Counts of Erbach – purchased a few years ago by the State of Hesse – has survived in good condition, certain pieces documented in *Kunst und Geräthschaften* have nonetheless disappeared (ills. pp. 179, 187). It is here that scholarship plays a highly beneficent role, since the works it publicizes, and whose importance it correspondingly underscores, can be much more easily traced. A case in point is the Rospigliosi Cup, which around 1850 was still in the possession of the noble family in Rome from which it takes its name, but which later reached America and is today housed in The Metropolitan Museum of Art in New York (ill. 24 and ill. p. 151). The cup – which was only recently recognized as a forgery – is illustrated in all major standard works on goldsmithery and cannot now vanish without being noticed. The same is true of many other such cases discussed in the specialist literature (cf. the bibliography in the appendix). When family ambitions coincide with the transformation of the family seat into a museum, important objects are not only preserved but are opened up to public view (ills. pp. 577–79).

Public collections strive to fulfil their task of preserving the artworks of the past and to make new acquisitions, insofar as their funds permit. Thus the Delft nautilus cup passed from the ownership of the Grand Duchy of Weimar into that of the Delft Museum (ill. p. 221), and the tiny portable altar that probably once belonged to Mary, Queen of Scots, into the possession of the Victoria and Albert Museum (ills. pp. 419–23). The latter is also home to one half of the two–part tapestry from the Alsace, the whereabouts of whose second half is unknown (ill. 25 and ills. pp. 511–27). Some of the pieces illustrated in *Kunstwerke und Geräthschaften* have travelled a long way since they were located by the editors. One such is the Norwegian church seat (ills. pp. 263–65). Franz Wilhelm Schiertz of Leipzig, who studied at the Dresden Academy of Art under the Danish Romantic painter Johan Christian Clausen Dahl (1788–1857), discovered the chair in 1837, in the course of executing drawings for the publication of his teacher's *Denkmale einer sehr ausgebildeten Holzbaukunst [...] Norwegens* (Monuments of Norway's Highly Developed Art of Woodworking). Dahl thereupon purchased the chair and is named as its owner by the editors of *Kunstwerke und Geräthschaften*. The chair subsequently changed hands a number of times before being sold at auction in 1936 as part of the posthumous estate of the Austrian banker and art collector Albert Figdor. It was bought by an Oslo art dealer, who sold it again that same year to the Kunstindustrimuseet in the Norwegian capital, where the chair is still housed .

The fact that many works are now in private collections means that even our new edition is unable to name the current owner in every case and can only cite an object's last documented location. This new edition nevertheless places a major standard work of the 19th century and a

Ill. 8
"St Henry's Cup" / „St.-Heinrichs-Kelch" / « Calice de saint Henri »
Fatimid, c. 1000; German, 12th century
Rock crystal, silver gilt, gems, h. 13 cm / 5 in., footplate ø 11 cm / 4⅜ in.
Munich, Residenz, treasury

pioneering act of art history at the disposal of the modern reader. A testament to the scope and vision of book-making in the past, it presents a panorama of surviving and lost objects in an abundance of magnificent illustrated plates, and thereby makes a veritable jewel of publishing accessible to all.

The dates appearing in the plates accompanied the original 19th-century publication; those given in the captions correspond to the current state of scholarship.

„Kunst im Bild"

Hefner-Altenecks und Beckers Darstellung der Kunstwerke des Mittelalters und der Renaissance

CARSTEN-PETER WARNCKE

Es ist der Geist einer anderen Zeit, der uns entgegentritt, blättern wir durch die Bildtafeln der *Kunstwerke und Geräthschaften*. Liebevoll, bis ins kleinste Detail genau gezeichnet sind diese Abbildungen und unaufdringlich die Farben – ohne übertrieben koloristische Effekte, nur selten bunt, dafür manchmal fast monochrom –, aber niemals eintönig und immer bemüht, ihren Gegenstand genau wiederzugeben und zugleich künstlerisch zu interpretieren. Keine fotografischen Reproduktionen, wie wir sie von unseren Kunstbüchern gewohnt sind, keine suggestiven Hochglanzseiten, die zart hingetuschte Aquarelle leuchten lassen wie Ölgemälde und zum Schillern bringen wie Lichtreflexe prunkvoller Pokale. Sicherlich ist das den damaligen technischen Bedingungen geschuldet, man war in der Mitte des 19. Jahrhunderts noch nicht in der Lage, die wenige Jahrzehnte vorher entwickelte Fotografie zur Illustration von Kunstbüchern einzusetzen. Das Farbfoto war noch lange nicht erfunden, und die lithografischen Drucktechniken steckten noch in den Kinderschuhen. Aber der Wahl des aufwendigen Reproduktionsverfahrens lag auch ein präziser Wille, eine wohl erwogene Absicht zugrunde. Lassen wir dazu einen der beiden Herausgeber, Jakob Heinrich von Hefner-Alteneck (Abb. 1), zu Wort kommen, der 27 Jahre nach dem Erscheinen der *Kunstwerke und Geräthschaften* eine zweite Auflage herausgab, in die er auch eine andere, schon früher begonnene Publikation mit aufnahm. Im Vorwort dazu schrieb er: „Die bildlichen Darstellungen dieser beiden nun vereinten Werke bestehen in Kupfer- und Stahlstichen, welche bei der gemalten Ausgabe nach meinen für diesen Zweck gefertigten Vorlagen durch geübte Koloristen ausgeführt wurden. Damals konnte ich mich noch nicht zur Anwendung des Farbendruckes entschließen, weil durch denselben die Schärfe und Bestimmtheit der Zeichnung, welche doch die Hauptsache bleibt, zu sehr gelitten hätte. Erst durch den Fortschritt

ILL. 9
Book cover / Buchdeckel / Couverture de livre
Ulm, early 16th century. Wood, velvet, silver, 26.5 x 20 cm / 10¼ x 7⅞ in.
Nuremberg, Germanisches Nationalmuseum

neuerer Zeit ist es gelungen den Kupferstich mit dem Farbendruck so zu vereinigen, dass ersterer seine volle Geltung behält und letzterer bei voller Klarheit der Farbe den Charakter einer Aquarellmalerei wiedergibt." Es ging nicht bloß um Reproduktion, um abbildliche Wiederholung, es war dem ambitionierten Autor Hefner-Alteneck auch daran gelegen, den besonderen Charakter der Druckvorlagen zu erhalten. Sie sind in der Tat auf ihre Art Kunstwerke eigenen Rechts. Zwar nehmen sie den Objekten, die sie uns vor Augen stellen, das Besondere ihrer materiellen Beschaffenheit, aber sie fügen auch keine Effekte hinzu. Im Wissen um ihre technischen Grenzen und in klarer Erkenntnis der Dialektik aller Imitation, die niemals Identität erreichen kann und trotz aller Ähnlichkeit immer dem Vorbild gegenübersteht, bescheiden sie sich damit, kolorierte Zeichnungen zu sein. Sie sind Produkte des beobachtenden Blicks und der überlegt eingesetzten, geschulten Hand, nicht der Mechanik des Apparates – also Werke der Kunst im ursprünglichen Sinne. Damit entsprechen sie auch den Entwürfen, die Künstler in den vormodernen Epochen vorlegten, um Auftraggeber für ihre Arbeiten zu gewinnen, Entwürfen, wie sie auch Tafeln in diesem Werk zugrunde liegen (Abb. 5, 6 und Abb. S. 204, 211, 585).

Der gesamte Produktionsprozess von den zeichnerischen Entwürfen über den Druck bis hin zur Kolorierung war sehr aufwendig, und dementsprechend teuer wurde eine solche Veröffentlichung. Seit Ausgang des 18. Jahrhunderts hatte sich eine zweckmäßige Form eingebürgert, um eine derartige Publikation zu finanzieren: Man brachte nicht abgeschlossene Bände heraus, sondern einzelne Lieferungen in zeitlichen Abständen zum stückweisen Erwerb. Damit zog sich das Erscheinen über einen längeren Zeitraum hin, und es erfolgte die Vollendung der Teile in Abständen von fünf, sechs Jahren. Der erste Band der *Kunstwerke und Geräthschaften* ist 1852 datiert, der zweite 1857 und der abschließende dritte 1863.

Die Finanzierung war jedoch nicht der einzige Grund für die Publikationsdauer. Ins Auge sticht nicht allein die künstlerische Qualität der Abbildungen, sondern auch die Heterogenität der rund 400 Gegenstände auf 216 Tafeln. Der Publikationszeitraum von elf Jahren ermöglichte es, Darstellungen unterschiedlichster Gegenstände aus den verschiedensten Orten zusammenzutragen. Neben Schränken für den Gebrauch im gehobenen Haushalt finden wir exklusive Erzeugnisse der Goldschmiedekunst, Schlosserarbeiten stehen neben Holz- und Elfenbeinreliefs (Abb. 2, 3 und Abb. S. 143, 385), profane Trinkgefäße folgen auf liturgisches Gerät wie Weihrauchfässer und Weihwasserkessel. Amtsinsignien wie Bischofsstäbe haben ihr Gegenüber in fürstlichen Prunkwaffen, Kirchenstühle reihen sich an Fingerringe und Halsketten, Löffel und Messer befinden sich in enger Nachbarschaft zu Reliquiaren, den ehrwürdigen Monumenten der Heiligenverehrung. Nur die oft herausragende Schönheit der Objekte und die subtile Meisterschaft ihrer Bearbeitung bewahrt davor, in der Fülle der Tafeln ein bloßes Sammelsurium in Buchform zu sehen. Ganz offenkundig gibt es keine ersichtliche Systematik der Zusammenstellung, und auch eine sinnvolle zeitliche Abfolge erschließt sich nicht, denn als Buchdeckelzier verwendete Elfenbeinreliefs aus dem 11. Jahrhundert werden z. B. von Handtüchern aus dem frühen 16. Jahrhundert begleitet, und auf einen früh-, bzw. hochmittelalterlichen Prunkkamm folgt eine Musterzeichnung aus der Mitte des 16. Jahrhunderts für eine tragbare Orgel, nach der wiederum geschnitzte Schachfiguren des 14. Jahrhunderts dargeboten werden (Abb. S. 203–207). Die Tatsache, dass Hefner-Alteneck und

Becker in ihrer Publikation eine derartige Vielfalt unterschiedlicher Artefakte vereinen und die
einzelnen Werke gleichwertig nebeneinanderstellen, erklärt sich, wenn man einen Blick auf den
damaligen Stand des kunsthistorischen Wissens wirft.

Zentrale Bedeutung hatten in der Mitte des 19. Jahrhunderts die öffentlichen Museen, deren
Einrichtung eine kulturgeschichtliche Neuerung war. Aus den Kunstschätzen der Fürsten und
großen adeligen Dynastien wurden allmählich allgemein zugängliche, als bürgerliche Bildungsstät-
ten verstandene Institutionen. Die Französische Revolution hatte dafür den Weg geebnet, und aus
den vereinzelten Initiativen aufgeschlossener Regenten entwickelte sich eine staatliche Aufgabe.
Es brauchte jedoch Jahrzehnte, bis öffentlich zugängliche Museen, die für uns heute selbstver-
ständlich geworden sind, verwirklicht werden konnten: 1753 wurde in London durch Beschluss des
Parlaments das British Museum gegründet, 1793 das Muséum central des arts de la République im
Louvre, aber erst 1891 konnte, nach jahrelanger Vorgeschichte, das Kunsthistorische Museum in
Wien eröffnet werden.

Diese Museen benötigten Fachleute, um die in ihnen versammelten Objekte zu erschließen, aber zunächst existierte kaum eine systematische kunstwissenschaftliche Ausbildung. Die ersten Lehrstühle für die akademische Disziplin waren gegründet worden, um andere Studiengebiete bildungsmäßig zu ergänzen. Die kunstgeschichtliche Publizistik lag vielfach in den Händen von Liebhabern und Sammlern. Eine prägende Persönlichkeit des jungen Faches wie Carl Schnaase, der Verfasser einer fünfbändigen Geschichte der bildenden Künste, war kein Fachmann im engeren Sinne, sondern ein Jurist, der sich erst nach seiner Pensionierung 1857 ganz kunsthistorischen Studien widmen konnte. Ihm stand Franz Kugler gegenüber, der seit 1844 eine ordentliche Professur für Kunstgeschichte an der Berliner Universität innehatte und bereits seit 1843 im preußischen Kulturministerium als Dezernent für Kunstsachen zuständig war. 1837 publizierte Kugler sein *Handbuch der Geschichte der Malerei* und 1842 das *Handbuch der Kunstgeschichte*. Beide Wissenschaftler vertraten unterschiedliche – aber in der Auseinandersetzung mit der idealistischen Kunstphilosophie Hegels entwickelte – universalistische Positionen mit deutlichem Schwerpunkt in den Gattungen der Architektur, Malerei und Skulptur, die als Hochkunst angesehen wurden.

Diese Beschränkung empfanden die Herausgeber der *Kunstwerke und Geräthschaften des Mittelalters und der Renaissance* als Defizit, und so formulierten sie programmatisch in der Einleitung des ersten Bandes: „Das Bestreben der Herausgeber dieses Werks, ist vorzugsweise dahin gerichtet, eine übersichtliche Reihenfolge von größtentheils unbekannten Kunstgebilden der Vorzeit, von der frühesten christlichen Epoche beginnend, bis zum Anfange des XVI. Jahrhunderts mitzutheilen, welche als Gegenstände des täglichen Gebrauchs, oder des Luxus, zu kirchlichen oder weltlichen Zwecken, einen Maaßstab für die Entwickelung der Cultur und der Civilisation, in den verschiedenen Jahrhunderten darbieten[...] [Hier] werden [...] die, den Kunstsinn und die Geschmacksrichtung bekundenden kleinern Werke, aus den verschiedenen Epochen, in getreuen Abbildungen vorgelegt, die zum nothwendigen Bedürfnis oder zum Schmuck der Kirchen, Palläste oder bürgerlichen Wohnungen geschaffen wurden und welche außer dem feinsten Geschmack und der vollendetsten Technik zugleich zeigen, nach welchen Prinzipien man in der Vorzeit verfuhr, um diese, mit der Baukunst und Bildnerei im engsten Zusammenhang stehenden Werke, dem Style der Zeit angemessen darzustellen. Während in neuerer Zeit, die größern Werke der Architektur, Plastik und Malerei, Gegenstände eifriger Forschung und Mittheilung waren, ist bisher für diese, dem Menschen zunächst stehenden Kunstgebilde nur Weniges geschehen."

Heute bezeichnen wir diese Objekte als Erzeugnisse des Kunsthandwerks, ein Begriff, der die Vorstellung von einer prinzipiellen qualitativen Unterschiedlichkeit der Kunstproduktion voraussetzt. Diese Unterscheidung ist jedoch weitgehend unhistorisch, sie war den vormodernen Epochen unbekannt. Erst im Verlauf des 16. Jahrhunderts begann sie sich herauszubilden und setzte sich dann im 18. Jahrhundert durch. Wie wenig sie mit der geschichtlichen Realität übereinstimmt, zeigen uns die in Hefner-Altenecks Tafelwerk versammelten Objekte. Der bedeutende spätgotische Bildhauer Tilman Riemenschneider (um 1460–1531) schuf nicht nur seine berühmten Schnitzaltäre und monumentalen Statuen wie die *Muttergottes auf der Mondsichel* (Abb. 4 und Abb. S. 177), sondern auch einen Tisch für den Rat der Stadt Würzburg (Abb. S. 161), dem er selbst

angehörte. Er war sogar 1520/21 Bürgermeister. Die Gestaltung eines Gebrauchsgegenstandes war in der damaligen Zeit derjenigen einer Skulptur gleichwertig – eine Tatsache, die heute bezeichnenderweise aus dem Bewusstsein der meisten verschwunden ist.

Auch die Spiegelkapseln (Abb. 3 und Abb. S. 229, 317, 385) sind Spitzenerzeugnisse der Elfenbeinschnitzkunst, wobei bereits die Kostbarkeit des Materials ihre Wertschätzung garantierte. Es wurde viel Mühe darauf verwandt, einen aus heutiger Sicht trivial anmutenden Gegenstand wie einen Handspiegel als Kunstwerk zu gestalten. Das seltene und mühsam zu beschaffende Elfenbein war den Angehörigen der gesellschaftlich höchsten sozialen Schicht vorbehalten, die sich das Material leisten konnten. Diese Aristokratie legte Wert darauf, nicht allein handwerkliche Virtuosität auf Spitzenniveau zu erhalten, sondern auch, gleichsam wie in einem doppelten Spiegel, die Ideale und Konventionen ihrer exklusiven Lebensführung wiedergegeben zu finden. Als Toilettenartikel der Schönheitspflege wurden die Handspiegel von Frauen benutzt, die sich an Darstellungen der Minnethematik erfreuten, jener im Hochmittelalter entwickelten Überhöhung des Verhältnisses zwischen den Geschlechtern, das die Denkweise adeliger Damen prägte, sich jedoch in der Realität des Alltags nicht wiederfand. Die Spiegelkapseln sind kulturgeschichtliche Zeugnisse ersten Ranges, denn sie führen vor Augen, wie die in der Literatur überlieferten Themen, Geschichten und Motive zur Anschauung gebracht wurden und – mehr noch – wie prägend sie die alltägliche Existenz beeinflussten, wenn jeder Handgriff die Nutzerinnen damit konfrontierte.

Größere Wandspiegel (Abb. S. 495) und Kämme, die Werkzeuge der Schönheitspflege, waren oft ebenso gestaltet, auch dann, wenn letztere nicht aus edlem Elfenbein, sondern aus dem günstigeren Buchsbaum gefertigt worden waren. Ihr Dekor konnte Klassiker der Minnedichtung zeigen, wie die Geschichte von Tristan und Isolde (Abb. S. 429). Nicht allein die einseitige Fixierung auf die sogenannte Hochkunst vermag uns das Lebensgefühl und die Gedankenwelt längst vergangener Zeiten und ihrer Menschen zu vermitteln; das kann nur die Fülle der materiellen und immateriellen Überlieferung in ihrer ganzen Breite. Schließlich beschränkte sich die bildliche Darstellung der von den Minnesängern gedichteten und vorgetragenen Legenden und Historien nicht auf Gebrauchsgegenstände, ihre Verbildlichung erstreckte sich auch auf den Schmuck der Räume, und den bildeten in erster Linie nicht etwa Wandgemälde oder Tafelbilder. Die zugigen und auch bei Fürsten nur mangelhaft geheizten Räumlichkeiten in den Burgen und Palästen stattete man vorzugsweise mit Wandteppichen aus.

Diese hatten den Vorzug, das Angenehme mit dem Nützlichen zu verbinden, indem sie das Ausstrahlen der Kälte und teilweise auch die Feuchtigkeit der Wände abhielten und zugleich durch ihre anmutigen Darstellungen den Blick gefangen nahmen. Da konnte man dann etwa die Szenen des altfranzösischen, auch im deutschen Raum bekannten Epos der Liebe von Willehalm und Amelie sehen (Abb. S. 401–407). Ideale, Überzeugungen und Konventionen des gesellschaftlichen Lebens und der ihnen zugrunde liegenden Weltanschauung waren dadurch allgegenwärtig.

So nimmt es nicht Wunder, dass auch Zeugnisse der Religiosität und des christlichen Glaubens auf profanen Gerätschaften zu finden sind (Abb. 14 und Abb. S. 267). Künstlerisch gestaltete Kämme boten Darstellungen der biblischen Geschichte wie die Verkündigung an Maria und den Besuch der Heiligen Drei Könige (Abb. S. 473). Interessant ist dies, weil es uns demonstriert, welche

ILL. 11
"Aschaffenburg Board Game" / „Aschaffenburger Brettspiel" / « Jeu de société d'Aschaffenbourg »
Rhenish (?), c. 1300
Wood, silver, jasper, earthenware, enamel, rock crystal, 46 x 34.5 cm / 18 ⅛ x 13 ⅓ in.
Aschaffenburg, Stiftmuseum, Stiftschatz St. Peter und Alexander

fundamentale Bedeutung der Ausschmückung damals zukam. Schon der Begriff des *decorum*, des Dekors, wurde seinerzeit viel umfassender verstanden und bezeichnete neben dem Zierrat auch das Angemessene, den Anstand, das Schickliche. Die künstlerische Durchmischung der Sphären des Lebens, der alltäglichen und der kultischen, war folgerichtig, und so beobachten wir eine prinzipielle Gleichartigkeit bei der Gestaltung von Funktionsobjekten. Was für die profane Existenz galt, hatte erst recht eine Funktion im Sakralen. So erhielten diejenigen Gefäße, die für Aufnahme der konsekrierten Gaben der Eucharistie eingesetzt wurden, eine Sonderrolle im Geschehen der Messe. Sie galten als *Vasa sacra*, als heilige Gefäße. Es erstaunt nicht, dass sich dies auch in ihrer Form niederschlug. Sie diente der praktischen Handhabung gleichzeitig brachte die Dekoration bei aller Beschränkung auf eine überschaubare Motivik, die dem knappen zur Verfügung stehenden Platz geschuldet war, die wichtigsten Themen des Glaubens zur Anschauung, seien es Engel, Heilige, Propheten (Abb. S. 501) oder die Kreuzigung und die Madonna mit dem Kinde (Abb. S. 189).

Visuelle Vergegenwärtigung führte im Spätmittelalter dazu, dass die geweihte Hostie, die nach katholischer Anschauung im Akt der Messe Transsubstantiation erfährt, also zum realen Leib Christi wird, in einem eigens entwickelten Behältnis aufbewahrt wurde, das ein reines Schaugefäß war und in dessen architektonischen Aufbau Christus und Heiligenfiguren eingefügt waren (Abb. S. 575). Selbst der reinen Aufbewahrung dienende Gerätschaften unterlagen diesem gestalterischen Grundsatz. Was unbefangenen modernen Blicken als Miniaturburg erscheint, erschließt sich dem Verständnis erst, wenn man sich in Erinnerung ruft, dass der Glaube und seine irdische Institution, die Kirche, als Festung galt, die dem himmlischen Jerusalem nachgebildet ist (Abb. S. 301).

Dieses Prinzip der Vergegenwärtigung erstreckt sich auch auf romanische Kirchenleuchter, deren Drachen und Dämonen in ihrer dienenden Stellung den Sieg des Lichts („Ego sum lux mundi": „Ich bin das Licht der Welt", Johannes 8,12) als Symbol des Guten über das Böse verkörpern, sprich den Sieg Gottes über den Teufel (Abb. S. 551). Auch die Handglocke, mit der während der Messe die liturgischen Abschnitte eingeläutet werden, wurde mit dem Reigen der Evangelistensymbole verziert (Abb. S. 217). Fast selbstverständlich ist, dass Kleidung und Schmuck kirchlicher Würdenträger (Abb. 10 und Abb. S. 227) und die Insignien kirchlicher Ämter mit Zierrat versehen sind, der die Verankerung des besonderen Status ihrer Träger in den Fundamenten der Kirche vorführt. Die besondere Bearbeitung des Materials, sei es bei Werken der Schnitzkunst (Abb. S. 243, 345) oder bei kunstvoll verarbeiteten Metallobjekten (Abb. S. 395, 465), unterstreicht die Wertschätzung, die immer eine doppelte ist. Die Krümmen der Bischofsstäbe bezeugen den Rang des Oberhirten, aber mehr noch rechtfertigen sie seine Stellung. So zeigen die Krümmen Darstellungen wie die Verkündigung (Abb. S. 465), den Gekreuzigten (Abb. S. 243), die Marienkrönung (Abb. S. 345) oder die Aufopferung für den Glauben im Exempel der Märtyrer (Abb. S. 395).

Den Glaubenszeugen, die sich durch ihre Vita und ihre Taten auszeichneten, galt traditionell besondere Verehrung. Diese fand ihren intensivsten Ausdruck im Reliquienkult, der nicht selten prunkvollen Bergung leiblicher Hinterlassenschaften von Heiligen. Es versteht sich, dass hier aufwendiger Dekor zur Anwendung kam, waren die Reliquien doch im wahrsten Sinne des Wortes „fassbar". Wunder wirkende Kraft sprach man ihnen zu und oft führten Wallfahrten zu den Orten ihrer Verwahrung. Reliquiare sind in einer unübersehbaren Fülle von Gebilden überliefert, vielfältig wie die Schicksale der Heiligen selbst, dem Wandel der Formen und Stile unterworfen, aber immer sprechend gestaltet. Da gab es Kästen und Kästchen zur Aufbewahrung (Abb. S. 427), komplette Schreine (Abb. S. 324/325), aber auch Büsten (Abb. S. 455) und Statuetten (Abb. S. 557). Auch das Zeichen des Glaubens, das Kreuz, war nicht nur Symbol, sondern diente vielfach als Träger materieller Korpora (Abb. S. 383, 461, 553). Die Spannbreite der Darstellungen und Formen reicht dabei von den konventionellen Darstellungen der Stationen des Lebens Jesu (Abb. S. 324/325, 427), die den allgemeinen Sinnbezug der Reliquien vorstellen, über Teil- und Ganzkörperbildwerke, die sofort eine Vorstellung des im Inneren Geborgenen vermitteln (Abb. S. 455, 557), bis hin zu hochkomplex gestaffelten Gefügen, die verschiedene Historien und Symbole kombinieren (Abb. S. 479, 481).

Der Geist der damaligen Zeit, der von unseren modernen Vorstellungen so gänzlich verschieden ist, ließ auch zu, Übertragungsprozesse vorzunehmen, die heute kurios erscheinen. Nicht nur die Themen konnten ausgetauscht werden, was religiöse Motive auf Dingen der täglichen Lebensführung möglich machte, auch die Träger der bildlichen Botschaften konnten problemlos ihre Bestimmung wechseln. Ein uns besonders ungewöhnlich anmutender Fall ist der des berühmten „Aschaffenburger Brettspiels" (Abb. 11 und Abb. S. 367–375). Es wurde von einem Spielzeug zu einem Reliquiar umfunktioniert, und die seitlich angebrachten Kästchen zur Aufbewahrung der Spielsteine nahmen die heiligen Partikel auf. Der Bilderschmuck ermöglichte diese Änderung der Funktion, denn genauso wie an den romanischen Leuchtern Dämonendarstellungen und Lichtsymbolik zusammenwirkten (Abb. S. 551), konnten die Fabelwesen auf den Spielfeldern als Dämonen begriffen werden. Sie gingen auf diese Weise mit den Reliquien eine inhaltliche Verbindung ein, und das ehrwürdige Gerät veranschaulichte den Sieg des Guten über das Böse.

Dieses Prinzip der Übertragbarkeit erstreckte sich auch auf die Wiederverwendungen älterer Kunstwerke in neuen Zusammenhängen, wenn z. B. ein fatimidischer Kristallnapf zum Teil eines christlichen Kelches wurde (Abb. 8 und Abb. S. 417). Auch ältere christliche Kunstwerke wurden in späterer Zeit häufig in neue sakrale Artefakte eingebunden. Diese Wiederverwendung begegnet häufig bei den Prachteinbänden kostbarer Manuskripte (Abb. 7 und Abb. S. 103). Aus dem Mittelstück eines dreiteiligen Elfenbeinreliefs, eines Triptychons, konnte aufgrund der inhaltlich passenden Motive der Darstellung das zentrale Feld der Vorderseite eines Einbanddeckels für ein Evangeliar werden, also eines Codex mit dem Text der vier Evangelien (Abb. S. 137). Dabei passte man gelegentlich das neuer Sinnbestimmung zugeführte ältere Kunstwerk dem veränderten Zweck an, indem man als überflüssig angesehene Teile ohne Hemmungen entfernte (Abb. S. 91).

Mit dem Ausklang des Mittelalters änderte sich an der Umgehensweise mit Werken der Vergangenheit und an der Art und Weise, Objekte zu gestalten und zu dekorieren, im Grundsatz nichts. Auch in der Renaissance, im Manierismus und im Frühbarock verzierte man Gebrauchsgegenstände mit sprechendem Dekor. So erhielten die Innenseiten von Schalen, die dazu dienten, Konfekt zu kredenzen, von eigens dafür beauftragten, hoch bezahlten Spezialisten Emailgemälde mit Darstellungen nach antiken Romanen (Abb. S. 577–579). Der Witz lag dann in der geistvollen Kombination von Geist und Tat. Erst wenn die Kredenzen geleert waren, wurde man der Bilder in ihrem Inneren gewahr, deren Themen wiederum nur die einschlägig Gebildeten verstehen konnten. Es ist gut vorstellbar, wie die Kredenz an der Tafel während eines Gastmahls spielerisch zum Einsatz kam. Der für die frühe Neuzeit charakteristische Zug, das Nützliche und das Unterhaltende zu verbinden, fand seinen sprachlichen Ausdruck in der von Horaz abgeleiteten lateinischen Redewendung *prodesse et delectare*.

Selbst Türklopfer wurden als ingeniöse Kleinkunstwerke intellektueller Doppelbödigkeit geformt, indem sie das Personal der Götterwelt als Allegorien der Wohlfahrt ihrer reichen Besitzer auftreten ließen (Abb. S. 547). Wie im Mittelalter entsprach es damals adeligem Selbstverständnis, sich ritterlich zu geben und mit der Darstellung von Begebenheiten aus der antiken Geschichte kaum verborgen auf zeitgenössische Schlüsselereignisse anzuspielen – und das sogar in der Verzierung von Rüstung und Sattelzeug (Abb. S. 157, 159, 378/379).

Wer aber glaubt, die gesellschaftliche Position der Auftraggeber hätte sich direkt auf die Wahl der dargestellten Themen und ihre Gestaltung ausgewirkt, der irrt. Sicherlich hingen der Aufwand der künstlerischen Ausstattung und der finanzielle Wert der verarbeiteten Materialien stets von der gesellschaftlichen Stellung der Auftraggeber und Eigentümer der Objekte ab, aber die Grundsätze der Gestaltung galten, angepasst an die jeweiligen Möglichkeiten, bei fast allen Auftraggebern. So finden wir nahezu die gleichen Themen und Motive auf den Werken für die Adeligen und denjenigen für das Bürgertum. Ein wahrscheinlich in kaiserlichem Auftrag gefertigter Prunkpokal, der sich durch seine schiere Größe, aber auch die Feinheit und Raffinesse der Goldschmiedekunst auszeichnet, zeigt ebenso den ritterlichen Tugendhelden Sankt Georg (Abb. S. 107) wie ein zum Bestand des Ratssilbers von Ingolstadt gehörender Deckelpokal, der ungefähr gleichzeitig entstand (Abb. S. 503). Die Gestaltungsaufgaben stellten naturgemäß hohe Anforderungen an diejenigen, die heute manchmal abschätzig als „Kunsthandwerker" bezeichnet werden. Die Zünfte achteten darauf, dass vor allem in den Städten, die für ihre künstlerischen Erzeugnisse europaweit berühmt und geachtet waren, der Ausbildungsstandard extrem hoch war, damit anspruchsvolle Werke realisiert werden konnten (Abb. 13 und Abb. S. 225). Ein Musterstück der Nürnberger Goldschmiede hat sich erhalten und demonstriert mit seiner Form, die äußerste handwerkliche Befähigung und Versiertheit in den Themen der klassischen Bildung vorausgesetzt, was man können musste, um dort Meister zu werden (Abb. 12 und Abb. S. 269–271).

Bürger und Adelige waren zwar ihrem Status nach strikt getrennt, aber die vielfältigen Konvergenzen im politischen und wirtschaftlichen Bereich bewirkten stetigen Austausch, der die gleichen Übertragungsprozesse begründete, wie sie zwischen sakraler und profaner Sphäre bestanden. Was gleichartige, wenn auch gesellschaftlich abgestufte Funktion hatte, erfuhr ähnliche Realisierungen. Deutlich erkennbar ist das an den Amts- und Korporationsinsignien. Was für die Pokale galt, das galt auch für die Schützenschilde und -ketten, wofür die umfangreiche, von den bayerischen Herzögen und Münchner Patriziern gemeinschaftlich gestiftete Münchner Schützenkette das vielleicht aufwendigste Beispiel ist (Abb. S. 359–363). Ihr stand aber eine dörfliche niederrheinische Schützenbruderschaft kaum nach, wie deren prächtiger, aus teilvergoldetem Silber geschaffener und mit Statuenschmuck versehener Schild beweist (Abb. S. 365). Auch die Zünfte selbst legten Wert auf angemessene Gestaltung ihrer Zeremonialgeräte, obwohl diese nicht aus dem edlen Silber, sondern aus Zinn hergestellt wurden (Abb. S. 474/475). Das Material war gewiss nicht ohne Bedeutung, denn es zeigte bereits an sich den Rang eines Objekts an, doch brachte die Materialwahl keine Einschränkung des Dekors mit sich. Auch ein irdenes Trinkgefäß wurde liebevoll mit Szenen aus der Bibel und der römischen Geschichte verziert (Abb. S. 113), und berühmte Meister stellten auf ihren Tonkrügen sakrale Zyklen dar (Abb. S. 133).

Die ambitionierten Herausgeber der *Kunstwerke und Geräthschaften des Mittelalters und der Renaissance* entfalten mit ihren Schautafeln ein ganzes Panorama der angewandten Kunstproduktion der Vormoderne. Kostbare Schmuckstücke wie Halsketten, Anhänger, Amulette und Fingerringe sollten mit ihren Madonnen- und Heiligendarstellungen die Glaubensstärke der Trägerinnen demonstrieren (Abb. S. 283, 333, 441). Kunstvolle Toilettenartikel, reich geschnitzten Schränke, Öfen als wahre Burgen der Programmkunst mit Wappen, Kriegern und Heiligen

ILL. 12
Columbine cup / Akeleipokal / Coupe « ancolie »
Unknown Master, Nuremberg, 1573–80. Silver, h. 21 cm / 8 ¼ in.
London, Victoria and Albert Museum

dekoriert (Abb. S. 415), Spitzenerzeugnisse exklusiver Goldschmiedekunst, aber auch Reliquiare, Monstranzen, Kelche, Leuchter und anderen Funktionsgeräte des kirchlichen Kultus – sie alle sind Denkmäler einer versunkenen Welt.

Die Präsentation dieser Objekte war in der sich formierenden kunstgeschichtlichen Forschung des 19. Jahrhunderts eine Pioniertat, und die Publikation avancierte schnell zu einem Standardwerk, das bald eine zweite Auflage erlebte. Dafür wurden die *Kunstwerke und Geräthschaften* mit den dreibändigen *Trachten des christlichen Mittelalters* vereint, die Hefner-Alteneck seit 1840 bearbeitet und herausgegeben hatte. Die Neuausgabe von 1879 bis 1889 fügte beide Publikationen zusammen, erweiterte sie um Kunstdenkmäler des 17. und 18. Jahrhunderts und reihte die einzelnen Werke nun chronologisch, sodass die Entwicklung der Kunstproduktion Schritt für Schritt nachvollzogen werden konnte. In dieser Form wurde die nun auf zehn Bände angewachsene, materialreiche Sammlung noch bis weit in das 20. Jahrhundert als Nachschlagewerk benutzt. Es entstand eine wahre Schatzkammer, deren Vorzug es war, die Kunst als Dokument einer vergangenen Kultur vorzuführen. In seinen *Lebens-Erinnerungen* erläutert Hefner-Alteneck: „Nachdem jenes erste Werk [die *Trachten*] einen guten Fortgang genommen hatte, erkannte ich, dass es sehr nützlich sei, wenn ausser diesem, das die nächste Umgebung des Menschen, d. h. Trachten, Waffen, Schmuck, etc. behandelt, noch ein zweites nebenher erscheine, welches einen Schritt weiter gehe und auch die fernere Umgebung des Menschen, als Utensilien jeder Art, zum täglichen Gebrauch wie zum Luxus, in verschiedenen Jahrhunderten, treu wiedergibt. Es erhielt den Titel: *Kunstwerke und Geräthschaften des Mittelalters und der Renaissance*."

Hefner-Altenecks bewusster Zugriff auf Objekte, die als Realien begriffen wurden, erfolgte aber nicht aus der distanzierten Position des Historikers. Vielmehr ging es dem Herausgeber darum, die Zeugnisse der Vergangenheit für die aktuelle Kunst fruchtbar zu machen. Die rasch voranschreitende industrielle Entwicklung prägte in der Mitte des 19. Jahrhunderts die soziale Wirklichkeit ebenso wie das Empfinden der Menschen. Die allgemeine Umbruchsituation zog in vielen Bereichen des Lebens eine tiefe Verunsicherung nach sich, so auch in der bildenden Kunst. „In welchem Style sollen wir bauen?" lautete der äußerst bezeichnende Titel vieler Abhandlungen in Architekturzeitschriften. Eine weit verbreitete Lösung war die Orientierung an den Monumenten der Vergangenheit, die als Muster für Bauwerke der Gegenwart dienten. Es war die Blütezeit des sogenannten Historismus: Neue Kirchen, Paläste, öffentliche Gebäude und Wohnhäuser prunkten als gotische oder barocke Bauwerke, und paradoxerweise kamen die historistischen Formen auch bei neuen Bauaufgaben zum Einsatz. Bibliotheken, Museen, ja, sogar Bahnhöfe traten auf wie griechische Tempel oder im Gewand der Renaissance.

Ein wesentliches Motiv für die Orientierung an der Vergangenheit war die Erkenntnis, dass mit der wachsenden Industrialisierung die handwerklichen und gestalterischen Fähigkeiten in Vergessenheit gerieten und damit die Qualität der Erzeugnisse sank. Neben den Bauten der Vergangenheit diente deshalb auch das überlieferte Kunsthandwerk als Vorbild. Historistische Künstler kauften alte Kunstwerke als Anregung für eigene Arbeiten. Sie trugen zum Teil gewaltige Sammlungen zusammen, wie der französische Architekt Hippolyte Destailleur (1822–1893). Seine umfassende Kollektion von Holzschnitten, Radierungen und Kupferstichen mit Entwürfen der

Spätgotik, der Renaissance, des Barock und Rokoko wurde 1879 für den Berliner Museumsbesitz aufgekauft und bildete den Grundstock für die weltgrößte Sammlung von Ornamentstichen. Seit der Mitte des 19. Jahrhunderts wurden auf staatliche Initiative spezielle Kunstgewerbemuseen eingerichtet, um die Schulung der zeitgenössischen Künstler an den Denkmälern früherer Epochen zu ermöglichen. 1852 wurde als erstes das South Kensington Museum, das heutige Victoria and Albert Museum, in London eröffnet, dann 1871 das Museum für Kunst und Industrie in Wien, danach in schneller Folge gleichartige Institute in Berlin, Leipzig und Hamburg.

Ein Exponent dieser Vorstellung, der die Werke der Vergangenheit als vorbildlich für die Gegenwart ansah, war der Mitherausgeber der *Kunstwerke und Geräthschaften,* Jakob Heinrich von Hefner-Alteneck. Er wurde 1811 in Aschaffenburg in eine im Rheingau und dem damaligen Kurmainz weitverzweigte und wohlhabende bürgerliche Familie hineingeboren. Sein Urgroßvater, sein Großvater und sein Vater, der 1814 geadelt wurde, waren Juristen, seine Mutter war die Inhaberin einer in Bamberg und Würzburg ansässigen Verlagsbuchhandlung, die unter anderem Hegels *Phänomenologie des Geistes* im Programm hatte. Die Eltern führten ein für seine Gastfreundschaft und seine stattliche Kunstsammlung berühmtes Haus. Zwar verlor Jakob Heinrich durch einen Reitunfall als Kind den rechten Arm, ließ sich aber dadurch nicht entmutigen. Er konnte seine ungewöhnliche zeichnerische Begabung durch intensiven Privatunterricht so schulen lassen, dass er in der Lage war, schon als Jugendlicher Kopien der Bilder des *Halleschen Heiltums* der Aschaffenburger Schlossbibliothek anzufertigen und später die meisten der hervorragenden Bildtafeln seiner Bücher zu zeichnen, auch die der *Kunstwerke und Geräthschaften.* Sein Interesse für die Kunst und ihre Geschichte wurde früh geweckt und durch viele mit dem Vater unternommene Reisen mit Besichtigungen der Sammlungen in Wien, Innsbruck, München, Nürnberg und Regensburg vertieft. Als der Vater 1832 Teilhaber einer Steingutmanufaktur wurde, übernahm Jakob Heinrich deren künstlerische Leitung. Außerdem erteilte er selbst Zeichenunterricht und erhielt 1836 den Professorentitel. Sein wahres Interesse galt jedoch der Kunstgeschichte und ihrer Dokumentation. 1838 erschien das erste seiner Mappenwerke, *Beitrag zur Geschichte der deutschen Goldschmiedekunst, besonders des XVI. Jahrhunderts*, mit dem er 1840 an der Universität Gießen promovierte. Um sich ganz seinen Publikationen widmen zu können, schied Hefner-Alteneck im selben Jahr aus der Manufaktur aus und begann mit der Arbeit an den *Trachten des christlichen Mittelalters.* Er fasste dann den Plan, parallel die *Kunstwerke und Geräthschaften* zu publizieren. Darüber schrieb er in seinen *Lebens-Erinnerungen*: „Meine Zeit und Kräfte, wie jene meines Verlegers, waren aber durch das erste Werk, welches noch im Erscheinen begriffen war, so sehr in Anspruch genommen, dass ich mich um einen anderen Verleger und einen Mitarbeiter umsehen musste. Ersteren fand ich in Heinrich Keller in Frankfurt a. M., den letzteren in Karl Becker, welcher zwar Alterthumskenner, aber nicht selbst Zeichner war. Er liess mir durch geschickte Künstler von den alten Originalen Zeichnungen herstellen, wobei der grössere Teil der Arbeit auf mir ruhen blieb." Anhand der Signaturen auf den Bildtafeln der *Kunstwerke und Geräthschaften* lässt sich erkennen, dass in der Tat Hefner-Alteneck den größten Teil der Vorlagen geschaffen hat.

Der 1794 geborene Karl (auf den Titelblättern „Carl") Becker war 1814 als Soldat mit den alliierten Truppen nach dem Sieg über Napoleon nach Paris gekommen und machte dort die Bekanntschaft

ILL. 13
Double cup / Doppelpokal / Double coupe à boire
Nuremberg, c. 1500. Silver gilt, h. 37.2 cm / 14⅔ in., each cup 20 cm / 7⅞ in.
Nuremberg, Germanisches Nationalmuseum

von Kunstkennern. Später war er an seinem Wohnort Würzburg als Kunstgelehrter und -sammler aktiv. Er verfasste 1840 die erste Monografie über den damals weitgehend vergessenen Tilman Riemenschneider, von dem er selbst die *Muttergottes auf der Mondsichel* (Abb. 4 und Abb. S. 177) besaß. 1852 bemühte er sich, dem neu gegründeten Germanischen Nationalmuseum Werke des bedeutenden spätgotischen Künstlers zu verschaffen. Noch vor Vollendung der *Kunstwerke und Geräthschaften* starb Carl Becker im Jahr 1859. Ihm ist es sicherlich zu verdanken, dass in der Publikation viele Würzburger Stücke Berücksichtigung fanden.

Auch wenn Hefner-Alteneck bei der alphabetischen Reihung der Namen auf den Buchtiteln Carl Becker den Vortritt ließ, so war dennoch ohne Zweifel er selbst die prägende Gestalt des Werkes, und das wussten auch die Zeitgenossen. Als Hefner-Alteneck 1852 nach München übersiedelte, wurde er in die Bayerische Akademie der Wissenschaften aufgenommen und erhielt ein Jahr später die Position des Konservators der Königlichen Vereinigten Sammlungen. 1861 wechselte er zum Königlichen Kupferstich- und Handzeichnungskabinett. 1868 ernannte ihn König Ludwig II. zum Königlichen Generalkonservator der Kunstdenkmale und Altertümer Bayerns, und wenige Monate später erfolgte die Berufung zum Direktor des Bayerischen Nationalmuseums. Seine Tätigkeit dort war nicht unumstritten, denn er verfolgte konsequent eine Ankaufs- und Präsentationspolitik, die den Charakter der Mustersammlung für das Kunsthandwerk seiner Zeit in den Vordergrund stellte. Dafür ließ er die von seinem Amtsvorgänger Karl Maria Freiherr von Aretin, dem Gründungsdirektor des Museums, eingerichteten Schauräume umgestalten, kaufte auch nichtbayerische Objekte, stellte die allgemeine deutsche Kunstüberlieferung in den Vordergrund und publizierte weitere Sammelwerke. Die Anfeindungen, die ihm das eintrug, ließen ihn zunehmend verbittern. Seinem Ruhestandsgesuch wurde nicht stattgegeben, weil noch Konservatoren einzuarbeiten waren. Erst 1885 konnte er das Amt verlassen und verstarb 1903 im Alter von 92 Jahren.

Hefner-Alteneck war zweifellos eine besondere Persönlichkeit. Typisch für ihn ist, dass er 1854 einen Antrag auf Namensergänzung stellte. Sein bürgerlicher Name Hefner war trotz Adelsprädikat des Vaters nicht singulär. Es gab noch einen anderen ebenfalls kunsthistorisch tätigen Josef von Hefner. Um Verwechslungen zu entgehen, schlug er den Zusatz „Alteneck" vor. Dieser Name beschrieb verkürzt seine Tätigkeit: Weil er bei der Recherche für seine Bücher nicht auf Literatur zurückgreifen konnte, musste er selbst das „Alte aus Winkel und Ecken" hervorsuchen. Eine detaillierte Forschungsliteratur, der man einschlägige Informationen hätte entnehmen können, existierte in der Tat noch nicht, und so war Hefner-Alteneck gezwungen, sich auf zahlreichen Reisen selbst nach den Objekten seines Interesses umzusehen. Er fand sie in den neu gegründeten Museen, aber mehr noch im Besitz von Kirchen, Bibliotheken und fürstlichen Sammlungen, im Kunsthandel und bei Privatleuten. In seinen *Lebens-Erinnerungen* erzählt er, wie er Ende der 1840er Jahre Gast auf Schloss Mainberg bei Schweinfurt war, wo ihm die Besitzer, der Fabrikant

ILL. 14
Cupboard / Schrank / Armoire
South German, 2nd half of the 15th century. Wood, 259 x 194 cm / 102 x 76 ⅜ in.
Nuremberg, Germanisches Nationalmuseum

Wilhelm Sattler und dessen Ehefrau, ihre reiche Sammlung zeigten und er einige bemerkenswerte Stücke zeichnete (Abb. S. 111, 117, 213).

Diese Recherche erforderte ohne Zweifel erheblichen Einsatz, doch dafür entschädigte ihn oft die Entdeckung seltener, kurioser und schöner Kunstwerke. Wie hoch sein Ansehen schon damals bei deren Eigentümern war, demonstriert sein Aufenthalt in Weimar, wo sich im Bestand der Großherzoglichen Sammlungen ein niederländischer Nautiluspokal befand. Kurzerhand gab ihm die Großherzogin das empfindliche und wertvolle Gefäß mit, damit er es in seiner Wohnung ganz in Ruhe zeichnen konnte. Für die *Kunstwerke und Geräthschaften* allerdings verwendeten er und sein Mitherausgeber Becker dann eine Wiedergabe des Leiters der Weimarer Zeichenakademie, Friedrich Preller (1804–1878), eines damals hoch angesehenen Malers (Abb. S. 221). Den Grund für diesen Wechsel der Vorlage kennen wir nicht, vielleicht wollte Hefner-Alteneck dem Großherzog, bei dem Preller so etwas wie die Funktion eines Hofkünstlers innehatte, seine Reverenz erweisen.

Aus heutiger Sicht war das keine gute Entscheidung, denn der Weimarer Künstler setzte zu stark auf malerische Effekte und inszenierte seine Wiedergabe auf Bildwirkung. Dagegen sticht die präzise, um dokumentarische Treue bemühte Darstellung des großen Pokals in Wiener Neustadt (Abb. S. 107) wohltuend ab. Die Musterzeichnung für diese Tafel hat Georg Christian Wilder (1797–1855) aus Nürnberg angefertigt, ein für seine verlässlichen, detailgenauen, in allen Teilen ebenso farbschönen wie korrekten Aquarelle, Feder-, Tusch- und Sepiazeichnungen von Kunstdenkmälern bekannter Zeichner und Radierer. Beide Blätter markieren die Spannbreite der stilistischen Auffassungen, die uns in den Bildtafeln der *Kunstwerke und Geräthschaften* begegnen.

Während die moderne kunstgeschichtliche Forschung die Monumente der Vergangenheit als Zeitzeugen um ihrer Eigenständigkeit willen schätzt, nahm man in der Zeit des Historismus im 19. Jahrhundert eine sehr viel unbefangenere Haltung ein. Man glaubte, den Lauf der Geschichte zu kennen und aus der Position des Zurückschauenden eine Übersicht gewonnen zu haben. So sah man sich in der Lage, Mängel und Fehlstellen der Überlieferung zu korrigieren. So wie die Architekten an ihren Bauten im Stil der Neogotik, der Neorenaissance, des Neobarock die typischen Formmerkmale systematischer einsetzten, als sie an den Gebäuden der für sie vorbildlichen Epochen auftreten, und gerade dadurch etwas Neues und Eigenes schufen, das nur äußerlich ähnlich erscheint, genauso ging man auch bei der kunstgeschichtlichen Dokumentation selbstbewusster und eigenmächtiger vor. Daher zeigen uns die Tafeln der *Kunstwerke und Geräthschaften* nicht einfach bildliche Kopien der Originale, sondern Wiedergaben und Rekonstruktionen. Hefner-Alteneck fühlte sich durchaus berechtigt, alte Ansichten neu zu gruppieren (Abb. 15, 16 und Abb. S. 89, 99–101), eigene hinzuzufügen (Abb. S. 73) und teilzerstörte Objekte zu ergänzen (Abb. S. 73, 177, 345–349, 413, 443, 485).

Charakteristisch für die Zeit war es ebenso, dass Hefner-Alteneck und Carl Becker selbst in erheblichem Umfang Kunst sammelten und das Material für ihre Publikation aus der Position von Kennern heraus zusammentrugen. So enthalten die *Lebens-Erinnerungen* Berichte von interessanten und wichtigen Erwerbungen. 1846 z. B. bot der Antiquar Leo Kronacher in Bamberg ein Konvolut von Malereien auf Pergament an. Hefner-Alteneck konnte sie kaufen, als Arbeiten des Münchner

Hofmalers Hans Mielich (1516–1573) identifizieren und darin Wiedergaben der Kleinodien des bayerischen Herzogs Albrecht V. und seiner Gemahlin Anna von Österreich erkennen. Die Objekte repräsentieren Spitzenstücke der deutschen Goldschmiedekunst des 16. Jahrhunderts, und Hefner-Alteneck zeichnete die bemerkenswertesten davon für die Veröffentlichung der *Kunstwerke und Geräthschaften* nach (Abb. S. 85, 89, 99–101). Kette und Anhänger des Halsgeschmeides (Abb. S. 89) sind außer auf den Miniaturen, die Hefner-Alteneck besaß, im *Kleinodienbuch der Herzogin Anna*, gemalt von Hans Mielich, aus der Staatsbibliothek München (Cod. Icon. 429) dargestellt, und zwar auf getrennten Tafeln (Abb. 15–16). Neben Pergamentmalereien erwarben die Herausgeber auch Entwurfszeichnungen (Abb. S. 123–125), aber vor allem Originale. Die Sammelleidenschaft des Herausgebers richtete sich auf die ganze Breite des Kunsthandwerks. Er kaufte Gebetbücher in ihren alten Einkleidungen für den Transport (Abb. S. 565), kunstvolle Buchdeckel (Abb. S. 393), elfenbeinerne Spiegelkapseln (Abb. S. 229), einen prächtigen Pokal (Abb. S. 559–563), zahlreiche Schmuckstücke (Abb. S. 257–259, 283, 307–309, 559), aber auch Nagelköpfe (Abb. S. 191), Handtücher (Abb. S. 172–173) und Tischdecken (Abb. S. 299). Nicht anders verhielt es sich bei Carl Becker. Neben herausragenden Skulpturen wie der *Madonna auf der Mondsichel* von Riemenschneider (Abb. 4 und Abb. S. 177) zeigen die *Kunstwerke und Geräthschaften* aus seinem Besitz Krüge und Kästchen (Abb. S. 93, 141), Schmuck (Abb. S. 283), eine Tischdecke (Abb. S. 165), Löffel und Entwürfe für Löffel (Abb. S. 115).

Noch wichtiger für das Mappenwerk waren aber die Beziehungen zu anderen Sammlern und Kunstfreunden. Die Herausgeber agierten als Mittelpunkt eines wahren Netzwerkes, und die Hauptaufgabe von Carl Becker bestand darin, Nachrichten und Hinweise zu bündeln, um dann Künstler mit Musterzeichnungen für die Reproduktionsstiche zu beauftragen. Weil individuelles Wissen und persönliche Beziehungen die Zusammenstellung der Publikation bestimmten, finden wir darin Werke aus italienischem, französischem, flämischem, aber doch überwiegend deutschem, vor allem süddeutschem Besitz.

Jahr um Jahr verging, bis das auf drei Bände von je 72 Tafeln berechnete Werk endlich vollendet war. Glücklicherweise und wohl auch, weil Hefner-Alteneck schon ein Jahr nach Publikation des ersten Bandes als Konservator der Vereinigten Königlichen Sammlungen in München eine herausragende Stellung einnahm, kam es zu keinen bemerkenswerten äußeren Beeinträchtigungen bei der Herausgabe des Werkes. Bei den *Trachten* war das noch ganz anders gewesen. Seit 1839 geplant und ab 1840 herausgebracht, geriet die Publikation in den Strudel der historischen Ereignisse. Der Verleger, Heinrich Hoff in Mannheim, war in die Revolution von 1848 verstrickt, musste nach Amerika fliehen und seinen Verlag in Konkurs gehen lassen. Mit Heinrich Keller in Frankfurt am Main konnte ein Nachfolger gewonnen werden, der dann die *Kunstwerke und Geräthschaften* übernahm und später auch die beide Werke vereinende erweiterte Neuausgabe von 1879 bis 1889 verlegte.

Die politischen Ereignisse überschlugen sich in diesen Jahrzehnten. 1848 wurde eine Nationalversammlung einberufen und wieder aufgelöst. Preußen und Österreich besiegten 1864 gemeinsam Dänemark, wodurch sie die Herzogtümer Schleswig, Holstein und Lauenburg gewannen, bekämpften sich dann aber 1866 gegenseitig. Der preußische Erfolg hatte die Auflösung des

ILL. 15
Miniature / Miniatur / Miniature
Hans Mielich, 1552–55, from *Kleinodienbuch der Herzogin Anna von Bayern*
Munich, Bayerische Staatsbibliothek München, Sign. Cod. icon. 429, folio 17v

Deutschen Bundes und die Entwicklung der sogenannten kleindeutschen Lösung zur Folge, die in den französisch-preußischen Krieg mündete und 1871 mit der Proklamation des preußischen Königs zum Deutschen Kaiser und der Gründung des Deutschen Reiches endete.

So fand sich der bayerische Staatsbeamte Hefner-Alteneck, ein glühender Anhänger des deutschen Nationalgedankens, in einer neuen europäischen Großmacht wieder. Politische, wirtschaftliche und kulturelle Blüte prägten die Jahre bis zu seinem Tod – Jahre, die vor allem eines kennzeichnet: Veränderung. Das bedeutete, Sammlungen wurden neu geordnet, zusammengelegt, Museen gegründet, fürstlicher und privater Kunstbesitz wandelte sein Gesicht. Kunstwerke wurden gekauft und verkauft, die Übersicht zu behalten war nicht leicht. In der Neuausgabe des nun *Trachten, Kunstwerke und Geräthschaften* genannten vereinten Sammelwerkes notierte der Herausgeber die neuen Besitzverhältnisse, musste aber nur allzu oft sein Nichtwissen eingestehen und zu Formulierungen greifen wie „seinerzeit im Besitz von".

Daran hat sich auch in der darauffolgenden Zeit nichts geändert. Auch bei den *Kunstwerken und Geräthschaften* bestätigt sich, dass der Wandel das einzig Konstante im menschlichen Leben ist. Zwei Weltkriege und die damit einhergehende Zerstörung der Städte, die Etablierung unterschiedlicher politischer Systeme und staatliche und geografische Neuordnung hinterließen ihre Spuren und wirkten sich negativ auf die Bewahrung und Erhaltung von Kunstwerken aus. Viele Objekte, die die Bildtafeln zeigen, sind unwiederbringlich verloren. Mehr als zehn dokumentierte Objekte und Objektgruppen aus Berliner Museen sind dem Krieg zum Opfer gefallen (Abb. S. 209, 245, 253, 257–259, 277, 307–309, 313, 333, 411, 540/541, 569–573), anderes wurde in Mitleidenschaft gezogen (Abb. 18, 21 und Abb. S. 207, 237). Kaum weniger schwer waren die Schäden für den Würzburger Domschatz. Verloren sind zwei Reliquienkästchen und eine Kanne (Abb. S. 183, 199, 223); ein bei der Inventarisierung im Jahr 1915 übersehenes Becken in einem Schrank konnte hingegen wiederentdeckt werden (Abb. S. 199). Der von Riemenschneider gefertigte Würzburger Ratstisch wurde gerettet, aber seine Originalplatte ist nicht erhalten (Abb. S. 161). Ein Reliquienschrein der Stadt Nürnberg, der sich heute im Germanischen Nationalmuseum befindet, ist nur in stark zerstörtem Zustand erhalten (Abb. S. 324/325). Doch nicht alles wurde zerstört. Bedeutende Stücke des Quedlinburger Domschatzes waren 1945 verschwunden, weil sie – wie sich später herausstellte – entwendet worden waren. Erst 1992 war es möglich, sie wiederzubeschaffen (Abb. 17, 22 und Abb. S. 203, 215). Vielleicht erlitt der berühmte *Rupertsberger Codex* der Hessischen Landesbibliothek in Wiesbaden, der seit 1945 verschollen ist, ein ähnliches Schicksal (Abb. S. 195).

Krieg und Zerstörung markieren jedoch nur eine Facette des historischen Prozesses, ökonomische Zwangslagen und wechselnde Interessen eine andere. Von ihnen sind auch die Sammlungen berühmter Adelsgeschlechter nicht verschont geblieben. 1928 gelangte in Frankfurt der Hohenzollern-Kunstbesitz auf Schloss Sigmaringen zur Versteigerung. Ein Teil der Sammlung kam dadurch in öffentliches Eigentum (Abb. S. 303, 401–407), anderes ist seither unauffindbar (Abb. S. 453). Und obwohl die bedeutende Gräflich Erbacher Kunstsammlung auf Schloss Erbach gut erhalten ist und vor wenigen Jahren vom Land Hessen angekauft wurde, sind etliche ihrer Objekte, die in den *Kunst und Geräthschaften* gezeigt werden, verschwunden (Abb. S. 179, 187). Hier wirkt

die Forschung durchaus wohltätig, denn die Werke, die sie bekannt macht und ihrem Rang entsprechend hervorhebt, lassen sich gut verfolgen. Der *Rospigliosi-Pokal*, der um 1850 noch im Besitz der namengebenden römischen Adelsfamilie war, kam später nach Amerika und befindet sich heute im Metropolitan Museum of Art (Abb. 24 und Abb. S. 151). Das erst spät als Fälschung erkannte Werk ist in allen wichtigen Standardpublikationen zur Goldschmiedekunst abgebildet und kann nicht unbemerkt verloren gehen. Das gilt ebenso für viele vergleichbare Fälle in der Fachliteratur, die unsere Dokumentation im Anhang auflistet. Wenn familiäre Ambitionen und museale Möglichkeiten zusammenwirken, bleibt Wichtiges nicht nur erhalten, sondern auch für das Publikum sichtbar (Abb. S. 577–579). Die öffentlichen Sammlungen versuchen, ihren Auftrag zur Erhaltung und Erschließung der kunsthistorischen Überlieferung zu erfüllen, und erwerben, was ihnen die Finanzmittel erlauben.

So gelangte der Delfter Nautiluspokal aus dem Besitz des Großherzogtums Weimar in das Delfter Museum (Abb. S. 221) und der wahrscheinlich zu den Kleinodien der schottischen Königin Maria Stuart gehörende kleine Reisealtar ins Victoria and Albert Museum in London (Abb. S. 419–423). Dort befindet sich auch ein Teil des zweiteiligen elsässischen Wandteppichs, von dessen zweitem Teil der Verbleib nicht bekannt ist (Abb. 25 und Abb. S. 511–537). Seit den Bemühungen von Carl Becker und Jakob Heinrich von Hefner-Alteneck legten manche der von ihnen abgebildeten Stücke einen langen Weg zurück, wie der norwegische Kirchenstuhl (Abb. S. 263, 265). Franz Wilhelm Schiertz aus Leipzig, der an der Dresdener Kunstakademie bei dem dänischen romantischen Maler Johan Christian Clausen Dahl (1788–1857) studierte, entdeckte den Stuhl 1837, als er für die Publikation seines Lehrers, *Denkmale einer sehr ausgebildeten Holzbaukunst [...] Norwegens*, Zeichnungen anfertigte. Dahl kaufte den Stuhl daraufhin, und als sein Eigentum veröffentlichten ihn die Herausgeber der *Kunstwerke und Geräthschaften*. Danach wechselte er mehrfach den Eigentümer. Aus dem Besitz des österreichischen Bankiers und Kunstsammlers Albert Figdor ersteigerte nach dessen Tod im Jahr 1936 ein Osloer Kunsthändler den Stuhl und verkaufte ihn im selben Jahr an das Kunstindustriemuseum der norwegischen Hauptstadt, wo sich das Objekt heute noch befindet.

Viele Werke sind heute noch in privater Hand, sodass auch unsere Neuausgabe nicht in allen Fällen die aktuellen Standorte angeben und nur auf frühere Besitzverhältnisse verweisen kann. Aber die Neuauflage macht ein wichtiges Standardwerk, eine großartige Pioniertat der Kunstgeschichte des 19. Jahrhunderts wieder verfügbar. Sie zeigt ein Panorama überlieferter und verlorener Werke, mehr noch: eine Fülle prächtiger Bildtafeln, und macht einen wahren Schatz alter Buchkunst allgemein zugänglich.

Die Datierungen auf den Tafeln stammen aus der Originalpublikation des 19. Jahrhunderts, diejenigen in den Erläuterungen entsprechen dem aktuellen Forschungsstand.

ILL. 16
Miniature / Miniatur / Miniature
Hans Mielich, 1552–55, from *Kleinodienbuch der Herzogin Anna von Bayern*
Munich, Bayerische Staatsbibliothek München, Sign. Cod. icon. 429, folio 12r

« L'Art en image »

La représentation des œuvres d'art du Moyen Âge et de la Renaissance par Hefner-Alteneck et Becker

CARSTEN-PETER WARNCKE

Les planches d'illustrations des *Œuvres d'art et Ustensiles du Moyen Âge et de la Renaissance* exhalent, sitôt qu'on les parcourt, l'esprit d'un autre temps. Dessinées, jusque dans le moindre détail, avec passion et exactitude, ces reproductions aux couleurs discrètes – exemptes d'effets exagérés, rarement polychromes, parfois même presque monochromes – ne sont néanmoins jamais monotones. D'un bout à l'autre de l'ouvrage, elles s'efforcent de restituer fidèlement leur objet tout en l'interprétant de manière artistique. Nous sommes ici loin des reproductions photographiques auxquelles nous ont habitués nos livres d'art, loin des images brillantes et suggestives où de délicates aquarelles étincèlent, pareilles à des peintures à l'huile, et miroitent, pareilles aux reflets de coupes somptueuses. Ceci s'explique assurément par les conditions techniques de l'époque ; au milieu du XIXᵉ siècle, en effet, on n'était pas encore en mesure d'utiliser la photographie, née quelques décennies plus tôt, pour illustrer les livres d'art. La photographie en couleur était loin de voir le jour et les techniques d'impression lithographique n'en étaient qu'à leurs balbutiements. Le choix de cet exigeant procédé de reproduction résultait toutefois, au-delà de ces considérations matérielles, d'une volonté déterminée, d'une intention mûrement réfléchie. Donnons ici la parole à l'un des deux directeurs de la publication, Jakob Heinrich von Hefner-Alteneck (ill. 1), qui, 27 ans après la parution des *Œuvres d'art et Ustensiles*, publia une nouvelle édition de l'ouvrage. Dans celle-ci, il mêla aux *Ustensiles* une publication antérieure et écrivit en avant-propos : « Les illustrations de ces deux ouvrages à présent réunis sont constituées de gravures sur cuivre et sur acier qui, dans l'édition peinte, ont été exécutées, d'après les modèles que j'ai effectués à cet effet, par des coloristes expérimentés. À l'époque, je ne pouvais pas encore me résoudre à faire usage de l'impression en

ILL. 17
"Henry I's Comb" / „Kamm Heinrichs I." / « Peigne d'Henri Iᵉʳ »
Syrian or Egyptian, 7th–8th century, German, 9th–11th century
Ivory, gold-foil setting with garnets, almandines, glass and pearls, 17 x 10 cm / 6 ¾ x 4 in.
Quedlinburg, St Servatius Abbey, "Zitter," treasury

couleur car la netteté et la précision du dessin, qui demeure la priorité, en auraient trop pâti. Seuls les progrès récents de la technique ont permis d'allier la gravure et l'impression en couleur de façon à ce que la première conserve toute sa valeur et la seconde restitue, dans la pleine clarté de la couleur, l'aspect d'une aquarelle. » L'auteur ambitieux qu'était Hefner-Alteneck ne voulait pas seulement reproduire, répéter en image une pièce originale, il tenait aussi à conserver la qualité particulière des dessins modèles. Ceux-ci, en effet, sont à leur manière des œuvres d'art à part entière. S'ils ôtent aux objets qu'ils offrent à nos regards la particularité de leur constitution matérielle, ils n'ajoutent pas pour autant d'effets superflus. Conscients de leurs limites techniques et de la dialectique de toute imitation, qui ne peut jamais atteindre l'identité et qui, en dépit de toute ressemblance, se distingue toujours du modèle, ils se contentent d'être des dessins colorés. Issus du regard observateur et de la main experte obéissant à la réflexion, et non de la mécanique de l'appareil, ils sont, au sens originel du terme, des œuvres d'art. À cet égard, ils correspondent aux dessins de projets que les artistes d'autrefois présentaient afin de gagner de nouveaux commanditaires – des projets tels que les restituent d'ailleurs certaines planches de l'ouvrage (ill. 5, 6 et ill. pp. 204, 211, 585). L'ensemble du processus de production, des dessins modèles à la coloration, en passant par l'impression, était très complexe, ce qui expliquait le coût élevé d'une telle publication. La fin du XVIIIᵉ siècle avait vu s'installer un usage destiné à en faciliter le financement : on ne publiait pas l'ouvrage achevé, mais des livraisons à acquérir à l'unité. La parution, ainsi, s'étendait sur une longue période comprenant des intervalles de cinq à six ans entre les différentes parties. Le premier volume des *Œuvres et Ustensiles* est daté de 1852, le second, de 1857 et le dernier, de 1863.

Le financement, toutefois, n'était pas le seul facteur expliquant la durée de cette publication. Outre la qualité artistique des illustrations, l'hétérogénéité des quelque 400 objets répartis sur 216 planches frappe le lecteur. Les onze années qui s'écoulèrent entre le début et la fin de la publication permirent de rassembler des représentations d'objets de la plus grande variété, provenant des lieux les plus divers.

Aux côtés d'armoires destinées aux intérieurs distingués figurent d'exceptionnelles pièces d'orfèvrerie ; serrures et reliefs de bois et d'ivoire se côtoient (ill. 2, 3 et ill. pp. 143, 385) ; récipients à boire profanes et objets de culte tels qu'encensoirs et vasques à eau bénite s'entremêlent. Des insignes de dignitaires tels que les crosses d'évêque sont juxtaposés aux armes d'apparat princières, des chaises d'église suivent bagues et colliers ; cuillères et couteaux frôlent les reliquaires, honorables monuments de l'adoration des saints. Seules la beauté, souvent remarquable, des objets ainsi que la subtile maîtrise de leur traitement nous interdisent de voir dans la profusion des planches un salmigondis, sous une forme livresque, de choses disparates. Manifestement, la composition n'obéit à aucun système, pas même à un ordre chronologique. En effet, des reliefs d'ivoire utilisés comme ornements de reliure et ayant vu le jour au XIᵉ siècle sont accompagnés de serviettes datant du début du XVIᵉ siècle ; à un peigne d'apparat des débuts, voire du haut Moyen Âge, succède un dessin de projet pour orgue portable exécuté au milieu du XVIᵉ siècle, à son tour suivi de pièces d'échecs sculptées datées du XIVᵉ siècle (ill. pp. 203–207).

Le fait que Hefner-Alteneck et Becker réunissent dans leur publication une telle variété d'artéfacts et juxtaposent les différentes œuvres en leur attribuant une même valeur s'explique par

la situation où se trouvait alors l'histoire de l'art. Au milieu du XIXᵉ siècle, les musées publics occupaient une place centrale ; leur ouverture constituait à elle seule une innovation dans l'histoire de la civilisation. Les trésors artistiques des princes et grandes dynasties se transformaient peu à peu en établissements culturels accessibles à l'ensemble des citoyens. La Révolution française avait frayé le chemin permettant aux initiatives isolées de souverains éclairés de devenir une mission nationale. Cependant, il fallut attendre des décennies avant que les musées publics accessibles à tous, lesquels sont aujourd'hui une évidence pour nous, devinssent une réalité. En 1753, le British Museum fut fondé à Londres par résolution parlementaire ; en 1793 fut inauguré au Louvre le Muséum central des arts de la République ; mais c'est seulement en 1891 que le Kunsthistorisches Museum de Vienne put, après des années d'épisodes préalables, ouvrir enfin ses portes.

Ces musées requéraient des spécialistes capables d'interpréter les objets réunis sous leur toit, or il n'existait alors guère de formation systématique en science de l'art. Les premières chaires de la discipline universitaire avaient été créées pour apporter à d'autres domaines d'études un complément culturel. Le journalisme scientifique d'art était pour l'essentiel entre les mains d'amateurs et de collectionneurs. Carl Schnaase, une personnalité marquante de la jeune discipline, auteur d'une histoire des arts plastiques en cinq volumes, n'était pas un spécialiste au sens strict mais un juriste qui dut attendre sa retraite, en 1857, pour pouvoir se consacrer pleinement aux études d'histoire de l'art. À ses côtés se trouvait Franz Kugler qui, depuis 1844, enseignait, en qualité de professeur titulaire, l'histoire de l'art à l'université de Berlin et qui, dès 1843, avait été nommé, au ministère prussien de la Culture, chef de service responsable des affaires artistiques. En 1837, Kugler publia un manuel d'histoire de la peinture (*Handbuch der Geschichte der Malerei*), suivi, en 1842, d'un manuel d'histoire de l'art (*Handbuch der Kunstgeschichte*). En dépit de ce qui les opposait, les deux hommes représentaient des positions universalistes issues d'un même intérêt porté à la philosophie idéaliste de l'art chez Hegel ; tous deux érigeaient l'architecture, la peinture et la sculpture en genres suprêmes de la création artistique.

Une vision que les directeurs de la publication des *Œuvres et Ustensiles du Moyen Âge et de la Renaissance* tenaient pour réductrice. L'introduction au premier volume fait, à cet égard, office de programme : « Les directeurs de cet ouvrage ont pour premier dessein de transmettre une vaste série d'objets d'art, le plus souvent méconnus, embrassant l'histoire ancienne, depuis les premiers temps de l'époque chrétienne jusqu'au début du XVIᵉ siècle, et permettant, qu'ils soient objets courants ou luxueux, destinés à un usage religieux ou bien profane, de mesurer l'évolution de la culture et de la civilisation au cours de ces différents siècles. De fidèles reproductions présentent des œuvres mineures témoignant du sens artistique et des tendances du goût de différentes époques. Créées par nécessité ou pour décorer les églises, les palais et les intérieurs bourgeois, elles montrent, outre le raffinement du goût et la perfection de la technique, les principes selon lesquels on procédait, jadis, pour adapter au style de l'époque des œuvres étroitement liées à l'architecture et à la sculpture. Tandis que les œuvres majeures de l'architecture, de l'art plastique et de la peinture suscitèrent récemment d'intenses recherches et publications, ces créations artistiques, lesquelles sont de l'homme les plus proches, furent jusqu'à ce jour négligées. »

Ill. 18
Chess piece / Schachfigur / Pièce d'échecs
Mid-14th century. Ivory, h. 7.3 cm / 2 ⅞ in.
Staatliche Museen zu Berlin, Kunstgewerbemuseum

Ill. 19
Ill. p. 207 (detail) / Abb. S. 207 (Detail) / ill. p. 207 (détail)

Aujourd'hui, ces objets sont qualifiés de produits de l'artisanat d'art, un concept qui présuppose une notion de différence qualitative au sein de la production artistique – une distinction anachronique, puisque les siècles précédant l'époque moderne l'ignoraient; c'est seulement dans le courant du XVIe siècle qu'elle vit le jour, avant de s'imposer au XVIIIe siècle. Les objets rassemblés dans l'ouvrage illustré de Hefner-Alteneck montrent à quel point elle est contraire à la réalité historique. L'important sculpteur du gothique tardif Tilman Riemenschneider (vers 1460–1531) exécuta non seulement ses célèbres retables sculptés et ses statues monumentales telles que *La Mère de Dieu sur le croissant de lune* (ill. 4 et ill. p. 177), mais aussi une table pour le conseil de Wurtzbourg (ill. p. 161) dont il était membre; en 1520/21, il y occupa même la fonction de maire.
À cette époque, la conception d'un objet d'usage courant avait la même valeur que celle d'une sculpture – un fait dont la plupart, aujourd'hui, n'ont significativement plus conscience. Les valves de miroir (ill. 3 et ill. pp. 229, 317, 385), dont la valeur du matériau les rendait d'emblée estimables, sont elles aussi des produits de première qualité de la sculpture d'ivoire. On se donnait beaucoup de peine

Ill. 20
Ill. p. 237 (detail) / Abb. S. 237 (Detail) / ill. p. 237 (détail)

Ill. 21
Chess piece / Schachfigur / Pièce d'échecs
South German, 2nd quarter of the 15th century. Walrus ivory, 13.9 x 3.2 x 6.1 cm / 5 ½ x 1 ¼ x 2 ¼ in.
Staatliche Museen zu Berlin, Bode-Museum

à créer comme des œuvres d'art des objets que le regard d'aujourd'hui considère comme triviaux, tels qu'un miroir à main. L'ivoire, rare et difficile à acquérir, était réservé aux membres des couches sociales les plus élevées, lesquelles pouvaient s'offrir le noble matériau. Cette aristocratie tenait beaucoup, non seulement à obtenir une virtuosité artisanale de haut niveau, mais aussi à voir se refléter, pour ainsi dire dans un double miroir, les idéaux et conventions de son élégant style de vie. Ces accessoires de toilette destinés aux soins de beauté étaient utilisés par des femmes avides de représentations liées au thème de l'amour courtois, cette sublimation, issue du haut Moyen Âge, des relations entre les sexes, dont la manière de penser des dames était alors imprégnée, mais qui n'existait guère dans la réalité. Les valves de miroir témoignent admirablement de l'histoire de la civilisation ; illustrations concrètes des thèmes, histoires et sujets transmis par la littérature, elles influençaient l'existence quotidienne de leurs utilisatrices, qui y étaient confrontées à chaque maniement de l'objet.
Les miroirs de plus grande taille (ill. p. 495) et les peignes, autres ustensiles des soins de beauté, étaient souvent pareillement conçus, même lorsque les derniers n'étaient pas fabriqués en précieux

ivoire, mais en buis. Leur décor pouvait montrer des classiques de la poésie courtoise, telle l'histoire de Tristan et Iseult (ill. p. 429). L'attachement exclusif à ce que l'on convient d'appeler le grand art ne peut transmettre le sentiment existentiel et l'univers mental d'époques depuis longtemps révolues et des hommes qui y vécurent ; seule la profusion de l'héritage matériel et immatériel considéré dans sa totalité peut y parvenir.

Enfin, la représentation iconographique des légendes et histoires écrites et récitées par les poètes courtois ne se limitait pas aux objets d'usage courant ; leur illustration s'étendait au décor des intérieurs, lequel n'était pas essentiellement constitué de tableaux muraux et de panneaux peints. Exposées aux courants d'air et insuffisamment chauffées, les pièces d'habitation des châteaux et palais étaient principalement décorées de tapisseries. Celles-ci présentaient l'avantage d'allier l'utile à l'agréable, en empêchant le froid de se répandre et en atténuant l'humidité des murs tout en attirant le regard par la grâce de leurs représentations. On pouvait y voir, entre autres, des scènes de l'épopée médiévale française, également célèbre sur le territoire allemand, contant l'amour de Guillaume et Amélie (ill. pp. 401–407). Les idéaux, convictions et conventions de la vie sociale ainsi que la conception du monde qui les sous-tendait étaient ainsi omniprésents.

Il n'est donc guère étonnant que les objets profanes témoignent également de la dévotion et de la foi chrétiennes (ill. 14 et ill. p. 267). Des peignes conçus avec art offrent ainsi des scènes de l'histoire biblique, telles que l'Annonciation à Marie et la visite des Rois mages (ill. p. 473) – un fait révélateur de l'importance cruciale que revêtait à cette époque l'ornementation. Le seul concept de *decorum*, décor, possédait alors un sens beaucoup plus large, désignant, outre la décoration, les convenances, la bienséance, la décence. L'interpénétration artistique des sphères de l'existence, le quotidien et le culte, coulait de source. Il n'est guère surprenant, partant, d'observer une similarité fondamentale dans la conception des objets fonctionnels. Ce qui valait pour l'existence profane valait *a fortiori* dans le domaine sacré. Ainsi les récipients eucharistiques, ou vases sacrés, destinés à accueillir le pain et le vin consacrés, jouaient un rôle particulier dans le déroulement de la messe. Leur forme facilitait le maniement de l'objet, tandis que leur décor, malgré sa réduction à une thématique simple due au peu d'espace disponible, illustrait les principaux sujets de la foi, que ce soient les anges, les saints, les prophètes (ill. p. 501) ou la Crucifixion et la Vierge à l'Enfant (ill. p. 189).

L'importance attachée à l'évocation visuelle conduisit à concevoir, à la fin du Moyen Âge, un contenant spécialement destiné à la conservation de l'hostie consacrée, laquelle, selon le dogme catholique de la transsubstantiation, se change, pendant la célébration de la messe, en substance réelle du corps du Christ. Ce récipient où était conservée et exposée l'hostie présentait une structure architecturale à laquelle étaient intégrés le Christ et les figures de saints (ill. p. 575). La conception des ustensiles dévolus à la seule conservation obéissait à un même principe ; ce que le regard non prévenu d'aujourd'hui qualifie de château fort miniature prend tout son sens dès lors qu'on se rappelle que la foi et son institution terrestre, l'Église, étaient considérées comme une forteresse, à l'image de la Jérusalem céleste (ill. p. 301).

Ce principe de visualisation s'étend par ailleurs aux chandeliers d'église d'époque romane, dont les dragons et les démons, au-delà de leur fonctionnalité, incarnent la victoire de la lumière (« Ego sum lux mundi », « Je suis la lumière du monde », Jean 8, 12), symbole du Bien, sur le Mal, à savoir le

triomphe de Dieu sur le diable (ill. p. 551). La cloche à main qui servait, pendant la messe, à sonner les étapes liturgiques, était elle-même ornée des symboles des évangélistes (ill. p. 217). Quant aux habits et joyaux des dignitaires ecclésiastiques (ill. 10 et ill. p. 227), nul ne s'étonnera qu'ils soient pourvus d'ornements mettant en évidence l'ancrage du statut de ceux qui les portaient dans les fondements de l'Église. Le traitement particulier du matériau, qu'il s'agisse d'œuvres sculptées (ill. pp. 243, 345) ou d'objets de métal exécutés avec art (ill. pp. 395, 465), souligne le respect dû à la fonction, lequel est toujours double. Les volutes des crosses pastorales témoignent du rang éminent de l'évêque tout en justifiant sa fonction. Les crosserons, en effet, contiennent des représentations telles que l'Annonciation (ill. p. 465), le Crucifié (ill. p. 243), le couronnement de Marie (ill. p. 345) ou encore le sacrifice pour la foi à l'exemple des martyrs (ill. p. 395).

Les témoins de la foi s'étant distingués par leur vie et leurs actes étaient traditionnellement l'objet d'une vénération particulière. Celle-ci trouvait son expression la plus forte dans le culte des reliques, la conservation souvent fastueuse des vestiges corporels transmis en héritage par les saints. Les reliques étant, dans la pleine acception du terme, «saisissables», elles imposaient le recours à un précieux décor. On leur attribuait un pouvoir aux effets miraculeux; de nombreux pèlerinages conduisaient jusqu'aux lieux de leur conservation. Les reliquaires transmis présentent une immense profusion de formes, dont la variété reflète celle des saintes destinées. Par-delà les changements formels et stylistiques auxquels ils furent soumis, leur conception est toujours expressive, qu'il s'agisse de coffres et de coffrets (ill. p. 427), de châsses (ill. pp. 324/325), de bustes (ill. p. 455) ou de statuettes (ill. p. 557). La croix elle-même, signe de la foi, n'était pas qu'un simple symbole; elle servait souvent à contenir des particules de la Sainte Croix (ill. pp. 383, 461, 553). L'éventail des représentations et des formes embrasse des scènes conventionnelles illustrant les événements de la vie de Jésus et établissant un lien sémantique général avec les reliques (ill. pp. 324/325, 427); des œuvres représentant des figures entières ou à mi-corps et évoquant d'emblée leur contenu (ill. pp. 455, 557); des structures très complexes à plusieurs niveaux où se mêlent histoires et symboles (ill. pp. 479, 481).

L'esprit de l'époque, si différent de nos conceptions modernes, autorisait en outre des conversions qui paraissent étranges aujourd'hui. Si les thèmes étaient interchangeables, ce qui permettait à des sujets religieux d'apparaître sur des objets de la vie courante, les supports des messages iconographiques pouvaient, sans la moindre difficulté, changer de destination. Le célèbre jeu de société d'Aschaffenbourg constitue à cet égard un cas particulièrement insolite à nos yeux (ill. 11 et ill. pp. 367–375). Initialement conçu comme un jeu d'échecs, il fut transformé en reliquaire; les coffrets latéraux destinés à la conservation des pièces accueillirent les saintes particules. Le décor permit ce changement de fonction car, de la même manière que les chandeliers romans faisaient interagir les représentations de démons et la symbolique de la lumière (il. p. 551), les créatures fabuleuses occupant les cases de l'échiquier pouvaient faire figure de démons, établissant ainsi un lien thématique avec les reliques. Le vénérable objet illustrait à son tour le triomphe du Bien sur le Mal.

Ce principe de conversion s'étendait également à la réutilisation d'œuvres d'art plus anciennes dans de nouvelles compositions, lorsqu'un ciboire d'art fatimide en cristal, par exemple, devenait élément d'un calice (ill. 8 et ill. p. 417). De même, par la suite, des œuvres d'art chrétiennes

anciennes furent souvent intégrées à de nouveaux artéfacts sacrés. Ce type de remaniement est fréquent en ce qui concerne les reliures de luxe de précieux manuscrits (ill. 7 et ill. p. 103). Le tableau central d'un relief d'ivoire en trois parties, un triptyque, put, dans la mesure où les motifs de la représentation étaient appropriés quant à leur contenu, devenir le champ central du plat avant de la reliure d'un évangéliaire, soit d'un codex contenant le texte des quatre Évangiles (ill. p. 137). Afin d'adapter une œuvre plus ancienne à sa nouvelle destination, on n'hésitait pas, le cas échéant, à supprimer des parties considérées comme superflues (ill. p. 91).

La fin du Moyen Âge n'apporta guère de changement fondamental dans la manière d'aborder les œuvres du passé ni dans celle de concevoir et de décorer les objets. Pendant la Renaissance, au temps du maniérisme et aux débuts du baroque, on continua à orner les objets d'usage courant de décors expressifs. Ainsi, les faces internes de coupes à friandises étaient décorées d'émaux peints représentant des scènes de romans antiques et exécutés par des spécialistes fort bien payés (ill. pp. 577–579). L'esprit et la chose se voyaient malicieusement liés : c'est seulement lorsque les coupes étaient vides que l'on apercevait les images contenues à l'intérieur, et seul qui possédait la culture s'y rapportant pouvait comprendre celles-ci. Aussi est-il aisé d'imaginer que de telles coupes prêtaient, lors des banquets, à maints divertissements. La tendance, caractéristique des débuts de l'époque moderne, à joindre l'utile à l'agréable, trouvait son expression langagière dans la formule latine empruntée à Horace, *prodesse et delectare.*

Les heurtoirs étaient eux-mêmes conçus comme d'ingénieuses œuvres d'art décoratif à double fond, ornées de figures du monde des dieux symbolisant la prospérité de leurs riches propriétaires (ill. p. 547). Comme au Moyen Âge, les nobles avaient alors d'eux-mêmes une conception chevaleresque, à laquelle correspondait la représentation d'épisodes empruntés à l'histoire antique, allusions à peine dissimulées aux événements-clés de l'époque – et ce, jusque dans l'ornementation des armures et des selles (ill. pp. 157, 159, 378/379).

Toutefois, il serait erroné de croire que la position sociale des commanditaires exerçait une influence immédiate sur le choix des thèmes représentés et sur la manière de les exécuter. Si le faste du traitement artistique et le coût des matériaux employés dépendaient assurément toujours du rang que les acquéreurs et propriétaires des objets occupaient dans la société, les principes inhérents à la création étaient, tout en s'adaptant aux possibilités de chacun, les mêmes pour la quasi-totalité des clients. Ainsi, les œuvres appartenant aux nobles présentent, à peu de choses près, les mêmes thèmes que celles qui étaient en la possession des bourgeois. Saint Georges, héros chevaleresque de la vertu, figure aussi bien sur une coupe d'apparat commandée probablement par l'Empereur et se distinguant, non seulement par sa taille, mais aussi par la délicatesse et le raffinement du travail d'orfèvrerie (ill. p. 107), que sur une coupe à couvercle appartenant à l'argenterie du

Ill. 22
Reliquary flask / Flakon-Reliquiar / Reliquaire-Flacon
Fatimid, 10th century; Lower Saxon mid-13th and 14th century
Rock crystal, silver, 18 x 10.5 cm / 7 x 4⅛ in.
Quedlinburg, St Servatius Abbey, "Zitter," treasury

conseil de la ville d'Ingolstadt et datant à peu près de la même époque (ill. p. 502). La conception des œuvres constituait, par nature, une tâche très exigeante pour ceux qu'on appelle parfois aujourd'hui, non sans un certain mépris, des « artisans d'art ». Afin que d'excellents ouvrages puissent voir le jour, les corporations veillaient à ce que la formation fût du plus haut niveau, notamment dans les villes qui, grâce à leurs productions artistiques, étaient célèbres et respectées dans l'Europe tout entière (ill. 13 et ill. p. 225). Conservée jusqu'à aujourd'hui, une pièce modèle des orfèvres nurembergeois révèle par son aspect, une connaissance des thèmes de la culture classique et un savoir-faire artisanal du plus haut degré, ce dont devait être capable qui aspirait à y devenir maître (ill. 12 et ill. pp. 269–271).

Si bourgeois et nobles étaient rigoureusement séparés quant à leur statut, les diverses convergences dans les domaines politique et économique provoquaient des échanges continus, créant les mêmes processus de conversion que ceux qui existaient entre la sphère sacrée et la sphère profane. Les objets destinés à des fonctions de même nature, bien que socialement nuancées, étaient exécutés d'une façon similaire. Les insignes de charges officielles et de corporation le reflètent nettement. Ce qui était vrai pour les coupes l'était aussi pour les boucliers et les chaînes des confréries de tireurs – la volumineuse chaîne munichoise, dont firent conjointement présent ducs bavarois et patriciens munichois, en est peut-être l'exemple le plus fastueux (ill. pp. 359–363). Une confrérie de tireurs d'un village de Basse-Rhénanie n'avait toutefois rien à envier aux Munichois, comme l'atteste son somptueux bouclier constitué d'argent partiellement doré et pourvu d'un décor statuaire (ill. p. 365). Il va sans dire que les corporations elles-mêmes accordaient une grande valeur à la conception de leurs ustensiles cérémoniels, même lorsque ceux-ci n'étaient pas fabriqués en précieux argent, mais en étain (ill. pp. 474/475). Indiquant, de manière intrinsèque, le rang d'un objet, le matériau avait sans aucun doute son importance. Néanmoins, son choix ne s'accompagnait d'aucune restriction au niveau du décor. Un récipient à boire en argile se voyait ainsi orné, avec application, de scènes empruntées à la Bible et à l'histoire romaine (ill. p. 113) ; de célèbres maîtres représentaient des cycles sacrés sur leurs chopes en terre cuite (ill. p. 133).

À travers leurs planches de présentation, les ambitieux directeurs de la publication des *Œuvres d'art et Ustensiles du Moyen Âge et de la Renaissance* déploient un panorama complet de la production des arts appliqués prémodernes. De précieuses parures telles que colliers, pendentifs, amulettes et bagues devaient, avec leurs représentations de Vierges et de saints, exhiber l'inébranlable foi de celles qui les portaient (ill. pp. 283, 333, 441). Des accessoires de toilette exécutés avec art, des armoires richement sculptées, des fours décorés – telles de véritables forteresses présentant un programme iconographique – de blasons, de guerriers et de saints (ill. p. 415), des pièces de première qualité issues d'une orfèvrerie raffinée ; mais également, parmi d'autres ustensiles liturgiques, des reliquaires, des ostensoirs, des calices et des chandeliers – tous témoignent d'un monde disparu.

Au XIXᵉ siècle, la présentation de ces objets constituait un acte pionnier dans la recherche naissante en matière d'histoire de l'art. La publication, qui ne tarda pas à faire autorité, connut bientôt une seconde édition. Pour celle-ci, on réunit les *Œuvres d'art et Ustensiles* et les trois tomes des *Costumes du Moyen Âge chrétien*, que Hefner-Alteneck avait commencé à publier en 1840. Dans

la nouvelle édition, qui s'étendit de 1879 à 1889, on assembla les deux ouvrages, on y ajouta des objets d'art des XVIIe et XVIIIe siècles et présenta les œuvres par ordre chronologique, afin de rendre compte, étape par étape, du développement de la production artistique. Sous cette forme, la collection, comprenant désormais dix tomes d'une grande richesse documentaire, servit d'ouvrage de référence jusqu'à une période tardive du XXe siècle. Un véritable trésor avait vu le jour, dont le mérite était de présenter l'art comme un témoignage d'une culture passée.

Dans ses mémoires *(Lebens-Erinnerungen)*, Hefner-Alteneck explique ceci : « Devant le succès de cette première œuvre [les *Costumes*], je compris qu'il pouvait être très utile que parût, parallèlement à celle-ci, qui traite des objets se trouvant à proximité immédiate de l'Homme – à savoir, entre autres, des costumes, armes et parures –, une seconde œuvre, laquelle franchît un pas supplémentaire et reproduisît aussi, fidèlement, les objets appartenant à un environnement plus éloigné, tels que des ustensiles de toutes sortes – destinés à un usage courant ou dévolus au luxe –, et de différents siècles. L'ouvrage fut intitulé *Œuvres d'art et Ustensiles du Moyen Âge et de la Renaissance*. »

Cependant, le choix délibéré de Hefner-Alteneck de recourir à des objets perçus comme des articles du quotidien ne résultait pas du point de vue distancié de l'historien. Il s'agissait plutôt, pour le directeur de la publication, de faire des témoignages du passé un terreau fertile devant profiter à l'art de son époque. Au milieu du XIXe siècle, le développement industriel qui avançait à grands pas marquait la réalité sociale ainsi que la manière dont les hommes ressentaient les choses. Le bouleversement général suscitait, dans de nombreux domaines de l'existence, y compris dans les arts plastiques, un sentiment profond d'incertitude. « Dans quel style devons-nous construire ? » était le titre, extrêmement révélateur, de nombreuses études paraissant dans les revues d'architecture. Une solution largement répandue consistait à s'inspirer des monuments du passé, lesquels tenaient lieu de modèles pour les constructions du présent. Ce fut la grande époque de ce que l'on appelle l'historicisme : de nouvelles églises, de nouveaux palais, bâtiments publics et immeubles d'habitation déployaient leur splendeur sous l'aspect de monuments gothiques ou baroques. Paradoxalement, les nouvelles missions architecturales s'inspiraient elles aussi des formes historisantes. Des bibliothèques, des musées et même des gares prenaient des allures de temples grecs ou d'édifices de la Renaissance.

Si l'on se tourna alors vers le passé, c'est essentiellement parce qu'on comprit que l'industrialisation croissante précipitait dans l'oubli les qualités artisanales et créatives, entraînant une baisse de qualité de la production. C'est pourquoi, outre les monuments anciens, l'artisanat d'art traditionnel servait, lui aussi, de modèle. Des artistes historisants firent l'acquisition d'œuvres anciennes, afin d'y puiser une inspiration pour leurs propres travaux. Certains en rassemblèrent à profusion, comme l'architecte français Hippolyte Destailleur (1822–1893). Sa collection très complète de gravures sur bois, à l'eau-forte et sur cuivre, comprenant des dessins de projet du gothique tardif, de la Renaissance, du baroque et du rococo, fut achetée en 1879 par les musées de Berlin et constitua le point de départ de la plus grande collection au monde de gravures d'ornement. Depuis le milieu du XIXe siècle, on créa, sur l'initiative de l'État, des musées spécialement dédiés aux arts décoratifs, afin de permettre aux artistes contemporains de se former en prenant comme exemples les œuvres

des époques passées. Le premier fut le South Kensington Museum – l'actuel Victoria and Albert Museum – inauguré à Londres en 1852, suivi, en 1871, par le Kunstindustriemuseum de Vienne. Puis, rapidement, des institutions du même type se succédèrent à Berlin, Leipzig et Hambourg.

Ces idées, qui érigeaient les œuvres du passé en modèles pour le présent, trouvèrent un coryphée en la personne de Jakob Heinrich von Hefner-Alteneck, codirecteur de la publication des *Œuvres d'art et Ustensiles*. Ce dernier vit le jour en 1811 à Aschaffenbourg, dans une famille bourgeoise aisée aux nombreuses ramifications dans le Rheingau et ce qui était, à l'époque, l'Électorat de Mayence. Son arrière-grand-père, son grand-père et son père, lequel fut anobli en 1814, étaient juristes. Sa mère possédait un commerce de libraire-éditeur établi à Bamberg et à Wurtzbourg et comptant au nombre de ses parutions la *Phénoménologie de l'Esprit* de Hegel. La maison parentale était célèbre pour son hospitalité et son imposante collection d'objets d'art. Enfant, Jakob Heinrich perdit son bras droit au cours d'un accident équestre, mais il ne se laissa pas décourager pour autant. Grâce à d'intensives leçons particulières qui lui permirent de développer son exceptionnel talent de dessinateur, il fut capable, dès l'adolescence, d'exécuter des copies du *Hallesches Heiltum* (trésor sacré de Halle), conservé à la bibliothèque du château d'Aschaffenbourg, et, plus tard, de dessiner la plupart des remarquables planches de ses livres, dont celles des *Œuvres d'art et Ustensiles*. Éveillé tôt, son intérêt pour l'art et son histoire fut approfondi par les nombreux voyages qu'il entreprit en compagnie de son père, et au cours desquels il visita des collections à Vienne, Innsbruck, Munich, Nuremberg et Ratisbonne. Lorsque son père devint, en 1832, associé dans une manufacture de grès, Jakob Heinrich se chargea de la direction artistique de celle-ci. Par ailleurs, il dispensa lui-même des cours de dessin et reçut en 1836 le titre de professeur.

Cependant, sa véritable inclination se portait sur l'histoire de l'art et sa documentation. En 1838 parut le premier de ses recueils d'illustrations, intitulé *Beitrag zur Geschichte der deutschen Goldschmiedekunst, besonders des XVI. Jahrhunderts* (contribution à l'Histoire de l'orfèvrerie allemande, en particulier celle du XVIe siècle), lequel constitua sa thèse de doctorat, qu'il soutint en 1840 à l'université de Gießen. La même année, Hefner-Alteneck quitta la manufacture pour se consacrer pleinement à ses publications. Il commença à travailler aux *Costumes du Moyen Âge chrétien*, puis conçut le projet de publier parallèlement les *Œuvres d'art et Ustensiles*. À ce sujet il écrivit dans ses mémoires : « Mon temps et mon énergie, tout comme ceux de mon éditeur, étaient toutefois tellement absorbés par le premier ouvrage, lequel était encore en cours de parution, que je dus chercher un autre éditeur, ainsi qu'un collaborateur. Je trouvai le premier en la personne de Heinrich Keller à Francfort, le second, en celle de Karl Becker. S'il était connaisseur d'objets

ILL. 23
Ill. p. 151 / Abb. S. 151 / ill. p. 151 (detail)

ILL. 24
Rospigliosi Cup / Rospigliosi-Pokal / Coupe de Rospigliosi
19th century. Gold, polychrome enamel and gems, h. 19.7 cm / 7 ¾ in.
New York, The Metropolitan Museum of Art

anciens, ce dernier ne savait pas dessiner. Il confia à des artistes habiles le soin d'exécuter des dessins à partir d'originaux ; la plus grande partie du travail, cependant, restait à ma charge. » Les signatures figurant sur les planches des *Œuvres d'art et Ustensiles* indiquent en effet que la majorité des modèles sont dus à Hefner-Alteneck.

Né en 1794, Karl (Carl sur les pages de titre) Becker, soldat accompagnant les troupes alliées, arriva en 1814 à Paris, suite à la victoire sur Napoléon. Là, il fit la connaissance d'amateurs d'art. Plus tard, il devint érudit en la matière et fervent collectionneur à Wurtzbourg, où il vivait. En 1840, il rédigea la première monographie consacrée à Tilman Riemenschneider, lequel, à l'époque, était dans une large mesure oublié, et dont il possédait la *Mère de Dieu sur le croissant de lune* (ill. 4 et ill. p. 177). En 1852, Becker s'efforça de procurer au Germanisches Nationalmuseum, qui venait d'être fondé, des œuvres de cet important artiste du gothique tardif. Il mourut en 1859, avant l'achèvement des *Œuvres d'art et Ustensiles*. C'est sûrement grâce à lui que de nombreuses pièces wurtzbourgeoises furent intégrées à la publication.

Si Hefner-Alteneck céda à Carl Becker la première place dans l'apparition par ordre alphabétique des noms sur les pages de titre, c'était pourtant lui – sans aucun doute – la figure marquante de l'œuvre, et ses contemporains le savaient. Quand il s'installa à Munich en 1852, il fut reçu à l'Académie bavaroise des sciences ; il accéda, un an plus tard, au poste de conservateur des collections royales réunies, et passa, en 1861, au Cabinet royal des estampes et dessins. En 1868, le roi Louis II le nomma conservateur général des monuments d'art et des antiquités de Bavière et, quelques mois plus tard, il fut désigné directeur du Bayerisches Nationalmuseum – une fonction qui ne lui épargna pas les critiques, sa politique résolue d'achat et de présentation tendant à transformer le musée en collection modèle à l'usage de l'artisanat d'art de son temps. Pour ce faire, il fit réaménager les salles d'exposition, qui avaient été installées par son prédécesseur, le baron Karl Maria von Aretin, directeur fondateur du musée. Il fit aussi l'acquisition d'objets non bavarois, mit au premier plan la tradition artistique de l'Allemagne tout entière et publia d'autres ouvrages collectifs. Tout ceci lui valut une hostilité qui le remplit d'une aigreur croissante. Sa demande de mise à la retraite fut rejetée, car il fallait au préalable former d'autres conservateurs. Ce n'est qu'en 1885 qu'il put quitter ses fonctions. Il décéda en 1903, à l'âge de 92 ans.

Hefner-Alteneck était sans aucun doute un personnage hors du commun. Sa demande de changement de nom, en 1854, est très révélatrice de sa personnalité. Malgré la particule nobiliaire héritée de son père, son nom d'état civil, Hefner, n'était pas unique ; un certain Josef von Hefner exerçait lui aussi la profession d'historien de l'art. Afin d'éviter toute confusion, Jakob Heinrich proposa d'ajouter « Alteneck » à son patronyme. Ce nom résumait son activité : ne pouvant, lors des recherches nécessaires à ses publications, se référer à des écrits spécialisés, il devait dénicher « les choses anciennes dans les angles et les coins » (en allemand, « das Alte aus Winkeln und Ecken »). En effet, il n'existait pas encore de littérature scientifique détaillée susceptible de fournir les informations requises. Hefner-Alteneck était donc contraint d'aller lui-même, au cours de nombreux voyages, à la découverte des objets qui l'intéressaient. Il trouvait ceux-ci dans les musées récemment fondés et, davantage encore, dans les trésors d'églises, dans les bibliothèques et dans les collections princières, sur le marché d'objets d'art et chez des particuliers. Dans ses mémoires, il

raconte ainsi qu'il fut invité, à la fin des années 1840, au château de Mainberg près de Schweinfurt, où les propriétaires, le fabricant Wilhelm Sattler et son épouse, lui montrèrent leur riche collection, dont il dessina quelques pièces remarquables (ill. pp. 11, 117, 213).

Si ces recherches exigeaient très certainement une énergie considérable, Hefner-Alteneck en fut souvent dédommagé par la découverte d'œuvres d'art rares, singulières et belles. Un séjour à Weimar, où une coupe nautile néerlandaise figurait dans l'inventaire des collections grand-ducales, montre en quelle haute estime le tenaient, déjà à cette époque, les propriétaires des objets. Sans hésiter, la grande-duchesse lui confia le fragile et précieux récipient afin qu'il puisse le dessiner chez lui en toute tranquillité. Néanmoins, Hefner-Alteneck et son codirecteur de publication Becker utilisèrent finalement, pour les *Œuvres d'art et Ustensiles*, une reproduction effectuée par le directeur de l'Académie de dessin de Weimar, Friedrich Preller (1804–1878), alors peintre de grand renom (ill. p. 221). On ignore la raison de ce choix ; il est possible que Hefner-Alteneck ait voulu honorer le grand-duc, auprès duquel Preller occupait pour ainsi dire la fonction d'artiste de cour.

D'un point de vue actuel, ce ne fut pas une bonne décision, car l'artiste weimarois misa trop sur l'aspect pittoresque et créa une mise en scène visant à obtenir des effets visuels. Précise, attachée à reproduire l'objet avec une fidélité documentaire, la représentation de la grande coupe de Wiener Neustadt (ill. p. 107) s'en distingue agréablement. Le dessin qui servit de modèle à cette planche fut exécuté à Nuremberg par Georg Christian Wilder (1797–1855), un dessinateur et graveur à l'eau-forte, connu pour ses reproductions de monuments à l'aquarelle ou au dessin à la plume, à l'encre de Chine ou à l'encre sépia, d'une facture en toutes parts aussi exacte que belle en couleurs. Ces deux feuillets délimitent l'éventail des différentes conceptions stylistiques rencontrées dans les planches des *Œuvres d'art et Ustensiles*.

Tandis que la recherche moderne en histoire de l'art apprécie les monuments du passé pour eux-mêmes, en tant que témoins d'une époque, l'historicisme du XIXᵉ siècle avait une approche beaucoup plus souple. Croyant connaître le cours de l'Histoire, on pensait que le regard rétrospectif pouvait prétendre à une vue d'ensemble. Aussi se jugeait-on capable de corriger les défauts et lacunes de l'héritage transmis. De même que les architectes, dans leurs constructions de styles néogothique, néorenaissance et néobaroque, utilisaient les caractéristiques formelles d'une manière plus systématique qu'elles n'apparaissaient sur les édifices des époques leur servant d'exemple — créant par-là même quelque chose de neuf et de personnel, et dont la ressemblance avec les modèles n'était qu'extérieure —, on agissait, pour documenter l'histoire de l'art, avec davantage d'assurance et d'arbitraire que ce n'est le cas aujourd'hui. C'est pourquoi les planches des *Œuvres d'art et Ustensiles* ne présentent pas de simples copies figurant les originaux, mais des restitutions et des reconstitutions. Hefner-Alteneck s'estimait tout à fait autorisé à modifier l'agencement d'anciennes vues d'un objet (ill. 15–16 et ill. pp. 89, 99–101), à en ajouter de sa propre création (ill. p. 73) et à restituer leur forme d'origine à des objets partiellement détruits (ill. pp. 73, 177, 345–349, 413, 443, 485).

Que Hefner-Alteneck et Carl Becker aient collectionné eux-mêmes un volume considérable d'objets d'art, et qu'ils aient assemblé, en qualité de connaisseurs, le matériau nécessaire à leur publication, révèle, là aussi, un trait distinctif de l'époque. Les mémoires de Hefner-Alteneck rapportent

ainsi d'intéressantes et importantes acquisitions. En 1846, à Bamberg, l'antiquaire Leo Kronacher proposa à Hefner-Alteneck une liasse de peintures sur parchemin. Celui-ci put les acquérir, les identifier comme étant des œuvres du peintre de cour munichois Hans Mielich (1516–1573) et y reconnaître les reproductions des joyaux d'Albert V, duc de Bavière, ainsi que de son épouse Anne d'Autriche. Ces objets constituaient des pièces maîtresses de l'orfèvrerie allemande du XVIᵉ siècle, et Hefner-Alteneck copia les plus remarquables d'entre elles pour la publication des *Œuvres d'art et Ustensiles* (ill. pp. 85, 89, 99–101). À quoi s'ajoutèrent des achats de dessins de projet (ill. pp. 123–125), mais aussi, surtout, de pièces originales. La passion du collectionneur qu'était le directeur de la publication embrassait l'artisanat d'art dans toute son étendue. Il acheta des livres de prières pourvus des anciens revêtements destinés à les protéger lors des transports (ill. p. 565), des couvertures de livre exécutées avec art (ill. p. 393), des valves de miroir en ivoire (ill. p. 229), une superbe coupe (ill. pp. 559–563), de nombreux bijoux (ill. pp. 257–259, 283, 307–309, 559), mais aussi des têtes de clou (ill. p. 191), des serviettes (ill. pp. 172–173) et des nappes (ill. p. 299).

Il en était de même pour Carl Becker. Outre de remarquables sculptures, telles que la *Mère de Dieu sur le croissant de lune* de Riemenschneider (ill. 4 et ill. p. 177), les *Œuvres d'art et Ustensiles* présentent, parmi les objets qui étaient en sa possession, des cruches et des coffrets (ill. pp. 93, 141), des colliers (ill. p. 283), une nappe (ill. p. 165), des cuillères et des dessins de projet pour cuillères (ill. p. 115). Cependant, les relations entretenues avec les collectionneurs et amateurs d'art revêtaient une importance encore plus grande pour ce recueil de planches. Les directeurs de la publication agissaient au centre d'un véritable réseau, la tâche principale de Carl Becker consistant à réunir des informations et des renseignements, avant de charger les artistes de dessiner les modèles pour les gravures de reproduction. Les connaissances individuelles et relations personnelles ayant joué un rôle déterminant dans l'élaboration de l'ouvrage, on y trouve pour l'essentiel, aux côtés d'œuvres issues de collections italiennes, françaises et flamandes, des objets ayant appartenu à des propriétaires allemands, surtout d'Allemagne du Sud.

Des années passèrent avant que l'œuvre, comprenant trois volumes de 72 planches chacun, fût enfin achevée. Par chance, mais aussi, probablement, parce que Hefner-Alteneck accéda, un an seulement après la publication du premier volume, à l'éminent poste de conservateur des collections royales réunies à Munich, aucune circonstance extérieure notable ne fit obstacle à l'édition de l'ou-

vrage. Pour les *Costumes*, les choses s'étaient passées bien différemment. En projet depuis 1839 et publiés à partir de 1840, ils furent emportés dans le tourbillon des événements historiques. Mêlé à la révolution de 1948, l'éditeur de Mannheim Heinrich Hoff dut s'exiler en Amérique et abandonner à la faillite sa maison d'édition. Il se trouva un successeur à Francfort en la personne de Heinrich Keller, lequel se chargea de l'édition des *Œuvres d'art et Ustensiles*, puis de la réédition élargie réunissant les deux ouvrages, laquelle s'étendit de 1879 à 1889.

Les événements politiques se précipitèrent au cours de ces décennies. En 1848, un parlement fut convoqué, puis dissout. La Prusse et l'Autriche vainquirent de concert le Danemark en 1864 – ce qui leur valut les duchés de Schleswig, de Holstein et de Lauenburg –, avant de se combattre mutuellement en 1866. Le succès prussien eut pour conséquence la dissolution de la Confédération germanique et la réalisation de la solution dite petite-allemande, laquelle aboutit à la guerre franco-prussienne et se termina en 1871, quand le roi de Prusse fut proclamé empereur d'Allemagne et que l'Empire allemand fut instauré.

C'est ainsi que le fonctionnaire d'État bavarois Hefner-Alteneck, fervent défenseur de l'idée nationale allemande, se retrouva dans une nouvelle grande puissance européenne. Une prospérité politique, économique et culturelle marqua les années qui s'écoulèrent jusqu'à sa mort – années caractérisées par le changement. Celui-ci se traduisit par la réorganisation et le regroupement de collections, la fondation de nouveaux musées, la métamorphose des collections princières et particulières d'objets d'art. Des œuvres furent achetées, puis vendues ; il n'était guère aisé de conserver une vue d'ensemble. Dans la nouvelle édition de l'ouvrage collectif, réunissant les deux publications précédentes et intitulé désormais *Costumes, Œuvres d'art et Ustensiles*, le directeur de la publication mentionna les changements de propriétaire, mais dut, bien souvent, reconnaître son ignorance et recourir à des formules telles que « autrefois en la possession de ».

Ill. 25
Tapestry / Bildteppich, „Rücklaken" / Tapisserie
Alsatian, mid-15th century. Wool, woven, 0.40 x 3.03 m / 1 ft 3 ¾ x 9 ft 11 ¼ in.
London, Victoria and Albert Museum

La période qui suivit ne modifia aucunement la situation. Les *Œuvres d'art et Ustensiles du Moyen Âge et de la Renaissance* attestent, elles aussi, que le changement est la seule constante de l'existence humaine. Deux guerres mondiales, la destruction des villes qui s'ensuivit, l'instauration de systèmes politiques différents ainsi que la réorganisation étatique et géographique tracèrent leur empreinte et eurent des effets néfastes sur la préservation et la conservation des œuvres d'art. De nombreuses pièces figurant sur les planches illustrées sont définitivement perdues. Plus de dix objets et groupes d'objets documentés, issus des musées de Berlin, furent engloutis par la guerre (ill. pp. 209, 245, 253, 257–259, 277, 307–309, 313, 411, 540/541, 569–573), d'autres détériorés (ill. 18, 21 et ill. pp. 207, 237).

Les dommages causés dans le trésor de la cathédrale de Wurtzbourg ne furent guère moins importants. Deux coffrets à reliques et un broc sont perdus (ill. pp. 183, 199, 223) ; tandis qu'un bassin se trouvant dans une armoire, oublié lors de l'inventaire dressé en 1915, put être redécouvert (ill. p. 199). La table du conseil de la ville de Wurtzbourg de Riemenschneider fut sauvée, mais son plateau d'origine disparut (ill. p. 161). Un reliquaire de la ville de Nuremberg, lequel se trouve aujourd'hui au Germanisches Nationalmuseum, est conservé dans un état fortement endommagé (ill. pp. 324/325). Néanmoins, tout ne fut pas détruit. D'importantes pièces du trésor de la cathédrale de Quedlinbourg disparues en 1945 furent, comme on le découvrit plus tard, dérobées. Il ne fut possible de les récupérer qu'en 1992 (ill. 17, 22 et ill. pp. 203, 215). Peut-être le célèbre *Rupertsberger Codex* (codex de Rupertsberg) de la bibliothèque régionale de Hesse à Wiesbaden, perdu depuis 1945, connut-il un destin similaire (ill. p. 195).

La guerre et les destructions ne reflètent toutefois qu'une facette du processus historique – les contraintes économiques et les intérêts fluctuants en constituent une autre. Ces derniers affectèrent même les collections de familles nobles renommées. En 1928, les objets d'art appartenant aux Hohenzollern furent mis aux enchères au château de Sigmaringen. Une partie de la collection devint ainsi propriété publique (ills pp. 303, 401–407), d'autres œuvres sont, depuis lors, introuvables (ill. p. 453). Et, malgré la bonne conservation de l'importante collection d'objets d'art des comtes d'Erbach, acquise il y a quelques années par le land de Hesse, quelques-unes de ses pièces, présentées dans les *Œuvres d'art et Ustensiles*, ont disparu (ills pp. 179, 187). La recherche agit assurément de manière bénéfique, car les œuvres qu'elle rend célèbres et met en valeur, conformément à leur rang, sont nettement plus faciles à suivre dans leur cheminement. La *coupe de Rospigliosi*, qui appartenait encore, en 1850, à la famille noble dont elle porte le nom, arriva plus tard en Amérique et se trouve aujourd'hui au Metropolitan Museum of Art. La pièce identifiée par la suite comme un faux étant reproduite dans tous les importants ouvrages de référence traitant de l'orfèvrerie (ill. 24 et ill. p. 151), sa disparition ne saurait passer inaperçue. Ceci vaut également pour de nombreux cas comparables recensés dans la littérature spécialisée, dont notre publication dresse une liste en annexe. Lorsque ambitions familiales et possibilités muséales concourent, les œuvres essentielles sont non seulement conservées, mais aussi visibles par tous (ills pp. 577–579). Les collections publiques s'efforcent de remplir leur mission de conservation et de mise en valeur de l'héritage laissé par l'histoire de l'art et font, dans la mesure de leurs moyens financiers, l'acquisition d'œuvres.

C'est ainsi que la coupe nautile de Delft, auparavant en la possession du grand-duché de Weimar, arriva au Stedelijk Museum Het Prinsenhof (ill. p. 221) et que le petit retable de voyage qui fait probablement partie des joyaux de la reine d'Écosse Marie Stuart, parvint au Victoria and Albert Museum de Londres (ill. pp. 419–423), où se trouve aussi une moitié de la tapisserie alsacienne en deux parties, la localisation de l'autre moitié demeurant inconnue (ill. 25 et ill. pp. 511–527). Depuis les efforts fournis par Carl Becker et Jakob Heinrich von Hefner-Alteneck, certaines des pièces représentées parcoururent un long trajet, comme la chaise d'église norvégienne (ill. pp. 263–265). Franz Wilhelm Schiertz, de Leipzig, qui étudiait à l'Académie des Beaux-Arts de Dresde auprès du peintre romantique danois Johan Christian Clausen Dahl (1788–1857), découvrit l'objet en 1837, alors qu'il exécutait des dessins pour une publication de son maître, intitulée *Denkmale einer sehr ausgebildeten Holzbaukunst* [...] *Norwegens* (monuments d'une architecture en bois très développée en Norvège). Peu après, Dahl fit l'acquisition de la chaise, que les directeurs de la publication désignèrent comme sa propriété. Par la suite, le meuble d'église changea plusieurs fois de main. Après avoir appartenu au banquier et collectionneur autrichien Albert Figdor, il fut mis aux enchères suite au décès de ce dernier, en 1936. Il fut alors adjugé à un marchand d'art d'Oslo, qui le vendit la même année au Kunstindustrimuseet de la capitale norvégienne, où il est encore conservé aujourd'hui.

De nombreuses œuvres se trouvant de nos jours encore en mains privées, notre réédition ne peut, elle non plus, indiquer pour la totalité des objets les lieux de conservation actuels, et ne peut, dans nombre de cas, renvoyer qu'à d'anciens propriétaires. En revanche, elle met de nouveau à notre disposition un important ouvrage de référence, une magnifique œuvre pionnière de l'histoire de l'art au XIXᵉ siècle. Elle présente un panorama de pièces conservées et perdues, plus encore, une profusion de somptueuses planches illustrées, rendant accessible à tous un véritable trésor de l'art ancien du livre.

Les datations des planches sont issues de la publication originale du XIXᵉ siècle, celles des commentaires correspondent à l'état actuel de la recherche.

(pp. 70/71)
Jewel box / Schmuckkästchen / Coffret à bijoux (detail)
German, c. 1500. Wood, painted, partly silvered, copper, gilded and engraved,
6.8 x 14.4 x 8.8 cm / 2 ⅝ x 5 ⅝ x 3 ½ in.

RELIEF

Michaelsberg abbey workshop Bamberg (?), c. 1090. Ivory, 18.2 x 11.3 cm / 7 ⅛ x 4 ½ in.
Würzburg, Universitätsbibliothek, Sign. M. p. th. F. 68

The ivory relief is set into the front cover of the *Burghard Gospels*, a parchment manuscript containing the text of the four Gospels. Legend recounts that the codex, which dates from the 2nd half of the 6th century, once belonged to Burghard, the first Bishop of Würzburg. Like the relief adorning the *Gospels of St Kilian* (cf. ill. p. 103), the present plaque shows the influence of the 9th-century ivory relief on the cover of the *Gospels of Otto III* housed in the Bayerische Staatsbibliothek in Munich. It employs a similar compositional framework of a baldachin supported by columns within a narrow beaded border. The central representation of the Virgin and Child with St Nicholas – the Virgin standing on a pedestal and the saint on volute-like clods of earth – imitates Byzantine forms and thus carries Greek inscriptions. The baldachin on the original plaque is today damaged. The back cover of the *Burghard Gospels* can be found on page 135.

RELIEF

Werkstatt Kloster Michaelsberg Bamberg (?), um 1090. Elfenbein, 18,2 x 11,3 cm
Würzburg, Universitätsbibliothek, Sign. M. p. th. F. 68

Das Originalrelief ist eingelassen in den Buchdeckel des *Burghard-Evangeliars*, einer Pergamenthandschrift mit dem Text der vier Evangelien aus der 2. Hälfte des 6. Jahrhunderts, das der Legende nach dem ersten Würzburger Bischof Burghard gehört haben soll. Das mit schmalem Perlstab gerahmte Relief zeigt, ebenso wie das des *Kilian-Evangeliars* (siehe Abb. S. 103), den Einfluss der Elfenbeintafel des *Evangeliars Kaiser Ottos III.* (Bayerische Staatsbibliothek München). Alle drei Werke verfügen über eine ähnliche Rahmenkomposition, die von einem auf Säulen ruhenden Baldachin gebildet wird. Auf dem Relief des *Burghard-Evangeliars* erheben sich unter dieser architektonischen Konstruktion Maria mit dem Jesuskind auf einer Fußplatte und der heilige Nikolaus auf einer volutenartigen Erdscholle. Die Darstellung der Gottesmutter mit dem Heiligen ahmt byzantinische Formen nach und trägt griechische Beischriften. Der Baldachin des Reliefs ist heutzutage beschädigt. Die Rückseite des Evangeliars ist auf Seite 135 zu sehen.

RELIEF

Atelier du monastère de Michaelsberg Bamberg (?), vers 1090. Ivoire, 18,2 x 11,3 cm
Wurtzbourg, Universitätsbibliothek, Cod. M. p. th. F. 68

Le relief d'origine est encastré dans la couverture de l'évangéliaire de Burchard, un manuscrit sur parchemin contenant le texte des quatre évangélistes et datant de la seconde moitié du VIᵉ siècle. Selon la légende, le livre aurait appartenu à Burchard, premier évêque de Wurtzbourg. Tout comme celle de l'évangéliaire de saint Kilian (cf. ill. p. 103), la représentation à bordure finement perlée de la Vierge à l'Enfant et de saint Nicolas s'inspire de l'évangéliaire de l'empereur Otton III, conservé à Munich. Imitant les formes byzantines, elle porte des inscriptions grecques. Sous un baldaquin soutenu par des colonnes, et aujourd'hui endommagé dans sa version originale, la mère de Dieu se tient sur une dalle, et saint Nicolas, sur des mottes de terre en forme de volutes. L'arrière de l'évangéliaire de Burchard est représenté dans la page 135.

ΝΙ
ΚΟ
ΛΑ
ΟΣ

ΜΡ ΟΥ

C. REGNIER.

950 — 1050.

DRESSER

West or north German, late 15th century. Oak, 183.6 x 132.3 x 64.8 cm / 72 ¼ x 52 x 25 ½ in.

<small>FORMERLY IN A PRIVATE COLLECTION – WHEREABOUTS UNKNOWN</small>

The dresser is symmetrical on either side of the central vertical axis and is decorated with Late Gothic scrolling ornament, whose motifs of leaves and clusters of grapes appeared on the original against a blue-dyed background.

FLASK AND PRUNT GLASSES

German, c. 1500. Flask: tin, h. 37.8 cm / 14 ¾ in.

<small>FORMERLY WITHIN THE ART TRADE – WHEREABOUTS UNKNOWN</small>

The flask is decorated with engraved leafy ornament in the Late Gothic style. The central medallion, painted in oil, shows a supporter with two coats of arms that cannot be identified and a banderole whose writing is blurred.

STOLLENSCHRANK

West- oder norddeutsch, Ende 15. Jahrhundert. Eichenholz, 183,6 x 132,3 x 64,8 cm

<small>EHEMALS IN PRIVATBESITZ – AUFBEWAHRUNGSORT UNBEKANNT</small>

Den symmetrisch aufgebauten Schrank schmücken spätgotische Rankenmuster mit Weintrauben- und Blattmotiven, deren Hintergrund am Original blau gefärbt war.

KRUG UND NOPPENGLÄSER

Deutsch, um 1500. Krug: Zinn, 37,8 cm hoch

<small>EHEMALS IM KUNSTHANDEL – AUFBEWAHRUNGSORT UNBEKANNT</small>

Der Krug ist mit spätgotischem Rankenornament in Gravur verziert. Das zentrale, in Öl gemalte Medaillon zeigt einen Schildhalter mit zwei unkenntlichen Wappen und verwischter Schrift auf einem Spruchzettel.

DRESSOIR

Allemagne de l'Ouest ou du Nord, fin du XVᵉ siècle. Bois de chêne, 183,6 x 132,3 x 64,8 cm

<small>AUTREFOIS EN COLLECTION PRIVÉE – LOCALISATION INCONNUE</small>

Construit symétriquement, le buffet est orné de motifs du gothique tardif, des entrelacs de pampres, dont le fond était à l'origine peint en bleu.

CRUCHE ET VERRES POINTE DE DIAMANT

Allemagne, vers 1500. Cruche: étain, hauteur 37,8 cm

<small>AUTREFOIS DANS LE COMMERCE D'OBJETS D'ART – LOCALISATION INCONNUE</small>

Sur la cruche sont gravés des rinceaux caractéristiques de l'époque. Le médaillon central peint à l'huile présente, sur un cartouche portant des inscriptions effacées, un personnage tenant des boucliers pourvus d'armoiries méconnaissables.

1490 — 1530.

HOLY THORN RELIQUARY

Albrecht Glim (?), Nuremberg, c. 1500. Rock crystal, silver gilt with gems and pearls, h. 33.5 cm / 13 in.
FORMERLY IN THE CASTLE CHURCH AT MARIENBERG FORTRESS
WÜRZBURG, MAINFRÄNKISCHES MUSEUM
The reliquary consists of a rock-crystal beaker originally worked in Venice around 1330, which around 1500 was fashioned into a covered goblet by a Nuremberg goldsmith – possibly Albrecht Glim in view of the letter "g" on the underside of the foot. The foot also bears the inscription "ANNO 1519 SWEINFURT," which was formerly interpreted as a reference to its place and date of origin but which is in fact the ownership mark of the city of Schweinfurt. Having previously functioned as a non-religious object, at an unknown point in time the goblet reached the Würzburg court, where it was used to house a relic of Christ's Crown of Thorns.

DORNEN-RELIQUIAR

Albrecht Glim (?), Nürnberg, um 1500. Bergkristall, Silber, vergoldet, mit Edelsteinen und Perlen, 33,5 cm hoch
EHEMALS IN DER SCHLOSSKIRCHE AUF DER FESTUNG MARIENBERG
WÜRZBURG, MAINFRÄNKISCHES MUSEUM
Das Reliquiar besteht aus einem um 1330 in Venedig gearbeiteten Bergkristallbecher, der um 1500, nach dem Zeichen „g" an der Fußunterseite möglicherweise von Albrecht Glim, in Nürnberg als Deckelpokal gefasst wurde. Im Fuß befindet sich auch die früher als Entstehungsangabe gedeutete Inschrift „ANNO 1519 SWEINFURT", bei der es sich jedoch um einen Besitzvermerk der Stadt Schweinfurt handelt. In unbekannter Zeit kam das bis dahin profane Gefäß an den Würzburger Hof und wurde als Behälter für eine Reliquie von der Dornenkrone Christi verwendet.

RELIQUAIRE DE LA COURONNE D'ÉPINES

Albrecht Glim (?), Nuremberg, vers 1500. Cristal de roche, argent, doré, garni de pierres précieuses et de perles, hauteur 33,5 cm
AUTREFOIS CONSERVÉ DANS L'ÉGLISE DE LA FORTERESSE DE MARIENBERG
WURTZBOURG, MAINFRÄNKISCHES MUSEUM
Le reliquaire est constitué d'un gobelet en cristal de roche exécuté en 1330 à Venise et transformé vers 1500 en coupe à couvercle peut-être, d'après le signe « g » sur le dessous du pied, par Albrecht Glim à Nuremberg. Sur le pied figure aussi l'inscription « ANNO 1519 SWEINFURT », autrefois interprétée comme étant une indication d'origine ; il s'agit en réalité d'une note de propriété de la ville de Schweinfurt. À une époque inconnue, le récipient, à l'origine profane, arriva à la cour wurtzbourgeoise et fut alors utilisé comme contenant d'une relique de la Couronne d'épines.

ANNO 1519 *SWENFVRT.*

1519.

(pp. 79–81)

A. HAND TOWEL

German (?), early 16th century. Linen, embroidered in a variety of colours, 125 x 34 cm / 49 ¼ x 13 ⅜ in.
FORMERLY SIGMARINGEN FÜRSTLICH HOHENZOLLERN'SCHE SAMMLUNGEN

The towel sold at auction in Frankfurt am Main in 1928, was said to have been presented to Emperor Charles V in 1520, on the occasion of his coronation in Aachen, by hereditary chamberlain Count Eitel Frederick of Zollern. It is embroidered with four medallions illustrating the supposed "Wiles of Women" and grouped into two sets of two, with one set facing in the opposite direction to the other. The explanation for this lies in the fact that the hand towel, when in use, was carried draped over one arm. The scenes appearing upside down on the plate show Samson and Delilah (top) followed by Virgil suspended in the basket beneath the window of his beloved. The two lower medallions depict Bathsheba at her bath and Xanthippe riding Socrates.

B & C. BORDER MINIATURES

Nikolaus Glockendon, Nuremberg, 1523/24, from the Missal of Cardinal Albrecht
ASCHAFFENBURG, JOHANNISBURG CASTLE HOFBIBLIOTHEK, SIG. MS. 10

The miniatures on the left and right-hand side of the plate originate from the Missal of Cardinal Albrecht of Brandenburg (vellum, page size 38.5 x 28 cm / 15 ⅛ x 11 in.), which was illuminated by the Nuremberg artist Nikolaus Glockendon with 24 full-page illustrations and 93 large historiated initials, as well as elaborate borders on several pages (cf. ill. p. 127).

B

A

C

4.

1520 – 1530.

(S. 79–81)

A. „HANDZWELE"

Deutsch (?), Anfang 16. Jahrhundert. Leinen, verschiedenfarbig bestickt, 125 x 34 cm
EHEMALS FÜRSTLICH HOHENZOLLERN'SCHE SAMMLUNGEN SIGMARINGEN

Das 1928 in Frankfurt versteigerte, in der Mitte der Tafel abgebildete Handtuch soll der Überlieferung
nach 1520 in Aachen Kaiser Karl V. bei seiner Krönung durch den Erbkämmerer Graf Eitel Friedrich von
Zollern überreicht worden sein. Die „Handzwele" schmücken vier Darstellungen der sogenannten
Weiberlist. Je zwei Paare sind in Gegenrichtung zueinander angeordnet, da das Handtuch beim Gebrauch
über dem Arm hängend getragen wurde. Dargestellt sind oben: Samson und Delila, Vergil im Korb vor
dem Fenster seiner Geliebten, und unten: Xanthippe, die auf Sokrates reitet, und Bathseba im Bade.

B & C. RANDLEISTEN-MINIATUREN

Nikolaus Glockendon, Nürnberg, 1523/24, aus: Missale des Kardinals Albrecht
ASCHAFFENBURG, SCHLOSS JOHANNISBURG HOFBIBLIOTHEK, SIG. MS. 10

Die Miniaturen auf der linken und rechten Seite der Tafel stammen aus dem Messbuch des Kardinals
Albrecht von Brandenburg (Kalbspergament, Blattgröße 38,5 x 28 cm), das der Nürnberger Künstler
Nikolaus Glockendon mit 24 ganzseitigen Darstellungen, 93 großen Bildinitialen und kunstvollen
Randleisten auf mehreren Seiten geschmückt hat (siehe Abb. S. 127).

(pp. 79–81)

A. SERVIETTE, « TOUAILLE »

Allemagne (?), début du XVIᵉ siècle. Lin, brodé de différentes couleurs, 125 x 34 cm
AUTREFOIS CONSERVÉE DANS LES COLLECTIONS PRINCIÈRES
DE LA MAISON HOHENZOLLERN, SIGMARINGEN

D'après la légende, le linge, vendu aux enchères à Francfort en 1928, aurait été remis par le camérier
Eitel Friedrich, comte de Zollern, à l'empereur Charles Quint, lors du couronnement de ce dernier à Aix-
la-Chapelle, en 1520. La « touaille » était ornée de quatre représentations de la prétendue rouerie féminine.
Quatre couples sont répartis en deux paires disposées en sens inverse l'une de l'autre, car la serviette était
suspendue au bras pendant son utilisation. Samson et Dalila, Virgile dans la corbeille devant la fenêtre de sa
bien-aimée sont représentés en haut, Xanthippe chevauchant Socrate, et Bethsabée dans son bain, en bas.

B & C. MINIATURES ORNANT LES BORDURES D'UN MISSEL

Nikolaus Glockendon, Nuremberg, 1523/24, provenant du missel du cardinal Albrecht
ASCHAFFENBOURG, CHÂTEAU DE JOHANNISBURG HOFBIBLIOTHEK, COD. MS. 10

Les miniatures proviennent du missel du cardinal Albrecht de Brandebourg (parchemin de veau,
dimensions de la feuille 38,5 x 28 cm) que l'artiste nurembergeois Nikolaus Glockendon a orné, sur
plusieurs pages, de 24 représentations en pleine page, de 93 grandes majuscules et de bordures
exécutées avec art (cf. ill. p. 127).

OVEN MODEL
German monogrammist H. G. D., 1550. Earthenware, dyed black, h. 28.4 cm / 11 in.
<small>FORMERLY IN A PRIVATE COLLECTION</small>
All the decorative elements are gilded. The narrower side of the model carries the Nassau-Saarbrücken coat of arms, whereas the front and back show portraits of a man wearing the badge of the Order of the Golden Fleece. From this it may be deduced that the model documents a commission by a prince for a monumental ceramic oven, since the chivalric order was open exclusively to princes and members of the senior aristocracy.

OFENMODELL
Deutscher Monogrammist H. G. D., 1550. Ton, schwarz gefärbt, 28,4 cm hoch
<small>EHEMALS IN PRIVATBESITZ</small>
Alle Verzierungen sind vergoldet. Auf der Schmalseite des Modells befindet sich das Wappen von Nassau-Saarbrücken. Vorder- und Rückseite zeigen männliche Bildnisse mit dem Orden des Goldenen Vlieses. Daraus lässt sich ableiten, dass es sich bei dem Werk um ein Vertragsmodell für die Anfertigung eines monumentalen Kachelofens im Auftrag eines Fürsten handelt, denn nur Angehörige des hohen Adels und Fürsten konnten Mitglieder des Ritterordens werden.

MODÈLE RÉDUIT D'UN FOUR
Monogrammiste allemand H. G. D., 1550. Terre cuite, coloration noire, hauteur 28,4 cm
<small>AUTREFOIS EN COLLECTION PRIVÉE</small>
Tous les ornements sont dorés. Sur le côté étroit du modèle se trouve le blason de Nassau-Sarrebruck. Les faces avant et arrière représentent des figures masculines arborant l'ordre de la Toison d'or. On peut en conclure qu'il s'agit d'un modèle de contrat pour l'exécution d'un poêle de faïence monumental commandé par un prince, car l'accession à cet ordre de chevalerie était réservée aux membres de la haute noblesse et aux princes.

1550

LIDDED TANKARD
German, c. 1540. Original lost, after a miniature by the court painter Hans Mielich, 1546–51
MUNICH, BAYERISCHES NATIONALMUSEUM

This illustration of a magnificent beer tankard, the original of which is today lost, is based on a miniature in the inventory of the jewels and precious objects owned by Albert V, Duke of Bavaria (cf. ills. pp. 89, 99–101). The inventory, of which only individual sheets now survive, was compiled between 1546 and 1551 and illustrated by Albert's court painter, Hans Mielich. The miniatures on the surviving sheets are executed in watercolour and gouache on parchment and in places heightened with gold. The tankard was probably fashioned from silver gilt and decorated with enamel. Its lid is crowned by the figure of Charity holding a heart with the monogram "A" before her breast. She and the two children accompanying her are supporting two shields, each studded with a gem. The handle of the tankard is formed by two interlacing snakes; a third child is seated on the thumb-rest. Hefner-Alteneck has here selected just one detail from the more comprehensive set of four illustrations offered by Mielich, who shows the tankard from the front, back and sides. Hefner-Alteneck has thereby added his own outline drawings of some of the design details (B–D).

PRUNKKRUG
Deutsch, um 1540. Original verloren, nach einer Miniatur des Hofmalers Hans Mielich, 1546–1551
MÜNCHEN, BAYERISCHES NATIONALMUSEUM

Die Tafel zeigt das Detail einer Darstellung aus einem nur in Einzelblättern erhaltenen Inventar der Kleinodien des bayerischen Herzogs Albrecht V., das zwischen 1546 und 1551 angefertigt wurde (siehe Abb. S. 89, 99–101). Die Einzelblätter (Aquarell und Gouache auf Pergament) sind teils mit Gold gehöht. Wiedergegeben ist auf dieser Tafel ein heute verlorenes Trinkgefäß, ein Bier-Kandel. Der wahrscheinlich aus vergoldetem Silber gearbeitete und mit Email verzierte Krug trägt als bekrönende Figur auf dem Deckel die Caritas, die ein Herz mit dem Monogramm „A" vor der Brust hält. Sie und die sie begleitenden Kinder halten zwei Schilde mit Edelsteinbesatz. Den Henkel bilden zwei verschlungene Schlangen; ein weiteres Kind sitzt auf der Daumenrast. Hefner-Alteneck bietet hier nur ein Detail einer weit umfangreicheren Abbildung Mielichs. Sie ist im Original vierteilig und zeigt den Krug von vorn, hinten und den Seiten. Die Umzeichnungen der Details (B–D) auf der Tafel sind freie Zufügungen von Hefner-Alteneck.

CHOPE D'APPARAT
Allemagne, vers 1540. Original perdu, d'après une miniature du peintre de cour Hans Mielich, 1546–1551
MUNICH, BAYERISCHES NATIONALMUSEUM

La planche montre un détail d'une représentation issue d'un inventaire des joyaux du duc Albert V de Bavière (cf. ill. pp. 89, 99–101). Conservé seulement sous la forme de feuilles isolées et partiellement rehaussées d'or (aquarelle et gouache sur parchemin), l'ouvrage a été confectionné entre 1546 et 1551. Le récipient à boire, reproduit sur la planche et aujourd'hui perdu, est une chope à bière, probablement exécutée en argent doré et décorée d'émail. Au sommet, sur le couvercle, se dresse la figure de la Charité tenant contre son sein un cœur pourvu du monogramme « A ». Aidée par deux enfants, elle soutient deux boucliers garnis de pierres précieuses. Deux serpents enlacés constituent l'anse ; un autre enfant est assis sur le repose-pouce. Hefner-Alteneck n'offre ici qu'un détail d'une illustration beaucoup plus riche de Mielich. Celle-ci se compose de quatre parties présentant la chope vue de face, de dos et des deux côtés. Les détails redessinés sur la planche (B–D) ont été librement ajoutés par Hefner-Alteneck.

D

A

6

C

B

1546 — 1555.

OSTENSORIUM

German, early 16th century. Silver, partly gilded with blue enamel flowers.
Original lost, after a miniature in Hallesches Heiltum, *1526*
ASCHAFFENBURG, JOHANNISBURG CASTLE, HOFBIBLIOTHEK, SIGN. MAN. ASCHAFFENBURG B. 14
The container held by two silver angels with gilded wings and housing a thorn from Christ's Crown
of Thorns was carved from rock crystal and mounted like a monstrance in a silver-gilt surround.
The openwork sides contain the statuettes of St Christopher and St John the Evangelist. At the angels'
feet, a lion supports the coat of arms of Archbishop Ernst of Halle. The plate reproduces a miniature from
Hallesches Heiltum, a codex compiled in 1526 and documenting, on 348 illustrated pages, the famous
collection of relics assembled by Cardinal Albrecht of Brandenburg in Halle. When the arrival of the
Reformation forced the Cardinal to flee Halle, he took the manuscript with him to Aschaffenburg.

RELIQUIENOSTENSORIUM

Deutsch, Anfang 16. Jahrhundert. Silber, teilvergoldet, mit blau emaillierten Blumen.
Original verloren, nach einer Miniatur im Halleschen Heiltum, *1526*
ASCHAFFENBURG, SCHLOSS JOHANNISBURG, HOFBIBLIOTHEK, SIGN. MAN. ASCHAFFENBURG B. 14
Das von zwei silbernen Engeln mit vergoldeten Flügeln gehaltene Gefäß zur Aufbewahrung und
Präsentation eines Dorns aus der Dornenkrone Christi bestand aus Bergkristall und war monstranzartig in
vergoldetem Silber gefasst. Im Sprengwerk befinden sich die Statuetten des heiligen Christophorus und
des heiligen Johannes, des Evangelisten. Zu Füßen der Engel hält ein Löwe das Wappen des Halle'schen
Erzbischofs Ernst. Die Miniatur befindet sich im *Halleschen Heiltum*, einem Codex, der auf 348 Bildseiten
die berühmte Reliquiensammlung des Kardinals Albrecht von Brandenburg in Halle zeigt.
Er wurde 1526 erstellt und gelangte, als der Kardinal wegen der Einführung der Reformation aus Halle
fliehen musste, nach Aschaffenburg.

RELIQUAIRE-OSTENSOIRE

Allemagne, début du XVIᵉ siècle. Argent, partiellement doré, fleurs émaillées de bleu.
Original perdu, d'après une miniature provenant du Hallesches Heiltum, *1526*
ASCHAFFENBOURG, CHÂTEAU DE JOHANNISBURG HOFBIBLIOTHEK, COD. MAN. ASCHAFFENBURG B. 14
Le récipient, porté par deux anges en argent aux ailes dorées et destiné à conserver et à présenter une
épine provenant de la couronne du Christ, était constitué de cristal de roche et enchâssé dans de l'argent
doré, à la manière d'un ostensoir. La structure architecturale servant de cadre à la relique abrite les
statuettes de saint Christophe et de saint Jean l'évangéliste. Aux pieds des anges, un lion tient le blason
d'Ernest, l'archevêque de Halle. La miniature se trouve dans le *Hallesches Heiltum* (le trésor sacré de Halle),
un codex présentant sur 348 pages la célèbre collection de reliques du cardinal Albrecht de Brandebourg
à Halle. Confectionné en 1526, le manuscrit parvint à Aschaffenbourg quand le cardinal dut fuir
Halle suite à l'instauration de la Réforme.

1490 — 1510.

NECKLACE
Original lost, after a miniature by the court painter Hans Mielich, 1546–51
MUNICH, BAYERISCHES NATIONALMUSEUM

The plate shows a detail of a miniature accompanying the inventory of the jewels and precious objects owned by Albert V, Duke of Bavaria (cf. ills. pp. 85, 99–101). The necklace in all probability belonged to the Duke's wife, Anne of Austria. The enamelled fruits are alternately studded with rubies and pearls. Suspended from the chain is a gold cross in a foliate design, containing four rubies and a five-petalled blue rose and terminating at the bottom in a large pearl.

HALSGESCHMEIDE
Original verloren, nach einer Miniatur des Hofmalers Hans Mielich, 1546–1551
MÜNCHEN, BAYERISCHES NATIONALMUSEUM

Die Tafel zeigt das Detail einer Miniatur aus dem Inventar der Kleinodien des bayerischen Herzogs Albrecht V. (siehe Abb. S. 89, 99–101). Das Halsgeschmeide gehörte sehr wahrscheinlich zum Schmuck der Herzogsgattin Anna von Österreich. Die emaillierten Früchte sind abwechselnd mit Rubinen und Perlen besetzt. An der Kette hängt ein Kreuz aus goldenem Blattwerk mit vier Rubinen und fünfblättriger blauer Rose. Den unteren Abschluss bildet eine große Perle.

COLLIER
Original perdu, d'après une miniature du peintre de cour Hans Mielich, 1546–1551
MUNICH, BAYERISCHES NATIONALMUSEUM

La planche présente le détail d'une miniature issue de l'inventaire des joyaux du duc Albert V de Bavière (cf. ill. pp. 85, 99–101). Le collier appartenait très vraisemblablement à l'épouse du duc, Anne d'Autriche. Les fruits émaillés sont alternativement sertis de rubis et de perles. Une croix en feuillages d'or, pourvue de quatre rubis et d'une rose bleue à cinq pétales, est suspendue au collier ; une grosse perle en constitue l'extrémité inférieure.

H. M.

1546 — 1555.

RELIEFS
Follower of the court school of Charles the Bald (?), c. 900
Ivory, 25.8 x 16.1 cm / 10 x 6 ⅜ in. (two parts side by side)
Würzburg, Universitätsbibliothek, Sign. M. p. th. f. 67

The ivory relief shows, on the left-hand plaque, the Lamb of God pointing to a book with its raised front right leg within a lozenge-shaped frame. Acanthus leaves encircle a bear, a boar and two lions above the lozenge, and four birds – upside down as if in a reflection – below it. On the right-hand plaque, which was probably positioned upside down beside the first, three large birds appear within winding foliage.
The ivory relief is set into the cover of a possibly Breton Gospel Book from the 8th or 9th century.
The two plaques, both originally some 9 cm (3 ½ in.) wide, were deliberately trimmed to fit the cover, namely by cutting off the egg-and-dart border on their left and right-hand sides, respectively.

RELIEFS
Nachfolge der Hofschule Karls des Kahlen (?), um 900
Elfenbein, 25,8 x 16,1 cm (beide Teile zusammen)
Würzburg, Universitätsbibliothek, Sign. M. p. th. f. 67

Das Elfenbeinrelief zeigt auf der linken Platte in rautenförmigem Rahmen das Lamm Gottes, das mit erhobener Pfote in ein Buch weist. Akanthusranken umschließen oberhalb der Raute einen Bären, einen Eber und zwei Löwen und unterhalb in Gegenüberstellung vier Vögel. Auf der rechten Platte, die vermutlich umgekehrt neben der anderen Platte angebracht war, sind in drei Windungen große Vögel zu sehen. Das Original-Elfenbeinrelief ist eingelassen in den Buchdeckel eines möglicherweise bretonischen Evangeliars aus der Zeit des 8. oder 9. Jahrhunderts. Die ursprünglich jeweils ca. 9 cm breiten Platten sind eigens für den Buchdeckel zugeschnitten worden, indem der linke bzw. rechte Eierstabrand entfernt wurde.

RELIEFS
Succession de l'école palatine de Charles le Chauve (?), vers 900
Ivoire, 25,8 x 16,1 cm (ensemble constitué de deux pièces)
Wurtzbourg, Universitätsbibliothek, Cod. M. p. th. f. 67

Sur le plateau de gauche, le relief en ivoire représente, dans un cadre en forme de losange, l'Agneau de Dieu désignant, de sa patte levée, l'intérieur d'un livre. Des rinceaux d'acanthes entourent, au-dessus du losange, un ours, un sanglier, deux lions et, en dessous, quatre oiseaux qui se font face. Sur le plateau de droite, qui était probablement fixé en sens inverse à côté de celui de gauche, on distingue trois rinceaux abritant chacun un grand oiseau. L'original du relief en ivoire est enchâssé dans la couverture d'un évangéliaire, peut-être breton, datant du VIII^e ou du IX^e siècle. Les plateaux, dont la largeur d'origine était pour chacun d'environ 9 cm, ont été découpés spécialement pour la couverture. Pour cela, les bordures d'oves ont été supprimées respectivement sur la gauche et sur la droite.

950–1050.

POT

Lower Rhenish, 1591. Stoneware, h. 16.7 cm / 6 ½ in.
FORMERLY WÜRZBURG, COLLECTION OF THE EDITOR CARL BECKER –
WHEREABOUTS UNKNOWN
The pot is elaborately decorated with grotesques and strapwork.
Both in its shape and its decorative motifs, it adheres to contemporary gold
and silverware pot designs.

KRUG

Niederrheinisch, 1591. Steingut, 16,7 cm hoch
EHEMALS IM BESITZ DES HERAUSGEBERS CARL BECKER IN WÜRZBURG,
AUFBEWAHRUNGSORT UNBEKANNT
Der Krug ist aufwendig mit Grotesken- und Beschlag-werkornament geschmückt
und folgt sowohl in der Gestalt wie auch in den Schmuckmotiven damaligen Kannen
der Gold- und Silberschmiedekunst.

CRUCHE

Rhénanie inférieure, 1591. Grès, hauteur 16,7 cm
AUTREFOIS EN LA POSSESSION DE CARL BECKER À WURTZBOURG–
LOCALISATION INCONNUE
La cruche est richement décorée de motifs grotesques et d'ornements auriculaires.
Tant par sa forme que par ses motifs ornementaux, elle s'apparente aux cruches issues
de l'orfèvrerie d'or et d'argent de l'époque.

A

B

C

1591.

BROOCH, *MONILE*

c. 1420/30. Copper, gilded, embossed, figures cast, ø 15.5 cm / 6 in.

DARMSTADT, HESSISCHES LANDESMUSEUM

A *monile* is a brooch or clasp used to fasten priestly robes over the chest. The example seen here shows, at the centre, St Agatha with the instrument of her martyrdom. According to legend, the saint's breasts were cruelly torn off with pincers. Her figure is flanked on the brooch by a surface-ground brownish-purple paste and a round-cut greenish paste, followed further to the left and right by angels. The stones in the prong settings are today lost. Of the original twelve decorative nail heads, only six survive today and in certain instances have been mounted in the wrong place. Hefner-Alteneck illustrates the work in its original, intact state.

AGRAFFE, „MONILE"

um 1420/30. Kupfer, vergoldet, getrieben, Figuren gegossen, ø 15,5 cm

DARMSTADT, HESSISCHES LANDESMUSEUM

Die Agraffe hält das Priestergewand über der Brust zusammen. Im Zentrum ist die heilige Agathe mit dem Werkzeug ihres Martyriums dargestellt. Der Legende nach wurden der Heiligen mit der Zange gewaltsam die Brüste entfernt. Ihre Figur ist auf der Agraffe flankiert von bräunlich-violettem Glasfluss in Flachschliff und grünlichem Glasfluss in Rundschliff. Links und rechts daneben befinden sich Engel. Die Besatzsteine in Grappeneinfassungen sind heute verloren. Von den ursprünglich zwölf Ziernägeln sind am Original nur sechs erhalten und zum Teil an falscher Stelle eingesetzt. Hefner-Alteneck zeigt das Werk in vollständigem Zustand.

AGRAFE, « MONILE »

vers 1420/30. Cuivre, doré, repoussé, figures fondues, ø 15,5 cm

DARMSTADT, HESSISCHES LANDESMUSEUM

L'agrafe maintient l'habit du prêtre au-dessus de la poitrine. Au centre, sainte Agathe est représentée avec les outils de son martyre. D'après la légende, ses seins lui furent violemment arrachés avec une tenaille. Sur l'agrafe, la figure est flanquée de pâte de verre brun violacé en taille-gravure et de pâte de verre verdâtre en taille ronde. De part et d'autre de celles-ci figurent des anges. La garniture de pierres serties en griffes est aujourd'hui perdue. Des douze clous ornementaux que l'objet comptait initialement, seuls six sont conservés sur l'original. Ils ont été, en partie, insérés aux mauvais endroits. Hefner-Alteneck présente l'œuvre dans son état achevé.

1480 – 1510.

A & C. CIBORIUM

Limoges, 13th century. Copper, embossed, gilded and enamelled

Total h. 26 cm / 10 ¼ in., cup 3.3 cm / 1 ¼ in., cover 7.8 cm /3 in., ø foot 13 cm / 5 in., ø pyx 6.3 cm / 2 ½ in.

DARMSTADT, HESSISCHES LANDESMUSEUM

Manufactured in Limoges with characteristic Limousin enamel decoration, the container in the form of a pyx (box) was used as a receptacle for the consecrated Host. In the 14th century, during the Gothic era and probably within the German-speaking sphere, it was mounted on a stand in order to serve as a ciborium.

B & D. CANDLEHOLDER

Limoges, 13th century. Copper, embossed, cast and enamelled, h. 24 cm / 9 ½ in.

FORMERLY IN THE COLLECTION OF BARON VON HÜBSCH; SUBSEQUENTLY DARMSTADT, HESSISCHES LANDESMUSEUM – WHEREABOUTS UNKNOWN

A & C. ZIBORIUM

Limoges, 13. Jahrhundert. Kupfer, getrieben, vergoldet und emailliert

Höhe: gesamt 26 cm, Kuppa 3,3 cm, Deckel 7,8 cm , ø Fuß 13 cm, ø Pyxis 6,3 cm

DARMSTADT, HESSISCHES LANDESMUSEUM

Das zur Aufbewahrung der konsekrierten Hostie dienende Gefäß in Form einer in Limoges gearbeiteten Pyxis (Dose) mit charakteristischem Emaildekor wurde in gotischer Zeit, im 14. Jahrhundert, wahrscheinlich im deutschen Raum auf einen Ständer gesetzt, um als Ziborium, als sogenannter Speisekelch, zu dienen.

B & D. LEUCHTER

Limoges, 13. Jahrhundert. Kupfer, getrieben und gegossen, emailliert, 24 cm hoch

EHEMALS SAMMLUNG BARON VON HÜBSCH; DANN HESSISCHES LANDESMUSEUM DARMSTADT VERBLEIB UNBEKANNT

A & C. CIBOIRE

Limoges, XIIIᵉ siècle. Cuivre, repoussé, doré et émaillé

Hauteur : total 26 cm, coupe 3,3 cm, couvercle 7,8 cm, ø pied 13 cm, ø pyxide 6,3 cm

DARMSTADT, HESSISCHES LANDESMUSEUM

Exécuté à Limoges, le récipient en forme de pyxide (boîte) et au décor d'émail caractéristique était destiné à la conservation de l'hostie consacrée. C'est probablement sur le territoire allemand qu'il fut, à l'époque gothique, vers le XIVᵉ siècle, installé sur un pied pour servir de ciboire (Ziborium), appelé aussi « coupe nourrissante » (Speisekelch).

B & D. CHANDELIER

Limoges, XIIIᵉ siècle. Cuivre, repoussé, fondu, émaillé, hauteur 24 cm

AUTREFOIS CONSERVÉ DANS LA COLLECTION DU BARON VON HÜBSCH, PUIS AU HESSISCHES LANDESMUSEUM DE DARMSTADT – LOCALISATION INCONNUE

C D

A

B

1100 — 1200.

(pp. 99–101)

CEREMONIAL SWORD OF ALBERT V, DUKE OF BAVARIA
Original lost, after a miniature by court painter Hans Mielich, 1546–51
MUNICH, BAYERISCHES NATIONALMUSEUM

Plates 13–15 offer views of a ceremonial sword once owned by Albert V, Duke of Bavaria, and documented in the inventory of his collection of jewels and precious objects, compiled between 1546 and 1551 (cf. ills. pp. 85, 89). The reproductions on the plates thereby adhere in their details to the inventory's miniatures by court artist Hans Mielich, but groups the views differently. The hilt of the sword features a double hand guard beside the cross-guard, a design that was at the time new. It was made of gold or silver gilt and was studded with diamonds and rubies and painted in polychrome enamel. The scabbard was covered with purple velvet. Such costly swords were worn only on ceremonial occasions at court. Plate 14 (ill. p. 100) shows details of the sword baldric, which was also covered with purple velvet, and includes a reconstruction of the baldric (B) by Hefner-Alteneck, as it would have been worn. Plate 15 (ill. p. 101, centre and right) shows the dagger that also formed part of the set. Beside it on the left is the handle of the knife, which in Mielich's original miniature appears next to the sword.

(S. 99–101)

PRUNKSCHWERTGARNITUR DES BAYERISCHEN HERZOGS ALBRECHT V.
Original verloren, nach einer Miniatur des Hofmalers Hans Mielich, 1546–1551
MÜNCHEN, BAYERISCHES NATIONALMUSEUM

Die Wiedergabe eines Prunkschwertes von Herzog Albrecht V. nach den Miniaturen Mielichs aus dem Inventar der herzoglichen Kleinodien (siehe Abb. S. 85, 89) entspricht in den Details den Darstellungen des Hofmalers, stellt aber die Ansichten neu zusammen. Der Griff des Prunkschwertes besitzt die in der damaligen Zeit neue Form mit zwei Bügeln neben der Parierstange. Er bestand aus Gold oder vergoldetem Silber und war mit Diamanten und Rubinen besetzt und mit farbigem Email bemalt. Die Scheide war mit violettem Samt überzogen. Solche Prunkschwerter wurden nur bei höfischen Festen getragen. Tafel 14 (Abb. S. 100) zeigt Details des ebenfalls mit violettem Samt überzogenen Wehrgehänges und bietet von dessen vollständigem Zustand (B) eine Rekonstruktion Hefner-Altenecks. Tafel 15 (Abb. S. 101, Mitte und rechts) zeigt den zum Ensemble gehörenden Dolch. Daneben ist der Griff des Messers dargestellt, das sich auf der Originalminiatur von Mielich neben dem Schwert befindet.

(pp. 99–101)

GARNITURE D'UNE ÉPÉE D'APPARAT DU DUC ALBERT V DE BAVIÈRE
Original perdu, d'après une miniature du peintre de cour Hans Mielich, 1546–1551
MUNICH, BAYERISCHES NATIONALMUSEUM

La reproduction d'une épée d'apparat du duc Albert V, effectuée d'après les miniatures de Mielich issues de l'inventaire des joyaux ducaux (cf. ill. pp. 85, 89), correspond jusque dans les détails aux illustrations de ce peintre de cour, tout en modifiant l'agencement des différentes vues de l'objet. Munie de deux arceaux de part et d'autre de la garde, la poignée de l'épée présente une forme nouvelle pour l'époque. Constituée d'or ou d'argent doré et peinte d'émail coloré, elle était garnie de diamants et de rubis. Le fourreau était recouvert de velours violet. De telles épées d'apparat n'étaient portées qu'à l'occasion des fêtes de cour. La planche 14 (ill. p. 100) présente des détails du baudrier, lui aussi recouvert de velours violet, et propose une reconstitution de son état complet (B) exécutée par Hefner-Alteneck. Sur la planche 15 (ill. p. 101, au centre et à droite) figure un poignard qui appartient également à l'ensemble. À ses côtés est représentée la poignée du couteau qui, sur la miniature de Mielich, se trouve près de l'épée.

1546 — 1555

1546 — 1555.

1546 — 1555.

FRONT COVER OF THE GOSPELS OF ST KILIAN

Würzburg and Bamberg, mid-15th century and c. 1090
Silver, frame 24.5 x 19 cm / 9 ⅝ x 7 ½ in., ivory relief 15 x 9.5 cm / 5 ⅞ x 3 ¾ in.
WÜRZBURG, UNIVERSITÄTSBIBLIOTHEK, SIGN. M. P. TH. Q. IA

The parchment manuscript of the Gospels of St Kilian was produced in north France in the period around 600 and takes its name from the patron saint of the city of Würzburg, in whose tomb – so legend recounts – it was found. In the middle of the 15th century, the codex was given a lavish front cover consisting of a large silver frame bearing the four symbols of the Evangelists and studded with a large central quartz on all four sides, accompanied by blue and green pastes as well as gems of amethyst, garnet and agate. Set into the centre of the frame is an older ivory relief, which shows an executioner beheading the three Irish Franconian apostles, SS Kilian, Colman and Totnan. A vine and a tree have sprung up out of their blood. In the upper half of the scene, which takes place beneath a baldachin supported by columns, angels are conducting the souls of the martyrs to Heaven. The relief originates from the same workshop that, around 1090, also carved the ivory plaque on the front cover of the *Burghard Gospels* (cf. ill. p. 73).

BUCHDECKEL DES KILIAN-EVANGELIARS

Würzburg und Bamberg, Mitte 15. Jahrhundert und um 1090,
Silberrahmen: 24,5 x 19 cm, Elfenbeinrelief: 15 x 9,5 cm
WÜRZBURG, UNIVERSITÄTSBIBLIOTHEK, SIGN. M. P. TH. Q. IA

Die nordfranzösische Pergamenthandschrift aus der Zeit um 600 soll der Legende nach aus dem Grab des Würzburger Stadtpatrons Kilian stammen. Das Evangeliar erhielt in der Mitte des 15. Jahrhunderts einen großen Silberrahmen mit den vier Evangelistensymbolen, der an allen Seiten neben einem in die Mitte gesetzten großen Bergkristall einen Besatz aus blauen und grünen Glasflüssen sowie einen Amethyst, Granat und Achat aufweist. Eingelassen in den Rahmen ist das Elfenbeinrelief, das zeigt, wie ein Henker unter einem auf Säulen ruhenden Baldachin die drei Frankenapostel Kilian, Kolonat und Totnan enthauptet. Aus dem Blut entsprießen eine Weinranke und ein Baum. Im oberen Teil des Reliefs geleiten Engel die Seelen der Märtyrer in den Himmel. Das Relief stammt aus der Werkstatt, die um 1090 auch das Relief des *Burghard-Evangeliars* anfertigte (siehe Abb. S. 73).

COUVERTURE DE L'ÉVANGÉLIAIRE DE SAINT KILIAN

Wurtzbourg et Bamberg, milieu du XVᵉ siècle et vers 1090,
Cadre d'argent: 24, 5 x 19 cm, relief en ivoire: 15 x 9,5 cm
WURTZBOURG, UNIVERSITÄTSBIBLIOTHEK, COD. M. P. TH. Q. IA

L'évangéliaire, un manuscrit sur parchemin exécuté dans le nord de la France vers l'an 600, proviendrait, d'après la légende, de la tombe de saint Kilian, saint patron de la ville de Wurtzbourg. Au milieu du XVᵉ siècle, l'objet reçut un cadre d'argent portant les quatre symboles des évangélistes. Un grand cristal de roche installé au centre de chaque côté ainsi qu'une garniture de pâtes de verre bleue et verte, une améthyste, un grenat et une agate verte en constituent l'ornement. Dans le cadre est enchâssé le relief en ivoire, qui montre, sous un baldaquin sur colonnettes, un bourreau décapitant les trois apôtres de la Franconie, les saints Kilian, Colman et Totnan. De leur sang jaillissent un sarment de vigne et un arbre. Dans la partie supérieure du relief, des anges accompagnent les âmes des martyrs vers le ciel. Le relief provient de l'atelier qui exécuta aussi, en 1090, le relief de l'évangéliaire de Burchard (cf. ill. p. 73).

950 – 1050 & 1480 – 1500.

DECORATIVE DETAILS OF THE GOSPELS OF ST KILIAN
Corner guards, clasps and other decorative binding elements, mid-16th century. Brass, silver chased
WÜRZBURG, UNIVERSITÄTSBIBLIOTHEK, SIGN. M. P. TH. Q. IA

VERZIERUNGEN DES KILIAN-EVANGELIARS
Eckbeschläge, Schließen und andere Einbandverzierungen, Mitte 16. Jahrhundert. Messing, Silber, ziseliert
WÜRZBURG, UNIVERSITÄTSBIBLIOTHEK, SIGN. M. P. TH. Q. IA

ORNEMENTS DE L'ÉVANGÉLIAIRE DE SAINT KILIAN
Cornières, boucles, et autres ornements de reliure Milieu du XVI^e siècle. Laiton, argent, ciselé
WURTZBOURG, UNIVERSITÄTSBIBLIOTHEK COD. M. P. TH. Q. IA

C

B
A

I
H

D

G
F

E

1540 - 1560.

CORVINUS GOBLET

Wolfgang Zulinger (?), Vienna, 1460–80 (?). Silver gilt, polychrome enamel, h. 81 cm / 31⅞ in.

WIENER NEUSTADT, STADTMUSEUM

The largest goblet surviving from the Gothic era was created, so legend would have it, to mark the peace treaty concluded in 1462 in Ödenburg between Emperor Frederick III (r. 1440–93) and Matthias Corvinus, King of Hungary (r. 1458–90). This date would appear to be supported by the heart-shaped shield held by the knight kneeling on the cover, which bears the imperial device AEIOU, which stands for *Alles Erdreich ist Österreich untertan* (All the world is subject to Austria), and the coat of arms of the Hungarian king. On the other hand, however, this shield was not added to the goblet until the 19th century. Inside the cover is a medallion of St George, to whom the numerous small dragons around the foot of the goblet, on the cup and on the cover also make reference. The goblet may therefore perhaps sooner be connected with the Order of St George founded by the Emperor in 1467, whose headquarters were relocated in 1479 to Wiener Neustadt. The plate bears witness to the magnificent colours – today largely lost – of the Hungarian filigree enamel. The master's mark "Z" is found along the foot rim of the goblet.

CORVINUS-POKAL

Wolfgang Zulinger (?), Wien, 1460–1480 (?). Silber, vergoldet, farbiges Email, 81 cm hoch

WIENER NEUSTADT, STADTMUSEUM

Der größte aus der Gotik erhaltene Pokal wurde der Legende nach anlässlich des 1462 zwischen Kaiser Friedrich III. (reg. 1440–1493) und dem ungarischen König Matthias Corvinus (reg. 1458–1490) in Ödenburg geschlossenen Friedens gestiftet. Der Herzschild des auf dem Deckel knienden Ritters mit der Devise des Kaisers, AEIOU, die für „Alles Erdreich ist Österreich untertan" steht, und dem Wappen des Königs weist auf dieses Datum hin. Allerdings wurde der Schild erst im 19. Jahrhundert am Pokal angebracht. Im Inneren des Deckels befindet sich ein Medaillon des heiligen Georg, auf den sich die zahlreichen kleinen Drachen auf dem Fuß, an der Kuppa und auf dem Deckel beziehen. Auf diese Weise wird eher ein Bezug zum 1467 vom Kaiser gestifteten St.-Georg-Ritterorden hergestellt, dessen Sitz 1479 nach Wiener Neustadt verlegt wurde. Die Tafel zeigt die am Original heute weitgehend verlorene Farbenpracht des ungarischen Drahtemails. Am Rande des Pokalfußes befindet sich die Meistermarke „Z".

COUPE DE CORVIN

Wolfgang Zulinger (?), Vienne, 1460–1480 (?). Argent, doré, émail coloré, hauteur 81cm

WIENER NEUSTADT, STADTMUSEUM

Selon la légende, la plus grande coupe gothique ayant été conservée fut commandée à l'occasion de la paix conclue à Sopron, en 1462, entre l'empereur Frédéric III (règne 1440–1493) et le roi de Hongrie, Matthias Corvin (règne 1458–1490). Pourvu de la devise impériale AEIOU qui signifie « Alles Erdreich ist Österreich untertan » (Toute la terre est sujette à l'Autriche) et du blason royal, le bouclier en forme de cœur, que tient le chevalier agenouillé sur le couvercle, indique cette date. Il n'a toutefois été fixé sur la coupe qu'au XIXᵉ siècle. À l'intérieur du couvercle se trouve un médaillon de saint Georges, auquel se réfèrent de nombreux petits dragons sur le pied, sur la coupe et sur le couvercle, ce qui permet d'établir un lien plus vraisemblable avec l'ordre de Saint-Georges, un ordre de chevalerie fondé en 1467 par l'empereur et dont le siège a été transféré en 1479 à Wiener Neustadt. La planche restitue les couleurs du cloisonné hongrois, dont l'original a en grande partie perdu l'éclat. Le bord du pied de la coupe est marqué du poinçon de maître « Z ».

BAPTISMAL FONT

Master Eckhart of Worms, Würzburg, 1279. Bronze, h. 65 cm / 25 ½ in., ø 92 cm / 36 ¼ in.
WÜRZBURG, ST KILIAN'S CATHEDRAL

The baptismal font designed by Master Eckhart of Worms represents the only surviving 13th-century example from southern Germany of a large object cast in bronze. The vat-like font itself is cast in one piece, whereas the decorative elements were produced individually and assembled with rivets. Between the foot and upper rim of the font, with their annular mouldings, projecting buttresses divide the wall vertically into eight fields, each containing a figural relief beneath twin pointed-arch canopies.
The reliefs are accompanied by a wealth of inscriptions and show the following scenes:
The Annunciation (1), The Nativity (2), The Baptism in the River Jordan (3), The Crucifixion (4), The Resurrection (5), The Ascension (6), Pentecost (7) and The Last Judgement (8). Scenes 1–3 can be seen on the font, while scenes 4–8 are shown separately in outline drawings.

TAUFBECKEN

Meister Eckard von Worms, Würzburg, 1279. Bronze, 65 cm hoch, ø 92 cm
WÜRZBURG, DOM ST. KILIAN

Bei dem Taufkessel des Meisters Eckard von Worms handelt es sich um das einzige erhaltene größere Erzgusswerk des 13. Jahrhunderts aus Süddeutschland. Das kufenförmige Gefäß mit Fuß- und Randprofilierung ist durch kräftig vorspringende Fialen in acht Felder geteilt, die mit figürlichen Reliefs unter gekuppelten Spitzbogenbaldachinen geschmückt sind. Der Kessel selbst ist in einem Stück gegossen, die Schmuckteile sind einzeln hergestellt und mit Nieten zusammengefügt. Die Darstellungen zeigen, jeweils reich mit Inschriften versehen, folgende Szenen:
Verkündigung an Maria (1), Geburt Christi (2), Taufe im Jordan (3), Kreuzigung (4), Auferstehung (5), Himmelfahrt (6), Ausgießung des Heiligen Geistes (7), Jüngstes Gericht (8). Die Szenen 1–3 sind auf dem Becken zu sehen. Die Szenen 4–8 werden gesondert in Umzeichnungen gezeigt.

FONTS BAPTISMAUX

Maître Eckhart de Worms, Wurtzbourg, 1279. Bronze, hauteur 65 cm, ø 92 cm
WURTZBOURG, CATHÉDRALE SAINT-KILIAN

Parmi les pièces coulées en bronze datant du XIIIᵉ siècle et provenant d'Allemagne du Sud, la cuve baptismale de Maître Eckhart de Worms est la seule de taille importante ayant été conservée. Le récipient en forme de seau, comportant des moulures au bord et à la base, est divisé en huit champs par quatre contreforts saillants. Les champs sont décorés de personnages en relief installés sous des dais jumelés en arc brisé. La cuve elle-même est coulée en une pièce ; les éléments décoratifs ont été exécutés un par un et assemblés par des rivets. Les scènes suivantes sont représentées, chacune richement pourvue d'inscriptions :
l'Annonciation (1), la Nativité (2), le baptême du Christ (3), la Crucifixion (4), la Résurrection (5), l'Ascension (6), la réception du Saint-Esprit (7), le Jugement dernier (8). Les scènes 1 à 3 sont visibles sur la cuve. Les scènes 4 à 8 sont reproduites séparément, par des dessins.

A

B

1279.

DISH

Limoges, 13th century. Copper, beaten, enamelled, d. 4.8 cm / 1 ¾ in., ⌀ 23 cm / 9 in.
FORMERLY SCHWEINFURT, MAINBERG CASTLE
WHEREABOUTS UNKNOWN

The well of the dish, whose outer rim is decorated with a dentate border, shows the half-length figure of an archangel. He is surrounded by medallions containing dragons and dragon slayers, who symbolize the triumph of Good over Evil.

SCHÜSSEL

Limoges, 13. Jahrhundert, Kupfer, geschlagen, emailliert, 4,8 cm tief, ⌀ 23 cm
EHEMALS AUF SCHLOSS MAINBERG BEI SCHWEINFURT
AUFBEWAHRUNGSORT UNBEKANNT

Das zentrale Feld der Schüssel mit einem Randschmuck im Zackenmuster zeigt die Halbfigur eines Erzengels, der umgeben ist von Medaillons mit Drachen und Drachenkämpfern, die den Triumph des Guten über das Böse symbolisieren.

PLAT

Limoges, XIIIᵉ siècle. Cuivre, martelé, émaillé, profondeur 4,8 cm, ⌀ 23 cm
AUTREFOIS CONSERVÉ DANS LE CHÂTEAU DE MAINBERG PRÈS DE SCHWEINFURT
LOCALISATION INCONNUE

Le champ central de ce plat orné d'une bordure de chevrons est occupé par un archange demi-figure entouré de médaillons, lesquels figurent des dragons et des tueurs de dragons symbolisant le triomphe du Bien sur le Mal.

B

1120 — 1220.

PILGRIM'S FLASK

South German, 1563. Hafner ware, h. 22 cm / 8 ½ in.

DARMSTADT, HESSISCHES LANDESMUSEUM

This pilgrim's flask is made of once-fired earthenware with a coloured lead glaze and features a banderole near the top, whose Latin inscription includes the date "1563". The figural scenes framed by leafy ornament were separately modelled and then mounted on the body of the flask. They show Salome worshipping an idol (left), Samson and Delilah (right) and the suicide of Lucretia (below). It is highly likely that the laundry scene at the top was not originally part of the pictorial programme.

PILGERFLASCHE

Süddeutsch, 1563. Hafnerware, 22 cm hoch

DARMSTADT, HESSISCHES LANDESMUSEUM

Die Pilgerflasche besteht aus einfach gebrannter Irdenware mit gefärbter Bleiglasur und trägt oben ein lateinisches Schriftband mit der Jahreszahl 1563. Die in Blumendekor gefassten, einzeln geformten und dann aufgelegten Szenen zeigen: links Salomos Götzendienst, rechts Samson und Delila und unten den Selbstmord der Lukrezia. Die Darstellung der Wäscherei gehörte ursprünglich sehr wahrscheinlich nicht zum Bildprogramm.

FLACON DE PÈLERIN

Allemagne du Sud, 1563. Poterie, hauteur 22 cm

DARMSTADT, HESSISCHES LANDESMUSEUM

Le flacon de pèlerin, en céramique à cuisson simple et vernis de plomb coloré, porte dans sa partie supérieure un ruban sur lequel une inscription latine mentionne l'année 1563. Entourées d'ornements floraux, les scènes ont été façonnées séparément puis disposées de manière à représenter, à gauche, l'idolâtrie de Salomon, à droite, Samson et Dalila, en bas, le suicide de Lucrèce. La scène de blanchissage, quant à elle, n'appartient très vraisemblablement pas au programme iconographique d'origine.

1563.

SPOON AND DESIGN DRAWINGS FOR SPOONS
Italian, final third of the 16th century. Silver gilt, iron, pen drawing
FORMERLY WÜRZBURG COLLECTION OF THE EDITOR CARL BECKER – WHEREABOUTS UNKNOWN
The spoon reproduced in two views (A and B) at the top of the plate was fashioned with a handle of inlaid iron and a body of silver gilt. The spoon designs underneath (C–E) are based on Italian pattern drawings: with their anthropomorphic forms adopted from grotesque ornament, they are typical of cutlery designs of the late 16th century.

LÖFFEL UND ENTWURFSZEICHNUNGEN FÜR LÖFFEL
Italienisch, 3. Drittel 16. Jahrhundert. Silber, vergoldet, Eisen, Federzeichnung
EHEMALS IM BESITZ DES HERAUSGEBERS CARL BECKER IN WÜRZBURG
AUFBEWAHRUNGSORT UNBEKANNT
Der Löffel wurde mit Stiel aus tauschiertem Eisen und Korpus aus vergoldetem Silber hergestellt (A und B). Die anderen Löffeldarstellungen (C–E) sind nach italienischen Musterzeichnungen wiedergegeben. Sie zeigen mit ihren anthropomorphen, aus der Groteskornamentik übernommenen Formen typische Gestaltungen von Essbestecken am Ausgang des 16. Jahrhunderts.

CUILLÈRES ET DESSINS DE PROJET POUR CUILLÈRES
Italie, 3ᵉ tiers du XVIᵉ siècle. Argent, doré, fer, dessin à la plume
AUTREFOIS EN LA POSSESSION DE CARL BECKER À WURTZBOURG – LOCALISATION INCONNUE
La cuillère se compose d'un manche en fer damasquiné et d'un cuilleron en argent doré (A et B). Les autres représentations de cuillères (C–E) restituent des dessins italiens. Par leurs formes anthropomorphes héritées de l'ornementation grotesque, elles montrent un décor caractéristique des couverts de table de la fin du XVIᵉ siècle.

A

B

C

D

E

1560 — 1600.

A & B–D. LIDDED FLASK AND TANKARD

German, late 16th century. Earthenware
FORMERLY SCHWEINFURT, MAINBERG CASTLE – WHEREABOUTS UNKNOWN
The ring flask (A) was probably of Lower Rhenish or Cologne manufacture. The coat of arms in its decoration suggests that it may have been a guild flask. The lidded tankard (B–D) was produced in the Electorate of Hesse and is decorated with strapwork, a type of ornamentation that was widely employed from the final third of the 16th century onwards.

E–F. GOLDWARE DESIGNS

German or Netherlandish, final third of the 16th century – WHEREABOUTS UNKNOWN
Designs for objects fashioned in gold and set with gems and pearls, probably items of jewellery.

A & B–D. KRÜGE

Deutsch, Ende 16. Jahrhundert. Ton
EHEMALS AUF SCHLOSS MAINBERG BEI SCHWEINFURT – AUFBEWAHRUNGSORT UNBEKANNT
Der Ring-Krug (A) stammt wahrscheinlich aus niederrheinischer oder kölnischer Fabrikation und war dem aufgelegten Wappen nach möglicherweise ein Zunftkrug. Der zweite Krug (B–D) stammt aus kurhessischer Herstellung. Er zeigt Beschlagwerkornamente, die seit dem 3. Drittel des 16. Jahrhunderts verbreitet waren.

E–F. ENTWURFSZEICHNUNGEN FÜR GOLDSCHMIEDEARBEITEN

Deutsch oder niederländisch, 3. Drittel 16. Jahrhundert – AUFBEWAHRUNGSORT UNBEKANNT
Muster für Goldschmiedearbeiten mit Edelstein- und Perlenbesatz, wahrscheinlich für Schmuckstücke.

A & B–D. CHOPES

Allemagne, fin du XVI⁰ siècle. Terre cuite
AUTREFOIS CONSERVÉES DANS LE CHÂTEAU DE MAINBERG PRÈS DE SCHWEINFURT
LOCALISATION INCONNUE
La chope en forme d'anneau (A), fabriquée probablement en Rhénanie inférieure ou à Cologne, était peut-être, d'après le blason qui y est apposé, destinée à une corporation. La seconde chope (B–D) a été fabriquée en Hesse Electorale. Elle présente des ornements auriculaires répandus depuis le troisième tiers du XVI⁰ siècle.

E–F. DESSINS DE PROJET POUR PIÈCES D'ORFÈVRERIE

Allemagne ou Pays-Bas 3⁰ tiers du XVI⁰ siècle – LOCALISATION INCONNUE
Modèles pour pièces d'orfèvrerie garnies de pierres précieuses et de perles, probablement des bijoux.

A

23.

F

E

D

B

C

1550 – 1600.

(pp. 119–21)

TABLE CLOCK

Lower German. Rock crystal, silver gilt (?), after a miniature, c. 1570

MUNICH, STAATLICHE GRAPHISCHE SAMMLUNG

The plate, which is based upon a miniature, shows a table clock whose works are housed in a cylinder of rock crystal. The cylinder is probably set in silver gilt and is decorated with polychrome enamel and gems. The top of the clock is crowned by a figurine of Pegasus. The original miniature also contains an inscription in which the individual components of the clock are defined. The inscription also reveals that the bottom section could be removed and was designed to be used as a salt cellar. This "salt cellar" is decorated with scenes from the lives of Adam and Eve as an allegory of the Ages of Man, combined with a representation of Death. Whether the miniature is based upon an actual clock, now lost, or upon a design drawing is unknown. The loose sheet was part of a collection of watercolours and gouache drawings of masterly items of metalwork. Amongst these drawings were miniatures by Hans Mielich illustrating an inventory of precious objects owned by Albert V, Duke of Bavaria (cf. ills. pp. 85, 89, 99–101), leading earlier authorities to erroneously attribute the present sheet likewise to the Bavarian court painter.

FINGER RINGS

German, late 16th/early 17th century. Gold, enamelled

FORMERLY WITHIN THE ART TRADE – WHEREABOUTS UNKNOWN

1546 — 1555.

(S. 119–121)

TISCHUHR
Niederdeutsch. Bergkristall; Silber, vergoldet (?), nach einer Miniatur, um 1570
MÜNCHEN, STAATLICHE GRAPHISCHE SAMMLUNG

Das Räderwerk der Tischuhr befindet sich in einem Bergkristallzylinder, der vermutlich in vergoldetem Silber gefasst und mit farbigem Email und Edelsteinbesatz verziert war. Bekrönt wird die Räderuhr von der Statuette des Pegasus. Die Miniatur, die für die Tafel als Vorlage diente, trägt eine Beschriftung, welche die einzelnen Teile der Uhr definiert und angibt, dass der untere Teil der Uhr abnehmbar war und als Salzfass dienen sollte. Auf diesem „Salzfass" ist die Vita von Adam und Eva als Darstellung der Lebensalter wiedergegeben und durch eine Darstellung des Todes ergänzt. Ob die Miniatur eine verloren gegangene Räderuhr darstellt oder sich auf eine Entwurfszeichnung bezieht, ist nicht bekannt. Das Einzelblatt war Teil einer Sammlung von Aquarell- und Gouachezeichnungen mit Darstellungen von Meisterwerken der Metallschmiedekunst, darunter auch die eines Schatzinventars durch Hans Mielich (siehe Abb. S. 85, 89, 99–101). Deshalb wurde das Blatt früher irrtümlicherweise ebenfalls dem bayerischen Hofmaler zugeschrieben.

FINGERRINGE
Deutsch, Ende 16./Anfang 17. Jahrhundert. Gold, emailliert
EHEMALS IM KUNSTHANDEL – AUFBEWAHRUNGSORT UNBEKANNT

(pp. 119–121)

HORLOGE DE TABLE
Allemagne du Nord. Cristal de roche ; argent, doré (?), d'après une miniature, vers 1570
MUNICH, STAATLICHE GRAPHISCHE SAMMLUNG

Les rouages de l'horloge de table se trouvent à l'intérieur d'un cylindre en cristal de roche qui était probablement enchâssé dans de l'argent doré, orné d'émail coloré et serti de pierres précieuses. L'horloge est surmontée d'une statuette de Pégase. La miniature qui sert de modèle à la planche porte une inscription définissant chaque élément de l'horloge et indiquant que sa partie inférieure était détachable et devait servir de salière. Sur celle-ci se déroule la vie d'Adam et Ève, évocation des âges de la vie que vient compléter une représentation de la Mort. On ignore si la miniature reproduit une horloge à rouages perdue ou si elle se réfère à un dessin de projet. Cette feuille isolée appartenait à une collection d'aquarelles et de gouaches représentant des chefs-d'œuvre de l'orfèvrerie et incluant un inventaire exécuté par Hans Mielich (cf. ill. pp. 85, 89, 99–101). Aussi la feuille fut-elle attribuée jadis, à tort, au peintre de cour bavarois.

BAGUES
Allemagne, fin du XVIe/début du XVIIe siècle. Or, émaillé
AUTREFOIS DANS LE COMMERCE D'OBJETS D'ART – LOCALISATION INCONNUE

(pp. 123–25)
DRESSER
West German, 2nd half of the 16th century. Oak, 130 x 100.6 x 48.6 cm / 51 ⅛ x 39 ⅝ x 19 ⅛ in.
FORMERLY IN A PRIVATE COLLECTION – WHEREABOUTS UNKNOWN
The decoration consists of individual panels mounted onto the dresser.
The panels are carved from one piece of wood in low relief and employ forms that are typical
of the German Renaissance.

VASE AND TWO CANDLESTICKS AFTER DESIGN DRAWINGS
German, 2nd third of the 16th century
FORMERLY IN THE POSSESSION OF THE EDITOR HEFNER-ALTENECK
WHEREABOUTS UNKNOWN

SOLDIER AND FALCONER STATUETTES AFTER PRINTS
German or Netherlandish, late 16th century
FORMERLY WITHIN THE ART TRADE – WHEREABOUTS UNKNOWN

SMALL SCULPTURAL GROUP AFTER A DESIGN DRAWING
Italian, mid-16th century
FORMERLY IN THE POSSESSION OF THE EDITOR CARL BECKER – WHEREABOUTS UNKNOWN
A tortoise provides the plinth for this small sculptural group of a lion attacking a horse.
The representation reproduces a design drawing (pen, watercolour and gouache) characterized
by a typically mannerist handling of form.

25.

Potiset Filse

1560 – 1600.

(S. 123–125)

STOLLENSCHRANK

Westdeutsch, 2. Hälfte 16. Jahrhundert. Eichenholz, 130 x 100,6 x 48,6 cm

Ehemals in Privatbesitz – Aufbewahrungsort unbekannt

Die Verzierungen des Stollenschrankes bilden einzelne, aus einem Stück geschnitzte Flachreliefplatten,
die aufgelegt wurden und typische Formen der deutschen Renaissance aufweisen.

VASE UND ZWEI LEUCHTENTRÄGER NACH ENTWURFSZEICHNUNGEN

Deutsch, 2. Drittel 16. Jahrhundert

Ehemals im Besitz des Herausgebers Hefner-Altenneck – Aufbewahrungsort unbekannt

KRIEGER- UND FALKENIERSTATUETTE
NACH DRUCKGRAPHISCHER VORLAGE

Deutsch oder niederländisch, Ende 16. Jahrhundert

Ehemals im Kunsthandel – Aufbewahrungsort unbekannt

KLEINPLASTISCHE GRUPPE NACH ENTWURFSZEICHNUNG

Italienisch, Mitte 16. Jahrhundert

Ehemals im Besitz des Herausgebers Carl Becker – Aufbewahrungsort unbekannt

Eine Schildkröte dient der kleinplastischen Gruppe eines Löwen, der ein Pferd reißt, als Basis.
Die Vorlage der Darstellung, die eine typisch manieristische Gestaltidee wiedergibt, ist eine
Entwurfszeichnung (Feder, Aquarell und Gouache).

(pp. 123–125)

DRESSOIR

Allemagne de l'Ouest, 2ᵉ moitié du XVIᵉ siècle. Chêne, 130 x 100,6 x 48,6 cm

Autrefois en collection privée – Localisation inconnue

Les ornements du dressoir sont constitués de plaques en bas-relief sculptées d'une pièce puis apposées,
et présentant des formes caractéristiques de la Renaissance allemande.

VASE ET DEUX CHANDELIERS, D'APRÈS DES DESSINS DE PROJET

Allemagne, 2ᵉ tiers du XVIᵉ siècle

Autrefois en la possession de Hefner-Altenneck – Localisation inconnue

STATUETTE DE GUERRIER ET DE FAUCONNIER, D'APRÈS UN
MODÈLE REPRODUIT EN IMPRESSION GRAPHIQUE

Allemagne ou Pays-Bas, fin du XVIᵉ siècle

Autrefois dans le commerce d'objets d'art – Localisation inconnue

GROUPE DE SCULPTURES MINIATURES, D'APRÈS UN DESSIN DE PROJET

Italie, milieu du XVIᵉ siècle

Autrefois en la possession de Carl Becker – Localisation inconnue

Une tortue constitue la base de ce groupe de sculptures miniatures comprenant un lion qui égorge
un cheval. Un dessin de projet (plume, aquarelle et gouache) a servi de modèle à cette représentation,
laquelle reflète une conception typiquement maniériste.

A. ALTARPIECE SUPERSTRUCTURE

German, late 15th century. Wood, painted and gilded, h. 31 cm / 12 ⅛ in.
FORMERLY IN A PRIVATE COLLECTION – WHEREABOUTS UNKNOWN
This ornamentation was part of the decorative superstructure above a winged altarpiece.

B & C. BORDER MINIATURES

Nikolaus Glockendon and Georg Stirleyn, Nuremberg, 1523/24, from the Missal of Cardinal Albrecht
ASCHAFFENBURG, JOHANNISBURG CASTLE, HOFBIBLIOTHEK, SIG. MS. 10
The border miniatures stem from the same missal as those in the illustration page 79. The decorative
foliage on the left, which accompanies the hymn *Gloria in excelsis deo* (Glory to God in the highest),
incorporates the signature of Glockendon's fellow artist, Georg Stirleyn.

A. ALTARGESPRENGE

Deutsch, Ende 15. Jahrhundert. Holz, vergoldet, bemalt, 31 cm hoch
EHEMALS IN PRIVATBESITZ – AUFBEWAHRUNGSORT UNBEKANNT
Bei dem Altargesprenge handelt es sich um einen Teil des oberen Schmuckaufsatzes eines Flügelaltars.

B & C. RANDLEISTEN-MINIATUREN

Nikolaus Glockendon und Georg Stirleyn , Nürnberg, 1523/24, aus: Missale des Kardinals Albrecht
ASCHAFFENBURG, SCHLOSS JOHANNISBURG, HOFBIBLIOTHEK, SIG. MS. 10
Die Randleistenminiaturen stammen aus demselben Missale (Messbuch) wie diejenigen auf
der Abbildung Seite 79. Auf der linken Seite ist beim Hymnus „Gloria in excelsis deo" (Ehre sei Gott
in der Höhe) eine von Glockendons Mitarbeiter Stirleyn signierte Ranke wiedergegeben.

A. ORNEMENT DE RETABLE

Allemagne, fin du XVᵉ siècle. Bois, doré, peint, hauteur 31 cm
AUTREFOIS EN COLLECTION PRIVÉE – LOCALISATION INCONNUE
Cet ornement constitue une partie du décor couronnant un polyptique.

B & C. MINIATURES ORNANT LES BORDURES D'UN MISSEL

Nikolaus Glockendon et Georg Stirleyn, Nuremberg, 1523/24, provenant du missel du cardinal Albrecht
ASCHAFFENBOURG, CHÂTEAU DE JOHANNISBURG, HOFBIBLIOTHEK, COD. MS. 10
Ces miniatures ornant des bordures proviennent du même missel que celles de l'illustration page 79.
Sur le côté gauche de la planche est reproduit un motif en entrelacs décorant la page de l'hymne
« Gloria in excelsis deo » (Gloire à Dieu au plus haut des cieux) et portant la signature de Stirleyn,
collaborateur de Glockendon.

B

A

C

1480 — 1533.

LIDDED TANKARD
Nuremberg (?), 1595. Silver gilt, engraved , H. 29.7 cm / 11 ¾ in.; ø at the foot 13.5 cm / 5 ⅜ in.
SCHWEINFURT, ST JOHN'S CHURCH

The inscription around the rim states that the tankard was presented as a gift to the ecclesiastical architect Georg Gadamer by the Kitzingen town council in 1595. The body is engraved with the figures of the three Jewish heroes Joshua, David and Maccabeus, who appear within a rich ornamental framework. The lid is crowned by a statuette of St John the Baptist (B), whereas the figurine of a Virtue (A) provides the thumb-rest on the handle (C). The Kitzingen municipal coat of arms is engraved on the inside of the lid. In the wake of the Reformation, the tankard passed into the possession of the church in Schweinfurt, where it was used as a Communion jug.

DECKELKANNE
Nürnberg (?), 1595. Silber, vergoldet, graviert, 29,7 cm hoch, ø Fuß 13,5 cm
SCHWEINFURT, ST. JOHANNIS

Die auf dem Rand angebrachte Inschrift besagt, dass die Kanne vom Rat der Stadt Kitzingen im Jahre 1595 dem Kirchenbaumeister Georg Gadamer als Geschenk verehrt wurde. Der Korpus zeigt in reicher ornamentaler Rahmung die Darstellungen der drei jüdischen Helden Josua, David und Makkabäus. Den Deckel krönt der heilige Johannes der Täufer (B), und eine Tugendfigur (A) bildet die Daumenrast am Henkel (C). Im Inneren des Deckels befindet sich das Wappen der Stadt Kitzingen. In der Folge der Reformation gelangte der Humpen in den Besitz der Kirche in Schweinfurt, wo er als Abendmahlskanne benutzt wurde.

CHOPE À COUVERCLE
Nuremberg (?), 1595. Argent, doré, gravé, hauteur 29,7 cm, ø du pied 13,5 cm
SCHWEINFURT, ÉGLISE SAINT-JEAN

Selon l'inscription apposée sur le bord, le conseil de la ville de Kitzingen fit présent de la chope, en 1595, au bâtisseur d'églises Georg Gadamer. Sur le récipient apparaissent, à l'intérieur de cadres richement décorés, les trois héros juifs Josué, David et Macchabée. Jean-Baptiste (B) est installé au sommet du couvercle ; une figure de la Vertu (A)constitue le repose-pouce sur l'anse (C). À l'intérieur du couvercle se trouve le blason de la ville de Kitzingen. Suite à la Réforme, la chope entra en la possession de l'église de Schweinfurt, où elle fut utilisée comme burette pour le vin de la messe.

A

B

C

1595.

TOP, A & C. DOUBLE-SIDED COMB

Syrian, 11th century. Ivory, 10.5 x 11.1 cm / 4 ⅛ x 4 ⅜ in.

BAMBERG, CATHEDRAL TREASURY

The teeth of the Bamberg comb are spaced more narrowly on one side than on the other. The decorative central strip shows two Eucharistic doves drinking from a chalice on one side (C) and, on the reverse (A), two guardian lions on either side of the holy tree.

BELOW, D & E. DOUBLE-SIDED COMB

French, c. 1500. Ivory, 10.3 x 16.3 cm / 4 x 6 ⅜ in.

WÜRZBURG, MAINFRÄNKISCHES MUSEUM

The comb is skilfully carved with delicate Late Gothic openwork decoration and carries a rebus-like inscription whose two parts are separated in the middle by an ornamental field.

OBEN, A & C. DOPPELKAMM

Syrisch, 11. Jahrhundert. Elfenbein, 10,5 x 11,1 cm

BAMBERG, DOMSCHATZ

Der Bamberger Kamm weist auf der einen Seite eine engere Zähnung auf als auf der anderen. Der mittlere Zierstreifen zeigt auf der einen Seite zwei eucharistische Tauben, die aus einem Kelch trinken (C) und auf der Gegenseite (A) zwei Schutzlöwen zu beiden Seiten des heiligen Baumes.

UNTEN, D & E. DOPPELKAMM

Französisch, um 1500. Elfenbein, 10,3 x 16,3 cm

WÜRZBURG, MAINFRÄNKISCHES MUSEUM

Der kunstvoll mit durchbrochen gearbeiteten, fragilen spätgotischen Ornamenten verzierte Kamm trägt eine rebusartige Inschrift, deren beide Teile in der Mitte durch ein Ornamentfeld getrennt sind.

EN HAUT, A & C. DOUBLE PEIGNE

Syrie, XIᵉ siècle. Ivoire, 10,5 x 11,1 cm

BAMBERG, TRÉSOR DE LA CATHÉDRALE

Le peigne de Bamberg possède une denture plus serrée d'un côté que de l'autre. Le bandeau ornemental du milieu présente, sur une face, deux colombes eucharistiques buvant dans un calice (C) et, sur la face opposée (A), deux lions protecteurs installés de part et d'autre de l'arbre sacré.

EN BAS, D & E. DOUBLE PEIGNE

France, vers 1500. Ivoire, 10,3 x 16,3 cm

WURTZBOURG, MAINFRÄNKISCHES MUSEUM

Décoré avec art de délicats ornements ajourés caractéristiques du gothique tardif, le peigne porte une inscription du type rébus dont les deux parties sont séparées au milieu par un champ ornemental.

A

C

1000 — 1100.

D

E

1500 — 1560.

A. HAFNER JUG

Paulus Preuning, Nuremberg, c. 1548. Lead-glazed earthenware, h. 41.5 cm / 16 ⅜ in.

WÜRZBURG, MAINFRÄNKISCHES MUSEUM

The lidded jug with its elaborate polychrome decoration in green, yellow, brown and blue represents one of the famous luxury vessels crafted by the Nuremberg master Paulus Preuning. Its central scene – not reproduced in the plate – depicts a Crucifixion group with Christ between the two thieves, accompanied by the Virgin and St John the Evangelist. The plate shows the figures of Mary Magdalene and the centurion Longinus in niches, with Adam and Eve appearing in the lower pictorial fields. The other fields, containing the Adoration of the Magi and Christ's Entry into Jerusalem, are not visible.

B & C. KNIVES

German, late 16th century – ORIGINALS LOST

A. HAFNERKRUG

Paulus Preuning, Nürnberg, um 1548. Töpferton mit Bleiglasurüberzug, 41,5 cm hoch

WÜRZBURG, MAINFRÄNKISCHES MUSEUM

Bei dem Krug mit aufwendiger farbiger Gestaltung in Grün, Gelb, Braun und Blau handelt es sich um eines der berühmten Prachtgefäße des Nürnberger Meisters Preuning. Das Gefäß zeigt als zentrale Darstellung die auf der Abbildung nicht wiedergegebene Kreuzigungsgruppe mit Christus zwischen den beiden Schächern und mit Maria und Johannes. Gezeigt werden auf der Tafel in den Nischen die Figuren der Magdalena und des Longinus. In den unteren Bildfeldern sind Adam und Eva dargestellt. Die weiteren Bildfelder mit der Anbetung der Könige und dem Einzug Christi in Jerusalem sind auf der Tafel nicht zu sehen.

B & C. MESSER

Deutsch, Ende 16. Jahrhundert – ORIGINALE VERLOREN

A. CHOPE EN POTERIE

Paulus Preuning, Nuremberg, vers 1548. Terre cuite recouverte de vernis de plomb, hauteur 41,5 cm

WURTZBOURG, MAINFRÄNKISCHES MUSEUM

Richement colorée de vert, de jaune, de marron et de bleu, la chope est l'un des célèbres récipients d'apparat du maître nurembergeois Preuning. Le calvaire comprenant le Christ entre les deux larrons, accompagné de Marie et de saint Jean, constitue l'élément central du récipient. Il n'apparaît toutefois pas sur l'illustration. Les figures de Marie-Madeleine et de saint Longin, occupant les niches, sont visibles sur la planche. Dans les champs inférieurs, on aperçoit Adam et Eve. Les autres champs, représentant l'Adoration des Mages et l'entrée dans Jérusalem, ne sont pas restitués sur la planche.

B & C. COUTEAUX

Allemagne, fin du XVIᵉ siècle – ORIGINAUX PERDUS

B A C

1550 — 1600.

RELIEF OF CHRIST IN MAJESTY

Back cover of the Burghard Gospels, *late 11th century. Silver, c. 25 x 12 cm / 10 x 4 ⅜ in.*
WÜRZBURG, UNIVERSITÄTSBIBLIOTHEK, SIGN. M. P. TH. F. 68

A medallion at the centre of the openwork relief shows Christ seated upon a backless throne against a segment of heaven, his legs in slight contrapposto and his hand extended in blessing, in a representation that follows the Byzantine type of the *Majestas Domini* (Christ in Majesty). The surrounding lozenge – a metaphor for the cosmos – is intersected by further medallions containing the symbols of the four Evangelists, identified by inscriptions. The intervening spaces are ornamented with winding tendrils alluding to the paradisiacal sphere in which the representation is set. The silver plaque originally formed the central field of a larger relief that was framed by a border filled with leafy ornament.
Only fragments of this border have come down to us, one of which is illustrated on the following plate (ill. p. 137). The front cover of the *Burghard Gospels* can be found on page 73.

RELIEF MIT DARSTELLUNG DER MAJESTAS DOMINI

Rückendeckel des Burghard-Evangeliars. *Ende 11. Jahrhundert. Silber, ca. 25 x 12 cm*
WÜRZBURG, UNIVERSITÄTSBIBLIOTHEK, SIGN. M. P. TH. F. 68

Das durchbrochen gearbeitete Relief zeigt im mittleren Medaillon vor einem Himmelssegment den auf einem Kastenthron sitzenden Christus in byzantinischem Typus mit leicht kontrapostischer Beinstellung und ausgestreckter Segenshand. In die zentrale Rautenform, Metapher für das Weltganze, schneiden Medaillons mit den Darstellungen der vier durch Beischriften bezeichneten Evangelistensymbole ein.
Die Rankenfüllungen der Reliefplatte deuten auf die paradiesische Sphäre der Darstellung.
Bei der Silberplatte handelte es sich ursprünglich um das zentrale Feld einer größeren Reliefplatte, die von einem rankengefüllten Rahmen umgeben war. Von dem Rahmen haben sich nur Bruchstücke erhalten, von denen eines oben auf der folgenden Tafel abgebildet ist (Abb. S. 137).
Die Vorderseite des Evangeliars ist auf Seite 73 zu sehen.

RELIEF REPRÉSENTANT LE CHRIST EN GLOIRE

Plat arrière de l'évangéliaire de Burchard, fin du XIᵉ siècle. Argent, env. 25 x 12 cm
WURTZBOURG, UNIVERSITÄTSBIBLIOTHEK, COD. M. P. TH. F. 68

Dans le médaillon central, le relief, exécuté en ajouré, représente - assis devant un segment de ciel, sur un trône carré - un Christ de type byzantin, les jambes en position légèrement hanchée, la main tendue dans un geste de bénédiction. Le losange central, métaphore de l'Univers, est entrecoupé de médaillons figurant les symboles des quatre évangélistes désignés par des inscriptions. Le plateau en relief est orné de remplissages en rinceaux faisant référence à la sphère paradisiaque qu'il évoque.
Exécuté en argent, il constituait à l'origine le champ central d'un plateau en relief plus grand, bordé d'un cadre rempli de rinceaux. De ce dernier ne sont conservés que des fragments (ill. p. 137) ; la page de couverture de l'évangéliaire est représentée sur la page 73.

950 – 1050.

DEËSIS RELIEF

Byzantine, 10th century, Fulda, 2nd third of the 9th century. Ivory relief, 11.1 x 9.3 cm / 4 ⅜ x 3 ⅝ in.
WÜRZBURG, UNIVERSITÄTSBIBLIOTHEK, SIGN. M. P. TH. F. 66

The 10th-century relief originally formed the central panel of a triptych and was later mounted within a gilt sheet-silver frame (23.3 x 11.5 cm / 9 ⅛ x 4 ½ in.). It depicts Christ flanked by the Virgin Mary and St John the Baptist, whereby all three figures are identified by abbreviated inscriptions in Greek. This Byzantine type of composition, called a Deësis, shows Christ on the Day of Judgement, with the Virgin and St John acting as his two assistant judges and interceding on behalf of the souls to be judged. Here, as so often, an earlier work of art originally fulfilling a different function has been integrated into another object. The relief adorns the cover of a codex presented – according to the dedicatory inscription – by the Bishop of Würzburg, Henry of Rothenburg (r. 993–1018), to that city's cathedral. Two initials from the codex are illustrated on the left and right of the plate. Above the Deësis relief can be seen a fragment of the silver frame from the back cover of the *Burghard Gospels* (cf. ill. p. 135).

RELIEF MIT DARSTELLUNG DER DEESIS

Byzantinisch, 10. Jahrhundert, Fulda, 2. Drittel 9. Jahrhundert. Elfenbeinrelief, 11,1 x 9,3 cm
WÜRZBURG, UNIVERSITÄTSBIBLIOTHEK, SIGN. M. P. TH. F. 66

Das Relief aus dem 10. Jahrhundert bildete ursprünglich die mittlere Tafel eines Triptychons und wurde später in einen Rahmen aus vergoldetem Silberblech (23,3 x 11,5 cm) eingelassen. Dargestellt und durch abgekürzte griechischen Beischriften gekennzeichnet sind Jesus Christus mit Maria und Johannes dem Täufer. Diese Deesis-Darstellung zeigt den Weltenrichter am Jüngsten Tag und seine beiden Beisitzer, die für die zu richtenden Seelen Fürbitte leisten. Ein älteres Kunstwerk von ursprünglich anderer Zweckbestimmung wurde hier – wie so häufig – in ein anderes Werk integriert. Das Relief schmückt den Einband eines Codex, den laut Widmungsgedicht Bischof Heinrich von Rothenburg (reg. 993–1018) dem Würzburger Dom schenkte. Aus dem Codex sind links und rechts auf der Tafel zwei Initialen abgebildet. Über dem Deesis-Relief ist ein Bruchstück des Silberrahmens der Einbandrückseite des *Burghard-Evangeliars* abgebildet (siehe Abb. S. 135).

RELIEF REPRÉSENTANT UNE DÉISIS

Byzance, Xᵉ siècle, Fulda, 2ᵉ tiers du IXᵉ siècle. Relief ivoire, 11,1 x 9,3 cm
WURTZBOURG, UNIVERSITÄTSBIBLIOTHEK, COD. M. P. TH. F. 66

Ce relief du Xᵉ siècle constituait à l'origine le tableau central d'un triptyque, enchâssé plus tard dans un cadre en lame d'argent dorée (23,3 x 11,5 cm). Il représente, désigné par des inscriptions grecques abrégées, le Christ accompagné de la Vierge et de Jean-Baptiste. Cette figuration de la déisis présente le Juge du Monde au Jour du Jugement et ses deux assesseurs formulant une prière d'intercession pour les âmes devant être jugées. Ici, une œuvre d'art plus ancienne, destinée initialement à un usage différent, a été – comme souvent – intégrée dans une autre œuvre. Le relief orne la couverture d'un codex, offert, d'après le poème dédicatoire, par l'évêque Heinrich von Rothenburg (règne 993-1018) à la cathédrale de Wurtzbourg. Deux initiales issues de ce codex sont représentés à droite et à gauche du tableau. Un fragment du cadre d'argent du plat arrière de l'évangéliaire de Burchard figure au-dessus du relief de la déisis (cf. ill. p. 135).

MP ΘV ὉΠΡΟΔΡ°

ΙC ΧC

950 – 1050.

DOUBLE CUP, "DOCKE"

Nuremberg, late 16th/early 17th century. Silver, partly gilded, h. approx. 24 cm / 9 ½ in.

FORMERLY WÜRZBURG, PRIVATE COLLECTION – WHEREABOUTS UNKNOWN

The double cup, which is designed in the shape of a young woman and hence was known in its day as a *Docke* or *Döcklein* (doll or dolly), was used in an entertaining drinking ritual for men and women. When the young woman is turned upside down, her richly ornamented spreading skirts become a beaker. At the same time, the swivelling smaller cup held in her hands swings around to face upwards and can also be used for drinking. Women drank from the smaller cup and men from the larger one.

KREDENZBECHER, „DOCKE"

Nürnberg, Ende 16./Anfang 17. Jahrhundert. Silber, teilvergoldet, ca. 24 cm hoch

EHEMALS IN WÜRZBURGER PRIVATBESITZ – AUFBEWAHRUNGSORT UNBEKANNT

Das in Gestalt einer jungen Frau gebildete und deswegen zur Entstehungszeit „Docke" oder „Döcklein" (Puppe, bzw. Püppchen) genannte Trinkgefäß fand bei einem spielerischen gemeinschaftlichen Trinkritual für Männer und Frauen Verwendung. Wenn der reichverzierte Rock der jungen Dame umgekehrt wird, dient er als Becher. Der in den Händen gehaltene bewegliche kleinere Becher dreht sich dann aufrecht und kann ebenfalls benutzt werden, wobei Frauen aus dem kleineren, Männer aus dem größeren Becher tranken.

DOUBLE GOBELET, « POUPÉE »

Nuremberg, fin du XVIe/début du XVIIe siècle. Argent, partiellement doré, hauteur env. 24 cm

AUTREFOIS EN LA POSSESSION D'UN PARTICULIER À WURTZBOURG – LOCALISATION INCONNUE

Le récipient présentant l'aspect d'une jeune femme, et appelé pour cette raison « poupée » ou « petite poupée » à l'époque de son exécution, était utilisé lors d'un rituel ludique destiné aux hommes et aux femmes et consistant à boire ensemble. Lorsqu'on la retourne, la jupe richement décorée de la demoiselle sert de gobelet. Plus petit et amovible, le gobelet que la poupée tient dans les mains se redresse alors et peut également être utilisé. Le premier est destiné aux hommes, le second aux femmes.

1590 — 1610.

CASKET
Lower Rhenish or Westphalian, c. 1500. 13.5 x 28.4 x 20.3 cm / 5 ⅜ x 11 x 8 in.
FORMERLY WÜRZBURG, COLLECTION OF THE EDITOR CARL BECKER
WHEREABOUTS UNKNOWN
The box with its tin-coated iron fittings was used to store documents.
The lock plate was backed by pale blue parchment.

KÄSTCHEN
Niederrheinisch oder westfälisch, um 1500. 13,5 x 28,4 x 20,3 cm
EHEMALS IM BESITZ DES HERAUSGEBERS CARL BECKER IN WÜRZBURG
AUFBEWAHRUNGSORT UNBEKANNT
Der Behälter mit verzinnten Eisenbeschlägen diente zum Aufbewahren von Urkunden.
Die Platte des Schlosses war mit hellblauem Pergament hinterlegt.

COFFRET
Rhénanie inférieure ou Westphalie, vers 1500. 13,5 x 28,4 x 20,3 cm
AUTREFOIS EN LA POSSESSION DE CARL BECKER À WURTZBOURG
LOCALISATION INCONNUE
Le récipient aux ferrures étamées servait à conserver des documents officiels.
La plaque de la serrure était installée sur un fond de parchemin bleu clair.

1480 – 1510.

RELIEF OF THE ENTOMBMENT
Hans Schwarz, Augsburg, 1516. Pearwood, 28.5 x 20 cm / 11 ⅛ x 7 ⅞ in.
STAATLICHE MUSEEN ZU BERLIN, BODE-MUSEUM
The relief, which is signed and dated in the pediment
of its elaborate Early Renaissance architectural surround, was carved by Hans Schwarz, the leading
medallist in Germany at that time. It was probably commissioned by the donors portrayed in the portrait
medallions at the top. Despite its modest dimensions, the panel imitates a monumental altar and
served as a so-called osculatorium or peace plate, which conveyed the kiss of peace
from the celebrant to the congregation.

RELIEF MIT DARSTELLUNG DER GRABLEGUNG CHRISTI
Hans Schwarz, Augsburg, 1516. Birnbaum, 28,5 x 20 cm
STAATLICHE MUSEEN ZU BERLIN, BODE-MUSEUM
Das im Giebelfeld des aufwendigen Frührenaissancerahmens signierte und datierte Relief schnitzte
Hans Schwarz, damals der führende deutsche Medailleur, vermutlich im Auftrag derjenigen
Stifter, die oben in den Bildnismedaillons dargestellt sind. Das Täfelchen, das trotz seiner geringen
Größe einen monumentalen Altar imitiert, diente als sogenannte Paxtafel,
die zum Friedenskuss gereicht wurde.

RELIEF REPRÉSENTANT LA MISE AU TOMBEAU DU CHRIST
Hans Schwarz, Augsbourg, 1516. Poirier, 28,5 x 20 cm
STAATLICHE MUSEEN ZU BERLIN, BODE-MUSEUM
Le relief, au riche cadre datant de la première Renaissance et portant sur son pignon la signature et la date,
a été sculpté par Hans Schwarz, le plus important médailleur allemand de l'époque. Il a probablement été
commandé par les donateurs représentés dans les médaillons-portraits de la partie supérieure.
Le petit plateau, imitant, malgré ses modestes dimensions, un autel monumental, servait donc
d'osculatoire présenté pour le baiser de paix.

1 5 1 6.

DOUBLE CUP

2nd quarter of the 15th century. Jasper, silver gilt, h. 38 cm / 15 in.

<small>Erbach, Gräfliche Sammlungen Schloss Erbach</small>

The cup probably stems originally from Jewish ownership and possibly served as a wedding chalice.
It consists of two identical halves. The reddish-brown jasper bowls are mounted in silver git and the
five-lobed feet engraved with ornament. The double cup was later documented in the collection of
Dietrich Schenk zu Erbach (r. 1443–1459), Archbishop of Mainz, who added his coat of arms
to its decoration (E).

DOPPELBECHER

2. Viertel 15. Jahrhundert. Jaspis, Silber, vergoldet; 38 cm hoch

<small>Erbach, Gräfliche Sammlungen Schloss Erbach</small>

Bei dem Pokal handelt es sich vermutlich um einen Hochzeitsbecher aus jüdischem Besitz, der aus zwei
gleichen Hälften besteht. Die rotbraunen Jaspis-Schalen sind in vergoldetem Silber gefasst und die
fünfpassigen Füße sind mit Ornamenten graviert. Der Doppelbecher befand sich später im Besitz des
Mainzer Erzbischofs Dietrich Schenk zu Erbach (reg. 1443–1459),
der auf dem Gefäß sein Wappen (E) anbringen ließ.

DOUBLE GOBELET

2ᵉ quart du XVᵉ siècle. Jaspe et argent doré, hauteur 38 cm

<small>Erbach, Gräfliche Sammlungen Schloss Erbach</small>

À l'origine, le récipient appartenait probablement à un propriétaire juif et servait peut-être de coupe
nuptiale. Il est constitué de deux moitiés identiques. En jaspe, de couleur cuivrée, les coupes sont
enchâssées dans de l'argent doré. Leurs pieds, à cinq lobes, sont gravés d'ornements. Le double gobelet
entra plus tard en la possession de l'archevêque de Mayence, Dietrich Schenk zu Erbach (règne 1443-1459),
qui y fit apposer son blason (E).

A

B

D

C

E

1434 – 1459.

(pp. 147–49)

DIPTYCH

French, late 13th/early 14th century. Ivory, each 16.5 x 13 cm / 6 ½ x 5 in.

FORMERLY WÜRZBURG, PRIVATE COLLECTION – WHEREABOUTS UNKNOWN

The scenes on the two halves of this diptych are laid out in registers, a compositional solution typical of medieval art. The narrative sequence begins at the top of plate 36 (ill. p. 147) with the Last Supper, followed directly underneath by the Agony in the Garden and the Arrest of Christ. It then continues in the upper register on plate 37 (ill. p. 149) with the Trial before Pilate and the Flagellation, goes back to the Road to Calvary and Crucifixion in the lower register on plate 36, and returns to plate 37 for the Deposition and Entombment, from where it jumps to the top of the same plate for the Resurrection. Thematic as well as visual parallels are thereby established between the scenes on the left and right-hand panels. According to the coats of arms added at a later date, the carved diptych was formerly owned by members of the Swiss and Franconian nobility.

(S. 147–149)

DIPTYCHON

Französisch, Ende 13./Anfang 14. Jahrhundert. Elfenbein, je 16,5 x 13 cm

EHEMALS IN WÜRZBURGER PRIVATBESITZ – AUFBEWAHRUNGSORT UNBEKANNT

Die Darstellung folgt dem typisch mittelalterlichen Schema der Reihung in Registern. Sie reicht vom Abendmahl links oben auf Tafel 36 (Abb. S. 147) über die Ölbergszene und die Verhaftung; sie fährt auf Tafel 37 (Abb. S. 149) fort mit dem Verhör vor Herodes und der Geißelung; geht zurück zur Kreuztragung und Kreuzigung auf Tafel 36; gefolgt von der Kreuzabnahme und Grablege auf Tafel 37, um dann nach oben zur Auferstehung zu springen. Durch diese Abfolge ist neben der Reihung auch eine inhaltliche Entsprechung der Szenen auf der linken und rechten Tafel erreicht. Nach den später aufgebrachten Wappen war das zweiteilige Schnitzwerk früher in schweizerischem und fränkischem Adelsbesitz.

J. Kispphahn. sc

1260 — 1320.

(pp. 147-149)

DIPTYQUE

France, fin du XIII⁰/début du XIV⁰ siècle. Ivoire, respectivement 16,5 x 13 cm

Autrefois en la possession d'un particulier à Wurtzbourg – Localisation inconnue

La représentation épouse le schéma typiquement médiéval de l'alignement en registres. Elle s'ouvre sur la Cène, dans la partie supérieure de la planche 36 (ill. p. 147), se poursuit avec l'épisode au mont des Oliviers et l'Arrestation ; continue en planche 37 (ill. p. 149) avec l'interrogatoire devant Hérode et la Flagellation ; revient, en planche 36, au Portement de Croix et à la Crucifixion, suivis de la descente de Croix et de la Mise au tombeau en planche 37, pour terminer, en revenant à la partie supérieure, par la Résurrection. Outre l'alignement des scènes figurant sur les deux planches, cette disposition permet d'établir entre celles-ci une correspondance thématique. D'après le blason apposé ultérieurement, le relief bipartite se trouvait autrefois en la possession de nobles suisses et franconiens.

1260 – 1320.

ROSPIGLIOSI CUP

19th century. Gold, polychrome enamel and gems, h. 19.7 cm / 7 ¾ in.

NEW YORK, THE METROPOLITAN MUSEUM OF ART

The Rospigliosi cup, supposedly once owned by Prince Rospigliosi in Rome, is not a genuine piece of Florentine craftsmanship from the 16th century, as assumed earlier, but a 19th-century forgery. The foot of the cup takes the shape of a tortoise with a dragon crouched on its back, which in turn supports the actual drinking cup. At one end of this scallop-shaped bowl sits a sphinx, a small red crab dangling from her breast into the cup. The plate also illustrates ornamental arabesques that are unconnected with the cup but which are indebted to pattern drawings from the 16th century.

ROSPIGLIOSI-POKAL

19. Jahrhundert. Gold, Emailfarben und Edelsteine, 19,7 cm hoch

NEW YORK, THE METROPOLITAN MUSEUM OF ART

Beim Rospigliosi-Pokal, der sich ehemals im Besitz der Fürsten Rospigliosi in Rom befand, handelt es sich nicht, wie früher angenommen, um ein authentisches Florentiner Stück aus dem 16. Jahrhundert, sondern um eine Fälschung des 19. Jahrhunderts. Den Fuß des Pokals bildet eine Schildkröte, auf deren Rücken ein Drache kauert, der das eigentliche Gefäß trägt. Am Rand dieser Muschelschale kauert eine Sphinx, von deren Brust ein kleiner roter Krebs in die Schale hängt. Auf der Tafel sind außerdem Ornamentranken abgebildet, die nicht mit dem Pokal in Verbindung stehen, sondern Vorlagenzeichnungen des 16. Jahrhunderts folgen.

COUPE DE ROSPIGLIOSI

XIX^e siècle. Or, couleurs d'émail et pierres précieuses, hauteur 19,7 cm

NEW YORK, THE METROPOLITAN MUSEUM OF ART

La coupe, qui se trouvait autrefois en la possession des princes Rospigliosi à Rome, n'est pas, comme on le supposait jadis, une authentique pièce florentine du XVI^e siècle, mais un faux datant du XIX^e. Son pied est constitué d'une tortue portant sur son dos un dragon accroupi, qui soutient le récipient proprement dit. Ce dernier revêt la forme d'une coquille sur le rebord de laquelle repose un sphinx. Un petit crabe rouge accroché à la poitrine de celui-ci pend vers l'intérieur de la coupe. Sur la planche figurent aussi des ornements en entrelacs n'ayant pas de lien avec la coupe mais reprenant un dessin de projet datant du XVI^e siècle.

1540 – 1570.

VIRON MOUNTS FROM CHURCH DOORS
German, late 15th/early 16th century. Architectural ironware
A – Door knocker from St John's chapel in Geroldshofen, Franconia.
B, D, E – Door rings and lock from the Catholic knight's chapel of Our Lady in Hassfurt, Lower Franconia
(cf. also ills. pp. 163, 181). C – Door lock from the parish church of the Assumption of Our Lady in Bad
Königshofen im Grabfeld, Lower Franconia. F – Door ring from the Catholic parish church of
SS Kilian, Colman and Totnan in Hassfurt.

BESCHLÄGE VON KIRCHENTÜREN
Deutsch, Ende 15./Anfang 16. Jahrhundert. Schlosserarbeiten, Eisen
A – Türklopfer der Johanniskapelle zu Geroldshofen/Franken. B, D, E – Pfortenringe und Türschloss der
katholischen Ritterkapelle St. Maria zu Haßfurt/Unterfranken (siehe auch Abb. S. 163, 181)
C – Türschloss der Pfarrkirche Mariä Himmelfahrt in Bad Königshofen im Grabfeld/Unterfranken
F – Pfortenring der katholischen Pfarrkirche St. Kilian, Kolonat und Totnan in Haßfurt.

FERRURES DE PORTES D'ÉGLISE
Allemagne, fin du XV^e/début du XVI^e siècle. Travaux de serrurerie, fer
A – Heurtoir de la chapelle Saint-Jean à Geroldshofen/Franconie. B, D, E – Anneaux de portes et serrure
de la chapelle catholique Sainte-Marie de Hassfurt/Basse-Franconie (cf. aussi ill. pp. 163, 181)
C – Serrure de l'église paroissiale de l'Assomption à Bad Königshofen im Grabfeld/Basse-Franconie
F – Anneaux de portes de l'église Saint-Kilian-Saint-Colman-Saint-Totnan à Hassfurt.

A

B

C

D

E

F

1470 – 1510.

JEWEL BOX
Augsburg (?), c. 1600. Silver, partly gilded, c. 10 x 15.6 x 12 cm / 4 x 6 ⅛ x 4 ¾ in.
Formerly within the art trade – Whereabouts unknown
The walls of the jewel box are made of silver filigree and rise above a floor of solid sheet silver with small gilt columns marking the corners. All the raised parts are gilded.

SCHMUCKKÄSTCHEN
Augsburg (?), um 1600. Silber, teilvergoldet, ca. 10 x 15,6 x 12 cm
Ehemals im Kunsthandel – Aufbewahrungsort unbekannt
Die Wände des Schmuckkästchens sind in Filigranarbeit aus Silberdraht hergestellt.
Den Boden bildet eine massive Silberplatte, an deren Ecken vergoldete Säulchen stehen.
Alle erhabenen Teile sind vergoldet.

COFFRET À BIJOUX
Augsbourg (?), vers 1600. Argent, partiellement doré, env. 10 x 15,6 x 12 cm
Autrefois dans le commerce d'objets d'art – Localisation inconnue
Les parois du coffret à bijoux sont exécutées en filigranes d'argent. Le fond est constitué d'une plaque massive en argent sur les coins de laquelle se dressent des colonnettes dorées.
Toutes les parties saillantes sont dorées.

1590 — 1610.

(pp. 157–59)

ORTENBURG CEREMONIAL SADDLE

Jörg Sigmann, Augsburg, 1555. Wood; iron and brass, partly gilded; leather, velvet
45 x 60 x 50 cm / 17 ¾ x 23 ⅝ x 19 ⅝ in.

ERBACH, GRÄFLICHE SAMMLUNGEN, SCHLOSS ERBACH

This ceremonial saddle, whose shape is that of a cuirassier's saddle, was made in 1555 by Augsburg goldsmith Jörg Sigmann, possibly for Count Joachim the Elder of Ortenburg. The pommel and cantle are made of iron and were originally gilded. They are decorated with tooled scenes of cavalry battles from antiquity, which may be understood as an allusion to Emperor Charles V's victories over King Henry II of France in Lorraine. The stirrup irons are similarly gilded.

(S. 157–159)

ORTENBURGER PRUNKSATTEL

Jörg Sigmann, Augsburg, 1555. Holz; Eisen und Messing, teilweise vergoldet; Leder, Samt
45 x 60 x 50 cm

ERBACH, GRÄFLICHE SAMMLUNGEN SCHLOSS ERBACH

Der Prunksattel in Form eines Küriss-Sattels wurde im Jahre 1555 von dem Augsburger Goldschmied Jörg Sigmann geschaffen, möglicherweise für den Grafen Joachim d. Ä. von Ortenburg. Die ursprünglich vergoldeten Vorder- und Hinterstege bestehen aus Eisen und zeigen in Treibarbeit Reiterschlachten der Antike, die als Verweis auf die Siege Kaiser Karls V. in Lothringen über König Heinrich II. von Frankreich zu verstehen sind. Die Steigbügel sind ebenfalls vergoldet.

A

B

1550 – 1570

(pp. 157–159)

SELLE D'APPARAT D'ORTENBURG

Jörg Sigmann, Augsbourg, 1555. Bois, fer et laiton, partiellement doré, cuir, velours
45 x 60 x 50 cm

ERBACH, GRÄFLICHE SAMMLUNGEN, SCHLOSS ERBACH

La selle d'apparat, qui revêt l'aspect d'une selle de cuirassier, a été fabriquée en 1555 par l'orfèvre augsbourgeois Jörg Sigmann, peut-être pour le comte Joachim l'Ancien d'Ortenburg. Dorés à l'origine, le pommeau et le troussequin sont constitués de fer et représentent, travaillées au repoussé, des batailles équestres de l'Antiquité. Ces dernières renvoient aux victoires que l'empereur Charles Quint, affrontant le roi Henri II de France, remporta en Lorraine. Les étriers sont également dorés.

A

B

C

1550—1570

ROUND COUNCIL TABLE

Tilman Riemenschneider, Würzburg, 1506. Oak, Solnhofen stone, h. 80 cm / 31 ½ in., ø tabletop 144 cm / 56 ¾ in.
WÜRZBURG, MAINFRÄNKISCHES MUSEUM

The circular table with a stone top supported on a single central foot – a design adopted from Italy – is the best-known example of its type in Germany. It was made by the celebrated stone sculptor and woodcarver Tilman Riemenschneider for the Würzburg city hall. The original stone tabletop was destroyed in the Second World War, but the bas-relief coat of arms of the Prince-Bishop of Eichstätt, Gabriel of Eyb, survived and has been re-incorporated within a reconstructed tabletop of Solnhofen stone. The table stands on a hexagonal base from which ribs in the Late Gothic style, originally painted in gold and green, extend upwards to meet the console supporting the stone top.

RUNDER RATSTISCH

Tilman Riemenschneider, Würzburg, 1506. Eichenholz, Solnhofener Stein, 80 cm hoch, ø Tischplatte 144 cm
WÜRZBURG, MAINFRÄNKISCHES MUSEUM

Der Tisch ist das berühmteste Beispiel für den aus Italien übernommenen Typus des einfüßigen runden Tisches mit steinerner Platte. Der berühmte Bildschnitzer Tilman Riemenschneider fertigte den Tisch für das Würzburger Rathaus. Die Originalplatte ist im Zweiten Weltkrieg zerstört worden, erhalten hat sich aber das reliefierte Wappen des Eichstätter Fürstbischofs Gabriel von Eyb, das heute in eine rekonstruierte Platte aus Solnhofener Stein eingelassen ist. Sie ruht auf den spätgotischen, ursprünglich golden und grün gefassten Originalrippen, die vom sechseckigen Sockelrahmengestell ausgehen und zur tragenden Konsole auslaufen.

TABLE DE CONSEIL DE FORME RONDE

Tilman Riemenschneider, Wurtzbourg, 1506. Bois de chêne, pierre de Solnhofen, hauteur 80 cm, ø du plateau 144 cm
WURTZBOURG, MAINFRÄNKISCHES MUSEUM

Cette table est le plus fameux exemple illustrant le modèle italien de la table ronde à un pied surmonté d'un plateau en pierre. Le célèbre sculpteur sur bois Tilman Riemenschneider l'a fabriquée pour le Conseil de Wurtzbourg. Le plateau originel a été détruit pendant la Seconde Guerre mondiale. Seules les armoiries en relief de Gabriel von Eyb, prince-évêque d'Eichstätt, ont été conservées. Elles sont aujourd'hui enchâssées dans un plateau reconstitué en pierre de Solnhofen. Les arcs en ogive initialement revêtus de doré et de vert sur lesquels ce dernier repose sont d'origine. Ils sont caractéristiques du gothique tardif et relient le socle hexagonal à la console porteuse.

A

C

D

B

E

F

1496 – 1520.

MALE NUDE
Franconian, c. 1500. Sandstone
HASSFURT, LOWER FRANCONIA, VESTIBULE OF THE CATHOLIC KNIGHT'S CHAPEL OF OUR LADY
Affixed to the ribs of the arched ceiling behind Gothic tracery, the unusual representation
of the naked Adam as ruler of the world spans one of the vaults in the vestibule of the knight's chapel
(cf. also ills. pp. 153, 181). Adam holds a vessel in his right hand and from it pours liquid into a second vessel
held out by a hand projecting from the side wall (detail, E). He holds a balance in his left hand (detail, D).

MÄNNLICHE AKTFIGUR
Fränkisch, um 1500. Sandstein
HASSFURT/UNTERFRANKEN, VORHALLE DER KATHOLISCHEN RITTERKAPELLE ST. MARIA
In der Kapellenvorhalle (siehe auch Abb. S. 153, 181) befindet sich hinter gotischem Maßwerk auf den
Rippen des Gewölbes die ungewöhnliche Darstellung des nackten Adam als Weltenherrscher.
Die Figur gießt mit der rechten Hand aus einem Gefäß Flüssigkeit in ein anderes Gefäß, das von einer
Hand gehalten wird, die aus der Seitenmauer ragt (Detail E). Die linke Hand hält eine Waage (Detail D).

SCULPTURE DE NU MASCULIN
Franconie, vers 1500. Grès
HASSFURT/BASSE-FRANCONIE, PORCHE DE LA CHAPELLE CATHOLIQUE SAINTE-MARIE
Placé derrière un remplage gothique, l'étonnante sculpture d'Adam nu, les côtes saillantes, recouvre,
en maître du monde, une voûte du porche de la chapelle (cf. aussi ill. pp. 153, 181).
De la main droite, Adam verse un liquide d'un récipient dans un autre, lequel est tenu par une main sortant
du mur latéral (détail, E). La main gauche tient une balance (détail, D).

A

C

D E

B

1490 — 1520.

TABLECLOTH

Schleusingen, probably 1568. Linen, embroidered with silk, gold and silver
135 x 135 cm / 53 ⅛ x 53 ⅛ in.

FORMERLY WÜRZBURG, COLLECTION OF THE EDITOR CARL BECKER – WHEREABOUTS UNKNOWN

The decoration embroidered on the tablecloth in silk, gold and silver thread probably alludes to the marriage of Count George Earnest of Henneberg and Elizabeth of Württemberg, which took place in 1568. The bridal couple are portrayed at the centre, surrounded by inner and outer borders embroidered with figures. The inner border is occupied by the musicians, and the outer border by the dancers: in the lower right-hand corner, two men are leading the dance in front of a trumpeter and drummer, followed by the bridal couple and the party of guests. The bridal couple in the centre are framed by Luther's chorale *Ein feste Burg ist unser Gott* (A Mighty Fortress is our God), set to the original melody by Martin Argricola. Staves containing the notes of a four-part piece of dance music divide the musicians in the inner border from the dancers around the outside.

TISCHDECKE

Schleusingen, wahrscheinlich 1568. Leinen, mit Seide, Gold- und Silberfäden bestickt, 135 x 135 cm

EHEMALS IM BESITZ DES HERAUSGEBERS CARL BECKER – AUFBEWAHRUNGSORT UNBEKANNT

Die mit Seide, Gold- und Silberfäden bestickte Decke zeigt eine Darstellung, die sich wahrscheinlich auf die Hochzeit des Grafen Georg Ernst von Henneberg mit Elisabeth von Württemberg im Jahre 1568 bezieht. Im Zentrum ist das Brautpaar dargestellt, im umgebenden Rahmen sind die Musiker zu sehen, dann außen die Tänzer, angeführt von zwei Vortänzern vor Trompeter und Pauker, dann das Brautpaar und die Schar der Gäste. Das Brautpaar im Bildzentrum wird gerahmt von Luthers Choral „Ein feste Burg ist unser Gott" mit den Noten der ursprünglichen Melodie von Martin Agricola. Den Rahmen der Musiker bilden die Noten einer vierstimmigen Tanzmusik.

NAPPE

Schleusingen, probablement 1568. Lin, brodé avec de la soie, des fils d'or et d'argent, 135 x 135 cm

AUTREFOIS EN LA POSSESSION DE CARL BECKER – LOCALISATION INCONNUE

Brodée avec de la soie, des fils d'or et d'argent, la nappe est ornée d'une représentation qui se réfère probablement au mariage du comte Georg Ernst von Henneberg avec Elisabeth von Württemberg, célébré en 1568. Au centre figurent les mariés ; dans le cadre qui les entoure, on distingue les musiciens. Ces derniers sont entourés de danseurs, eux-mêmes conduits par deux hommes ouvrant la danse devant le trompettiste et le timbalier. Suivent les mariés et, derrière eux, le cortège des invités. Au centre de l'image, le choral de Luther « Une forteresse sûre est notre Dieu », accompagné des notes de la mélodie originale de Martin Agricola, forme un cadre autour des mariés. Quant aux musiciens, ils sont encadrés par les notes d'une musique de danse à quatre voix.

1562 – 1568

(pp. 167–69)

A–D. RELIQUARY SHRINE
German, late 15th century. Wood, painted
Formerly Erbach, Odenwald, Schloss Erbach, Rittersaal chapel – Original lost
The back of the shrine (A) shows St Ursula with a knight kneeling before her and an unidentified coat of arms. The narrow sides are decorated with the figures of St Odilia (B) and a bishop saint (C). Glass panels on the front of the shrine allow a view of the relics inside (D).

E–G. RELIQUARY CASKET
German, late 15th century. Wood, painted
From the Protestant parish church in Friedberg in der Wetterau, Hesse
Formerly in a private collection – Whereabouts unknown
The reliquary casket shows a donor kneeling in worship before the Virgin and Child, a banderole carrying his prayer (E). The coat of arms depicted on the far side of the Virgin is that of a bourgeois family. St Margaret (F) and St Bartholomew (G) can be seen on the narrow sides of the casket.

H–K. EXAMPLE OF DECORATIVE LEAFY ORNAMENT
German, 1494. Miniatures (pen and ink and watercolour) from a prayer book made for a member of the von Greiffenklau family
Sold to a St Petersburg buyer in the mid-19th century
Whereabouts unknown

1480 — 1500.

(S. 167–169)

A–D. RELIQUIENSCHREIN

Deutsch, Ende 15. Jahrhundert. Holz, bemalt

EHEMALS KAPELLE AM RITTERSAAL DES SCHLOSSES ERBACH IM ODENWALD –
ORIGINAL VERSCHOLLEN

Die Rückseite des Schreins (A) zeigt die heilige Ursula und einen vor ihr knienden Ritter sowie ein ungedeutetes Wappen. An den Schmalseiten des Reliquiars sind die heilige Odilia (B) und ein heiliger Bischof (C) dargestellt. Die Vorderseite (D) zeigt hinter Glas die Reliquien.

E–G. RELIQUIENKÄSTCHEN

Deutsch, Ende 15. Jahrhundert. Holz, bemalt

AUS DER EVANGELISCHEN PFARRKIRCHE ZU FRIEDBERG IN DER WETTERAU/HESSEN
EHEMALS IN PRIVATBESITZ – AUFBEWAHRUNGSORT UNBEKANNT

Das Reliquienkästchen zeigt die Darstellung eines Stifters mit Spruchband, der die Madonna anbetet (E). Zusätzlich ist ein bürgerliches Wappen abgebildet. An den Schmalseiten des Kästchens sind die heilige Margareta (F) und der heilige Bartholomäus (G) zu sehen.

H–K. RANKENVERZIERUNGEN

Deutsch, 1494. Miniaturen (Federzeichnung mit Aquarell) aus einem Gebetbuch für ein Mitglied der Familie von Greiffenklau

MITTE DES 19. JAHRHUNDERTS NACH ST. PETERSBURG VERKAUFT
AUFBEWAHRUNGSORT UNBEKANNT

(pp. 167–169)

A–D. RELIQUAIRE

Allemagne, fin du XV^e siècle. Bois, peint

AUTREFOIS CONSERVÉ DANS LA CHAPELLE JOUXTANT LA SALLE DES CHEVALIERS DU
CHÂTEAU D'ERBACH DANS L'ODENWALD – ORIGINAL DISPARU

La face arrière du reliquaire (A) montre sainte Ursule et un chevalier agenouillé devant elle ainsi qu'un blason non identifié. Sur les côtés étroits de la châsse figurent sainte Odile (B) et un saint évêque (C). La face antérieure (D) montre, derrière du verre, les reliques.

E–G. COFFRET À RELIQUES

Allemagne, fin du XV^e siècle. Bois, peint

PROVENANT DE LA PAROISSE PROTESTANTE DE FRIEDBERG DANS LE WETTERHAU/HESSE
AUTREFOIS EN LA POSSESSION D'UN PARTICULIER – LOCALISATION INCONNUE

Le coffret à reliques montre un donateur accompagné d'un cartouche et adorant la Vierge (E). Un blason bourgeois y figure également. Sur les côtés étroits du coffret, on distingue sainte Marguerite (F) et saint Bartholomée (G).

H–K. RINCEAUX

Allemagne, 1494. Miniatures (dessin à la plume avec aquarelle) extraites d'un livre de prières confectionné pour un membre de la famille von Greiffenklau

VENDU À UN ACHETEUR DE SAINT-PÉTERSBOURG AU MILIEU DU XIX^e SIÈCLE
LOCALISATION INCONNUE

COVER OF A GOSPEL BOOK FROM ST GEORGE'S CHURCH IN COLOGNE
Cologne, 1050/60 and 1480. Ivory, silver-plated copper, gold, rock crystal
Relief 15.2 x 9.6 cm / 6 x 3 ¾ in., Copper plaque 25 x 18.7 cm / 10 x 7 ⅜ in.
Darmstadt, Hessisches Landesmuseum
Set into the front cover of a Bavarian evangeliary dating from the early 11th century and formerly
housed in St George's Church in Cologne, the ivory relief was carved in the mid-11th century in
Cologne. It shows Christ on the Cross with Ecclesia and the Virgin on the left and St John and the
Synagogue on the right, framed by an acanthus border. The symbols of the four Evangelists are
depicted in the corners, and Sol and Luna can be seen above the arms of the Cross. At the foot of
the Cross are a chalice, a dragon – symbolizing victory over Evil – and the primogenitor, Adam. The
copper cover, also produced in Cologne but dating from the 15th century, is engraved with the
figures of St George – patron saint of the church in which the book was housed – slaying the dragon
on the left, and on the right St Liborius. The cover is decorated along the top with fish-bladder
ornament and along the bottom with scrolling foliage and an owl.

BUCHDECKEL EINES EVANGELIARS AUS ST. GEORG IN KÖLN
Köln, 1050/60 und 1480. Elfenbein, versilbertes Kupfer, Gold, Bergkristall
Relief 15,2 x 9,6 cm, Kupfertafel 25 x 18,7 cm
Darmstadt, Hessisches Landesmuseum
Das Elfenbeinrelief des ehemals in St. Georg in Köln aufbewahrten bayerischen Evangeliars
(frühes 11. Jahrhundert) wurde in der Mitte des 11. Jahrhunderts in Köln gearbeitet und zeigt in einem
Akanthusrahmen den Gekreuzigten mit Ecclesia und Maria zur Linken sowie Johannes und der Synagoge
zur Rechten. In den Ecken befinden sich die Evangelistensymbole, über dem Querbalken des Kreuzes sind
Sol und Luna angeordnet, unten am Fuß des Kreuzes sind dargestellt: ein Kelch, ein Drache, der das
besiegte Böse symbolisiert, und der Urvater Adam. Auf dem im 15. Jahrhundert ebenfalls in Köln
hergestellten und mit Gravuren versehenen Einbanddeckel sind links der Drachentöter St. Georg, der
Kirchenpatron, und rechts der heilige Liborius dargestellt. Den Rahmen ziert oben ein
Fischblasenornament und unten eine Ranke mit Eule.

COUVERTURE D'UN ÉVANGÉLIAIRE DE SAINT-GEORGES À COLOGNE
Cologne, 1050/60 et 1480. Ivoire, cuivre argenté, or, cristal de roche
Relief 15,2 x 9,6 cm, plaque de cuivre 25 x 18,7 cm
Darmstadt, Hessisches Landesmuseum
Exécuté à Cologne au milieu du XIᵉ siècle, le relief en ivoire de l'évangéliaire bavarois (début du
XIᵉ siècle) autrefois conservé dans l'église Saint-Georges de la ville rhénane montre le crucifié encadré de
feuilles d'acanthe. À gauche se tiennent l'Église et Marie, à droite, Jean et la Synagogue. Dans les coins
figurent les symboles des évangélistes ; au-dessus de la traverse du gibet sont disposés Sol et Luna ; en bas,
au pied de la croix, on distingue un calice, un dragon – symbole du triomphe sur le Mal – et Adam, le père
original. Sur la couverture fabriquée au XVᵉ siècle, également à Cologne, et pourvue de motifs gravés
apparaissent, à gauche, saint Georges, le tueur de dragons et patron de l'église, et, à droite, saint Liboire.
Le cadre présente, en haut, un ornement en forme de vessies de poisson et, en bas,
des arabesques végétales abritant une chouette.

14

15

0 1

0.

0

(pp. 172/73)

HAND TOWELS

German, late 15th/early 16th century
Linen, embroidered, 162 x 51.3 cm / 63 ¾ x 20 ⅛ in. (A), 143.5 x 48.8 cm / 56 ½ x 19 ¼ in. (B)
AUCTIONED IN 1904 FROM THE ESTATE OF THE EDITOR HEFNER-ALTENECK
WHEREABOUTS UNKNOWN

A Late Gothic background of leafy tendrils, inhabited by birds and hares as symbols of love, provides the setting for an allegorical love scene in which a unicorn pursued by a hunter takes refuge in the lap of a virgin (A). Widespread in German art until it was banned by the Council of Trent (first period, 1545–47), the composition represents a sacred allegory, in which the hunter is the Archangel Gabriel and his hounds are the Virtues. The unicorn – a symbol of virginity – takes refuge in the lap of the Virgin Mary, who is seated in a *hortus conclusus* (an "enclosed garden" that also symbolizes Mary's virginity).
The mystical unicorn made a frequent appearance in artistic representations of courtly love, in which the fabulous beast – strictly speaking a religious symbol – was interpreted in the idealized context of medieval chivalry. The significance of the scene depicted on the second hand towel (B) is also sacred in nature.
Beneath the banderole with the inscription "Mütterlin las mich dir befolhen sin" (Mother, let me be commanded by you), a small boy is hastening towards a seated woman. That the two figures signify the Virgin and the Christ Child is indicated by the symbols of Christ appearing within circular fields on either side: the phoenix rising from the ashes (Resurrection) and the pelican feeding its young with its own blood (Sacrifice on the Cross).

(S. 172/173)

HANDTÜCHER

Deutsch, Ende 15./Anfang 16. Jahrhundert. Leinen, bestickt, 162 x 51,3 cm (A), 143,5 x 48,8 cm (B)
AUS DEM NACHLASS DES HERAUSGEBERS HEFNER-ALTENECK, 1904 VERSTEIGERT
AUFBEWAHRUNGSORT UNBEKANNT

Die allegorische Liebesdarstellung (A) in spätgotischem Rankenornament mit Vögeln und Hasen als Symboltieren der Liebe zeigt einen Jäger, der ein Einhorn jagt, das sich in den Schoß einer Jungfrau flüchtet. Es handelt sich bei der Darstellung um eine bis zum Verbot im Konzil von Trient (1. Periode 1545–1547) im deutschen Raum verbreitete sakrale Allegorie: Der Verkündigungsengel Gabriel als Jäger verfolgt das Einhorn, das sich in den Schoß der im Hortus conclusus sitzenden Maria birgt. Seine Hunde verkörpern die Tugenden. Das mystische Fabelwesen Einhorn galt als Symboltier der Jungfräulichkeit und wurde deswegen gern in höfischen Minnedarstellungen gezeigt, die das an sich sakrale Thema im Sinne der höfischen Liebe interpretierten. Ebenfalls sakrale Bedeutung hat die Darstellung des zweiten Handtuchs (B). Unter dem Spruchband „Mütterlin las mich dir befolhen sin" eilt ein kleiner Junge zu einer sitzenden Frau. Dass Maria und Jesus gemeint sind, zeigen die seitlich ebenfalls im Rund platzierten Christussymbole des Phönix aus der Asche (Auferstehung) und des Pelikans, der seine Jungen mit seinem Blute nährt (Kreuzesopfer).

(pp. 172/173)

LINGE DE TOILETTE

Allemagne, fin du XV^e/début du XVI^e siècle
Lin, brodé, 162 x 51,3 cm (A), 143,5 x 48,8 cm (B)
Vendu aux enchères en 1904 Succession de Hefner-Alteneck
Localisation inconnue

Insérée dans un décor caractéristique du gothique tardif – des rinceaux peuplés d'oiseaux et de lièvres, animaux symbolisant l'amour –, la représentation allégorique du sentiment amoureux (A) montre un chasseur chassant une licorne, laquelle se réfugie dans le sein d'une vierge. Il s'agit d'une allégorie sacrée qui, jusqu'à son interdiction lors du Concile de Trente (1^{ère} période 1545-1547), était très répandue sur le territoire allemand : l'ange Gabriel, l'Annonciateur, apparaît sous les traits du chasseur poursuivant la licorne, laquelle se réfugie dans le giron de la Vierge assise dans l'Hortus conclusus. Les chiens qui l'accompagnent incarnent les vertus. Considéré comme l'animal symbolique de la virginité, la licorne, créature fabuleuse mystique, apparaissait fréquemment dans les représentations de l'amour, traduisant dans le langage courtois un thème à l'origine sacré. La représentation figurant sur la seconde serviette (B) revêt également un sens sacré. Sous le cartouche « Mütterlin las mich dir befolhen sin » (Tendre mère, laisse-moi m'en remettre à toi), un petit garçon se précipite dans les bras d'une femme assise. Disposés sur les côtés et également placés à l'intérieur d'un cercle, les symboles christiques, le phénix renaissant de ses cendres (symbole de la Résurrection) et le pélican nourrissant ses petits de son sang (symbole du sacrifice de la Croix) indiquent qu'il s'agit de la Vierge Marie et de l'Enfant Jésus.

VIRGIN AND CHILD ON THE CRESCENT MOON
Tilman Riemenschneider, Würzburg, c. 1516–22. Sandstone, 156.5 x c. 56 x 23 cm / 61 ½ x c. 22 x 9 in.
FROM THE FAÇADE OF THE ABBEY CURIA IN WÜRZBURG
FRANKFURT AM MAIN, LIEBIEGHAUS SKULPTURENSAMMLUNG
The plate offers an impression – albeit one that is probably not altogether reliable – of Riemenschneider's
sculptural group in its original polychrome condition. With the exception of just a few traces of paint,
the stone is today completely exposed and the figures are entirely grey (ill. p. 17). The sculpture was
originally situated on the façade of the former abbey curia in Würzburg, where it stood over the entrance
at 21, Martinsgasse. The building was destroyed in 1945, but the figure had already found its way into the
possession of Carl Becker in the 19th century.

MUTTERGOTTES AUF DER MONDSICHEL
Tilman Riemenschneider, Würzburg, um 1516–1522. Sandstein, 156.5 x ca. 56 x 23 cm
VON DER FASSADE DER STIFTSKURIE IN WÜRZBURG
FRANKFURT AM MAIN, LIEBIEGHAUS SKULPTURENSAMMLUNG
Die ursprünglich farbig gefasste Figur, von deren Aussehen die Tafelansicht eine wahrscheinlich
nicht ganz verlässliche Anschauung vermittelt, ist heute bis auf wenige Farbreste gänzlich grau und
steinsichtig (Abb. S. 17). Ursprünglich befand sich die Skulptur an der Fassade der ehemaligen Stiftskurie
in Würzburg über dem Eingang in der Martinsgasse 21. Das Gebäude wurde 1945 zerstört,
jedoch befand sich die Figur bereits im 19. Jahrhundert im Besitz von Carl Becker.

LA MÈRE DE DIEU SUR LE CROISSANT DE LUNE
Tilman Riemenschneider, Wurtzbourg, vers 1516–1522. Grès, 156.5 x env. 56 x 23 cm
AUTREFOIS SUR LA FAÇADE DE LA COLLÉGIALE DE WURTZBOURG
FRANCFORT-SUR-LE-MAIN, LIEBIEGHAUS SKULPTURENSAMMLUNG
Initialement revêtue de couleurs, la sculpture, dont l'image de la planche ne reflète probablement
pas une idée très fiable, laisse aujourd'hui paraître la pierre dans sa grise nudité, exception faite de quelques
restes de couleur (ill. p. 17). À l'origine, l'œuvre ornait la façade de l'ancienne collégiale de Wurtzbourg,
dont elle surmontait l'entrée, au numéro 21 de la Martinsgasse. L'édifice fut détruit en 1945.
La sculpture, toutefois, était déjà, au XIXᵉ siècle, la propriété de Carl Becker.

1515 — 1525.

A–D. PROCESSIONAL CROSS

German, late 11th/early 12th century. Wood, copper, gilded, engraved, h. 45.4 cm / 17 ⅞ in.

FORMERLY ERBACH, GRÄFLICHE SAMMLUNGEN SCHLOSS ERBACH – UNTRACED

The cross consists of a wooden core faced with copper plaques decorated with engraved scenes and ornament. On the back of the cross (A), these show the Lamb of God in the centre surrounded on the outside by the symbols of the four Evangelists. Immediately beneath the Lamb is the figure of the Holy Roman Emperor Henry II, identified by an inscription. The front (B) is occupied by Christ, his figure embossed in high relief, shown crucified with four nails (cf. ills. pp. 201, 555). The plate also shows a detail view of one of the ends of the cross (C), which were formerly adorned with crystals in the centre and pearls at the sides, and a detail of the spike (D) by means of which the cross could be affixed onto a support for processions.

E–G. FINGER RING

Spanish, 12th century. Copper gilt, 4 x 3.5 cm / 1 ½ x 1 ⅜ in.

FORMERLY IN A PRIVATE COLLECTION WITHIN THE NOBILITY – WHEREABOUTS UNKNOWN

The ring, which is designed to be worn over a glove, is decorated with the coat of arms of Aragon and the symbols of the four Evangelists.

A–D. PROZESSIONSKREUZ

Deutsch, Ende 11./Anfang 12. Jahrhundert. Holz, Kupfer, vergoldet, graviert, 45,4 cm hoch

EHEMALS GRÄFLICHE SAMMLUNGEN SCHLOSS ERBACH – VERSCHOLLEN

Auf einem Holzkern sind Kupferplatten mit gravierten Darstellungen aufgebracht. Sie zeigen auf der Rückseite des Kreuzes (A) im Zentrum das Lamm Gottes und außen die Evangelistensymbole. Unter dem Lamm befindet sich die Darstellung des inschriftlich bezeichneten heiligen Kaisers Heinrich II. Die Vorderseite (B) nimmt der in Hochrelief getriebene Christus im „Viernageltypus" ein (siehe Abb. S. 201, 555). Außerdem wird ein Detail eines der Kreuz-Enden (C), die früher im Zentrum mit Kristallen und seitlich mit Perlen verziert waren, und ein Detail des Dorns (D) zum Aufstecken des Kreuzes bei Prozessionen gezeigt.

E–G. FINGERRING

Spanisch, 12. Jahrhundert. Kupfer, vergoldet, 4 x 3,5 cm

EHEMALS IN ADELIGEM PRIVATBESITZ – AUFBEWAHRUNGSORT UNBEKANNT

Der über einem Handschuh zu tragende Ring ist mit dem Wappen Aragoniens und den vier Evangelistensymbolen geschmückt.

A–D. CROIX DE PROCESSION

Allemagne, fin du XIᵉ/début du XIIᵉ siècle. Bois, cuivre, doré, gravé, hauteur 45,4 cm

AUTREFOIS CONSERVÉE DANS LES GRÄFLICHE SAMMLUNGEN SCHLOSS ERBACH – DISPARU

Sur un fond en bois sont fixées des plaques de cuivre pourvues de représentations gravées. Elles montrent, sur la face arrière de la croix (A), l'Agneau de Dieu, au centre, et les symboles des évangélistes, à l'extérieur. Sous l'Agneau figure celui qu'une inscription désigne comme le saint empereur Henri II. La face antérieure (B) est occupée par le Christ sculpté en haut-relief et fixé par quatre clous (cf. ill. pp. 201, 555). L'image montre, en outre, un détail d'une des extrémités de la croix (C), qui étaient autrefois ornées de cristaux au centre, et de perles sur les côtés, ainsi qu'un détail du support sur lequel reposait la croix lors des processions (D).

E–G. BAGUE

Espagne, XIIᵉ siècle. Cuivre, doré, 4 x 3,5 cm

AUTREFOIS EN LA POSSESSION D'UN NOBLE – LOCALISATION INCONNUE

Destinée à être portée sur un gant, la bague est ornée du blason d'Aragon et des symboles des quatre évangélistes.

A

E

50

F

G

B

C

D

OIGFIE
RI·IV
SSIT

VIII

PAR ZOLL.

1000 — 1100.

ARCHITECTURAL IRONWARE
German, late 15th and late 16th century. Iron, h. c. 24 cm / 9 ½ in. (A and C)
A and B – Door knocker from the pilgrimage church of Our Lady in the Vineyard, on Kirchberg hill, near
Volkach, Franconia. C – Door knocker formerly on the door of the armoury at Mainberg Castle, near
Schweinfurt. D – Mounts from the side door of the parish church of the Assumption of Our Lady in Bad
Königshofen im Grabfeld, Lower Franconia (cf. ill. p. 153). E and F – Door mounts from the Catholic
knight's chapel of Our Lady in Hassfurt, Lower Franconia (cf. ills. pp. 153, 163).

SCHLOSSERARBEITEN
Deutsch, Ende 15. und Ende 16. Jahrhundert. Eisen, ca. 24 cm hoch (A und C)
A und B – Türklopfer der Wallfahrtskirche St. Maria im Weingarten auf dem Kirchberg
bei Volkach/Franken. C – Türklopfer, ehemals an der Tür der Waffenhalle auf Schloss Mainberg bei
Schweinfurt. D – Türbeschlag der Seitentür der Pfarrkirche Mariä Himmelfahrt in Bad Königshofen im
Grabfeld/Unterfranken (siehe Abb. S. 153) E und F – Türbeschläge der katholischen Ritterkapelle
St. Maria zu Haßfurt/Unterfranken (siehe Abb. S. 153, 163).

SERRURERIES
Allemagne, fin du XVᵉ et fin du XVIᵉ siècle. Fer, hauteur env. 24 cm (A et C)
A et B – Heurtoir de la porte de l'église de pèlerinage Sainte-Marie-des-Vignes, sur le Kirchberg
près de Volkach/Franconie. C – Heurtoir autrefois fixé sur la porte de la salle d'armes du château
de Mainberg près de Schweinfurt. D – Ferrure de la porte latérale de l'église paroissiale
de l'Assomption à Bad Königshofen im Grabfeld/Basse-Franconie (cf. ill. p. 153)
E et F – Ferrures de porte de la chapelle catholique Sainte-Marie de Hassfurt/
Basse-Franconie (cf. ill. pp. 153, 163).

A

1490 — 1510.

C

1590 — 1610.

RELIQUARY CASKET

Sicilian–Norman, 2nd half of the 12th century. Painted ivory, wood, 18 x 38 x 20 cm / 7 x 15 x 7 ⅞ in.

FORMERLY WÜRZBURG, CATHEDRAL TREASURY – WARTIME LOSS

The box was originally made for secular purposes and was only later used to house relics (cf. also ill. p. 223).
The small ivory panels were affixed to the wooden casket with brass nails. The front view (A) shows an
enthroned Oriental prince (C) surrounded by musicians and drinkers (D–H). The circular medallions
within the arabesque frieze (I) running along the top contain various recurring animals: ibex, eagles with
ducks in their talons, peacocks and cheetahs. The back of the box is decorated with narrow friezes
incorporating groups of animals and trees. The chequerboard-style lid (B) is decorated with
arabesques and animal figures (K).

RELIQUIENKÄSTCHEN

Sizilianisch-normannisch, 2. Hälfte 12. Jahrhundert. Elfenbein, bemalt; Holz, 18 x 38 x 20 cm

EHEMALS WÜRZBURG, DOMSCHATZ – KRIEGSVERLUST

Das ursprünglich für profane Zwecke angefertigte Kästchen wurde später zur Aufbewahrung von
Reliquien verwendet (siehe auch Abb. S. 223). Die Elfenbeintäfelchen waren mit Messingnägeln auf dem
Holzkasten befestigt. Die Vorderansicht (A) zeigt Darstellungen eines thronenden orientalischen Fürsten
(C), umgeben von Musikern und einem Zecher (D–H). Die Rundmedaillons des Arabesken-Frieses (I) der
Vorderseite umfassen sich wiederholende Tierfiguren: Steinböcke, Adler mit Enten in den Krallen, Pfauen,
Geparde. Auf der Rückseite des Kästchens finden sich schmale Friese mit Tier- und Baumgruppen. Den
schachbrettartigen Deckel (B) zieren Arabesken und Tierfiguren (K).

COFFRET À RELIQUES

Sicile normande, 2ᵉ moitié du XIIᵉ siècle. Ivoire, peint, bois, 18 x 38 x 20 cm

AUTREFOIS CONSERVÉ À WURTZBOURG, TRÉSOR DE LA CATHÉDRALE – PERTE DE GUERRE

À l'origine destiné à un usage profane, le coffret fut utilisé plus tard pour la conservation de reliques
(cf. aussi ill. p. 223). Les petits panneaux d'ivoire étaient fixés sur le coffre en bois à l'aide de clous en laiton.
La face antérieure (A) montre un prince oriental assis sur un trône (C), à ses côtés, musiciens et buveurs
(D–H). La frise d'arabesques (I) qui s'y déroule est parsemée de médaillons circulaires contenant des
animaux dont la représentation se répète : bouquetins, aigles tenant des canards dans leurs serres, paons,
guépards. Sur la face postérieure du coffret courent d'étroites frises comprenant bosquets et animaux.
Le couvercle aux allures d'échiquier (B) est orné d'arabesques et de figures animales (K).

CHRISTLICHES RELIQUIEN-KAESTCHEN ORIENTALISCHEN URSPRUNGS.

A–C. TABLE

West German, c. 1500. Oak, 77.8 x 155.5 x 110.2 cm / 30 ½ x 61 ¼ x 43 ⅜ in.
FORMERLY IN A PRIVATE COLLECTION – WHEREABOUTS UNKNOWN
A table from a middle-class household.

D–F. DECORATIVE CARVINGS

Cologne, 14th century. Oak
FORMERLY COLOGNE ST. MARIA IM KAPITOL – WARTIME LOSS
Details from the choir stalls (E and F) and a confessional (D) in the Catholic parish church
of St. Maria im Kapitol in Cologne.

A–C. TISCH

Westdeutsch, um 1500. Eichenholz, 77.8 x 155.5 x 110, 2 cm
EHEMALS IN PRIVATBESITZ – AUFBEWAHRUNGSORT UNBEKANNT
Der Tisch stammt aus bürgerlichem Haushalt.

D–F. VERZIERUNGEN

Köln, 14. Jahrhundert. Eichenholz
EHEMALS KATHOLISCHE PFARRKIRCHE ST. MARIA IM KAPITOL, KÖLN –KRIEGSVERLUST
Details vom Chorgestühl (E und F) und einem Beichtstuhl (D)
aus St. Maria im Kapitol in Köln.

A–C. TABLE

Allemagne occidentale, vers 1500. Bois de chêne ; 77.8 x 155.5 x 110.2 cm
AUTREFOIS EN COLLECTION PRIVÉE – LOCALISATION INCONNUE
Table issue d'une maison bourgeoise.

D–F. ORNEMENTS

Cologne, XIVe siècle. Bois de chêne
AUTREFOIS CONSERVÉS DANS L'ÉGLISE PAROISSIALE CATHOLIQUE
SAINTE-MARIE-DU-CAPITOLE, COLOGNE – PERTE DE GUERRE
Détails de stalles (E et F) et d'un confessionnal (D) provenant
de l'église Sainte-Marie-du-Capitole à Cologne.

A

F

E

B

C 0 1 2 Pariser Fuss.

C

D

1500 — 1510.

CEREMONIAL SHIELD
Italian, early 16th century. Iron, partly gilded, ⌀ 55 cm / 21 ⅝ in.
FORMERLY ERBACH, GRÄFLICHE SAMMLUNGEN SCHLOSS ERBACH – UNTRACED
The shield is decorated with a representation of the Rape of Helen.
The gilt figures stand out in high relief against the black finish of the ground.

PRUNKSCHILD
Italienisch, Anfang 16. Jahrhundert. Eisen, teilvergoldet, ⌀ 55 cm
EHEMALS GRÄFLICHE SAMMLUNGEN SCHLOSS ERBACH – VERSCHOLLEN
Der Schild zeigt im Hochrelief eine Darstellung des Raubs der schönen Helena.
Die vergoldeten Figuren heben sich vom geschwärzten Grund ab.

BOUCLIER D'APPARAT
Italie, début du XVIᵉ siècle. Fer, partiellement doré, ⌀ 55 cm
AUTREFOIS CONSERVÉE DANS LES GRÄFLICHE SAMMLUNGEN SCHLOSS ERBACH – DISPARU
Le bouclier montre, exécutée en haut-relief, une représentation du rapt de la belle Hélène.
Les personnages dorés se détachent sur le fond noirâtre.

1 Pariser Fuss.

1540 — 1570.

J. Klippmann sc.

CHALICE

Frankfurt am Main (?), early 16th century. Silver gilt, h. c. 20 cm / 7 ⅞ in.

FRANKFURT AM MAIN, CATHEDRAL TREASURY

The cup of this Eucharistic chalice sits upon a highly textured base. The shaft with its nodus and canted sides rises above a six-lobed foot with applied leaf ornament. The central lobe of the foot shows a sculpturally modelled Crucifixion group with soldiers engraved in the background. The remaining lobes are engraved with half-length representations of Christ as the Man of Sorrows in the tomb, St George and the Dragon, St Catherine, St Barbara and the Virgin and Child.

KELCH

Frankfurt am Main (?), Anfang 16. Jahrhundert. Silber, vergoldet, ca. 20 cm hoch

FRANKFURT AM MAIN, DOMSCHATZ

Die Kuppa des eucharistischen Kelches ist plastisch unterfangen. Der Schaft mit Nodus und Verkantungen erhebt sich über einem sechspassigen Fuß mit aufgelegten Blattornamenten. Das zentrale Passfeld des Fußes zeigt eine plastische Kreuzigungsgruppe und dahinter gravierte Soldaten. Auf den übrigen Passfeldern befinden sich Gravuren mit halbfigurigen Darstellungen von Christus als Schmerzensmann im Grabe, Georg dem Drachentöter, den Heiligen Katharina und Barbara sowie von Maria mit dem Kind.

CALICE

Francfort-sur-le-Main (?), début du XVIᵉ siècle. Argent, doré, hauteur env. 20 cm

FRANCFORT, TRÉSOR DE LA CATHÉDRALE

La coupe du calice eucharistique est soutenue par une sculpture. La tige, pourvue d'un nœud et d'arêtes saillantes, s'élève sur un pied à six lobes recouvert d'ornements en forme de feuilles. Sur le lobe central du pied est sculpté un calvaire ; en arrière-plan de celui-ci sont gravés des soldats. Sur les autres lobes sont gravées des représentations à mi-corps du Christ souffrant au tombeau, de saint Georges le tueur de dragons, des saintes Catherine et Barbara ainsi que de la Vierge à l'Enfant.

1480 — 1500.

A–H. PRIE-DIEU CABINET WITH IRON MOUNTS
German, late 13th/early 14th century. Oak, iron
GELNHAUSEN, PROTESTANT PARISH CHURCH OF OUR LADY
The overall view of the cabinet (A) is accompanied by details of the mounts and handles (B–H).

I & K. NAIL HEADS
German, early 16th century. Iron
FORMERLY IN THE POSSESSION OF THE EDITOR HEFNER-ALTENECK – WHEREABOUTS UNKNOWN

L. ORNAMENTAL PLAQUE
German, early 16th century. Iron
FORMERLY WÜRZBURG, PRIVATE COLLECTION – WHEREABOUTS UNKNOWN
The openwork iron plaque originally formed the side wall of a casket.

A–H. BETSTUHLSCHRÄNKCHEN MIT EISENBESCHLÄGEN
Deutsch, Ende 13./Anfang 14. Jahrhundert. Eichenholz, Eisen
GELNHAUSEN, EVANGELISCHE PFARRKIRCHE ST. MARIEN
Die Gesamtansicht des Schränkchens (A) wird ergänzt durch Detaildarstellungen
der Beschläge und Türklopfer (B–H).

I & K. NAGELKÖPFE
Deutsch, Anfang 16. Jahrhundert. Eisen
EHEMALS IM BESITZ DES HERAUSGEBERS HEFNER-ALTENECK – AUFBEWAHRUNGSORT UNBEKANNT

L. ZIERPLATTE
Deutsch, Anfang 16. Jahrhundert. Eisen
EHEMALS IN WÜRZBURGER PRIVATBESITZ – AUFBEWAHRTUNGSORT UNBEKANNT
Die in durchbrochener Arbeit gefertigte Platte bildete ursprünglich die Seitenwand eines Kästchens.

A–H. PETITE ARMOIRE DE PRIE-DIEU AVEC FERRURES
Allemagne, fin du XIIIᵉ/début du XIVᵉ siècle. Bois de chêne, fer
GELNHAUSEN, ÉGLISE PAROISSIALE PROTESTANTE SAINTE-MARIE
La vue d'ensemble de la petite armoire (A) est complétée par la représentation de détails
des ferrures et heurtoirs (B–H).

I & K. TÊTES DE CLOU
Allemagne, début du XVIᵉ siècle. Fer
AUTREFOIS EN LA POSSESSION DE HEFNER-ALTENECK – LOCALISATION INCONNUE

L. PLAQUE ORNEMENTALE
Allemagne, début du XVIᵉ siècle. Fer
AUTREFOIS EN LA POSSESSION D'UN PARTICULIER DE WURTZBOURG – LOCALISATION INCONNUE
Travaillée en ajouré, la plaque constituait à l'origine la paroi latérale d'un coffret.

56.

1490 - 1510.

CARPET
Franconian, 12th century. Wool, woven, 200.9 x 155.5 cm / 79 x 61 ¼ in.
EISENACH, WARTBURG
The carpet, whose original function is unclear, is patterned with fifteen representations of symbolic animals and magical beasts against a decorative background of plant motifs, surrounded by a wide border.

TEPPICH
Fränkisch, 12. Jahrhundert. Wolle, gewirkt, 200,9 x 155,5 cm
EISENACH, WARTBURG
Den Teppich, dessen ursprüngliche Funktion unklar ist, schmücken 15 Darstellungen symbolischer Tiere und Fabelwesen auf rankenornamentiertem Grund, umgeben von einem breiten Rahmen.

TAPIS
Franconie, XII^e siècle. Laine, tricoté, 200,9 x 155,5 cm
EISENACH, WARTBURG
Le tapis, dont la fonction originelle est incertaine, est orné de quinze représentations d'animaux symboliques et de créatures fabuleuses sur un fond parsemé d'entrelacs et entouré d'un large bord.

A. CENSER

Rhenish, mid-13th century. Bronze, h. 22.4 cm / 8 ¾ in., ø 10.2 cm / 4 in. (max.), at the foot 7.2 cm / 2 ¾ in.

MAINZ, BISCHÖFLICHES DOM- UND DIÖZESANMUSEUM

The censer is decorated in a purely ornamental fashion, devoid of all figural references. The presence, even at this early date, of motifs borrowed from Gothic architecture indicates that the censer was produced during the transitional phase from the Romanesque to the Gothic era.

B–E. DECORATIVE MOUNTS

Rhenish, late 14th/early 15th century. Bronze

MAINZ, BISCHÖFLICHES DOM- UND DIÖZESANMUSEUM

The mounts originally decorated the wooden cover of a hymnal in Mainz cathedral.

G–I. BOOK MOUNTS

Rhenish, 14th century. Bronze

FORMERLY WIESBADEN, HESSISCHE LANDESBIBLIOTHEK – UNTRACED

The bronze mounts adorned the *Rupertsberg Codex*, the only surviving manuscript recording the visions of St Hildegard of Bingen compiled during her lifetime. Formerly housed in Wiesbaden, the manuscript has been missing since 1945, but its miniatures are preserved in a facsimile copy made in the abbey of Sankt Hildegard in Eibingen from 1927 to 1933. An unillustrated manuscript of the visions of St Hildegard, still in Wiesbaden library today, features book mounts from the same workshop.

A. WEIHRAUCHFASS

Rheinisch, Mitte 13. Jahrhundert. Bronze, 22,4 cm hoch, ø Gefäß 10,2 cm , ø Fuß 7,2 cm

MAINZ, BISCHÖFLICHES DOM- UND DIÖZESANMUSEUM

Das Rauchfass verzichtet ganz auf figürlichen Dekor und zeigt rein ornamentalen Schmuck. Es nimmt bereits Motive der gotischen Baukunst auf und ist dementsprechend in der Übergangsphase von der Romanik zur Gotik entstanden.

B–E. ZIERSTÜCKE

Rheinisch, Ende 14./Anfang 15. Jahrhundert. Bronze

MAINZ, BISCHÖFLICHES DOM- UND DIÖZESANMUSEUM

Die Verzierungen stammen vom hölzernen Deckel eines Choralbuches des Mainzer Doms.

G–I. BUCHBESCHLÄGE

Rheinisch, 14. Jahrhundert. Bronze

EHEMALS HESSISCHE LANDESBIBLIOTHEK, WIESBADEN – VERSCHOLLEN

Die Buchbeschläge zierten den Rupertsberger Codex, die einzige überlieferte, zu Lebzeiten der heiligen Hildegard von Bingen hergestellte Handschrift mit Aufzeichnung ihrer Visionen. Der Codex ist seit 1945 verschollen, die Miniaturen der Wiesbadener Handschrift sind jedoch in einem Faksimile überliefert, das 1927–1933 in der Abtei St. Hildegard in Eibingen hergestellt wurde. Eine zweite, von derselben Werkstatt hergestellte Serie von Buchbeschlägen ist an einer nicht illustrierten Handschrift der Visionen der heiligen Hildegard in der Wiesbadener Bibliothek verwendet worden.

B

C

F

G

H

A

J

4 Par: Zoll.

1250 — 1450.

(p. 195)

A. ENCENSOIR
Rhénanie, milieu du XIII^e siècle. Bronze, hauteur 22,4 cm ; ø récipient 10,2 cm, ø pied 7,2 cm
MAYENCE, BISCHÖFLICHES DOM- UND DIÖZESANMUSEUM
L'encensoir renonce entièrement au décor figuratif au profit d'un décor purement ornemental.
Les motifs qu'il emprunte à l'architecture gothique permettent de situer sa création pendant
la période de transition du roman au gothique.

B–E. PIÈCES ORNEMENTALES
Rhénanie, fin du XIV^e/début du XV^e siècle. Bronze
MAYENCE, BISCHÖFLICHES DOM- UND DIÖZESANMUSEUM
Les ornements proviennent de la couverture en bois d'un livre de chorals de la cathédrale de Mayence.

G–I. FERRURES DE LIVRE
Rhénanie, XIV^e siècle. Bronze
AUTREFOIS CONSERVÉES DANS LA BIBLIOTHÈQUE RÉGIONALE DE HESSE, WIESBADEN – DISPARUES
Les ferrures ornaient le codex de Rupertsberg, l'unique manuscrit consignant les visions d'Hildegarde
de Bingen et élaboré du vivant de la sainte qui ait été transmis à la postérité. Le codex a disparu
en 1945 ; les miniatures du manuscrit de Wiesbaden ont toutefois été transmises par un fac-similé exécuté
en 1927–1933 dans l'abbaye Sainte-Hildegarde d'Eibingen. Une deuxième série de ferrures de livre issue
du même atelier a été utilisée, dans la bibliothèque de Wiesbaden, pour orner un manuscrit
non illustré des visions d'Hildegarde.

(p. 199)

CENTRE & A. EWER

Würzburg (?), c. 1500. Brass, h. 48 cm / 18 ⅞ in.
FORMERLY WÜRZBURG CATHEDRAL TREASURY – WARTIME LOSS

B. DETAIL OF A BASIN

Würzburg (?), c. 1500. Copper, embossed, cast, engraved and chased,
h. 8 cm / 3 ⅛ in., ø 63 cm / 24 ¾ in. (dimensions of the basin as a whole)
WÜRZBURG, MUSEUM AM DOM

The ewer from Würzburg cathedral formed part of a set with a basin. Cast and in part turned, it was crowned by a cross-shaped finial (A). Ewers of this type were produced in large numbers within the south German sphere. The accompanying basin, of which the plate shows only a detail (B), still survives and can be seen in the Würzburg cathedral museum, on loan from the cathedral authorities. It was used on Maundy Thursday for the foot-washing ceremony in the cathedral and therefore has two handles, one on either side. As seen in the detail on the plate, the ends of each handle are gripped by a pair of hands.

C. AQUAMANILE

South German, 14th century. Bronze, h. 24.4 cm / 9 ⅝ in.
OBERWESEL, MUSEUM HÜTTE

The aquamanile, a water jug for washing the hands, is here designed in the shape of a round-bellied pot. The property of the parish of Liebfrauen und St Martin in Oberwesel, it was restored in 2001 and is on permanent loan to the Museum Hütte. The hand bell (D), formerly also housed in the Liebfrauenkirche in Oberwesel, is today missing.

MITTE & A. KANNE
Würzburg (?), um 1500. Messing, 48 cm hoch
Ehemals Würzburg, Domschatz – Kriegsverlust

B. DETAIL EINES BECKENS
Würzburg (?), um 1500. Kupfer, getrieben, gegossen, graviert und ziseliert,
8 cm hoch, ø 63 cm (Maße des gesamten Beckens)
Würzburg, Museum am Dom

Die zu einem Wasserbecken gehörende Kanne des Würzburger Domes war gegossen und teilweise gedreht. Auf dem Deckel befand sich eine Kreuzblume (A). Kannen dieses Typs wurden im süddeutschen Raum überaus häufig hergestellt. Das zugehörige Becken, von dem die Tafel eine Teilabbildung zeigt (B), ist erhalten und wird heutzutage als Leihgabe der Domkirchenstiftung im Museum am Dom ausgestellt. Es diente am Gründonnerstag im Dom der rituellen Fußwaschung und hat deshalb seitlich zwei Haltegriffe, die von Händepaaren umfangen werden.

C. AQUAMANILE
Süddeutsch, 14. Jahrhundert. Bronze, 24.4 cm hoch
Oberwesel, Museum „Hütte"

Der als bauchiger Krug gestaltete Wasserspender ist Eigentum der Pfarrei Liebfrauen und St. Martin in Oberwesel. Er wurde 2001 restauriert und befindet sich als Dauerleihgabe im Museum. Die früher ebenfalls in der Liebfrauenkirche in Oberwesel aufbewahrte Handglocke (D) ist verschollen.

AU MILIEU & A. BROC
Wurtzbourg (?), vers 1500. Laiton, hauteur 48 cm
Autrefois conservé à Wurtzbourg Trésor de la cathédrale – Perte de guerre

B. DÉTAIL D'UN BASSIN
Wurtzbourg (?), vers 1500. Cuivre, repoussé, fondu, gravé et ciselé,
hauteur 8 cm, ø 63 cm (dimensions du bassin entier)
Wurtzbourg, Museum am Dom

Le broc de la cathédrale de Wurtzbourg appartenait à un bassin et était fondu et partiellement tourné. Le couvercle était surmonté d'un fleuron (A). La fabrication de ce type de broc était extrêmement fréquente dans le sud de l'Allemagne. Le bassin auquel il appartenait et dont la planche montre une reproduction partielle (B) a été conservé ; il est aujourd'hui exposé au musée de la cathédrale comme prêt de la Domkirchenstiftung (Fondation de la cathédrale). Il servait, lors de la célébration du Jeudi saint dans la cathédrale, au rite du lavement des pieds. C'est pourquoi il possède deux poignées latérales, respectivement tenues par une paire de mains.

C. AQUAMANILE
Allemagne du Sud, XIV^e siècle. Bronze, hauteur 24.4 cm
Oberwesel, Museum « Hütte »

Le dispensateur d'eau conçu comme une cruche bombée est la propriété des églises paroissiales Notre-Dame et Saint-Martin à Oberwesel. Restauré en 2001, il se trouve au musée en prêt permanent. La cloche à main (D), jadis également conservée dans l'église Notre-Dame d'Oberwesel, a disparu.

A

B

59.

4 Pariser Zoll

D

C

1300—1400.

FRAGMENTS OF A BOOK COVER

Rhenish, 11th century. Copper, gilt, embossed, enamelled, figure of Christ, h. 23.7 cm / 9 ⅜ in.
FORMERLY IN A PRIVATE COLLECTION – WHEREABOUTS UNKNOWN
The plate shows fragments from a representation of the Crucifixion. Christ, wearing a crown,
is crucified with four nails in line with earlier artistic tradition (cf. also ills. pp. 179, 555).
Of the symbols of the four Evangelists, only the lion of St Mark and the eagle of St John have survived.
The apostles Peter and Paul are also illustrated.

RESTE EINES BUCHDECKELS

Rheinisch, 11. Jahrhundert. Kupfer, vergoldet, getrieben, emailliert, Christusfigur 23,7 cm hoch
EHEMALS IN PRIVATBESITZ – AUFBEWAHRUNGSORT UNBEKANNT
Die Tafel zeigt Teile einer Kreuzigungsdarstellung. Der gekrönte Gekreuzigte ist im altertümlichen
„Viernageltypus" dargestellt (siehe auch Abb. S. 179, 555). Von den vier Evangelistensymbolen
haben sich nur der Löwe des Markus und der Adler des Johannes erhalten. Abgebildet sind außerdem
die Apostel Petrus und Paulus.

RESTES D'UNE COUVERTURE DE LIVRE

Rhénanie, XI^e siècle. Cuivre, doré, repoussé, émaillé, Christ: hauteur 23,7 cm
AUTREFOIS EN COLLECTION PRIVÉE – LOCALISATION INCONNUE
La planche montre des parties d'un calvaire. Conformément à la représentation médiévale,
le crucifié couronné est fixé sur la croix par quatre clous (cf. aussi ill. pp. 179, 555).
Des quatre symboles des évangélistes, seuls le lion de Marc et l'aigle de Jean ont été conservés.
Les apôtres Pierre et Paul sont également reproduits.

D

E

0 1 2

Pariser Zoll.

A

C

B

1000 — 1100.

"HENRY I'S COMB"

Syrian or Egyptian, 7th–8th century, German, 9th–11th century
Ivory, gold-foil setting with garnets, almandines, glass and pearls, 17 x 10 cm / 6 ¾ x 4 in.
QUEDLINBURG, ST SERVATIUS'S ABBEY "ZITTER," TREASURY
Made in Syria or Egypt, the ivory comb passed into the possession of the abbey via an unknown route.
According to legend, it was used as a beard comb by the beardless King Henry I of Germany (r. 947–55).
It is more probable that it played a ritual role in the coronation ceremony. The upper part of the comb,
that is the handle, was later given a setting of gold foil in Germany and studded with garnets, pearls, pieces
of green glass and a violet gem, some of which are today missing (cf. ill. p. 50). The decoration thereby
traces the shapes of the manes, bridles and reins of two horses, whose accompanying heads are today also
missing. They were originally attached to the top and gave the comb a rectangular overall form.

„KAMM HEINRICHS I."

Syrisch oder ägyptisch, 7.–8. Jahrhundert, Deutsch, 9.–11. Jahrhundert
Elfenbein; Goldblech mit Granaten, Almandinen, Glas, Perlen, 17 x 10 cm
QUEDLINBURG, STIFTSKIRCHE ST. SERVATIUS „ZITTER", DOMSCHATZ
Der in Syrien oder Ägypten hergestellte Kamm kam auf unbekanntem Wege in den Besitz der
Stiftskirche. Der Legende nach verwendete ihn der bartlose König Heinrich I. (reg. 947–955) als
Bartkamm. Wahrscheinlicher ist, dass er während des Krönungsrituals Verwendung fand.
Das Oberteil des Kammes bildet die Handhabe, deren später in Deutschland hergestellte Fassung aus
Goldblech ist und mit Granaten, Perlen, grünen Glasstücken und violettem Edelstein verziert wurde,
die heute teilweise fehlen (siehe Abb. S. 50). Die Schmuckformen zeichnen ein Pferdezaumzeug
einschließlich der Zügel und der Pferdemähnen nach. Es fehlen oben die zugehörigen Pferdeköpfe,
die das Ganze zur rechteckigen Form gefügt haben.

« PEIGNE D'HENRI I^ER »

Syrie ou Égypte, VII^e–VIII^e siècle, Allemagne, IX^e–XI^e siècle
Ivoire, monture d'or avec grenats, almandines, verre, perles, 17 x 10 cm
QUEDLINBURG, ÉGLISE COLLÉGIALE SAINT-SERVAIS « ZITTER », TRÉSOR DE LA CATHÉDRALE
Fabriqué en Syrie ou en Égypte, le peigne devint par un moyen inconnu la propriété de l'église collégiale.
Si la légende rapporte que le roi imberbe Henri I^er (règne 947–955) l'utilisait comme peigne à barbe, l'objet
servit plus vraisemblablement pendant le rituel du couronnement. La partie supérieure du peigne en
constitue la poignée, dont la monture fabriquée ultérieurement en Allemagne est en lames d'or et ornée de
grenats, de perles, de morceaux de verre de couleur verte ainsi que de pierres précieuses violettes faisant
aujourd'hui partiellement défaut (cf. ill. p. 50). La disposition des joyaux imite une bride incluant rênes
et crinières. Il manque, dans la partie supérieure, les têtes de cheval qui appartenaient à l'ensemble
et lui donnaient une forme rectangulaire.

900 1000.

POSITIVE ORGAN AFTER A DESIGN DRAWING
Peter Flötner, Nuremberg, 1527. Pen and India ink on paper, 21.2 x 17.9 cm / 8 ⅜ x 7 in.
STAATLICHE MUSEEN ZU BERLIN, KUPFERSTICHKABINETT
The representation of the positive organ on this plate is based on a design drawing by Peter Flötner.
An artist who played a particularly important role in spreading the new forms of the Renaissance in
Germany, Flötner created numerous designs for handcrafted objects (cf. also ills. pp. 18, 21, 211).
Plate 62 is based on the larger of two surviving designs for portable organs (ill. p. 21). Flötner's original
drawing is executed in black and brown ink, heightened in white and gold.

TISCHORGEL NACH MUSTERZEICHNUNG
Peter Flötner, Nürnberg, 1527. Tusche mit Feder auf Papier, 21,2 x 17,9 cm
STAATLICHE MUSEEN ZU BERLIN, KUPFERSTICHKABINETT
Die Darstellung der Tischorgel auf dieser Tafel erfolgte auf der Grundlage einer Entwurfszeichnung von
Peter Flötner. Dieser für die Verbreitung neuer Renaissanceformen in Deutschland besonders wichtige
Künstler schuf zahlreiche Muster für kunsthandwerkliche Umsetzungen (siehe auch Abb. S. 18, 21, 211).
Als Vorlage für Tafel 62 diente die größere von zwei erhaltenen Entwurfszeichnungen für tragbare
Tischorgeln (Abb. S. 21). Die Originalzeichnung ist in Schwarz und Braun getuscht
und zudem weiß und golden gehöht.

ORGUE DE TABLE D'APRÈS UN DESSIN DE PROJET
Peter Flötner, Nuremberg, 1527. Encre de Chine avec plume sur papier, 21,2 x 17,9 cm
STAATLICHE MUSEEN ZU BERLIN, KUPFERSTICHKABINETT
L'orgue de table représenté sur cette planche reproduit un dessin de projet exécuté par Peter Flötner, un
artiste ayant largement contribué à la diffusion en Allemagne des nouvelles formes issues de la Renaissance.
De nombreux modèles destinés à la conversion artisanale (cf. aussi ill. pp. 18, 21, 211) lui sont dus.
Le dessin original ayant servi de modèle à cette planche est le plus grand de deux projets conservés d'orgues
portables (ill. p. 21). Exécuté à l'encre de Chine noire et marron, il est en outre rehaussé de blanc et d'or.

14th century

CHESS PIECE
Mid-14th century. Ivory, h. 7.3 cm / 2 ⅞ in.
STAATLICHE MUSEEN ZU BERLIN, KUNSTGEWERBEMUSEUM

The bishop is part of the same chess set as the knight (cf. ills. pp. 54–55, 235–37). The present piece shows the bishop in full regalia seated on his cathedra. Holding his crosier, or *pedum*, in his left hand, he raises his gloved right hand, with its bishop's ring, in blessing. The ivory figure is mounted on a wooden base and retains traces of paint, which are also reproduced in the plate.

SCHACHFIGUR
Mitte 14. Jahrhundert. Elfenbein, 7.3 cm hoch
STAATLICHE MUSEEN ZU BERLIN, KUNSTGEWERBEMUSEUM

Die Figur ist Teil eines Schachspieles, das den Bischof als Läufer und einen Ritter als Springer aufwies (siehe Abb. S. 54–55, 235–237). Auf Englisch wird der Läufer auch heute noch als „bishop" bezeichnet. Die abgebildete Schachfigur zeigt den Bischof in vollem Ornat auf der Kathedra sitzend. Mit der behandschuhten, ringgeschmückten Rechten segnet er, und in der Linken hält er das Pedum, den Bischofsstab. Die Figur ist auf einen Holzsockel montiert und zeigt Spuren von Bemalung, die auch auf der Tafel wiedergegeben werden.

PIÈCE D'UN JEU D'ÉCHECS
Milieu du XIVᵉ siècle. Ivoire, hauteur 7.3 cm
STAATLICHE MUSEEN ZU BERLIN, KUNSTGEWERBEMUSEUM

La pièce fait partie d'un jeu d'échecs dans lequel le fou apparaissait sous les traits d'un évêque, le cavalier, sous ceux d'un chevalier (cf. ill. pp. 54–55, 235–237). En anglais, le fou est aujourd'hui encore appelé « bishop ». La pièce reproduite montre l'évêque revêtu de ses ornements et assis dans sa chaire épiscopale. De sa main droite gantée et garnie d'une bague, il donne la bénédiction ; dans sa main gauche, il tient le pedum, crosse épiscopale. La pièce est montée sur un socle en bois et présente des traces de peinture également visibles sur la planche.

CHESS PIECE
Mid-14th century. Ivory
FORMERLY LEIPZIG, COLLECTION OF THE DEUTSCHE GESELLSCHAFT ZUR ERFORSCHUNG VATERLÄNDISCHER SPRACHE AND ALTERTÜMER – WHEREABOUTS UNKNOWN

The bishop is seated on a richly ornamented cathedra and is flanked by deacons.

SCHACHFIGUR
Mitte 14. Jahrhundert. Elfenbein
EHEMALS SAMMLUNG DER DEUTSCHEN GESELLSCHAFT ZUR ERFORSCHUNG VATERLÄNDISCHER SPRACHE UND ALTERTÜMER, LEIPZIG – AUFBEWAHRUNGSORT UNBEKANNT

Der Bischof sitzt auf einer reich verzierten Kathedra und wird von Diakonen flankiert.

PIÈCE D'UN JEU D'ÉCHECS
Milieu du XIVᵉ siècle. Ivoire
AUTREFOIS CONSERVÉE DANS LA COLLECTION DE LA SOCIÉTÉ ALLEMANDE D'EXPLORATION DE LA LANGUE ET DES ANTIQUITÉS NATIONALES, LEIPZIG – LOCALISATION INCONNUE

Flanqué de diacres, l'évêque est assis sur une chaire richement décorée.

1150 — 1250.

KEYS

Saxon, 2nd half of the 12th century. A–C: Bronze, c. 20 x 9 cm / 7 ⅞ x 3 ½ in. (A)
MARBURG, ST ELIZABETH CHURCH
D–E: Lead, 7.5 x 4.5 cm / 3 x 1 ¾ in. (D)
FORMERLY BERLIN, KUNSTGEWERBEMUSEUM, STAATLICHE MUSEEN ZU BERLIN – ORIGINAL UNTRACED

Both keys employ typical Romanesque decorative forms (human figures and animal heads, and in the case of the Berlin key, a stylized dragon as a handle) of the kind also found on liturgical items. The Marburg key (A–C) is made of bronze and exhibits lingering traces of fire gilding in the present plate. The Berlin key (D–E), missing since 1945, was probably a relatively modern lead cast of a bronze key acquired by the museum in 1895 and still on display there today. This bronze key originates from the former abbey of Memleben on the River Unstrut. The stylistic similarities between the Marburg and Berlin keys mean that the former cannot date – as Carl Becker and Jakob Heinrich Hefner-Alteneck assumed – from the period of construction of Marburg's Gothic church (begun in 1235, consecrated in 1283, spires completed in 1340).

SCHLÜSSEL

Sächsisch, 2. Hälfte 12. Jahrhundert. A–C: Bronze, ca. 20 x 9 cm (A)
MARBURG, ELISABETHKIRCHE
D–E: Blei, 7.5 x 4.5 cm (D)
EHEMALS KUNSTGEWERBEMUSEUM, STAATLICHE MUSEEN ZU BERLIN – ORIGINAL VERLOREN

Beide Schlüssel zeigen typisch romanische Dekorformen (menschliche Figuren und Tierköpfe bzw. einen stilisierten Drachen als Griff), wie sie auch bei sakralem Gerät vorkommen. Der Marburger Schlüssel (A–C) mit menschlichen Figuren und Tierköpfen besteht aus Bronze und zeigte auf der Tafel noch Reste einer Feuervergoldung. Bei dem Berliner Schlüssel (D–E), der seit 1945 verschollen ist, handelte es sich wahrscheinlich um einen neuzeitlichen Bleiabguss eines 1895 vom Museum erworbenen bronzenen Schlüssels, der sich heute noch im Museum befindet und dort ausgestellt ist. Dieser Bronzeschlüssel stammt aus dem ehemaligen Kloster Memleben an der Unstrut. Da der Marburger Schlüssel die gleichen Stilformen zeigt wie der Berliner, kann er nicht, wie Becker und Hefner-Alteneck vermuten, aus der Erbauungszeit der gotischen Marburger Kirche (begonnen 1235, Weihe 1283, Vollendung der Türme 1340) stammen.

CLÉS

Saxe, 2ᵉ moitié du XIIᵉ siècle. A–C: Bronze, env. 20 x 9 cm (A)
MARBOURG, ÉGLISE SAINTE-ÉLISABETH
D–E: Plomb, 7.5 x 4.5 cm (D)
AUTREFOIS CONSERVÉE AU KUNSTGEWERBEMUSEUM, STAATLICHE MUSEEN ZU BERLIN
ORIGINAL PERDU

Les deux clés présentent des décors caractéristiques du style roman (figures humaines et têtes d'animaux, en l'occurrence un dragon stylisé en guise d'anneau) tels qu'ils apparaissent également dans les objets de culte. La clé de Marbourg (A–C) aux figures humaines et têtes d'animaux est faite de bronze et présente des restes d'une dorure au feu, visibles sur la planche. La clé de Berlin (D–E), disparue depuis 1945, était probablement un moulage de plomb moderne d'une clé de bronze acquise par le musée en 1895 et qui y est aujourd'hui encore conservée et exposée. Cette clé de bronze provient de l'ancien monastère de Memleben au bord de l'Unstrut. Présentant les mêmes formes stylistiques que celle de Berlin, la clé de Marbourg ne peut pas, comme le supposent Becker et Hefner-Alteneck, dater de l'époque de construction de l'église gothique de la ville (commencée en 1235, inaugurée en 1283, tours achevées en 1340).

1100 — 1200.

ARMCHAIR AFTER A DESIGN DRAWING

Peter Flötner, Nuremberg, 1535. Pen and India ink on paper, 19 x 15.5 cm / 7 ½ x 6 in.

STAATLICHE MUSEEN ZU BERLIN, KUPFERSTICHKABINETT

The armchair clearly illustrates the imaginative, visually captivating and entertaining handling of form that characterizes the German Renaissance style. The armrests are supported by two male nudes, who are probably intended to represent youth and old age, while the chair legs are provided with putti riding on dolphins. Both motifs are taken from the repertoire of Italian grotesque ornamentation. The illustration of the armchair in the plate goes back to a design drawing in brown, black and reddish ink by Peter Flötner (ill. p. 18).

ARMSESSEL NACH MUSTERZEICHNUNG

Peter Flötner, Nürnberg, 1535. Tusche mit Feder auf Papier, 19 x15,5 cm

STAATLICHE MUSEEN ZU BERLIN, KUPFERSTICHKABINETT

Der Armsessel veranschaulicht gut die fantasievolle, auf Augenreiz und Amüsement abzielende Gestaltungsweise der deutschen Renaissance. Die Armlehnen des Sessels ruhen auf zwei männlichen Aktfiguren, die vermutlich Jugend und Alter darstellen sollen. Auf Delfinen reitende Putten dienen als Beine. Beide Motive stammen aus der italienischen Groteskornamentik. Die Darstellung des Armlehnstuhls geht zurück auf eine Zeichnung in brauner, schwarzer und rötlicher Tusche von Peter Flötner (Abb. S. 18).

FAUTEUIL À ACCOUDOIRS D'APRÈS UN DESSIN DE PROJET

Peter Flötner, Nuremberg, 1535. Encre de Chine avec plume sur papier, 19 x 15,5 cm

STAATLICHE MUSEEN ZU BERLIN, KUPFERSTICHKABINETT

Le fauteuil à accoudoirs illustre bien le style de la Renaissance allemande, conçu pour attirer le regard et divertir. Les accoudoirs reposent sur deux sculptures de nus masculins, lesquels représentent probablement la jeunesse et la vieillesse ; des putti chevauchant des dauphins servent de pieds – deux motifs issus de l'art grotesque italien. Le fauteuil reproduit un dessin à l'encre de Chine marron, noire et rougeâtre exécuté par Peter Flötner (ill. p. 18).

P·F

TWO STAINED-GLASS ROUNDELS
South German, 13th century. ø 86.4 cm / 34 in.

FORMERLY SCHWEINFURT, CHAPEL OF MAINBERG CASTLE

According to long-standing tradition, the stained-glass roundels in the Late Gothic chapel of Mainberg Castle came from the imperial residence at Ingelheim. The upper roundel, whose border inscription has not survived, shows the Expulsion of the Money-changers from the Temple. The scene in the lower roundel, to which the Latin inscription makes reference, shows Mary Magdalene washing Christ's feet.

ZWEI GLASGEMÄLDE
Süddeutsch, 13. Jahrhundert. ø 86,4 cm

EHEMALS IN DER KAPELLE DES SCHLOSSES MAINBERG BEI SCHWEINFURT

Nach alter Überlieferung kamen die Glasgemälde aus der Kaiserpfalz Ingelheim in die spätgotische Schlosskapelle. Die obere Scheibe mit nicht erhaltenem Inschriftenrand zeigt die Vertreibung der Wechsler aus dem Tempel. Auf der unteren ist die Fußwaschung Christi durch Maria Magdalena dargestellt, worauf die lateinische Umschrift Bezug nimmt.

DEUX VITRAUX
Allemagne du Sud, XIII^e siècle. ø 86,4 cm

AUTREFOIS CONSERVÉS DANS LA CHAPELLE DU CHÂTEAU DE MAINBERG PRÈS DE SCHWEINFURT

D'après une légende ancienne, les vitraux furent transférés du palais impérial d'Ingelheim dans la chapelle flamboyante du château. Le vitrail supérieur, dont les inscriptions que contenait le bord ont disparu, montre l'expulsion des changeurs du Temple. Le vitrail inférieur représente Marie-Madeleine lavant les pieds du Christ, scène à laquelle renvoie la légende latine.

RELIQUARY FLASK

Fatimid, 10th century; Lower Saxon, mid-13th and 14th century
Rock crystal, silver, 18 x 10.5 cm / 7 x 4 ⅛ in.

QUEDLINBURG, ST SERVATIUS'S ABBEY "ZITTER," TREASURY
The reliquary flask, which is said to house a drop of the Virgin's milk, is the largest of what were once six vessels of carved rock crystal housed in the Quedlinburg cathedral treasury. Originally crafted in North Africa in the 10th century for non-religious purposes, the flask combines the silhouettes of two birds on either side with palmettes and volute patterns. It was later furnished with ornamental silver fittings and a ring from which it could be hung, in line with its new use as a reliquary (cf. also ill. p. 59).

FLAKON-RELIQUIAR

Fatimidisch, 10. Jahrhundert; niedersächsisch, Mitte 13. und 14. Jahrhundert
Bergkristall, Silber, 18 x 10,5 cm

QUEDLINBURG, STIFTSKIRCHE ST. SERVATIUS, „ ZITTER", DOMSCHATZ
Das Reliquiar ist das größte der ursprünglich sechs Bergkristallgefäße des Quedlinburger Domschatzes.
Darin wird angeblich ein Tropfen der Muttermilch der Jungfrau Maria aufbewahrt.
Das ursprünglich für profane Zwecke im 10. Jahrhundert in Nordafrika in Bergkristallschnitt hergestellte Gefäß verbindet die Silhouetten von zwei Vögeln an den Seiten mit Palmetten und Volutenmuster.
Für die Verwendung als Reliquiar wurde der Flakon mit Verzierungen und einer Hängevorrichtung aus Silber versehen (siehe auch Abb. S. 59).

RELIQUAIRE-FLACON

Fatimide, X^e siècle; Basse-Saxe, milieu du XIII^e et XIV^e siècle
Cristal de roche, argent, 18 x 10,5 cm

QUEDLINBURG, ÉGLISE COLLÉGIALE SAINT-SERVAIS « ZITTER », TRÉSOR DE LA CATHÉDRALE
Le reliquaire est le plus grand des récipients en cristal de roche du trésor de la cathédrale de Quedlinburg, qui étaient à l'origine au nombre de six. On prétend qu'une goutte du lait maternel de la Vierge Marie y serait conservée. Taillé dans le cristal de roche en Afrique du Nord au X^e siècle, le récipient, initialement conçu pour un usage profane, associe les silhouettes de deux oiseaux occupant les côtés à des motifs en forme de palmettes et de volutes. Pour son utilisation comme reliquaire, le flacon a été pourvu d'ornements et d'un dispositif d'accrochage en argent (cf. aussi ill. p. 59).

A B

900 – 1000.

HAND BELL

French, 2nd half of the 12th century. Bronze, h. 16 cm / 6 ¼ in.
REIMS, PALAIS DU TAU ET DU MUSÉE DE L'ŒUVRE
The hand bell, cast in openwork, shows the symbols of the four Evangelists,
each identified by an inscription.

HANDGLOCKE

Französisch, 2. Hälfte 12. Jahrhundert. Bronze, 16 cm hoch
REIMS, PALAIS DU TAU ET DU MUSÉE DE L'ŒUVRE
Die in durchbrochener Arbeit gegossene Handglocke zeigt die vier Evangelistensymbole
mit inschriftlichen Bezeichnungen.

CLOCHE À MAIN

France, 2ᵉ moitié du XIIᵉ siècle. Bronze, hauteur 16 cm
REIMS, PALAIS DU TAU ET DU MUSÉE DE L'ŒUVRE
Travaillée en ajouré, la petite cloche fondue présente les quatre symboles des évangélistes
accompagnés d'inscriptions les désignant.

68.

1150–1200.

CENSER
Würzburg, 2nd quarter of the 15th century. Silver, h. 24 cm / 9 ½ in.
FROM THE AUGUSTINIAN CHURCH IN WÜRZBURG
WÜRZBURG, MAINFRÄNKISCHES MUSEUM
The eight-lobed foot and eight-lobed charcoal pan are cast and chased with the gadroon decoration at that time becoming common for goblets. The angels on consoles depicted in the plate are today missing from the original. The Augustinian church in Würzburg originally belonged to a Dominican monastery. It is likely, therefore, that the censer was formerly the property of the Dominicans.

WEIHRAUCHFASS
Würzburg, 2. Viertel 15. Jahrhundert. Silber, 24 cm hoch
AUS DER KIRCHE DES AUGUSTINERKLOSTERS ZU WÜRZBURG
WÜRZBURG, MAINFRÄNKISCHES MUSEUM
Der achtpassige Fuß und die achtpassige Kohlenschale sind in Buckelungen gegossen, die an Pokalen damals üblich wurden, und sie sind ziseliert. Die auf der Tafel dargestellten Engelsfiguren auf Konsolen sind am Original heute verloren. Die Kirche des Augustinerklosters gehörte ursprünglich zum Dominikanerkloster. Daher stammt das Weihrauchfass vermutlich aus dem Klostergut der Dominikaner.

ENCENSOIR
Wurtzbourg, 2ᵉ quart du XVᵉ siècle. Argent, hauteur 24 cm
PROVENANT DE L'ÉGLISE DU MONASTÈRE AUGUSTIN DE WURTZBOURG
WURTZBOURG, MAINFRÄNKISCHES MUSEUM
Fondus et ciselés, le pied et le brasero, tous deux octolobés, présentent des bosses qui, à l'époque, étaient en train de devenir usuelles dans la fabrication des coupes. Apparaissent sur la planche des figures d'ange se tenant sur des consoles et n'ayant pas été conservées sur l'original. Initialement, l'église du monastère augustin appartenait au monastère dominicain. L'encensoir provient donc probablement des fonds de ce dernier.

1450 — 1500

NAUTILUS CUP

Adriaen de Grebber, Delft, 1607. Nautilus shell mounted in a silver gilt setting, h. 23.8 cm / 9 ⅜ in.

DELFT, STEDELIJK MUSEUM HET PRINSENHOF

The foot of the cup takes the form of a fabulous beast with the paws of a beast of prey, the tail of a fish and the shell of a turtle. With its head raised and jaws gaping, the beast twists back on its neck towards the stem of the cup. A Triton seated on top of the turtle's shell supports the nautilus shell, which is crowned by Cupid riding a dragon-like monster. The neck and head of a sea creature resembling an octopus, rendered here in a separate drawing, are modelled in the round on the front of the cup. The clasps securing the cup to the stem take the form of crustaceans.

NAUTILUSPOKAL

Adriaen de Grebber, Delft, 1607. Nautilus in vergoldeter Silberfassung, 23,8 cm hoch

DELFT, STEDELIJK MUSEUM HET PRINSENHOF

Den Fuß des Pokals bildet ein Fabelwesen mit Raubtierpranken, Fischschwanz und Schildkrötenpanzer. Mit aufgerissenem Maul hebt es seinen Kopf, den es zusammen mit dem Hals zum Schaft dreht. Auf dem Panzer befindet sich ein Triton als Tragefigur. Die Nautilusmuschel bekrönt Amor, der auf einem drachenartigen Ungeheuer reitet. An der Vorderseite des Pokals befindet sich der vollplastische Hals und Kopf eines tintenfischartigen Meerwesens, die auch in einer gesonderten Umzeichnung zu sehen sind. Krabben bilden die seitlichen Befestigungsspangen.

COUPE NAUTILE

Adriaen de Grebber, Delft, 1607. Nautile enchâssé dans de l'argent doré, hauteur 23,8 cm

DELFT, STEDELIJK MUSEUM HET PRINSENHOF

Le pied de la coupe est constitué d'une créature fabuleuse dotée de pattes de bête féroce, d'une queue de poisson et d'une carapace de tortue. La gueule grande ouverte, elle lève sa tête, qu'elle tourne en même temps que son cou, vers la tige. Sur la carapace se tient un triton faisant office de figure porteuse. La coquille de nautile est couronnée de l'Amour chevauchant un monstre pareil à un dragon. Sur la face antérieure de la coupe se détachent le corps et la tête, sculptés en relief, d'une créature marine ressemblant à une seiche et restituée par le dessin figurant à côté. Des crabes constituent les attaches latérales.

F.P. d.IvH.

I.K.

1540 — 1570.

RELIQUARY CASKET

Venetian, 11th–12th century. Ivory, wood, 15 x 26.5 x 18.5 cm / 5 ⅞ x 10 ¼ x 7 ¼ in.

FORMERLY WÜRZBURG, CATHEDRAL TREASURY – WARTIME LOSS

Originally crafted as a secular item, the casket – like that on page 183 – was later used to house relics. The ivory reliefs are affixed to the wooden body by copper-gilt clasps. The lid (A) and front wall (B) of the casket are decorated with animal scenes bordered by bands of rosettes (C and D). In the centre of the lid, a pair of dragons (F) is accompanied on either side by gryphon-like beasts with lambs in their claws (G). On the front wall, harpies (I) flank the somewhat smaller relief of a centaur. A peacock (H), roebuck and roe deer are depicted on the rear wall and a hart (K), hind and an eagle with a hare in its talons (E) on the side walls.

RELIQUIENKÄSTCHEN

Venedig, 11. bis 12. Jahrhundert. Elfenbein, Holz, 15 x 26,5 x 18,5 cm

EHEMALS WÜRZBURG, DOMSCHATZ – KRIEGSVERLUST

Ursprünglich für profane Zwecke geschaffen, wurde das Kästchen ebenso wie das auf Seite 183, für die Aufbewahrung von Reliquien verwendet. Die Elfenbeinreliefs sind mit vergoldetem Kupfer auf dem Holzkasten montiert. Den Deckel (A) und die Vorderseite (B) des Kästchens zieren Tierszenen, die von Rosettenbändern (C und D) gerahmt sind. Im Zentrum des Deckels befindet sich ein Drachenpaar (F) das seitlich von greifenartigen Bestien mit Lämmern in ihren Klauen (G) begleitet wird. An der Vorderwand flankieren Harpyen (I) das kleinere Relief eines Zentaurn. Auf der Rückseite sind Pfau (H), Rehbock und Reh und auf den Seitenwänden Hirsch (K), Hirschkuh sowie Adler mit Hase in den Klauen (E) abgebildet.

COFFRET À RELIQUES

Venise, XIᵉ–XIIᵉ siècle, Ivoire, bois, 15 x 26,5 x 18,5 cm

AUTREFOIS CONSERVÉ À WURTZBOURG, TRÉSOR DE LA CATHÉDRALE – PERTE DE GUERRE

Conçu à l'origine pour un usage profane, le coffret, tout comme celui de la page 183, fut utilisé pour la conservation de reliques. Les reliefs en ivoire sont fixés sur le coffre en bois à l'aide de cuivre doré. Le couvercle (A) et la paroi antérieure (B) du coffret sont ornés de scènes animales encadrées d'une frise de rosettes (C et D). Au centre du couvercle s'enchaînent des dragons (F) et des bêtes aux allures de griffons portant des agneaux dans leur gueule (G). Sur la paroi antérieure, on distingue des harpies (I) et un centaure ; sur la face postérieure, un paon (H), un chevreuil et une chevrette ; sur les parois latérales, un cerf (K), une biche ainsi qu'un aigle tenant un lièvre dans ses serres (E).

C

A

B

D

E

F

G

H

I

K

1000 — 1100.

DOUBLE CUP

Nuremberg, c. 1500. Silver gilt, h. 37.2 cm / 14 ⅝ in., each cup 20 cm / 7 ⅞ in.

NUREMBERG, GERMANISCHES NATIONALMUSEUM

The double cup consists of a matching pair of gadroon-embossed goblets, one inverted on top of the other (cf. also p. 41). On top of the seven-lobed foot rim, seven gadroons converge towards the stem and sweep upwards in the form of convex fluting. The point at which they arrive at the cup is emphasized by decorative hoops of bent wire hanging from twisted silver-gilt rope. The columbine-shaped body of the cup consists of four rows of gadroons that ascend toward the rim, which is engraved with decorative foliage. In 1632, cast medallions (not illustrated) of Gustav Adolf and his wife were added to the undersides, which suggests that the cup was a victory gift of Nuremberg's city council to the Swedish king.

DOPPELPOKAL

Nürnberg, um 1500. Silber, vergoldet, Gesamthöhe 37.2 cm, Einzelpokal 20 cm

NÜRNBERG, GERMANISCHES NATIONALMUSEUM

Der aus zwei gegenläufig ineinandergesteckten, gebuckelten Pokalen bestehende Doppelpokal hat einen siebenpassigen Fußrand und sieben am Fuß spitz zulaufende Buckel (siehe auch Abb. S. 41). Die gedrehten Buckelschwänze am Schaft werden am Ende jeweils von zwei Reifen aus gebogenen Drähten betont, die an gedrehten Schnüren hängen. Das akeleiförmige Gefäß besteht jeweils aus vier Buckelreihen, die kurze, zylindrische Wandung ist mit gravierter Blattranke geschmückt. Die 1632 an den Unterseiten hinzugefügten, nicht abgebildeten Gussmedaillen auf Gustav Adolf und seine Gattin legen nahe, dass der Pokal als Siegesgabe des Nürnberger Rates für den Schwedenkönig verwendet wurde.

DOUBLE COUPE À BOIRE

Nuremberg, vers 1500. Argent, doré, hauteur 37.2 cm, hauteur de chaque coupe 20 cm

NUREMBERG, GERMANISCHES NATIONALMUSEUM

La double coupe à boire, composée de deux coupes bosselées et béchevetées, possède un pied au bord pourvu de sept lobes, et sept bosses se terminant en pointe sur le pied (cf. aussi ill. p. 41). Les queues des bosses qui s'enroulent autour de la tige sont chacune mises en relief à leur extrémité par deux anneaux constitués de fils exécutés par torsion et suspendus à des cordelettes torsadées. Le récipient en forme d'ancolie se compose respectivement de quatre rangées de bosses ; étroite et cylindrique, la cloison entre les deux coupes est ornée de rinceaux gravés. Les médailles coulées à l'effigie de Gustave Adolphe et de son épouse, ajoutées en 1632 sur les faces inférieures des pieds et ne figurant pas sur l'illustration, laissent supposer que la coupe a été offerte au roi de Suède par le Conseil de Nuremberg en hommage à sa victoire.

72.

A

B

C

D

1520 — 1550.

CLASP FOR A COPE
Reineke van Dressche, Minden, before 1484. Silver, partly gilded, ø 14 cm / 5 ½ in.
FROM THE CATHEDRAL OR ST MAURICE'S CHURCH IN MINDEN
STAATLICHE MUSEEN ZU BERLIN, KUNSTGEWERBEMUSEUM

According to the inscription on the back, dated 1484, this clasp for a cope was made by the Minden goldsmith Reineke van Dressche and was donated by the Minden canon Albert of Letelen, who died in 1483. It shows the two patron saints of Minden cathedral – St Peter, enthroned in the centre, and St Gorgonius on the left – beneath an elaborate baldachin. They are accompanied on the right by St Maurice, patron saint of the Benedictine monastery. Kneeling underneath is the smaller figure of the donor (cf. also ill. p. 31).

CHORMANTELSCHLIESSE
Reineke van Dressche, Minden, vor 1484. Silber, teilvergoldet, ø 14 cm
AUS DEM DOM ODER ST. MAURITIUS IN MINDEN
STAATLICHE MUSEEN ZU BERLIN, KUNSTGEWERBEMUSEUM

Die Chormantelschließe wurde laut 1484 datierter Inschrift auf der Rückseite von dem Mindener Goldschmied Reineke van Dressche angefertigt und ist eine Stiftung des Mindener Domherrn Albert von Letelen, der 1483 starb. Unter reicher Baldachinarchitektur thront der heilige Petrus mit dem heiligen Gorgonius zur Linken. Neben den beiden Patronen des Doms steht auf der rechten Seite der heilige Mauritius, der Patron des Benediktinerklosters. Kniend ist unten der Stifter dargestellt (siehe auch Abb. S. 31).

AGRAFE DE CHAPE CHORALE
Reineke van Dressche, Minden, avant 1484. Argent, partiellement doré, ø 14 cm
PROVENANT DE LA CATHÉDRALE OU DE L'ABBAYE SAINT-MAURICE À MINDEN
STAATLICHE MUSEEN ZU BERLIN, KUNSTGEWERBEMUSEUM

Selon l'inscription figurant au dos, datée de 1484, l'agrafe a été exécutée par l'orfèvre de Minden Reineke van Dressche. Son donateur, originaire de la même ville, est le chanoine Albert von Letelen, mort en 1483. Saint Pierre, à la gauche duquel apparaît saint Gorgon, trône sous un dais richement architecturé. À côté des deux saints patrons de la cathédrale se tient, sur le côté droit, saint Maurice, patron de l'abbaye bénédictine. Le donateur est représenté en bas, à genoux (cf. aussi ill. p. 31).

Anno + dm + m° + ccc + lxxxiiii + albertus + de + letelen +

1484.

MIRROR CASES

French, early 14th century. Ivory, 9.5 x 10 cm / 3 ¾ x 4 in. (above), ⌀ 8.9 cm / 3 ½ in. (below)

Formerly in the possession of Hefner-Alteneck, and Berlin, Kunstgewerbemuseum

As was the convention in the Middle Ages for cosmetic and toiletry items, these two mirror cases are decorated on the front with scenes of courtly love (cf. ills. pp. 14, 317, 385). The scene at the top of the plate illustrates a piece that was auctioned in 1904 from the estate of the editor Hefner-Alteneck, and shows a young couple playing chess within a multifoil surround. Bearded masks fill the spandrels and dragon-like monsters crouch on the circular rim. In the Berlin mirror case illustrated below, the winged and crowned god of Love appears within a hexafoil rose. He is standing at the top of a tower and holds an arrow in each hand. One is aimed at the standing figure of a virgin, before whom a youth already pierced by an arrow is kneeling, whereas the other targets an embracing couple.

SPIEGELKAPSELN

Französisch, Anfang 14. Jahrhundert. Elfenbein, 9,5 x 10 cm (oben), ⌀ 8,9 cm (unten)

Ehemals Sammlung Hefner-Alteneck und Kunstgewerbemuseum, Berlin

Wie im Mittelalter für Geräte zur Schönheitspflege üblich, zeigen die Vorderseiten der Spiegelkapseln Minneszenen (siehe Abb. S. 14, 317, 385). Die obere Abbildung gibt ein Stück wieder, das 1904 aus dem Nachlass des Herausgebers Hefner-Alteneck versteigert wurde. Es zeigt in Passform ein junges Paar beim Schachspiel, in den Zwickeln sind bärtige Masken und auf dem Rund drachenartige Monster dargestellt. Das auf der Tafel unten abgebildete Berliner Exemplar zeigt in einer sechsteiligen Rose auf einem Turm den geflügelten und gekrönten Liebesgott, der aus jeder Hand einen Pfeil herabsendet. Der eine ist auf eine stehende Jungfrau gerichtet, vor der ein bereits von einem Pfeil getroffener Jüngling kniet. Der andere Pfeil trifft ein sich liebkosendes Paar.

VALVES DE MIROIR

France, début du XIVe siècle. Ivoire, partie supérieure, 9,5 x 10 cm, partie inférieure : ⌀ 8,9 cm

Autrefois conservées dans la collection

Hefner-Alteneck et au Kunstgewerbemuseum Berlin

Comme il était d'usage, au Moyen Âge, pour les accessoires de beauté, les faces antérieures des valves de miroir figurent des scènes courtoises (cf. ill. pp. 14, 317, 385). L'illustration du haut reproduit une pièce issue de la succession du directeur de publication Jakob von Hefner-Alteneck et mise aux enchères en 1904. Un couple jouant aux échecs apparaît à l'intérieur des lobes, des masques barbus occupent les angles et des monstres ayant l'aspect de dragons sont installés sur le pourtour. L'exemplaire berlinois reproduit en bas de la planche représente, à l'intérieur d'une rose à six pétales, le dieu de l'Amour ailé et couronné qui, du haut d'une tour, darde de chaque main une flèche vers le bas. L'une est pointée vers une jeune fille devant laquelle est agenouillé un jeune garçon déjà touché par une flèche, l'autre atteint un couple s'adonnant à des cajoleries.

1250 – 1350.

HAND MIRROR AND TWO SPOONS
Nuremberg or Dresden, c. 1600. Glass, silver gilt, serpentine, enamel
DRESDEN, GRÜNES GEWÖLBE
The spoons (C–F), carved from serpentine stone, are set in silver gilt with enamel decoration.

HANDSPIEGEL UND ZWEI LÖFFEL
Nürnberg oder Dresden, um 1600. Glas, Silber, vergoldet, Serpentin, Email
DRESDEN, GRÜNES GEWÖLBE
Die aus Serpentinstein geschnittenen Löffel (C–F) sind in vergoldetem Silber gefasst und
mit emailliertem Zierrat versehen.

MIROIR À MAIN ET DEUX CUILLÈRES
Nuremberg ou Dresde, vers 1600. Verre, argent, doré, pierre de serpentine, émail
DRESDE, GRÜNES GEWÖLBE
Taillées dans de la pierre de serpentine, les cuillères (C–F) sont enchâssées dans de l'argent doré
et pourvues d'ornements émaillés.

C E A F D

G

B

1550 – 1600.

l. v. H.

J. K. sc.

OINTMENT JAR

Limoges (?), last quarter of the 13th century. Copper gilt, sunk enamel, h. 18 cm / 7 in.

STAATLICHE MUSEEN ZU BERLIN, KUNSTGEWERBEMUSEUM

The slender jar, which performed a liturgical function, widens towards the top, where its rounded shoulders end in a narrow neck. It carries a crisscross pattern of concave, gilt bands, with leaf rosettes at their points of intersection. The lozenge-shaped fields within the geometric decoration contain a variety of animals and birds, in representations employing gold interior drawing against a sunk-enamel ground in lapis lazuli blue.

SALBFLASCHE

Limoges (?), letztes Viertel 13. Jahrhundert. Kupfer, vergoldet, Grubenschmelz, 18 cm hoch

STAATLICHE MUSEEN ZU BERLIN, KUNSTGEWERBEMUSEUM

Das kultische Funktionsgerät in schlanker, runder Form mit abgerundeter Schulter und engem Hals verbreitert sich nach oben. Netzförmig umspannt wird es von konkaven vergoldeten Bändern mit Blattrosetten an den Kreuzungspunkten. In den Rautenfeldern des Netzes befinden sich Tierdarstellungen mit goldener Binnenzeichnung vor lapislazuliblauem Emailgrund in Grubenschmelz.

AMPOULE AUX SAINTES HUILES

Limoges (?), dernier quart du XIII^e siècle. Cuivre, doré, émail champlevé, hauteur 18 cm

STAATLICHE MUSEEN ZU BERLIN, KUNSTGEWERBEMUSEUM

Le récipient à fonction cultuelle, de forme ronde et élancée, à l'épaule arrondie et au col étroit, s'évase vers le haut. Des bandeaux concaves dorés, munis à leurs points d'intersection de rosettes de feuilles, l'enveloppent à la manière d'un filet. Dans les losanges de celui-ci figurent, sur un fond bleu lapis-lazuli en émail champlevé, des représentations d'animaux au dessin interne en or.

1120 — — 1220.

(pp. 235–37)

CHESS PIECE

South German, 2nd quarter of the 15th century. Walrus ivory, 13.9 x 3.2 x 6.1 cm / 5 ½ x 1 ¼ x 2 ¼ in.

STAATLICHE MUSEEN ZU BERLIN, BODE-MUSEUM

The figure is one of a group of chess pieces whose design is very similar but whose sizes differ, and which must therefore have belonged to different sets (cf. also ills. pp. 54–55, 207). All the pieces follow the same basic design: the main figure – whether the mounted bishop or knight, or the enthroned king or queen – is accompanied by miniature figures (often fourteen) of members of their retinue, who are clustered around the base. Together they represent a lance, the smallest unit in the feudal army.

The bishop and knight thereby represent the principal imperial estates. Of the pieces that have survived, a knight and a bishop are in Berlin, a knight in the Germanisches Nationalmuseum in Nuremberg, a bishop in the Bayerisches Nationalmuseum in Munich, the king in the Victoria and Albert Museum in London, a knight in the Nationalmuseet in Copenhagen and a bishop in the Grünes Gewölbe in Dresden.

The Berlin knight is accompanied by two crossbowmen. Clues to the piece's dating are provided by the costume (helmet, gorget and long-sleeved tunic worn over the armour) and arms (sword in his left hand, three-corned shield in his right). The horse's head on the original has broken off. During the war, moreover, the material was exposed to great heat, which has consequently transformed it into a glassy substance (calcium phosphate with additives). The figure of the king (E and F) is based on an illustration in another 19th-century publication.

II. 5.

B C D

E A F

I. v. H. del: I. K. fec.

1300 – A – 1350.

(S. 235–237)

SCHACHFIGUR

Süddeutsch, 2. Viertel 15. Jahrhundert. Walrosszahn, 13,9 x 3,2 x 6,1 cm

STAATLICHE MUSEEN ZU BERLIN, BODE-MUSEUM

Die Figur gehört zu einer Gruppe von Schachfiguren, die sich in der Gestaltung gleichen, aber in der Größe unterscheiden und demnach zu verschiedenen Spielen gehörten (siehe auch Abb. S. 54–55, 207). Alle Figuren haben den gleichen Aufbau. Um die Hauptfigur, den reitenden Bischof oder Ritter beziehungsweise den thronenden König oder die thronende Dame, drängen sich dicht die maßstäblich verkleinerten Gefolgsleute (oft 14). Zusammen stellen sie die kleinste Kampfeinheit der Feudalheere dar, die sogenannte Lanze oder Gleve. Bischof und Ritter als Läufer und Springer repräsentieren dabei die tragenden Reichsstände. Von den Figuren haben sich ein Springer und ein Läufer in Berlin, ein Springer im Germanischen Nationalmuseum in Nürnberg, ein Läufer im Bayerischen Nationalmuseum in München, der König im Victoria and Albert Museum in London, ein Springer im Nationalmuseet Kopenhagen und ein Läufer im Grünen Gewölbe in Dresden erhalten. Der Ritter der Berliner Schachfigur wird von zwei Armbrustschützen begleitet. Die Datierung der Figur ergibt sich aus dem Gewand (Helm, Halsberge und Rock mit langen Hängeärmeln über der Rüstung) und der Bewaffnung (Schwert in der Linken, dreieckiger Schild in der Rechten). Am Original ist der Pferdekopf abgebrochen. Im Krieg war das Material zudem großer Hitze ausgesetzt, wodurch es sich in eine glasige Substanz (Kaliumphosphat mit Zusätzen) verwandelt hat. Die Königsfigur (E und F) folgt der Darstellung in einer Publikation des 19. Jahrhunderts.

(pp. 235–237)

PIÈCE D'ÉCHECS

Allemagne du Sud, 2ᵉ quart du XVᵉ siècle. Dent de morse, 13,9 x 3,2 x 6,1 cm

STAATLICHE MUSEEN ZU BERLIN, BODE-MUSEUM

La pièce provient d'un groupe de pièces d'échecs de conceptions semblables mais de tailles diverses et qui, partant, appartenaient à des jeux différents (cf. aussi ill. pp. 54–55, 207). Toutes les pièces présentent la même structure. Autour de la figure principale – soit l'évêque ou le chevalier, chevauchant, soit le roi ou la dame, trônant – les gens de la suite (souvent au nombre de 14), figurés à une échelle plus petite, se tiennent en rang serré. Ensemble, ils représentent la plus petite unité de combat des armées féodales, appelée lance ou glaive. L'évêque et le chevalier, en tant que fou et cavalier, personnifient ici les principaux États impériaux. De ces pièces, un cavalier et un fou sont conservés à Berlin, un cavalier au Germanisches Nationalmuseum de Nuremberg, un fou au Bayerisches Nationalmuseum de Munich, le roi au Victoria and Albert Museum de Londres, un cavalier au Nationalmuseet de Copenhague et un fou au Grünes Gewölbe de Dresde. Le chevalier de la pièce d'échecs berlinoise est accompagné de deux arbalétriers. La pièce peut être datée grâce aux vêtements (casque, bavière, tunique à longues manches suspendues au-dessus de l'armure) et à l'armement (épée dans la main gauche, bouclier triangulaire dans la main droite). Sur l'original, la tête du cheval s'est rompue. Pendant la guerre, de surcroît, le matériau a été exposé à une grande chaleur qui l'a transformé en une substance vitreuse (phosphate de potassium avec additifs). La figure du roi (E et F) reprend la représentation d'une publication du XIXᵉ siècle.

LECTERN
Venice, 14th century. Bronze
VENICE, SS GIOVANNI E PAOLO

The design of the lectern is based on a play of symbolic shapes: from the base via the column to the capital, it rises in a superimposed succession of hexagonal, round and triangular forms, which stand for Creation, Infinity and the Holy Trinity, respectively. The desk itself consists of a doubleheaded eagle, whose heads stand for divine and secular rule. The bird triumphs over a demon, embodying evil, and stands on a hemisphere, the symbol of the world. His outspread wings support the book.

LESEPULT
Venedig, 14. Jahrhundert. Bronze
VENEDIG, SS. GIOVANNI E PAOLO

Der Aufbau des Lesepults spielt mit symbolischen Formen, die sich von der Basis über die Säulchen zum Kapitell in ständigem Wechsel vom Sechseck, dem Symbol der Schöpfung, zum Rund, das für die Ewigkeit steht, bis zur Dreizahl der Dreieinigkeit staffeln. Die eigentliche Pultkonstruktion besteht aus einem doppelköpfigen Adler, dessen Köpfe für die göttliche und die weltliche Herrschaft stehen. Der Vogel triumphiert über einen Dämon, der das Böse verkörpert, und sitzt auf einer Halbkugel, dem Symbol der Welt. Seine ausgebreiteten Schwingen tragen das Buch.

LUTRIN
Venise, XIVᵉ siècle. Bronze
VENISE, BASILIQUE SAINT-JEAN-ET-SAINT-PAUL

La structure du lutrin joue avec les formes symboliques s'échelonnant depuis la base jusqu'au chapiteau, faisant continuellement alterner l'hexagone, symbole de la Création, les formes rondes, représentant l'éternité, et les ensembles ternaires, évoquant la Trinité. La structure du pupitre à proprement parler est constituée d'un aigle à deux têtes, qui renvoient, l'une, à la puissance divine, l'autre, au pouvoir temporel. L'oiseau triomphe d'un démon incarnant le Mal ; il est assis sur un hémisphère, symbole du monde. Ses ailes déployées portent le livre.

DRINKING HORN "GREIFENKLAUE"

Nuremberg, c. 1400; Thuringia, 1618. Horn, silver gilt, h. 22.5 cm / 8 ⅞ in.

DRESDEN, GRÜNES GEWÖLBE

This drinking horn is clasped between the wings of a gryphon with the front legs of an eagle and the hind legs of a beast of prey. The design thereby makes reference to an alternative German name for a drinking horn in the Middle Ages, *Greifenklaue* (gryphon's claws). The tip of the horn is crowned by a miniature fortress with windows and doors, and with three helmeted heads (A–C) rising from its battlements. Around the mouth of the horn, a quatrefoil containing the engraved and ligated letters "a" and "e" is repeated four times. The cover is a later addition and was made in Thuringia in 1618.

TRINKHORN „GREIFENKLAUE"

Nürnberg, um 1400; Thüringen, 1618. Horn, Silber, vergoldet, 22,5 cm hoch

DRESDEN, GRÜNES GEWÖLBE

Das Trinkhorn ruht auf den gravierten, hoch gestellten Flügeln eines Greifen mit Adlerständer und raubtierartigen Hinterpranken. Die Hornspitze bekrönt eine hoch aufgetürmte Burganlage mit Fenstern und Türen, auf deren Zinnen sich drei behelmte Köpfe (A–C) erheben. Am Lippenrand der Gefäßöffnung wird viermal ein Vierpass wiederholt, der die gravierten und ligierten Buchstaben „a" und „e" umfasst. Bei dem Deckel handelt es sich um eine ursprünglich nicht zugehörige thüringische Arbeit von 1618.

CORNE À BOIRE « SERRES DE GRIFFON »

Nuremberg, vers 1400 ; Thuringe, 1618. Corne, argent doré, hauteur 22,5 cm

DRESDE, GRÜNES GEWÖLBE

La corne à boire repose sur les ailes gravées et relevées d'un griffon aux pattes d'aigles et aux membres postérieurs ressemblant à ceux d'un carnassier. La pointe de la corne est couronnée d'un ensemble castral hautement érigé et percé de fenêtres et de portes ; sur les créneaux des tours s'élèvent trois têtes casquées (A–C). Sur le rebord du récipient, un quadrilobe dans lequel s'inscrivent les lettres gravées et ligaturées « a » et « e » se répète quatre fois. Le couvercle est un travail thuringien de 1618 qui, à l'origine, ne faisait pas partie de l'ensemble.

A B C

2 Par. Zoll.

1450 — 1500.

Left and right / Links und rechts / À gauche et à droite
CROOK OF A CROSIER, "CURVA"
French, end of the 1st third of the 14th century. Ivory, h. 21 cm / 8 ¼ in.
METZ, ST STEPHAN'S CATHEDRAL, TREASURY
Supported by a kneeling angel and decorated with leafy ornament, the crook of the crosier, or *curva*, is carved in the round on both sides with figural scenes: on one side, the Crucifixion with the Virgin and St John, and on the other, the Virgin and Child accompanied by two angels.

KRÜMME EINES BISCHOFSSTABES, „CURVA"
Französisch, Ende 1. Drittel 14. Jahrhundert. Elfenbein, 21 cm hoch
METZ, KATHEDRALE SAINT-ETIENNE, SCHATZKAMMER
Die von einem knienden Engel getragene und mit Blattwerk verzierte, geschnitzte Krümme zeigt im Rund auf der einen Seite den Gekreuzigten mit Maria und Johannes und auf der anderen Seite Maria mit dem Kind, begleitet von zwei Engeln.

CROSSERON D'ÉVÊQUE « CURVA »
France, fin du 1er tiers du XIVe siècle. Ivoire, hauteur 21 cm
METZ, CATHÉDRALE SAINT-ÉTIENNE, TRÉSOR ÉPISCOPAL
Le crosseron sculpté, porté par un ange à genoux et orné de feuilles, présente à l'intérieur du cercle, sur une face, le Christ crucifié accompagné de Marie et de saint Jean. La Vierge à l'Enfant, flanquée de deux anges, figure sur l'autre face.

Centre / Mitte / Au centre
RELIEF
French, 14th century. Ivory, 12.6 x 6.2 x 1.7 cm / 5 x 2 ½ x ⅝ in.
KLASSIK STIFTUNG WEIMAR, SCHLOSSMUSEUM
The ivory relief shows the Virgin and Child in a niche. The Virgin is wearing a crown and is thus identified as the Queen of Heaven. She carries the Infant on her left arm and holds a flower in her right hand. Angels with the crown insignia of the Queen of Heaven are depicted in the spandrels.

RELIEF
Französisch, 14. Jahrhundert. Elfenbein, 12,6 x 6,2 x 1,7 cm
KLASSIK STIFTUNG WEIMAR, SCHLOSSMUSEUM
Das Elfenbeinrelief zeigt die gekrönte und so als Himmelskönigin gekennzeichnete Madonna mit dem Kind in einer Nische. Sie hält den Jesusknaben auf dem linken Arm und in der Rechten eine Blume. In den Zwickeln sind Engel mit den Kroninsignien der Himmelskönigin dargestellt.

RELIEF
France, XIVe siècle. Ivoire, 12,6 x 6,2 x 1,7 cm
KLASSIK STIFTUNG WEIMAR, SCHLOSSMUSEUM
Le relief en ivoire montre, dans une niche, la Vierge à l'Enfant, le front ceint d'une couronne l'érigeant en reine du ciel. Sur son bras gauche elle tient l'Enfant Jésus, dans sa main droite une fleur. Des anges portant les insignes royaux de la reine du ciel apparaissent dans les angles.

II.

8.

L.V.H. del.

1220 — 1320.

C. BECKER del.

CASKET

German, c. 1500. Iron, 10 x 19 x 12 cm / 4 x 7 ½ x 4 ¾ in.

FORMERLY BERLIN, KUNSTGEWERBEMUSEUM – UNTRACED

The rectangular, wrought-iron box with its arched lid is decorated on its sides and lid with an openwork pattern of Gothic tracery backed with red leather. Two rings are mounted on each of the narrower sides. The object has been untraced since 1945, but the museum owns another, very similar casket fitted with the same type of lock (ill. p. 463).

KÄSTCHEN

Deutsch, um 1500. Eisen, 10 x 19 x 12 cm

EHEMALS KUNSTGEWERBEMUSEUM, BERLIN – VERSCHOLLEN

Das viereckige, längliche schmiedeeiserne Kästchen mit gewölbtem Deckel trug an den Seiten und auf dem Deckel in durchbrochener Arbeit gotische Maßwerkmuster, die mit rotem Leder unterlegt waren. An den beiden Schmalseiten befinden sich je zwei Ringe. Seit 1945 ist das Objekt verschollen, das Museum besitzt aber noch ein ganz ähnliches, mit gleichartigem Schloss ausgestattetes Kästchen (Abb. S. 463).

COFFRET

Allemagne, vers 1500. Fer, 10 x 19 x 12 cm

AUTREFOIS CONSERVÉ AU KUNSTGEWERBEMUSEUM BERLIN – DISPARU

Le coffret rectangulaire en fer forgé et au couvercle bombé était pourvu, sur les côtés et sur le couvercle, de motifs en forme de remplages gothiques ajourés, placés sur un fond de cuir rouge. Sur chacun des deux côtés étroits sont installés deux anneaux. L'objet a disparu en 1945, mais le musée possède un coffret très ressemblant, pourvu d'une serrure similaire (ill. p. 463).

B

A

C

A. ORIGINALGRÖSSE. B. UND C. ½ ORIGINALGRÖSSE.

FRAGMENT OF A RELIEF

German, 19th century. Ivory, 16.5 x 10.5 cm / 6 ½ x 4 ⅛ in.

NUREMBERG, GERMANISCHES NATIONALMUSEUM

This relief, which presents itself as a fragment, was long believed to be a genuine antique but is in fact a 19th-century fake. It shows the Battle of Göllheim, which took place on 2 July 1298, in which the armies of Adolf of Nassau – the former elected King of Germany who had been recently deposed by the Electors – met those of his Habsburg successor, Albrecht of Austria. Adolf was killed in the fighting and in a second, proper election after his victory, Albrecht had himself confirmed as king.

BRUCHSTÜCK EINES RELIEFS

Deutsch, 19. Jahrhundert. Elfenbein, 16,5 x 10,5 cm

NÜRNBERG, GERMANISCHES NATIONALMUSEUM

Das als Bruchstück angelegte Relief galt lange als authentisch, ist aber eine Fälschung des 19. Jahrhunderts. Dargestellt ist die Schlacht bei Göllheim am 2. Juli 1298, in der die Heere des gewählten, aber dann von den Kurfürsten für abgesetzt erklärten deutschen Königs Adolf von Nassau und des habsburgischen Gegenkönigs Albrecht von Österreich gegeneinander kämpften. Adolf wurde in der Schlacht getötet, und Albrecht ließ sich nach seinem Sieg in zweiter und regulärer Wahl als König bestätigen.

FRAGMENT D'UN RELIEF

Allemagne, XIXᵉ siècle. Ivoire, 16,5 x 10,5 cm

NUREMBERG, GERMANISCHES NATIONALMUSEUM

Conçu comme un fragment, le relief a longtemps été considéré comme authentique, mais il s'agit en réalité d'un faux datant du XIXᵉ siècle. Il représente la bataille de Göllheim du 2 juillet 1298, opposant les armées du roi allemand Adolphe de Nassau – élu puis destitué par les princes électeurs – et celles de l'antiroi habsbourgeois Albrecht d'Autriche. Adolphe fut tué pendant la bataille et Albrecht, à l'issue de sa victoire, fit confirmer son titre de roi par une deuxième élection, organisée en bonne et due forme.

1280 — 1320.

BOTTLE COVER
South German, 1518. Leather, h. 17.8 cm / 7 in., ø 11.4 cm / 4 ½ in.
NUREMBERG, GERMANISCHES NATIONALMUSEUM
The bottle cover of embossed brown leather decorated with leafy ornament was designed to hold a bottle or flask. It could be carried on a strap threaded though the eyelets on the sides.

FLASCHENFUTTERAL
Süddeutsch, 1518. Leder, 17,8 cm hoch, ø 11,4 cm
NÜRNBERG, GERMANISCHES NATIONALMUSEUM
Das Futteral aus gepresstem braunem Leder mit Rankenverzierungen diente als Hülle für eine Flasche oder einen Flakon. An den Seiten befinden sich Ösen zum Durchziehen eines Bandes für eine Aufhängung.

ÉTUI À BOUTEILLE
Allemagne du Sud, 1518. Cuir, hauteur 17,8 cm, ø 11,4 cm
NUREMBERG, GERMANISCHES NATIONALMUSEUM
L'étui en cuir pressé marron, orné de rinceaux, servait à envelopper une bouteille ou un flacon. Sur les côtés se trouvent des œillets permettant de passer un ruban de suspension.

1518.

CRUCIFIX

Limoges, 13th century. Copper gilt, sunk enamel, glass paste, 50.6 x 27.5 cm / 20 x 10 ¾ in.

NUREMBERG, GERMANISCHES NATIONALMUSEUM

The crucifix shows Christ crucified with three nails rather than four, in line with the historically still burgeoning artistic tradition of portraying one foot crossed over the other and fastened to the *suppedaneum* – the foot support – with a single nail. The object has come down to us in a fragmentary state: the figures and enamel plaques originally mounted on the front and back, where the drill holes are visible, are lost. Only the enamelled representation of Christ Teaching on the back has survived. The drill holes at the bottom of the crucifix indicate that it served as a processional cross. The parts surrounding the original crucifix fragment are later additions.

KRUZIFIX

Limoges, 13. Jahrhundert
Kupfer, vergoldet; Grubenschmelz, Glasflüsse, 50,6 x 27,5 cm
NÜRNBERG, GERMANISCHES NATIONALMUSEUM

Das Kruzifix zeigt Christus bereits im historisch jüngeren „Dreinageltypus", bei dem die Füße übereinandergelegt und mit einem einzigen Nagel an der Fußkonsole, dem Suppedaneum, befestigt sind. Das Stück ist nur fragmentarisch erhalten. Die an Vorder- und Rückseite ursprünglich an den Bohrlöchern befestigten Figuren und Emailplatten sind verloren. Nur die emaillierte Darstellung des lehrenden Christus an der Rückseite hat sich erhalten. Die Bohrlöcher am unteren Ende des Kreuzes verweisen darauf, dass es sich um ein Vortragekreuz handelt. Die an das Kruzifixfragment angefügten Teile sind spätere Hinzufügungen.

CRUCIFIX

Limoges, XIIIᵉ siècle
Cuivre, doré, émail champlevé, pâtes de verre, 50,6 x 27,5 cm
NUREMBERG, GERMANISCHES NATIONALMUSEUM

Ce crucifix présente le Christ sur une croix à trois clous, caractéristique d'une période plus récente de l'Histoire. Posés l'un sur l'autre, les pieds sont fixés par un seul clou sur la tablette, le *suppedaneum*. La pièce n'est conservée qu'en état fragmentaire. Sur les faces antérieure et postérieure, les figures et les plaques d'émail, fixées à l'origine sur les trous de perçage, sont perdues. Seule la figure émaillée du Christ enseignant, au dos de la croix, est préservée. Les trous percés à l'extrémité inférieure du crucifix indiquent qu'il s'agit d'une croix de procession. Les parties ajoutées au fragment du crucifix sont des adjonctions ultérieures.

A–C. CLASP
North German, 15th century. Silver, 9 x 8 x 2 cm / 3 ½ x 3 ⅛ x ¾ in.
FORMERLY BERLIN, KUNSTGEWERBEMUSEUM – UNTRACED
The clasp, which has been untraced since 1945, shows the Brandenburg coat of arms worked in high relief within a quatrefoil surround. The eagle on the shield was enamelled in red. In view of the stylistic vocabulary employed, it is unlikely that the clasp dates from the same period as the censer also illustrated on the plate. Clasps were used to fasten robes of all kinds. A brooch designed specifically for priestly vestments was called a *monile* (cf. ill. p. 95).

D & E. CENSER
German, 14th century. Bronze, h. 25.2 cm / 9 ⅞ in.
FORMERLY WEIMAR, STADTKIRCHE ST. PETER UND PAUL
KLASSIK STIFTUNG WEIMAR, KUNSTSAMMLUNGEN
The censer with its plain Gothic forms is decorated in a purely ornamental style. It thereby differs markedly from Romanesque censers, which were characterized as a rule by figural decoration (cf. ill. p. 467).

A–C. AGRAFFE
Norddeutsch, 15. Jahrhundert. Silber, 9 x 8 x 2 cm
EHEMALS KUNSTGEWERBEMUSEUM, BERLIN – VERSCHOLLEN
Die seit 1945 verschollene Agraffe zeigte in vierpassförmigem Rahmen eine in Hochrelief gearbeitete Darstellung des Wappens von Brandenburg. Der Adler auf dem Schild war rot emailliert. Angesichts der Stilformen ist eine Datierung in die Zeit des ebenfalls auf der Tafel abgebildeten Rauchfasses unwahrscheinlich. Die Gewandnadel ist eine für profane wie sakrale Zwecke verwendbare Agraffe. Als Schließe eines Messgewandes trägt sie die Bezeichnung Monile (siehe Abb. S. 95).

D & E. RAUCHFASS
Deutsch, 14. Jahrhundert. Bronze, 25,2 cm hoch
EHEMALS WEIMARER STADTKIRCHE ST. PETER UND PAUL
KLASSIK STIFTUNG WEIMAR, KUNSTSAMMLUNGEN
Das Rauchfass ist in schlichten gotischen Formen rein ornamental gestaltet und unterscheidet sich dadurch deutlich von den in der Regel figürlich geschmückten romanischen Exemplaren (siehe Abb. S. 467).

A–C. AGRAFE
Allemagne du Nord, XVᵉ siècle. Argent, 9 x 8 x 2 cm
AUTREFOIS CONSERVÉE AU KUNSTGEWERBEMUSEUM BERLIN – DISPARUE
L'agrafe, disparue depuis 1945, représentait, en haut-relief et à l'intérieur d'un cadre quadrilobé, le blason du Brandebourg. L'aigle apparaissant sur l'écu était émaillé de rouge. Compte tenu des éléments stylistiques, il n'est guère possible de situer l'agrafe et l'encensoir, qui figure également sur la planche, à la même époque. Cette épingle à vêtements était destinée à un usage profane aussi bien que sacré. Lorsqu'elle servait d'épingle à chasuble, elle était désignée par le terme « monile » (cf. ill. p. 95).

D & E. ENCENSOIR
Allemagne, XIVᵉ siècle, Bronze, hauteur 25,2 cm
AUTREFOIS CONSERVÉ DANS L'ÉGLISE, SAINT-PIERRE-ET-SAINT-PAUL DE WEIMAR
KLASSIK STIFTUNG WEIMAR, KUNSTSAMMLUNGEN
Présentant des formes gothiques simples, l'encensoir est conçu de manière purement ornementale, ce qui le distingue nettement des exemplaires romans, qui possèdent, en règle générale, un décor figuratif (cf. ill. p. 467).

II.

A

B

C

13.

ORIGINAL.

E.
GRÖSSE.

D

E

2 Pariser Zoll

1300 — 1350.

TORCH HOLDER, BANNER HOLDER
Niccolò Grosso, known as Il Caparra, Florence, c. 1500. Wrought iron
FLORENCE, PALAZZO STROZZI

The two models seen here belong to a whole series of similar wrought-iron torch and banner holders that are mounted on the front façade of the Palazzo Strozzi in Florence, some of them furnished – as in the case of the left-hand holder on the plate – with the Strozzi coat of arms. They number amongst the only documented works by the ironsmith Niccolò Grosso, known as Il Caparra ("down payment"). Grosso was given his nickname by Lorenzo de' Medici, because he would accept no commissions without first being paid a deposit (cf. also ill. p. 297).

FACKELHALTER, BANNERTRÄGER
Niccolò Grosso, genannt Caparra, Florenz, um 1500. Schmiedeeisen
FLORENZ, PALAZZO STROZZI

Die schmiedeeisernen Stücke gehören zu einer ganzen Reihe gleichartiger Konstruktionen für Fackeln und Banner, die an der Außenfront des Palazzo Strozzi in Florenz angebracht sind und teilweise, wie der linke Träger auf der Tafel, mit dem Wappen der Strozzi verziert sind. Sie gehören zu den einzigen beglaubigten Arbeiten des Kunstschmiedes Niccolò Grosso, genannt Caparra (= Vorschuss). Der Schmied erhielt diesen Namen von Lorenzo de' Medici, weil er keine Aufträge ohne vorherige Zahlung eines Handgeldes annahm (siehe auch Abb. S. 297).

SUPPORT POUR FLAMBEAU, SUPPORT POUR ÉTENDARD
Niccolò Grosso, dit Caparra, Florence, vers 1500. Fer forgé
FLORENCE, PALAZZO STROZZI

Les pièces en fer forgé appartenaient à toute une série de constructions similaires pour flambeaux et étendards, fixées sur la façade extérieure du Palais Strozzi à Florence et ornées, en partie, comme le support figurant à gauche sur la planche, du blason des Strozzi. Elles font partie des seuls travaux attestés de Niccolò Grosso, dit Caparra (= acompte). Le forgeron reçut ce nom de Laurent de Médicis, car il n'acceptait aucune commande sans versement préalable d'arrhes (cf. aussi ill. p. 297).

1489 — 1500.

(pp. 257–59)

A. BRIDAL CROWN
German, 17th–19th century. Silver, partly gilded, h. 7 cm / 2 ¾ in. , w. 15 cm / 6 in.
FORMERLY BERLIN, KUNSTGEWERBEMUSEUM – UNTRACED
The crown, whose decorative wreath of leaves and flowers was studded with fresh-water pearls and imitation gems, was worn by the bride during the wedding service. Allegedly housed in earlier times in a church in Jutland, it was acquired by the museum from the Munich art trade in 1858. It has been untraced since 1945.

B. PENDANT
German, late 16th/early 17th century. Silver, partly gilded, 8 x 5 cm / 3 ⅛ x 2 in.
FORMERLY WÜRZBURG, COLLECTION OF THE EDITOR HEFNER-ALTENECK
The figure of Charity with two children is seen standing against a gilt openwork background of scrolling forms, from which hang three pear-shaped appendants in imitation of pearls.

C & D. PENDANT
German, c. 1600. Silver gilt, painted enamel, pearl, c. 3 x 2.5 cm / 1 ⅛ x 1 in.
FORMERLY WITHIN THE ART TRADE – WHEREABOUTS UNKNOWN
Made as a bridal gift, the pendant shows a pair of lovers on the front (C) and a heart held by two hands as a symbol of love on the back (D).

B

C

D

1550 — 1600.

I. v. H.

I. K.

(S. 257–259)
A. BRAUTKRONE
Deutsch, 17.–19. Jahrhundert. Silber, teilvergoldet, 7 cm hoch, 15 cm breit
EHEMALS KUNSTGEWERBEMUSEUM, BERLIN – VERSCHOLLEN

Die Krone diente bei der Hochzeit als Schmuck der Braut. Der wulstartige Kranz war mit Blättern und Blüten aus Flussperlen und falschen Steinen besetzt. Das Stück soll sich früher in einer Kirche in Jütland befunden haben, es gelangte dann 1858 aus dem Münchner Kunsthandel in Berliner Museumsbesitz. Seit 1945 ist die Krone verschollen.

B. ANHÄNGER
Deutsch, Ende 16./Anfang 17. Jahrhundert. Silber, teilvergoldet, 8 x 5 cm
EHEMALS IN DER SAMMLUNG DES HERAUSGEBERS HEFNER-ALTENECK

Vor dem durchbrochen gearbeiteten und vergoldeten Fond in Schweifwerk mit den drei birnenförmigen, Perlen imitierenden Anhängseln steht die Figur der Caritas mit zwei Kindern.

C & D. ANHÄNGER
Deutsch, um 1600, Silber, vergoldet, mit Maleremail, Perle, ca. 3 x 2,5 cm
EHEMALS IM KUNSTHANDEL – AUFBEWAHRUNGSORT UNBEKANNT

Der als Brautgeschenk gearbeitete Anhänger zeigt auf der Vorderseite (C) ein Liebespaar und auf der Rückseite (D) ein von zwei Händen gehaltenes Herz als Liebessymbol.

(pp. 257–259)
A. COURONNE DE MARIÉE
Allemagne, XVIIᵉ–XIXᵉ siècle. Argent, partiellement doré, hauteur 7 cm, largeur 15 cm
AUTREFOIS CONSERVÉE AU KUNSTGEWERBEMUSEUM BERLIN – DISPARUE

Le jour du mariage, la couronne servait de parure à la mariée. Pareille à un bourrelet, elle était garnie de feuilles et de fleurs en perles d'eau douce et en fausses pierres. La pièce aurait jadis été conservée dans une église du Jutland, avant de devenir, en passant par le commerce munichois d'objets d'art, la propriété du musée de Berlin. Elle a disparu en 1945.

B. PENDENTIFS
Allemagne, fin du XVIᵉ/début du XVIIᵉ siècle. Argent, partiellement doré, 8 x 5 cm
AUTREFOIS CONSERVÉS DANS LA COLLECTION DE HEFNER-ALTENECK

Devant un fond ajouré et doré, aux motifs chantournés auxquels sont accrochées trois pendeloques piriformes imitant des perles, se tient la figure de la Charité accompagnée de deux enfants.

C & D. PENDENTIF
Allemagne, vers 1600. Argent, doré, émail peint, perle, env. 3 x 2,5 cm
AUTREFOIS DANS LE COMMERCE D'OBJETS D'ART – Localisation inconnue

Conçu comme cadeau de mariage, le pendentif représente, sur la face antérieure (C), un couple d'amoureux et, sur la face postérieure (D), un cœur tenu par deux mains, symbole de l'amour.

GLASS PAINTING
Saxon, 13th century. H. 23.5 cm / 9 ¼ in.
FORMERLY LEIPZIG, COLLECTION OF THE HISTORISCHER VEREIN
WHEREABOUTS UNKNOWN
The upper part of a trefoil window, showing a dragon.

GLASGEMÄLDE
Sächsisch, 13. Jahrhundert. 23.5 cm hoch
EHEMALS IM BESITZ DES LEIPZIGER HISTORISCHEN VEREINS
AUFBEWAHRUNGSORT UNBEKANNT
Der obere Teil eines dreipassig gewölbten Fensters zeigt einen Drachen.

VITRAIL
Saxe, XIIIᵉ siècle. Hauteur 23.5 cm
AUTREFOIS EN LA POSSESSION DE LA SOCIÉTÉ D'HISTOIRE DE LEIPZIG
LOCALISATION INCONNUE
La partie supérieure de la baie trilobée représente un dragon.

1200 — 1300.

CHURCH SEAT

Norwegian, late 15th/early 16th century. Coniferous wood, 94 x 93 cm / 37 x 36 ⅝ in.
Surface of seat 58 x 46.5 cm / 22 ⅞ x 18 ¼ in.

FROM THE CHURCH IN GÅRÅ IN THE NORWEGIAN PROVINCE OF TELEMARK

OSLO, KUNSTINDUSTRIMUSEET, NASJONALMUSEET

The Romanesque chair, with its wooden seat supported on four square legs, originates from the church in Gårå in the Norwegian province of Telemark. The front uprights end in carved animal heads with tendrils scrolling out of their jaws. The rear uprights carry the backrest, which consists of a solid piece of wood terminating at each end in a lion's head and resting on six richly carved pillars. On the lower front panel, an openwork arcade runs between the two front uprights and a border of leafy ornament descends from the front edge of the seat. The sides of the chair are characterized by two rounded arches and carved ornament, which on the side illustrated in the plate (A) includes a representation of Samson riding on a lion. The curving armrests are decorated with scrolling motifs.

KIRCHENSTUHL

Norwegisch, Ende 15./Anfang 16. Jahrhundert. Nadelholz, 94 x 93 cm, Sitzfläche 58 x 46,5 cm
AUS DER KIRCHE IN GÅRÅ IN DER NORWEGISCHEN PROVINZ TELEMARKEN
OSLO, KUNSTINDUSTRIMUSEET, NASJONALMUSEET

Der romanische Stuhl mit Brettsitz auf vier vierkantigen Füßen stammt aus der Kirche in Gårå in der norwegischen Provinz Telemarken. Auf den vorderen Pfosten des Stuhls erheben sich geschnitzte Tierköpfe mit Ranken im Rachen. Die rückwärtigen Pfosten tragen die Lehne, die aus einem Brett besteht, das auf sechs reich geschnitzten Stützen ruht. Zwischen den Vorderpfosten schmücken den Stuhl eine Bogenstellung und Rankenornamente. Die Seitenansichten des Stuhls zieren je zwei Rundbogen und darüber Rankenwerk. Die Seitenansicht zeigt Simson, der auf einem Löwen reitet. Die Armlehnen bestehen aus ausgerundeten Brettern mit Rankenornament.

CHAISE D'ÉGLISE

Norvège, fin du XV^e/début du XVI^e siècle. Sapin, 94 x 93 cm, surface de l'assise 58 x 46,5 cm
PROVENANT DE L'ÉGLISE DE GÅRÅ DANS LA PROVINCE NORVÉGIENNE DE TELEMARK
OSLO, KUNSTINDUSTRIMUSEET, NASJONALMUSEET

La chaise romane, à l'assise en forme de planche reposant sur quatre pieds carrés, provient de l'église de Gårå, dans la province norvégienne de Telemark. Sur ses poteaux antérieurs s'élèvent des têtes d'animaux sculptées portant dans leur gueule des rinceaux. Les poteaux postérieurs soutiennent le dossier, constitué d'une planche reposant sur six petits piliers richement sculptés. Entre les poteaux antérieurs, la chaise est décorée d'une arcade et d'ornements en rinceaux. Les faces latérales sont chacune ornées de deux arcs en plein-cintre surmontés d'entrelacs. La vue latérale figurant sur la planche montre Samson chevauchant un lion. Les accoudoirs, enfin, sont constitués de planches incurvées, ornées de rinceaux.

1 Bar. Fuss

A

B

1150 — 12 50.

CHURCH CHAIR

Norwegian, late 15th/early 16th century. Coniferous wood, 94 x 93 cm / 37 x 36 ⅝ in.
Surface of seat 58 x 46.5 cm / 22 ⅞ x 18 ¼ in.
FROM THE CHURCH IN GÅRÅ IN THE NORWEGIAN PROVINCE OF TELEMARK
OSLO, KUNSTINDUSTRIMUSEET, NASJONALMUSEET

Plate 18 shows the back of the chair from Gårå church (ill. p. 263). Between the two lions' heads on either side, the figures of three men and three women are carved in low relief on the backrest. They are wearing long robes and stand hand in hand. Beneath the seat, a relief showing two knights on horseback, one of them sounding a horn, rests on an arcade of five carved columns.

KIRCHENSTUHL

Norwegisch, Ende 15./Anfang 16. Jahrhundert. Nadelholz, 94 x 93 cm, Sitzfläche 58 x 46,5 cm
AUS DER KIRCHE IN GÅRÅ IN DER NORWEGISCHEN PROVINZ TELEMARKEN
OSLO, KUNSTINDUSTRIMUSEET, NASJONALMUSEET

Tafel 18 zeigt die Rückseite des Kirchenstuhls aus Gårå (Abb. S. 263). Die Rückseite der Lehne zieren seitlich Löwenköpfe und dazwischen in Flachrelief drei Männer und drei Frauen in langen Gewändern, die sich die Hände reichen. Unterhalb der Sitzfläche ruht auf einer Arkatur von fünf geschnitzten Stützen ein Relief mit zwei Rittern zu Pferde, von denen einer in ein Horn bläst.

CHAISE D'ÉGLISE

Norvège, fin du XVᵉ/début du XVIᵉ siècle. Sapin, 94 x 93 cm, surface de l'assise 58 x 46,5 cm
PROVENANT DE L'ÉGLISE DE GÅRÅ DANS LA PROVINCE NORVÉGIENNE DE TELEMARK
OSLO, KUNSTINDUSTRIMUSEET, NASJONALMUSEET

La planche 18 montre la chaise d'église de Gårå vue de dos (ill. p. 263). La face arrière du dossier est ornée sur les côtés de têtes de lion ; celles-ci encadrent un bas-relief figurant trois hommes et trois femmes vêtus de longs vêtements et se tenant par la main. Au-dessous de l'assise, un relief représentant deux chevaliers chevauchant, dont l'un sonne du cor, repose sur une arcade soutenue par cinq petits piliers sculptés.

1150 — 1250.

CUPBOARD

South German, c. 1450. Spruce with maple veneer, 233 x 180 x 59 cm / 91 ¾ x 70 ⅞ x 23 ¼ in.
MUNICH, BAYERISCHES NATIONALMUSEUM
This magnificent cupboard is decorated with fantastical Gothic ornament in low relief. The tracery
rosettes appear against a blue ground. Traces of earlier painting can be seen on the carvings.

SCHRANK

Süddeutsch, um 1450. Fichtenholz mit Ahornfurnier, 233 x 180 x 59 cm
MÜNCHEN, BAYERISCHES NATIONALMUSEUM
Der prächtige Schrank ist mit flach geschnitztem fantastischem gotischem Ornament geschmückt.
Die Maßwerkrosetten sind blau unterlegt, an den Schnitzereien finden sich Spuren alter Bemalung.

ARMOIRE

Allemagne du Sud, vers 1450. Sapin et placage en érable, 233 x 180 x 59 cm
MUNICH, BAYERISCHES NATIONALMUSEUM
Cette somptueuse armoire est décorée d'ornements gothiques merveilleux sculptés
en bas-relief. Les rosaces en remplage sont logées sur un fond bleu ; les sculptures présentent
des traces de peinture ancienne.

4 PARISER FUSS

1400—1450.

(pp. 269–71)

COLUMBINE CUP

Unknown master, Nuremberg, 1573–1580. Silver, h. 21 cm / 8 ¼ in.

LONDON, VICTORIA AND ALBERT MUSEUM

The cup, acquired by the museum from the art trade (cf. ill. p. 38), is sometimes attributed to Wenzel Jamnitzer and until 1868 belonged to the Nuremberg Goldsmiths' Guild. It was used as the model for one of the three "masterpieces" that apprentices were required to submit in order to qualify as master goldsmiths. The design of the cup is based on the shape of the columbine flower and is typical of Nuremberg production. Six gadrooned lobes tapering downwards interlock with six others tapering upwards. The trefoil foot consists of two smooth mouldings, the first convex and the second concave, ringed at the top by an engraved band of egg and dart. From here the stem commences as a nodus decorated with cast rams' heads and bunches of fruit, and continues as a hexagonal baluster. The succession of different types of decoration, of smooth surfaces followed by repoussé relief, in combination with solidly cast elements, demands supreme technical virtuosity. The cup itself is ornamented with strapwork, flora and decorative masks that provide the setting for representations of Honour and Virtue in the shape of Lucretia, Diana and Judith with the head of Holofernes.

1550 — 1600.

(S. 269–271)

AKELEIPOKAL

Unbekannter Meister, Nürnberg, 1573–1580. Silber, 21 cm hoch
LONDON, VICTORIA AND ALBERT MUSEUM

Der aus dem Kunsthandel ins Museum gelangte Pokal (siehe Abb. S. 38), der gelegentlich Wenzel Jamnitzer zugeschrieben wird, befand sich bis 1868 im Besitz der Innung der Nürnberger Goldschmiede und diente dort als Muster für eines der drei Meisterstücke, die ein angehender Nürnberger Goldschmiedemeister anzufertigen hatte. Der Pokal variiert die Form einer Akelei in der für Nürnberg klassischen Gestalt, bei der die Kuppa dieser Glockenblume ähnelt. Eine Reihe von sechs langgezogenen Buckelsegmenten verzahnt sich mit sechs weiteren in Gegenrichtung. Auf einem dreipassigen Fuß mit glattem Wulst, glatter Hohlkehle und gravierter Eierstableiste erhebt sich der Schaft des Pokals, der aus einem Nodus mit gegossenen Widderköpfen und Fruchtgehängen und einem sechseckigen Balusterstück gebildet wird. Die Abfolge unterschiedlichen Dekors, glatter und reliefierter Teile in Treibarbeit in Kombination mit massiv gegossenen Elementen, erfordert höchste handwerkliche Virtuosität.

Die Kuppa zieren Schweif- und Rollwerkornamente, florale Formen und Ziermasken, die als Rahmenelemente für die Darstellungen von Ehre und Tugend in Gestalt der Lukrezia, Diana und Judith mit dem Haupt des Holofernes dienen.

(pp. 269–271)

COUPE « ANCOLIE »

Maître inconnu, Nuremberg, 1573–1580. Argent, hauteur 21 cm
LONDRES, VICTORIA AND ALBERT MUSEUM

Parfois attribué à Wenzel Jamnitzer, le récipient entra en la possession du musée par l'intermédiaire du commerce d'objets d'art (cf. ill. p. 38). En 1868, il était la propriété de la corporation des orfèvres nurembergeois, où il servit de modèle à l'une des trois pièces de maître qu'un futur maître orfèvre de Nuremberg devait exécuter. Par sa forme, il constitue une variante de l'ancolie et revêt un aspect typiquement nurembergeois, la ressemblance avec la campanule se situant au niveau de la coupe. Six bosses allongées et tronquées formant un rang s'encastrent dans six autres, placées en sens inverse. Au-dessus de la base trilobée à bourrelet lisse, à moulure concave lisse et à rang d'oves gravé, s'élève le pied de la coupe, constitué d'un nœud pourvu de têtes de bélier et de festons fondus, ainsi que d'un balustre hexagonal. La succession de décors variés, de parties lisses et de parties en relief exécutées au repoussé, associées à des éléments en fondu massif, témoigne de la plus grande virtuosité artisanale.

La coupe est décorée de motifs chantournés et de volutes, de formes florales et de masques ornementaux servant de cadre aux figures de l'Honneur et de la Vertu incarnées par Lucrèce, Diane, et Judith tenant la tête d'Holopherne.

FOLDING CHAIR
Venice, 2nd half of the 14th century. Wood, leather, ivory, 124 x 70 cm / 48 ¾ x 27 ½ in.
MUNICH, BAYERISCHES NATIONALMUSEUM
The folding chair may represent a *faldistorium*, the ceremonial seat of a bishop. The brown wood
is inlaid with decorative patterns of ivory dyed yellow and green, combined with black and brown wood.
The embossed decoration on the leather seat and backrest is partly coloured in black.

KLAPPSTUHL
Venedig, 2. Hälfte 14. Jahrhundert. Holz, Leder, Elfenbein, 124 x 70 cm
MÜNCHEN, BAYERISCHES NATIONALMUSEUM
Bei dem Klappstuhl handelt es sich möglicherweise um ein „Faldistorium", den als Würdezeichen
anzusehenden Sitz eines Bischofs. Eingelegt in das braune Holz des Stuhls sind Muster aus gelb und grün
getöntem Elfenbein sowie schwarzem und braunem Holz. Die in das Leder der Sitzfläche und der
Rückenlehne eingepressten Verzierungen sind teils schwarz ausgemalt.

CHAISE PLIANTE
Venise, 2ᵉ moitié du XIVᵉ siècle. Bois, cuir, ivoire, 124 x 70 cm
MUNICH, BAYERISCHES NATIONALMUSEUM
Cette chaise pliante est peut-être un « faldistoire », siège d'évêque marquant la dignité de ce dernier.
Dans le bois marron de la chaise sont incrustés des motifs en ivoire teinté de jaune et de vert,
d'autres en bois noir ou marron. Les ornements pressés dans le cuir de l'assise et du dossier sont,
en partie, peints en noir.

II. A

E

B 21.

C

D

0 1 2 PARISER FUSS

1350 - 1400.

JEWEL BOX

North Italian (?), 1st third of the 15th century. Wood, ivory, 6.8 x 16.3 x 18 cm / 2 ⅝ x 6 ⅜ x 7 in.

NUREMBERG, GERMANISCHES NATIONALMUSEUM

The ivory reliefs illustrated on the plate are made up of multiple plaques that are individually affixed to the wooden core. On the lid, a wide border of leafy ornament, made up of eight small plaques, surrounds eight larger plaques, each depicting a single figure. The latter are arranged in two rows of four, one above the other. In the top row, a female dancer is flanked by two male dancers, accompanied on the far right by a jester. In the bottom row, a musician on the far left is followed by three dancers, repeated from the top row. The front of the box shows a dog on the left of the keyhole and a hunter with a spear on the right. The remaining sides also show details of hunting scenes. The year 1425, which appears on the left-hand side wall, was added at a later date and is not authentic.

SCHMUCKKÄSTCHEN

Norditalienisch (?), 1. Drittel 15. Jahrhundert. Holz, Elfenbein, 6,8 x 16,3 x 18 cm

NÜRNBERG, GERMANISCHES NATIONALMUSEUM

Die auf der Tafel gezeigten Elfenbeinreliefs sind in Einzelplatten auf dem Holzkern des Kästchens angebracht. Den Deckel ziert ein breiter Rahmen mit Rankenwerk, der aus acht Plättchen zusammengesetzt ist und wiederum Einzeldarstellungen aus acht Platten umfasst. Diese sind in zwei übereinandergesetzten Reihen von je vier Platten zusammengefasst. In der oberen Reihe wird eine Tänzerin von zwei Tänzern eingerahmt. Rechts neben diesen Figuren befindet sich die Darstellung eines Narren. Die untere Reihe zeigt von links einen Musikanten und wiederholt daneben die drei Tänzerfiguren der oberen Reihe. Die Vorderseite des Kästchens zeigt neben dem Schloss links einen Hund und rechts einen Jäger mit Spieß. Die übrigen Seiten zeigen ebenfalls Elemente von Jagdszenen. Das Kästchen trägt auf der linken Seitenwand die Datierung 1425, die aber später hinzugefügt wurde und nicht authentisch ist.

COFFRET À BIJOUX

Italie du Nord (?), 1er tiers du XVe siècle. Bois, ivoire, 6,8 x 18 x 16,3 cm

NUREMBERG, GERMANISCHES NATIONALMUSEUM

Les reliefs en ivoire présentés sur la planche sont fixés en plaques individuelles sur le fond en bois du coffret. Le couvercle est décoré d'un large cadre orné de rinceaux, lequel est constitué de huit plaquettes. Il encadre, à son tour, des figures individuelles logeant sur huit plaques. Ces dernières sont assemblées en deux rangées de quatre plaques chacune, installées l'une au-dessus de l'autre. Dans la rangée supérieure, une danseuse est flanquée de deux danseurs ; un fou est représenté plusieurs fois, à leur droite. La rangée inférieure montre, en partant de la gauche, un musicien et les trois figures de danseurs de la rangée supérieure. Un chien apparaît sur la face antérieure du coffret, à gauche de la serrure. Un chasseur portant un épieu figure à droite de celle-ci. Les faces restantes représentent, elles aussi, des éléments de scènes de chasse. Sur la face latérale gauche le coffret porte la date 1425, inscription ajoutée ultérieurement et donc apocryphe.

I. K. s.

0 1 2 3 4 5 6 P: Zoll.

1425.

FOUR GAMING TOKENS

German, 12th century. Antler, ø c. 6.5 cm / 2 ½ in.

FORMERLY BERLIN, SKULPTURENSAMMLUNG – UNTRACED

All the pieces illustrated on the plate have been untraced since 1945.

One (F) was originally housed in a private collection. The first token (A) shows Mother Earth suckling a hare and a dragon at her breast and carries a corresponding Latin inscription (B) around its edge. The second token (C) shows Achilles shooting at two centaurs. The Latin inscription (D) around its edge may be translated as: "The wild beasts are driven away by Achilles' arrows." The scene on token E has yet to be identified, whereas the representation on token F is once again bordered by a Latin inscription, which may be translated as: "The strong Samson defeats the strong lion." From remnants of paint, it would seem that tokens C and E were once red; the others were left their natural colour.

VIER SPIELSTEINE

Deutsch, 12. Jahrhundert. Hirschhorn, ø ca. 6,5 cm

EHEMALS SKULPTURENSAMMLUNG, BERLIN – VERSCHOLLEN

Alle abgebildeten Steine sind seit 1945 verschollen.

Einer (F) befand sich ursprünglich in einer Privatsammlung. Der erste abgebildete Stein (A) zeigt Mutter Erde, die einen Hasen und einen Drachen an ihrer Brust nährt. Am Rand trägt er eine lateinische Bezeichnung (B). Der zweite Stein (C) zeigt Achill, der auf zwei Zentauren schießt. Der Rand trägt die lateinische Inschrift (D), deren deutsche Übersetzung „Durch Achills Pfeile werden die Wilden vertrieben" lautet. Der Stein E zeigt eine ungedeutete Darstellung, während F wiederum eine lateinische Inschrift aufweist, die zur Darstellung passt und deren deutsche Übersetzung lautet: „Der starke Samson besiegte den starken Löwen." Nach den Farbresten waren die Spielsteine C und E früher rot gefärbt, die anderen im Naturton gehalten.

QUATRE PIONS

Allemagne, XII^e siècle. Bois de cerf, ø env. 6,5 cm

AUTREFOIS CONSERVÉS À LA SKULPTURENSAMMLUNG BERLIN – DISPARUS

Tous les pions reproduits ont disparu en 1945.

L'un d'entre eux (F) se trouvait à l'origine dans une collection privée. Le premier pion représenté (A) montre la Terre-Mère allaitant un lapin et un dragon. Sur le bord, il porte une désignation latine (B). Le deuxième pion (C) figure Achille tirant sur deux centaures. Le rebord porte une inscription, signifiant « De ses flèches Achille chasse les sauvages ». Le pion E n'a pas été interprété, tandis que le pion F porte à son tour une inscription latine concordant avec la figure représentée et dont la traduction française est : « Le fort Samson vainquit le lion fort. » D'après les restes de couleur, les pions C et E étaient autrefois teintés de rouge, les autres avaient conservé leur teinte naturelle.

TERRA, LEPVS, DRACO,

TELIS ARGILEI · RVLSE · STFERE ·

1150 — 1250.

PORTUGAL

3 4 P. Fuss.

(pp. 278–81)

BRIDAL CHEST

Franconian, 1592. Various woods, w. 194.4 cm / 76 ½ in., d. 113.4 cm / 44 ⅝ in.

FORMERLY IN A PRIVATE COLLECTION WITHIN THE FRANCONIAN NOBILITY — WHEREABOUTS UNKNOWN

In view of the lavishness of its decoration and its incorporation of the coats of arms of members of the Heldritt and Marschall von Ostheim families, both drawn from the Franconian nobility, it is highly likely that the chest was made on the occasion of a marriage. At the centre of the chest is the Holy Trinity, with a hunting scene below it. Standing at either end, identified by inscriptions, are personifications of England and Portugal, whose connection with the marriage remains unexplained.

(S. 278–281)

BRAUTTRUHE

Fränkisch, 1592. Verschiedene Hölzer, 194.4 cm breit, 113.4 cm tief

EHEMALS IN FRÄNKISCHEM ADELSBESITZ – AUFBEWAHRUNGSORT UNBEKANNT

Die Truhe ist überreich mit Zierat versehen und sehr wahrscheinlich anlässlich einer Hochzeit angefertigt worden. Nach den oben angebrachten Wappen wurde diese zwischen Mitgliedern der fränkischen Adelsfamilien Heldritt und Marschall von Ostheim geschlossen. Im Zentrum der Truhe ist die Heilige Dreifaltigkeit dargestellt. Darunter ist eine Jagdszene zu sehen. An den Seiten befinden sich durch Beischriften bezeichnete Personifikationen von England und Portugal, deren Beziehung zu den übrigen Darstellungen ungeklärt ist.

(pp. 278–281)

COFFRE DE MARIÉE

Franconie, 1592. Bois d'essences variées, largeur 194,4 cm, profondeur 113,4 cm

AUTREFOIS EN LA POSSESSION DE NOBLES FRANCONIENS – LOCALISATION INCONNUE

Très richement garni d'ornements, le coffre fut, d'après les blasons de familles nobles franconiennes placés dans la partie supérieure, très probablement exécuté à l'occasion d'un mariage de membres des familles Heldritt et Marschall von Ostheim. La Sainte Trinité est représentée au centre du coffre ; en dessous, on aperçoit une scène de chasse ; sur les côtés se trouvent, désignées par des inscriptions, les personnifications de l'Angleterre et du Portugal, dont le rapport avec les autres figures demeure obscur.

NECK JEWELLERY
Nuremberg or Augsburg, mid- to late 16th century. Silver gilt, enamelled
FORMERLY IN THE POSSESSION OF THE EDITORS BECKER AND HEFNER-ALTENECK
WHEREABOUTS UNKNOWN
Some of the items of jewellery are furnished with religious motifs: pendants B and E show St Veronica and the Sudarium, pendants F and H the Crucifixion.

HALSSCHMUCK
Nürnberg oder Augsburg, Mitte bis Ende 16. Jahrhundert. Silber, vergoldet, emailliert
EHEMALS IM BESITZ DER HERAUSGEBER BECKER UND HEFNER-ALTENECK
AUFBEWAHRUNGSORT UNBEKANNT
Einige der Schmuckstücke zieren sakrale Darstellungen:
Die Anhänger B und E zeigen das Schweißtuch der Veronika, die Anhänger F und H den Gekreuzigten.

COLLIERS
Nuremberg ou Augsbourg, milieu à fin du XVIe siècle. Argent, doré, émaillé
AUTREFOIS EN LA POSSESSION DE BECKER ET HEFNER-ALTENECK
LOCALISATION INCONNUE
Certains de ces bijoux sont ornés de figures saintes : les pendentifs (B) et (E) représentent le suaire de sainte Véronique, les pendentifs (F) et (H) montrent le Christ crucifié.

A

C

F

D

B

G

E

H

1510. — 1530

RELIQUARY SHRINE
Meuse-Rhenish, 13th century. Wood, copper gilt, enamelled, h. 16.2 x 5.9 cm / 6 ⅜ x 2 ⅜ in.
FORMERLY WITHIN THE ART TRADE – WHEREABOUTS UNKNOWN
The shrine consists of a wooden box onto which gilded and enamelled copper plaques have been nailed. The roof shows scenes from the martyrdom of saint Thomas Becket: on one side, his murder in front of the altar during Mass (B), and on the other his entombment by a bishop and two deacons (A). Two unidentified saints (C and D) are depicted on the gable walls.

RELIQUIENSCHREIN
Rheinisch-maasländisch, 13. Jahrhundert. Holz, Kupfer, vergoldet, emailliert, 16,2 cm x 5,9 cm
EHEMALS IM KUNSTHANDEL – AUFBEWAHRUNGSORT UNBEKANNT
Der Schrein besteht aus einem hölzerne Kasten, auf den vergoldete und emaillierte Kupferplatten aufgenagelt sind. Die Seitenflächen des Daches zeigen Szenen aus dem Martyrium des heiligen Thomas Becket, der während der Messe am Altar ermordet wird (B). Außerdem ist seine Grablege durch einen Bischof und zwei Diakone (A) dargestellt. Auf den Giebelflächen sind zwei unbekannte Heilige (C und D) zu sehen.

RELIQUAIRE
Rhénanie, Maasland, XIIIᵉ siècle. Bois, cuivre, doré, émaillé, 16,2 x 5,9 cm
AUTREFOIS DANS LE COMMERCE D'OBJETS D'ART – LOCALISATION INCONNUE
Le reliquaire est constitué d'un coffret en bois sur lequel sont clouées des plaques de cuivre dorées et émaillées. Les surfaces latérales du couvercle en forme de toit montrent des scènes du martyre de saint Thomas Becket, assassiné près de l'autel pendant la messe (B). Sa mise au tombeau, à laquelle procèdent un évêque et deux diacres (A), y figure également. On aperçoit enfin deux saints inconnus sur les surfaces du pignon (C et D).

D

B

A

C

4 Par: Zoll.

1100 — 1200.

EUCHARISTIC CHALICE
Paderborn, 3rd quarter of the 14th century. Silver gilt, h. 16 cm / 6 ¼ in.
BORCHEN (PADERBORN), CATHOLIC PARISH CHURCH OF NEU-ST. MEINOLPHUS
The High Gothic chalice rises above a round foot with a concave moulding patterned with rosettes around its rim. The hexagonal stem with its cast nodus supports the smooth-sided cup. The chalice bears the coat of arms and inscription of the donor, Bishop Henry III of Spiegel, and was made in Paderborn for the cathedral.

EUCHARISTISCHER KELCH
Paderborn, 3. Viertel des 14. Jahrhunderts. Silber, vergoldet, 16 cm hoch
BORCHEN (KREIS PADERBORN), KATHOLISCHE PFARRKIRCHE NEU-ST. MEINOLPHUS
Der hochgotische Kelch besitzt einen runden Fuß mit Hohlkehle und Rosettenmuster. Über dem sechseckigen Schaft mit gegossenem Nodus erhebt sich die glatte Kuppa. Der Kelch trägt das Wappen und die Inschrift des Stifters, Bischof Heinrich III. von Spiegel, und wurde ursprünglich in Paderborn für den Dom angefertigt.

CALICE EUCHARISTIQUE
Paderborn, 3ᵉ quart du XIVᵉ siècle. Argent, doré, hauteur 16 cm
BORCHEN (ARRONDISSEMENT DE PADERBORN)
NOUVELLE ÉGLISE PAROISSIALE CATHOLIQUE SAINT-MEINOLPHE
Ce calice du gothique classique possède un pied rond pourvu d'une moulure creuse ornée de motifs en forme de rosettes. Au-dessus de la tige hexagonale et de son nœud fondu s'élève la coupe lisse. Le calice porte les armoiries et l'inscription du donateur, l'évêque Heinrich III von Spiegel, et fut initialement fabriqué à Paderborn pour la cathédrale.

4 Pariser Zoll.

CUPBOARD

German, 2nd half of the 15th century. Wood, h. 2.08 m / 6 ft 9 ⅛ in.

Munich, Bayerisches Nationalmuseum

The tall living-room cupboard consists of two compartments. Additional illustrations show details of its iron mounts (C–E) and quatrefoil decoration, carved in low relief and coloured blue and red (A and B).

SCHRANK

Deutsch, 2. Hälfte 15. Jahrhundert, Holz, 208 cm hoch

München, Bayerisches Nationalmuseum

Den zweistöckigen Wohnzimmerschrank schmücken Eisenbeschläge (C–E) und flach geschnittene Vierpassverzierungen, die rot und blau gefärbt sind und zusätzlich in Detailabbildungen (A und B) gezeigt werden.

ARMOIRE

Allemagne, 2ᵉ moitié du XVᵉ siècle. Bois, hauteur 208 cm

Munich, Bayerisches Nationalmuseum

L'armoire de salon à deux étages est décorée de ferrures (C–E) et d'ornements (A et B) plats peints en rouge et bleu. On les aperçoit dans les reproductions de détails.

A

B

C

D

E

I. v. H. A.

I. K. sc.

4 Pariser Fuss.

1450 — 1500.

CASKET

German, early 16th century. Wood, 7.6 x 11.8 x 20.4 cm / 3 x 4 ⅝ x 8 in.

FORMERLY IN A PRIVATE COLLECTION WITHIN THE WÜRTTEMBERG NOBILITY
WHEREABOUTS UNKNOWN

The decorative panels are carved out of a thin piece of wood and laid over a red and blue background. Their abstract patterns are derived from the grotesque style of ornament discovered in Italy shortly before 1500.

KÄSTCHEN

Deutsch, Anfang 16. Jahrhundert. Holz, 7,6 x 20,4 x 11,8 cm

EHEMALS IN WÜRTTEMBERGISCHEM ADELSBESITZ
AUFBEWAHRUNGSORT UNBEKANNT

Die Füllungen des Kästchens sind aus einer flachen Platte ausgeschnitten und auf blau und rot gefärbten Untergrund gelegt. Sie zeigen abstrahierte Muster der Groteskornamentik, die kurz vor 1500 in Italien entdeckt und ab diesem Zeitpunkt dort verwendet wurde.

COFFRET

Allemagne, début du XVIᵉ siècle. Bois, 7,6 x 11,8 x 20,4 cm

AUTREFOIS EN LA POSSESSION DE NOBLES DU WURTEMBERG
LOCALISATION INCONNUE

Les ornements du coffret sont découpés dans une planche de bois et posés sur un fond peint en bleu et rouge. Ils présentent des motifs abstraits de l'art grotesque découvert en Italie juste avant l'an 1500.

A

B

C

I. v. H. A.

I. K. sc.

4 Par: Zoll.

1480 — 1500.

WELL SURROUNDS
Venice, 13th century. Marble
VENICE, CASA BORSATA (ABOVE) AND PALAZZO CORNER (BELOW)
The two wells are situated in the inner courtyards of the Casa Borsata and Palazzo Corner in Venice.
The upper well carries a German inscription, "hilf. her. got" ("Help [us], Lord God"), and may therefore
be the work of a German sculptor. This suggestion is supported by its shape and decoration,
which correspond to those of a German Romanesque capital. The lower well is also decorated
with Romanesque forms, with birds integrated within scrolling leafy ornament.

BRUNNENEINFASSUNGEN
Venedig, 13. Jahrhundert. Marmor
VENEDIG, CASA BORSATA (OBEN), PALAZZO CORNER (UNTEN)
Die beiden Brunnen befinden sich in den Innenhöfen der Häuser. Gemäß der Inschrift „hilf. her. got"
wurde der obere Brunnen von einem deutschen Bildhauer gearbeitet. Dafür sprechen auch die
Verzierungen, die denen deutscher romanischer Kapitelle entsprechen. Den unteren Brunnen schmücken
ebenfalls romanische Verzierungen mit in Ranken integrierten Vögeln.

ENCADREMENTS DE PUITS
Venise, XIII^e siècle. Marbre
VENISE, CASA BORSATA (EN HAUT) ET PALAZZO CORNER (EN BAS)
Les deux puits se trouvent dans les cours intérieures de ces demeures. D'après l'inscription « hilf. her. got »
(Aide-moi Seigneur), le puits reproduit en haut de la planche a été exécuté par un sculpteur
allemand, supposition que confirment les ornements correspondant à ceux des chapiteaux allemands
de style roman. Le puits reproduit en bas présente également des ornements romans,
comprenant des rinceaux peuplés d'oiseaux.

1300 — 1400.

CANDLEHOLDER
German, late 12th/early 13th century. Copper, cast, gilded, h. approx. 18 cm / 7 in.
FORMERLY MUNICH, IN THE POSSESSION OF ART COLLECTOR AINMILLER
SAINT LOUIS ART MUSEUM
Although the candleholder features the zoomorphic decoration characteristic of the Romanesque era,
the lavishness with which it is employed and combined is so untypical that the piece
may in fact represent a historicist 19th-century imitation. The candleholder is documented
to have been in the possession of the Munich art collector Ainmiller in the mid-1800s
and a number of casts were made of it around 1875.

LEUCHTER
Deutsch, Ende 12./Anfang 13. Jahrhundert. Kupfer, gegossen, vergoldet, ca. 18 cm hoch
EHEMALS IM BESITZ DES MÜNCHNER SAMMLERS AINMILLER
SAINT LOUIS ART MUSEUM
Der Leuchter besitzt für die Zeit der Romanik charakteristisches zoomorphes Dekor,
das aber in solch untypischer Überfülle verwendet und zusammengesetzt ist, dass es sich bei dem Stück
möglicherweise um eine historistische Nachschöpfung des 19. Jahrhunderts handelt.
Der Leuchter befand sich in der Mitte des 19. Jahrhunderts im Besitz des Münchner Sammlers Ainmiller,
und um 1875 wurden davon etliche Nachgüsse hergestellt.

CHANDELIER
Allemagne, fin du XII^e/début du XIII^e siècle. Cuivre, fondu, doré, hauteur env. 18 cm
AUTREFOIS EN LA POSSESSION DU COLLECTIONNEUR MUNICHOIS AINMILLER
SAINT LOUIS ART MUSEUM
Le chandelier présente un décor zoomorphe caractéristique de l'art roman, mais utilisé et composé avec
une profusion si inhabituelle qu'il s'agit peut-être d'une copie datant du XIX^e siècle.
Au milieu de ce dernier, le chandelier était en la possession du collectionneur munichois Ainmiller
et, en 1875, un bon nombre de copies en ont été exécutées.

I · v · HEFNER-ALTENECK · del ·

I · KLIPPHAHN · sc ·

1050 — 1200 .

A. LANTERN
Niccolò Grosso, known as Il Caparra, Florence, c. 1500. Wrought iron
FLORENCE, PALAZZO STROZZI
The plate shows one of the originally four lanterns that numbered amongst the works in wrought iron
fashioned by Il Caparra for the Palazzo Strozzi (cf. ill. p. 255). Considered to mark a high point
of Renaissance artistic wrought iron, the lanterns were mounted on the corners of the palace
(one has been untraced since 1903). The tall central spike and the curved spikes around the top
of the lantern were designed to support flaming pitch torches.

B & C. DOOR HANDLES
German, 15th century. Wrought iron
FORMERLY INGOLSTADT, PRIVATE COLLECTION – WHEREABOUTS UNKNOWN
Found by a farmer in a field near Ingolstadt in the mid-19th century, the skilfully crafted
door handle (B) is elaborately decorated with Gothic architectural elements.

A. LATERNE
Niccolò Grosso, gen. Caparra, Florenz, um 1500. Schmiedeeisen
FLORENZ, PALAZZO STROZZI
Die Tafel zeigt eine der ursprünglich vier an den Ecken des Palazzo Strozzi angebrachten Laternen,
die zu den von Caparra für den Palast angefertigten Eisenarbeiten gehören (siehe Abb. S. 255)
und als Höhepunkt der Schmiedekunst der Renaissance gelten. Seit 1903 fehlt eine der vier Laternen.
Bei diesen Leuchtern handelt es sich um Körbe mit Mitteldorn und geschwungenen Zacken,
die zur Aufnahme von brennenden Pechkränzen dienten.

B & C. TÜRGRIFFE
Deutsch, 15. Jahrhundert. Schmiedeeisen
EHEMALS IN INGOLSTÄDTER PRIVATBESITZ – AUFBEWAHRUNGSORT UNBEKANNT
Das kunstvoll gearbeitete, aufwendig mit gotischen Architekturornamenten geschmückte Stück (B) wurde
um die Mitte des 19. Jahrhunderts von einem Bauern auf einem Feld bei Ingolstadt gefunden.

A. LANTERNE
Niccolò Grosso, dit Caparra, Florence, vers 1500. Fer forgé
FLORENCE, PALAZZO STROZZI
La planche montre une des lanternes installées dans les angles du Palais Strozzi et qui, à l'origine,
étaient au nombre de quatre. Depuis 1903, l'une d'entre elles fait défaut. Figurant parmi les ouvrages forgés
que Caparra exécuta pour le palais (cf. ill. p. 255), ces lanternes sont considérées comme l'apogée de la
ferronnerie d'art à l'époque de la Renaissance. Elles se présentent sous la forme de corbeilles munies d'une
tige centrale et de pointes recourbées qui servaient à recevoir les cercles goudronnés.

B & C. POIGNÉES DE PORTE
Allemagne, XVe siècle. Fer forgé
AUTREFOIS EN LA POSSESSION D'UN PARTICULIER D'INGOLSTADT – LOCALISATION INCONNUE
Vers la moitié du XIXe siècle, la pièce, exécutée avec art et richement décorée d'ornements architecturaux
gothiques (B), a été découverte par un paysan dans un champ près d'Ingolstadt.

B

C

A

1489 — 1500.

Top / oben / en haut

TABLECLOTH
South German, 1st third of the 16th century
Linen, embroidered, 64.8 x 68 cm / 25 ½ x 26 ¾ in.
STAATLICHE MUSEEN ZU BERLIN, KUNSTGEWERBEMUSEUM

TISCHDECKE
Süddeutsch, 1. Drittel 16. Jahrhundert. Leinen, bestickt, 64,8 x 68 cm
STAATLICHE MUSEEN ZU BERLIN, KUNSTGEWERBEMUSEUM

NAPPE
Allemagne du Sud, 1er tiers du XVIe siècle. Lin, brodé, 64,8 x 68 cm
STAATLICHE MUSEEN ZU BERLIN, KUNSTGEWERBEMUSEUM

Below / unten / en bas

TABLECLOTH
German, 1st third of the 16th century. Linen, embroidered, 48.6 x 51.8 cm / 19 ⅛ x 20 ⅜ in.
FORMERLY IN THE POSSESSION OF THE EDITOR HEFNER-ALTENECK – WHEREABOUTS UNKNOWN
The scenes on the two tablecloths are each embroidered in white linen thread and outlined
in brown thread. A similar tablecloth, but richer in the elaboration of its detail,
is housed in the textile collection of the Kunstgewerbemuseum in Berlin.

TISCHDECKE
Deutsch, 1. Drittel 16. Jahrhundert. Leinen, bestickt, 48,6 x 51,8 cm
EHEMALS IM BESITZ DES HERAUSGEBERS HEFNER-ALTENECK
AUFBEWAHRUNGSORT UNBEKANNT
Die Darstellungen beider Decken auf der Tafel sind mit weißem Leinenzwirn gestickt und
mit braunem Zwirn eingefasst. Ein ähnliches, aber in der Ausarbeitung der Details reicheres Stück
befindet sich in der Textilsammlung des Berliner Kunstgewerbemuseums.

NAPPE
Allemagne, 1er tiers du XVIe siècle. Lin, brodé, 48,6 x 51,8 cm
AUTREFOIS EN LA POSSESSION DE HEFNER-ALTENECK – LOCALISATION INCONNUE
Les représentations qui ornent les deux nappes sont brodées au fil de lin blanc et ourlées de fil brun.
Une pièce similaire, mais plus riche dans l'exécution des détails, se trouve dans la collection
de tissus du musée berlinois des Arts décoratifs.

1520 — 1540.

I v H A. I K · se·

0 ———————— Rhp·Fuss·

CONTAINER FOR HOLY OILS
Westphalian, 1482. Copper gilt, h. 32 cm / 12 ⅝ in.
WARBURG, WESTPHALIA, ALTSTÄDTER KIRCHE ZU MARIÄ HEIMSUCHUNG
The container takes the shape of a fortress with three round towers and three flanking corner turrets, which are crowned with crenellations and low spires. The hexagonal stem rises from a six-lobed foot, which is additionally decorated with a head of Christ and a Latin inscription containing the date.

GEFÄSS FÜR DIE HEILIGEN ÖLE
Westfälisch, 1482. Kupfer, vergoldet, 32 cm hoch
WARBURG/WESTFALEN, ALTSTÄDTER KIRCHE ZU MARIÄ HEIMSUCHUNG
Das Gefäß besitzt die Form einer Burg mit drei Rundtürmen und drei flankierenden Ecktürmen, die mit Zinnen und stumpfen Helmen bekrönt sind. Über dem sechspassigen Fuß steigt der sechspassige Schaft auf. Auf dem Fuß befinden sich ein Christuskopf und eine lateinische Inschrift mit der Datierung.

VASE AUX SAINTES HUILES
Westphalie, 1482. Cuivre, doré, hauteur 32 cm
WARBURG EN WESTPHALIE, ALTSTÄDTER KIRCHE ZU MARIÄ HEIMSUCHUNG
Le récipient revêt la forme d'un château fort à trois tours circulaires flanquées de trois tours angulaires.
Les tours sont surmontées de créneaux et de combles pyramidaux aux extrémités arrondies.
Au-dessus du pied hexalobé s'élève la tige à six lobes. Sur le dessous du pied figurent une tête de Christ ainsi qu'une inscription latine datant l'objet.

I. K. v.

1489.

BEAKER

Venetian, 1529. Blue glass with enamel painting, h. 9 cm / 3 ½ in., ø at the top 7.5 cm / 3 in.

FRANKFURT AM MAIN, MUSEUM FÜR KUNSTHANDWERK

The museum acquired the beaker in 1929, when the Hohenzollern-Sigmaringen collection was sold at auction. Earlier authorities considered the portrait medallions to show Emperor Frederick III together with the German King Ferdinand I and his wife, Anne of Hungary. Today, however, no firm identifications are proposed.

BECHER

Venedig, 1529. Blaues Glas mit Schmelzmalerei, 9 cm hoch, ø 7.5 cm (oben)

FRANKFURT AM MAIN, MUSEUM FÜR KUNSTHANDWERK

Das Museum erwarb den Becher 1929 bei der Versteigerung der Fürstlich Hohenzollern'schen Sammlung, Sigmaringen. Die Porträtmedaillons stellen nach Meinung früherer Forscher Kaiser Friedrich III. sowie den deutschen König Ferdinand I. und seine Gemahlin Anna von Ungarn dar. Heute nimmt man keine exakte Identifizierung mehr vor.

GOBELET

Venise, 1529. Verre bleu avec peinture en émail, hauteur 9 cm, ø supérieur 7.5 cm

FRANCFORT-SUR-LE-MAIN, MUSEUM FÜR KUNSTHANDWERK

Le musée fit l'acquisition du gobelet en 1929, lors de la vente aux enchères de la collection princière des Hohenzollern, à Sigmaringen. Selon d'anciens chercheurs, les portraits en médaillon représentent l'empereur Frédéric III ainsi que le roi allemand Ferdinand Ier et son épouse Anne de Hongrie – une identification dont l'exactitude est aujourd'hui contestée.

1529.

CRADLE

German, last quarter of the 15th century. Copper gilt, l. 23.8 cm / 9 ¼ in., w. 11.9 cm / 4 ⅝ in.

FORMERLY FRANKFURT AM MAIN, PRIVATE COLLECTION – WHEREABOUTS UNKNOWN

The unusual lengthways direction of the rockers makes it highly likely that the miniature cradle formed part of a Christmas Crib scene in the Late Gothic era.

WIEGE

Deutsch, letztes Viertel 15. Jahrhundert. Kupfer, vergoldet, 23,8 cm lang und 11,9 cm breit

EHEMALS IN FRANKFURTER PRIVATBESITZ – AUFBEWAHRUNGSORT UNBEKANNT

Die ungewöhnliche Längswiegung lässt darauf schließen, dass die Wiege sehr wahrscheinlich Bestandteil einer spätgotischen Weihnachtskrippe war.

BERCEAU

Allemagne, dernier quart du XVᵉ siècle. Cuivre, doré, longueur 23,8 cm, largeur 11,9 cm

AUTREFOIS EN LA POSSESSION D'UN PARTICULIER DE FRANCFORT – LOCALISATION INCONNUE

Le dispositif de bascule qui, contrairement à l'usage, est placé dans le sens de la longueur laisse fortement supposer que le berceau appartenait à une crèche de Noël datant du gothique tardif.

A

B

C

4 Par. Zoll.

I. K.

1480 — 1500.

(pp. 307–09)

A, C–F. NECK JEWELLERY

German, 1st half of the 16th century. Silver gilt, painted enamel, gems, pearls
FORMERLY MUNICH, PRIVATE COLLECTION (A AND E)
AUCTIONED IN 1904 FROM THE ESTATE OF THE EDITOR HEFNER-ALTENECK (C, D AND F)
WHEREABOUTS UNKNOWN
The pendants are furnished with religious motifs, including St George (A),
the Crucifixion (C and E) and the ichthys Christogram (F).

B. CHAIN AND PENDANT

German, 1589. Silver, partly gilded, l. 35 cm / 13 ¾
FORMERLY BERLIN, KUNSTGEWERBEMUSEUM – UNTRACED
In May 1846, two identical chains and pendants were found in the garden of Bliesendorf vicarage,
near Werder on the River Havel, not far from Potsdam. The Frederick William IV, King of Prussia
(r. 1840–61), transferred the necklaces to the Kunstkammer, from where they passed into the
Kunstgewerbemuseum. They have been untraced since 1945. The chain illustrated here was fashioned of
sheet-metal links. The gilt heart is decorated in low relief with a representation of the Holy Trinity.
The back carries the date 1589 and a dedicatory inscription.

(S. 307–309)

A, C–F. HALSSCHMUCK

Deutsch, 1. Hälfte 16. Jahrhundert. Silber, vergoldet, mit Maleremail, Edelsteine und Perlen
EHEMALS IN MÜNCHNER PRIVATBESITZ (A UND E)
AUS DEM BESITZ DES HERAUSGEBERS HEFNER-ALTENECK 1904 VERSTEIGERT (C, D UND F)
AUFBEWAHRUNGSORT UNBEKANNT
Die Anhänger zieren sakrale Darstellungen mit dem heiligen Georg (A),
dem Gekreuzigten (C und E) und dem Jesusmonogramm (F).

B. KETTE MIT ANHÄNGER

Deutsch, 1589. Silber, teilvergoldet, 35 cm lang
EHEMALS KUNSTGEWERBEMUSEUM, BERLIN – VERSCHOLLEN
Im Mai 1846 wurden im Garten des Pfarrhauses zu Bliesendorf bei Werder an der Havel in der Nähe
Potsdams zwei gleichartige Ketten mit Anhängern gefunden. Der preußische König Friedrich Wilhelm IV.
(reg. 1840–1861) überwies die Fundstücke an die Kunstkammer, von wo sie in das Kunstgewerbemuseum
gelangten. Seit 1945 sind sie verschollen. Die abgebildete Kette war aus Blechstreifen gebildet.
Das vergoldete Herz zeigte ein Flachrelief mit der Darstellung der Dreifaltigkeit.
Die Rückseite trug die Datierung 1589 und eine Widmungsinschrift.

(pp. 307–309)

A, C–F. COLLIERS

Allemagne, 1ère moitié du XVIe siècle. Argent, doré, émail peint, pierres précieuses, perles
AUTREFOIS EN LA POSSESSION D'UN PARTICULIER MUNICHOIS (A ET E); AUTREFOIS EN LA POSSESSION
DE HEFNER-ALTENECK (C, D ET F) – LOCALISATION INCONNUE
Les pendentifs sont ornés de représentations sacrées où apparaissent saint Georges (A),
le Crucifié (C et E) et le monogramme de Jésus (F).

B. CHAÎNE AVEC PENDENTIF

Allemagne, 1589. Argent, partiellement doré, longeur 35 cm
AUTREFOIS CONSERVÉE AU KUNSTGEWERBEMUSEUM BERLIN – DISPARUE
En mai 1846, deux chaînes similaires avec pendentifs furent trouvées dans le jardin du presbytère
de Bliesendorf près de Werder-sur-Havel, dans les environs de Potsdam. Le roi de Prusse Frédéric-
Guillaume IV (règne 1840–1861) confia les objets trouvés à la Chambre des Arts, d'où ils furent transférés
au musée des Arts décoratifs. Depuis 1945, on ignore où ils se trouvent. La chaîne ici reproduite était
constituée d'un ruban de tôle. Le cœur doré arborait un bas-relief représentant la Trinité.
Au dos étaient inscrites la date 1589 ainsi qu'une dédicace.

JEWEL BOX
German, final third of the 15th century. Wood, polished iron, 4.5 x 11 x 8 cm / 1 ¾ x 4 ⅜ x 3 ⅛ in.

FORMERLY FRANKFURT AM MAIN, PRIVATE COLLECTION – WHEREABOUTS UNKNOWN

The lid of this ladies' jewel box is richly carved with Late Gothic vegetal decoration.
A banderole borne by a dove bears the words: "ich. finde. an. dir. mins. herzes. gir"
(I find in you my heart's desire).

KÄSTCHEN
Deutsch, letztes Drittel 15. Jahrhundert. Holz, poliertes Eisen, 4.5 x 11 x 8 cm

EHEMALS IN FRANKFURTER PRIVATBESITZ – AUFBEWAHRUNGSORT UNBEKANNT

Das Schmuckkästchen einer Dame ist auf dem Deckel mit reichem spätgotischem vegetabilischem Dekor
verziert. Eine Taube hält ein Spruchband mit dem Text: „ich. finde. an. dir. mins. herzes. gir".

COFFRET
Allemagne, dernier tiers du XVᵉ siècle. Bois, fer poli, 4.5 x 11 x 8 cm

AUTREFOIS EN LA POSSESSION D'UN PARTICULIER DE FRANCFORT – LOCALISATION INCONNUE

Le coffret à bijoux d'une dame est orné sur son couvercle d'un riche décor végétal du gothique tardif.
Une colombe tient un cartouche où est écrit : « ich. finde. an. dir. mins. herzes. gir »
(De mon cœur tu combles le désir).

A

B

1480 – 1500.

A–D. CUP
South German, c. 1600. Bronze, gilded and painted, glass
FORMERLY BERLIN, KUNSTGEWERBEMUSEUM – WARTIME LOSS
In order to use this comic cup, the "lady" must be turned upside down so that her skirts are facing upwards.
Her upper body is fashioned from bronze gilt, whereas the actual cup is made of glass with engraved
decoration. The engraved coats of arms (D) are very probably those of the former owner.

E. CUP WITH NEO-GOTHIC DECORATION
South German, early 17th century. Silver gilt, glass
FORMERLY MUNICH, PRIVATE COLLECTION – WHEREABOUTS UNKNOWN

A–D. BECHER
Süddeutsch, um 1600. Bronze, vergoldet und bemalt, Glas
EHEMALS KUNSTGEWERBEMUSEUM, BERLIN – KRIEGSVERLUST
Das Scherzgefäß muss zur Benutzung umgedreht, das heißt mit dem offenen Rock nach oben gekehrt
werden. Der Becherteil besteht aus Glas mit eingeschliffenen Verzierungen, der Oberkörper aus
vergoldeter Bronze. Die eingeschliffenen Wappen (D) sind sehr wahrscheinlich diejenigen
des früheren Besitzers.

E. BECHER MIT NEOGOTISCHEM DEKOR
Süddeutsch, Anfang 17. Jahrhundert. Silber, vergoldet, Glas
EHEMALS IN MÜNCHNER PRIVATBESITZ – AUFBEWAHRUNGSORT UNBEKANNT

A–D. GOBELET
Allemagne du Sud, vers 1600. Bronze, doré et peint, verre
AUTREFOIS CONSERVÉ AU KUNSTGEWERBEMUSEUM BERLIN – PERTE DE GUERRE
Conçu comme une attrape, le récipient, pour être utilisé, devait être retourné, ce qui revenait à renverser
la jupe. Le gobelet est en verre, orné de motifs gravés, le buste, en bronze doré. Les armoiries que l'on
aperçoit (D) sont très vraisemblablement celles de l'ancien propriétaire.

E. GOBELET AU DÉCOR NÉOGOTHIQUE
Allemagne du Sud, début du XVIIe siècle. Argent, doré, verre
AUTREFOIS EN LA POSSESSION D'UN PARTICULIER MUNICHOIS – LOCALISATION INCONNUE

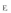

E

D

C

A

B

1580 — 1600.

GOLD PLAQUE WITH STAUROSIS

Byzantine, mid-12th century. Gold, enamel cloisonné, 25 x 18.5 cm / 10 x 7 ¼ in.

MUNICH, RESIDENZ, TREASURY

It is highly likely that this Byzantine painting of the Crucifixion – a type of icon known as a *Staurosis* (from the Greek *stauros*, a "stake" or "post") – formerly served as the cover of a book. It is executed on gold foil and decorated in cloisonné enamel, a technique in which the details of the design are outlined with thin wire soldered to the base, creating cells (cloisons) that are then filled in with coloured enamel pastes. From the earthly zone at the bottom of the plaque, where the soldiers are dividing up Christ's robes beneath the head either of Gaia (Mother Earth) or of the defeated Adam, the representation of the *Christus Mortuus* ("Dead Christ") leads up to the celestial sphere at the top, where four angels mourn the death of Christ beneath the sun and the moon. The crucified Christ is flanked by Mary Magdalene and the Virgin Mary on the left and St John the Evangelist and the Good Captain on the right. A stream of blood flows out of the wound in his side into an amphora. The inscriptions reproduce the words spoken by Christ on the Cross: "Behold your son" and "Behold your mother" (John 19:26–27).

GOLDENE TAFEL DER STAUROSIS

Byzantinisch. Mitte 12. Jahrhundert. Gold, Zellenschmelz, 25 x 18,5 cm

MÜNCHEN, SCHATZKAMMER DER RESIDENZ

Die früher höchstwahrscheinlich als Deckel eines Bucheinbandes dienende byzantinische Darstellung der Kreuzigung (griech. „Staurosis") wurde aus Goldblech gefertigt und mit Email in Zellenschmelz dekoriert; das bedeutet, aufgelötete Stege, welche die Darstellungsdetails umreißen, wurden mit farbigem Glasfluss gefüllt. Die Darstellung des „Mortuus" reicht aus der irdischen Zone mit dem Kopf der Gaia (Mutter Erde) oder des überwundenen Adam, unter dem die Soldaten die Kleider Christi teilen, bis in die himmlische Sphäre, wo unter Sonne und Mond vier Engel den Tod Christi beklagen. Den Gekreuzigten flankieren links Maria Magdalena und Maria, rechts der Evangelist Johannes und der bekehrte Hauptmann. Aus Christi Seitenwunde ergießt sich ein Blutstrahl in eine Amphore. Die Inschriften geben die Worte Christi am Kreuz wieder: „Siehe dein Sohn" und „Siehe deine Mutter" (Johannes 19,26–27).

TABLEAU DORÉ FIGURANT LA CRUCIFIXION

Byzance, milieu du XII^e siècle. Or, émail cloisonné, 25 x 18,5 cm

MUNICH, TRÉSOR DE LA RÉSIDENCE

La représentation byzantine de la Crucifixion (ou Staurosis), qui constituait jadis très probablement la couverture d'un livre relié, a été exécutée en tôle d'or. Le décor est en émail cloisonné : de minces arêtes soudées sur la tôle dessinent le contour des motifs puis sertissent la pâte colorée. Sortie des profondeurs terrestres où gît la tête de Gaia (Terre-Mère) – ou d'Adam vaincu –, sous laquelle les soldats se partagent les vêtements du Christ, la représentation du défunt s'élève jusque dans la sphère céleste où, sous le soleil et la lune, quatre anges déplorent sa mort. À gauche du Crucifié se tiennent Marie-Madeleine et la Vierge Marie, à sa droite, Jean l'évangéliste et le centurion converti. Jaillissant de la plaie latérale de Jésus Christ, un jet de sang se déverse dans une amphore. Les inscriptions restituent les paroles du Christ sur la croix : « Voici ton fils » et « Voici ta mère » (Jean 19, 26–27).

MIRROR CASE

French, early 14th century. Ivory, ø 14 cm / 5 ½ in.

As was the convention in the Middle Ages for cosmetic and toiletry items, the front of this mirror case shows a scene of courtly love (cf. ills. pp. 14, 229, 385). Knights are preparing to capture the castle of Venus. The goddess herself can be seen ready to loose an arrow from the highest battlements, accompanied by virgins who are assisting her in the battle or already sounding their victory trumpets. Through the gate below, two virgins armed with flowering stalks in place of lances are sallying forth to attack the knights, whose shields bear roses instead of coats of arms. That there is nothing very martial about this "war of the roses" can be seen on the left, where a knight has climbed up onto his saddle in order to kiss one of the virgins, who sticks her head out of the grated window. Beside him, a second knight with a crossbow is shooting with a rose in place of a bolt. Roses are being thrown, loosed and scattered throughout the scene.

SPIEGELKAPSEL

Französisch, Anfang 14. Jahrhundert. Elfenbein, ø 14 cm

Wie im Mittelalter für Geräte zur Schönheitspflege üblich (siehe Abb. S. 14, 229, 385) zeigt die Vorderseite der Spiegelkapsel eine Minneszene. Ritter schicken sich an, das Schloss der Venus zu erobern. Die Göttin selbst sieht man von der obersten Zinne einen Pfeil abschießen, begleitet wird sie von Jungfrauen, die sie im Kampf unterstützen oder bereits in die Siegestrompeten blasen. Aus dem Tor machen zwei mit Blumenstängeln anstelle von Lanzen bewaffnete Jungfrauen einen Ausfall gegen die Ritter, die Schilde mit Rosen statt Wappen tragen. Wie wenig martialisch dieser Rosenkrieg ist, zeigt sich links, wo sich ein Ritter im Sattel aufgerichtet hat und eine Jungfrau küsst, die ihren Kopf aus dem vergitterten Fenster reckt, während ein anderer daneben mit seiner Armbrust eine Rose abschießt. Rosen werden überall geworfen, geschossen und ausgeschüttet.

VALVE DE MIROIR

France, début du XIV^e siècle. Ivoire, ø 14 cm

Comme il était d'usage au Moyen Âge pour les accessoires de toilette (cf. ill. pp. 14, 229, 385), la face antérieure de la valve figure une scène courtoise. Des chevaliers se disposent à conquérir le château de Vénus. Accompagnée de jeunes filles qui la secondent dans le combat et dont certaines embouchent déjà les trompettes du triomphe, la déesse en personne tire une flèche du haut du créneau le plus élevé. Surgissant de la porte, deux jeunes filles, armées de tiges de fleurs en guise de lances, mènent une attaque contre les chevaliers, qui sont armés de boucliers arborant des roses au lieu d'un blason. Une scène, à gauche, illustre combien cette guerre des roses est peu martiale : un chevalier se dressant sur sa selle embrasse une jeune fille qui lui tend sa tête par la fenêtre grillagée, tandis qu'un autre, à côté, darde une rose avec son arbalète. Partout, des roses sont lancées, tirées et déversées.

1280. — 1320.

I. KLIPPHAHN. SC.

(pp. 318–21)

ALTAR SUPPORT (STIPES) FROM ST KILIAN'S ALTAR

Würzburg, mid-13th century. Sandstone, 1.62 x 3.5 m / 5 ft 3 ¾ in. x 11 ft 5 in. (front)
WÜRZBURG, NEW MINSTER ST KILIAN'S CRYPT
The stipes here in the shape of a rectangular block serves as the base supporting the altar table, or *mensa*.
It is assembled from sandstone slabs and is hollow inside to house relics. It incorporates two pointed-arch
windows in the left-hand side wall (not illustrated) and a circular opening on the front.
Slender columns along the walls are crowned by capitals decorated with foliage, each in a different design.
The metal plaques visible in the present plate and bearing the figures of saints were a later addition and
concealed traces of earlier painting. They have today been removed from the original.

(S. 318–321)

ALTARSTIPES „KILIANSALTAR"

Würzburg, Mitte 13. Jahrhundert. Sandstein, 162 x 350 cm (Vorderseite)
WÜRZBURG, KILIANSGRUFT IN DER NEUMÜNSTERKIRCHE
Der als Unterbau einer Altarmensa dienende blockartige Aufbau besteht aus einem Gefüge von
Sandsteintafeln und ist innen hohl, um Reliquien aufnehmen zu können. Als Öffnungen fungieren die
beiden spitzbogigen Fenster an der linken Seitenwand (nicht abgebildet) und die runde Aussparung an der
Vorderseite. Die Wände sind mit Säulchen besetzt, deren Kapitelle mit unterschiedlichem Laubwerk
geschmückt sind. Von der alten Bemalung sind noch Reste erhalten, die in späterer Zeit mit den hier
wiedergegebenen Darstellungen von Heiligenfiguren auf Metallplatten bedeckt wurden.
Am Original sind diese Metallplatten heutzutage wieder entfernt worden.

(pp. 318–321)

SUPPORT D'AUTEL « AUTEL DE SAINT KILIAN »

Wurtzbourg, milieu du XIIIᵉ siècle. Grès, 162 x 350 cm (face antérieure)
WURTZBOURG, CRYPTE DE SAINT KILIAN DANS L'ÉGLISE NEUMÜNSTER
La construction en forme de bloc, servant de soubassement à une pierre d'autel, est constituée d'un
agencement de plateaux de grès. Elle est creuse à l'intérieur afin de pouvoir accueillir des reliques.
Les deux baies en arc brisé sur la paroi latérale gauche (sans illustration) et la forme circulaire sur la face
antérieure font office d'ouvertures. Les parois sont garnies de colonnettes aux chapiteaux ornés de
feuillages divers. De l'ancienne peinture demeurent des restes, qui ont été recouverts, à une époque plus
tardive, par les images, reproduites ici, de saints figurant sur des plaques métalliques.
Celles-ci ont été, par la suite, retirées de l'original.

CUPBOARD
South German, late 15th century. Walnut, tin-plated iron, h. 2.92 m / 9 ft 7 in.
FORMERLY MUNICH, PRIVATE COLLECTION – WHEREABOUTS UNKNOWN
The cupboard, with its Late Gothic architectural forms and skilfully crafted iron mounts, may have been made for a sacristy.

SCHRANK
Süddeutsch, Ende 15. Jahrhundert. Nussbaum, verzinntes Eisen, 292 cm hoch
EHEMALS IN MÜNCHNER PRIVATBESITZ – AUFBEWAHRUNGSORT UNBEKANNT
Der Schrank mit spätgotischem architektonischem Zierat und kunstvollen Eisenbeschlägen wurde möglicherweise als Sakristeischrank gefertigt.

ARMOIRE
Allemagne du Sud, fin du XVe siècle. Noisetier, fer étamé, hauteur 292 cm
AUTREFOIS EN LA POSSESSION D'UN PARTICULIER MUNICHOIS – LOCALISATION INCONNUE
L'armoire, aux ornements architecturaux du gothique tardif et aux ferrures exécutées avec art, a peut-être été conçue comme une armoire de sacristie.

I. H. v. Hefner-A. del.

L. Klipphahn sc.

6 Par : Fuss.

1460 — 1500.

J. Klipphahn. sc.

0.

(pp. 324/25)

RELIQUARY SHRINE

Nuremberg, late 15th/early 16th century
Wood, silver and lead, gilded and cast, 62 x 147 x 41 cm / 24 ⅜ x 57 ⅞ x 16 ⅛ in.
NUREMBERG, GERMANISCHES NATIONALMUSEUM

From the High Middle Ages onwards, reliquary shrines generally followed the shape of a sarcophagus crowned by a gable roof. The present example represents a slight variation upon the conventional design, insofar as it features a hipped roof. The shrine consists of a wooden core encased in sheets of lead gilt around the sides and silver gilt on the roof. A row of finials runs along the ridge of the roof, its ends emphasized by the two larger, differently shaped finials. The sides of the roof bear an ornamental design. The walls underneath are decorated with small plaques, again in line with established tradition. These show the Virgin and Child alternating with the figural group of St Elizabeth and the young John the Baptist. The representation of the Triumphant Christ in the centre is a later addition, as is a door on the opposite side wall (not illustrated), bearing the Beheim coat of arms and the date 1645. Mounted at each corner is the figure of St Sebastian beneath a baldachin crowned by a finial. The reliquary shrine was housed from 1513 in St Sebastian's chapel. After the latter was demolished in 1553, the shrine was transferred to Nuremberg's municipal library and was later placed in the Germanisches Nationalmuseum on permanent loan. It is today badly damaged: all four Sebastians and two of their baldachins are untraced, as are the plaques on both narrower ends of the shrine, a plaque from one of the long sides, the Beheim coat of arms and the gilding on the plaques.

(S. 324/325)

RELIQUIENSCHREIN

Nürnberg, Ende 15./Anfang 16. Jahrhundert
Holz. Silber und Blei, vergoldet und gegossen, 62 x 147 x 41 cm
NÜRNBERG, GERMANISCHES NATIONALMUSEUM

Seit dem hohen Mittelalter besitzen Reliquienschreine üblicherweise die Form eines Sarkophages, der von einem Satteldach geschlossen wird. Hier handelt es sich um eine Variante dieses Typus, da das Dach als Walmdach ausgeführt ist. Der Schrein besteht aus einem hölzernen Kern, der im Untergeschoss mit vergoldeten Blei- und im Dachgeschoss mit vergoldeten Silberplatten belegt ist. Auf dem Dachfirst befindet sich eine Reihe von Kreuzblumen, deren Beginn und Ende durch Größe und Form betont ist. Die Dachflächen sind ornamental gemustert. Das Untergeschoss zieren, ebenfalls in Fortführung einer alten Tradition, Plaketten, die alternierend die Madonna mit dem Kind und die heilige Elisabeth mit dem Johannesknaben zeigen. Die zentrale Darstellung des triumphierenden Christus ist eine spätere Ergänzung, ebenso eine nachträglich eingesetzte Tür an einer der Längsseiten mit dem Beheim'schen Wappen und der Datierung 1645. An den vier Ecken befindet sich jeweils eine Figur des heiligen Sebastian unter einem fialengekrönten Baldachin. Seit 1513 befand sich der Schrein in der 1553 abgebrochenen Sebastianskapelle, wurde dann in die Stadtbibliothek verbracht und kam später als Dauerleihgabe in das Germanische Nationalmuseum. Er ist inzwischen schwer beschädigt. Alle Sebastiansfiguren und zwei ihrer Baldachine fehlen, ebenso die Plaketten der Schmalseiten, eine der Längsseiten, das Beheim'sche Wappen und die Vergoldungen der Plaketten.

(pp. 324/325)

RELIQUAIRE

Nuremberg, fin du XV^e/début du XVI^e siècle
Bois, argent et plomb, doré et fondu , 62 x 147 x 41 cm
NUREMBERG, GERMANISCHES NATIONALMUSEUM

La châsse prend la forme, usuelle depuis le haut Moyen Âge, d'un sarcophage fermé par un toit en pente.
Il s'agit ici d'une variante de ce modèle, le couvercle ayant été exécuté sous forme de toit en croupe.
Elle est constituée d'un fond en bois recouvert de plaques ; celles-ci sont en plomb doré au niveau inférieur
et en argent doré au niveau du toit. Des fleurons, dont le premier et le dernier se distinguent par leur taille
et par leur forme, sont alignés sur le faîte du toit. Les surfaces de ce dernier sont pourvues de motifs
ornementaux. Respectant, lui aussi, une vieille tradition, le niveau inférieur est orné de plaquettes où
apparaissent, alternativement, des Vierges à l'Enfant et sainte Élisabeth accompagnée de saint Jean
Baptiste enfant. La figure centrale, le Christ en gloire, est un ajout ultérieur. Il en est de même pour une
petite porte aménagée dans l'une des parois longitudinales et portant le blason des Beheim ainsi que la date
de 1645. Aux quatre coins de la châsse figure saint Sébastien sous un dais couronné de pinacles.
Depuis 1513, la châsse se trouvait dans la chapelle Saint-Sébastien, détruite en 1553. Puis elle fut transférée
à la bibliothèque de la ville avant de parvenir, en tant que prêt permanent, au Musée national germanique.
Elle est aujourd'hui très détériorée. De nombreux éléments font défaut : l'ensemble des statuettes
de saint Sébastien et deux de leurs baldaquins, les plaquettes des petits côtés, une du grand côté,
le blason des Beheim ainsi que les dorures des plaquettes.

I H. v. HEFNER=ALTENECK. *Gel.*

C.REGNIER del.

(pp. 328–31)

FOLDING GAME BOARD

German, late 15th century. Wood, each half 34 x 34 cm / 13 ⅜ x 13 ⅜ in.

Munich, Bayerisches Nationalmuseum

The two halves of the board are hinged in the middle so that they can be folded up. They contain two fields belonging to the game of tric-trac, a French variant of backgammon (cf also ill. p. 373). The fields are surrounded by an elaborately carved border whose decoration shows a hunter with hounds, a young woman, a pair of lovers, a beggar and two other male figures. Situated on the outer sides of the box are a Nine Men's Morris board and a chequerboard, their borders decorated with the coats of arms of various towns. The fields themselves are inlaid with woods of different colours.

(S. 328–331)

SPIELBRETT

Deutsch, Ende 15. Jahrhundert. Holz, je 34 x 34 cm

München, Bayerisches Nationalmuseum

Die mittels Scharnier zu einem Klappbrett verbundenen Tafeln bergen in aufwendig geschnitztem Rahmen zwei Felder des Tric-Trac-Spiels, der französischen Variante des Backgammon (siehe auch Abb. S. 373). Der figürliche Schmuck zeigt einen Jäger mit Hunden, eine Frauenfigur, ein Liebespaar sowie einen Bettler und andere Gestalten. Auf den äußeren Seiten befinden sich ein Mühle- und ein Damespiel, deren Ränder mit Wappen verschiedener Städte verziert sind. Die Spielfelder sind jeweils aus verschiedenfarbigen Hölzern eingelegt.

(pp. 328–331)

TABLIER DE JEU

Allemagne, fin du XVᵉ siècle. Bois, chaque plateau 34 x 34 cm

Munich, Bayerisches Nationalmuseum

Assemblés à l'aide d'une charnière pour former un tablier pliant, les plateaux renferment, dans un cadre richement sculpté, deux compartiments d'un jeu de trictrac, la variante française du backgammon (cf. aussi ill. p. 373). Le décor figuratif représente, entre autres personnages, un chasseur et des chiens, une figure féminine, un couple d'amoureux ainsi qu'un mendiant. Les faces extérieures du tablier présentent un jeu du moulin et un jeu de dames, aux contours ornés des blasons de plusieurs villes. Les surfaces de jeu sont chacune marquetées de bois de différentes couleurs.

A–D. AMULET
German, 1st half of the 16th century. Silver gilt, engraved, cast
FORMERLY MUNICH, PRIVATE COLLECTION WITHIN THE NOBILITY — WHEREABOUTS UNKNOWN
The amulet is designed in the form of a winged altarpiece and, when opened, shows the Coronation of the Virgin (A) in the centre and St Barbara and St Andrew on the wings. In the closed position, the outer wings show the apostles Peter (B) and Paul (C). The back of the amulet is decorated with a Crucifixion featuring the Virgin Mary and St John the Evangelist (D).

E. MEDALLION
German, 16th century. Mother-of-pearl, gold, 4 x 3 cm / 1 ⅝ x 1 ⅛ in.
FORMERLY BERLIN, KUNSTGEWERBEMUSEUM – UNTRACED
The medallion, which has been untraced since 1945, shows a female bust carved from mother-of-pearl within a blue-enamelled gold frame.

F–I. FINGER RINGS
German, mid-16th century. Gold
FORMERLY IN THE POSSESSION OF THE BAVARIAN ROYAL FAMILY — WHEREABOUTS UNKNOWN
The finger rings were discovered in 1853, upon the opening of the Hohenzollern tombs in Heilsbronn abbey, near Ansbach. They had been buried with Marchioness Emilie of Saxony, the third wife of Margrave George the Pious.

K–P. ITEMS OF JEWELLERY WITH COATS OF ARMS AND RELIGIOUS MOTIFS
German, mid-16th century. Gold, silver, gems, pearls, enamel
FORMERLY IN THE POSSESSION OF THE EDITOR HEFNER-ALTENECK
WHEREABOUTS UNKNOWN

A

B C

O P

F H

D

G

M N

E

K L

I. v. HEFNER A I. KURMANN sc.

1530 — 1590.

(S. 333)

A–D. AMULETT

Deutsch, 1. Hälfte 16. Jahrhundert. Silber, vergoldet, graviert, gegossen
EHEMALS IN MÜNCHNER ADELSBESITZ – AUFBEWAHRUNGSORT UNBEKANNT
Das in Form eines Flügelaltares gestaltete Amulett zeigt im Inneren die Krönung Mariens (A) und auf den
Flügeln die Heiligen Barbara und Andreas. Auf der Rückseite (D) ist die Kreuzigung mit Maria und
Johannes dargestellt, und auf den Flügeln (B–C) sind die Apostel Petrus und Paulus zu sehen.

E. MEDAILLON

Deutsch, 16. Jahrhundert, Perlmutt. Gold, 4 x 3 cm
EHEMALS KUNSTGEWERBEMUSEUM, BERLIN – VERSCHOLLEN
Das 1945 verschollene Medaillon zeigte ein aus Perlmutt geschnittenes weibliches Brustbild
in blau emailliertem goldenem Rahmen.

F–I. FINGERRINGE

Deutsch, Mitte 16. Jahrhundert. Gold
EHEMALS IN KÖNIGLICH BAYERISCHEM BESITZ – AUFBEWAHRUNGSORT UNBEKANNT
Die Fingerringe wurden 1853 bei der Öffnung der Hohenzollern'schen Fürstengräber in Kloster Heilsbronn
bei Ansbach im Grab der Markgräfin Aemilia von Sachsen, der dritten Gemahlin des Markgrafen Georg,
des Frommen, entdeckt.

K–P. SCHMUCKSTÜCKE MIT WAPPEN UND SAKRALEN MOTIVEN

Deutsch, Mitte 16. Jahrhundert. Gold, Silber, Edelsteine, Perlen, Email
EHEMALS IM BESITZ DES HERAUSGEBERS HEFNER-ALTENECK
AUFBEWAHRUNGSORT UNBEKANNT

(p. 333)

A–D. AMULETTE
Allemagne, 1^{ère} moitié du XVI^e siècle. Argent, doré, gravé, fondu

AUTREFOIS EN LA POSSESSION DE NOBLES MUNICHOIS – LOCALISATION INCONNUE

L'amulette en forme de polyptyque représente, à l'intérieur, le couronnement de la Vierge (A) et, sur les volets, sainte Barbara et saint André. Au dos (D) est représentée la Crucifixion en présence de la Vierge et de saint Jean, tandis qu'on distingue, sur les volets (B–C), les apôtres Pierre et Paul.

E. MÉDAILLON
Allemagne, XVI^e siècle. Nacre, or, 4 x 3 cm

AUTREFOIS CONSERVÉ AU KUNSTGEWERBEMUSEUM BERLIN – DISPARU

Le médaillon, disparu en 1945, représentait le buste en nacre sculpté d'une femme, à l'intérieur d'un cadre d'or émaillé de bleu.

F–I. BAGUES
Allemagne, milieu du XVI^e siècle. Or

AUTREFOIS EN LA POSSESSION DES ROIS DE BAVIÈRE – LOCALISATION INCONNUE

Les bagues ont été découvertes en 1853 à l'occasion de l'ouverture des tombes princières des Hohenzollern dans l'abbaye de Heilsbronn, près de Ansbach. Elles se trouvaient dans la tombe de la margravine Émilie de Saxe, troisième épouse du margrave George I^{er}, dit le Pieux.

K–P. BIJOUX ORNÉS DE BLASONS ET DE MOTIFS SACRÉS
Allemagne, milieu du XVI^e siècle. Or, argent, pierres précieuses, perles, émail

AUTREFOIS EN LA POSSESSION DE HEFNER-ALTENECK
LOCALISATION INCONNUE

CASKET

Austrian, c. 1400. Leather, wood, iron, 16 x 25 x 13 cm / 6 ¼ x 10 x 5 in.

NUREMBERG, GERMANISCHES NATIONALMUSEUM

The casket consists of a wooden body that has been covered with brownish leather. The walls are decorated with the figures of fabulous beasts in emphatic relief. These were embossed into the steam-softened leather and their silhouettes then reinforced with incised lines. Such boxes frequently take up the medieval theme of courtly love (Ger. *Minne*) in their decoration and have become known in more recent times as *Minnekästchen* ("love boxes"; cf. also ills. pp. 439, 449). They were used to house documents, jewellery and, not infrequently, too, relics.

KÄSTCHEN

Österreichisch, um 1400. Leder, Holz, Eisen, 16 x 25 x 13 cm

NÜRNBERG, GERMANISCHES NATIONALMUSEUM

Das Kästchen besteht aus einem hölzernen Korpus, der mit bräunlichem Leder bezogen ist. Die Wandungen zieren Fabeltiere, die in kräftigem Relief aus dem in feuchter Hitze erweichten Leder herausgetrieben wurden. Die Umrisse wurden anschließend durch eingeschnittene Linien markiert. Derartige Kästchen, die in jüngerer Zeit oft als Minnekästchen bezeichnet werden (siehe auch Abb. S. 439, 449), dienten zur Aufbewahrung von Urkunden, Schmuck und nicht selten auch von Reliquien.

COFFRET

Autriche, vers 1400. Cuir, bois, fer, 16 x 25 x 13 cm

NUREMBERG, GERMANISCHES NATIONALMUSEUM

Le coffret est constitué d'un corps en bois recouvert de cuir brunâtre. Les parois sont ornées d'animaux fabuleux au relief très saillant – exécutés au repoussé sur un cuir ramolli à la chaleur humide – et aux contours marqués par des lignes incisées. Ce type de coffret, appelé à une époque plus récente « coffret de courtoisie » (cf. aussi ill. pp. 439, 449), était destiné à la conservation de papiers officiels, de bijoux et, fréquemment, de reliques.

MONSTRANCE

German, c. 1500. Silver gilt, h. 58.3 cm / 23 in.

FORMERLY IN A PRIVATE COLLECTION WITHIN THE NOBILITY — WHEREABOUTS UNKNOWN

The body of the Late Gothic monstrance is flanked by flying buttresses. At its centre is the glass-fronted receptacle for the Host with the lunette, the crescent-shaped clip that holds the Host, which are not visible in the representation.

MONSTRANZ

Deutsch, um 1500. Silber, vergoldet, 58.3 cm hoch

EHEMALS IN ADELIGEM PRIVATBESITZ – AUFBEWAHRUNGSORT UNBEKANNT

Die spätgotische Monstranz ist mit Fialen verziert. Im Zentrum des Korpus befindet sich die mit Glas verschlossene Aussparung für die Hostie mit der Lunula, dem halbmondförmigen Träger, die auf der Darstellung nicht zu sehen sind.

OSTENSOIR

Allemagne, vers 1500. Argent, doré, hauteur 58,3 cm

AUTREFOIS EN LA POSSESSION DE NOBLES – LOCALISATION INCONNUE

L'ostensoir du gothique tardif est orné de pinacles. Au centre du corps se trouve l'emplacement destiné à accueillir l'hostie, lequel est fermé par un disque de verre et contient la lunule, le support en forme de demi-lune.

B

A

1480 —

1510

6 Par. Zoll

J.H. v. Hefner-A.

J. Klipphahn. sc.

CANDLEHOLDER
Lower Lorraine, 2nd half of the 12th century. Copper, cast and gilded, h. 13.8 cm / 5 ½ in.
ÜBERLINGEN, MINSTER OF ST NICHOLAS
The Romanesque candleholder is decorated with zoomorphic motifs, whereby the battle
of the eagle against the dragon symbolizes Christ's triumph over Evil.

LEUCHTER
Niederlothringisch, 2. Hälfte 12. Jahrhundert. Kupfer, gegossen und vergoldet, 13,8 cm hoch
ÜBERLINGEN, MÜNSTERKIRCHE ST. NIKOLAUS
Den romanischen Leuchter ziert reicher zoomorpher Schmuck, wobei der Kampf der Adler
gegen die Drachen den Triumph Christi über das Böse symbolisiert.

CHANDELIER
Basse-Lorraine, 2ᵉ moitié du XIIᵉ siècle. Cuivre, fondu et doré, hauteur 13,8 cm
UBERLINGEN, ÉGLISE SAINT-NICOLAS
Le chandelier roman est décoré de riches ornements zoomorphes, le combat entre aigles
et dragons symbolisant ici le triomphe du Christ sur le Mal.

(pp. 342/43)
RELIEF
South German, 1527. Solnhofen stone, 17 x 22 cm / 6 ¾ x 8 ½ in.
FORMERLY MEININGEN, PRIVATE COLLECTION – WHEREABOUTS UNKNOWN
The two knights are identified as Habsburg princes by the imperial double-headed
eagle and the Bohemian lion. The event to which the relief refers nevertheless remains unclear.

(S. 342/343)
RELIEF
Süddeutsch, 1527. Solnhofener Stein, 17 x 22 cm
EHEMALS IN MEININGER PRIVATBESITZ, AUFBEWAHRUNGSORT UNBEKANNT
Die dargestellten Ritter werden durch den kaiserlichen Doppeladler und den böhmischen Löwen als
Habsburger Fürsten gekennzeichnet. Dennoch ist fraglich, auf welches Ereignis das Relief verweist.

(pp. 342/343)
RELIEF
Allemagne du Sud, 1527. Pierre de Solnhofen, 17 x 22 cm
AUTREFOIS EN LA POSSESSION D'UN PARTICULIER À MEININGEN – LOCALISATION INCONNUE
L'aigle impérial à deux têtes et le lion de Bohême permettent d'identifier les chevaliers représentés
sur la planche comme étant des princes habsbourgeois. Il n'est guère possible, toutefois,
de définir l'événement auquel se réfère le relief.

I. H. v. Hefner-A. del.

I. Klipphahn. sc.

3 Par. Zoll.

1050 — 1100.

CROOK OF A CROSIER, "CURVA"

French, mid-14th century. Ivory, h. 19.5 cm / 7 ⅝ in.

FORMERLY ALTAICH, BENEDICTINE ABBEY (?)

MUNICH, BAYERISCHES NATIONALMUSEUM

The crook, or *curva*, of the crosier contains the figural scene of the Coronation of the Virgin: an angel places the crown on Mary's head as she receives the blessing of God the Father. Below, a seated angel holds one end of a leafy Gothic tendril that runs up and over the outside of the crook. The plate also offers a rear view of the crook on a smaller scale. Traces of the original painting have survived, whereby they are seen more clearly on the plate than is the case in real life.

KRÜMME EINES BISCHOFSSTABS, „CURVA"

Französisch, Mitte 14. Jahrhundert. Elfenbein, 19,5 cm hoch

EHEMALS BENEDIKTINERABTEI ALTAICH (?)

MÜNCHEN, BAYERISCHES NATIONALMUSEUM

Die Curva zeigt innerhalb der mit gotischem Laubwerk verzierten Ranke, die von einem sitzenden Engel getragen wird, eine Marienkrönung. Während ein Engel der Gottesmutter die Krone aufsetzt, segnet Gottvater Maria. Die Rückseite der Curva ist auf der Tafel in kleinerem Maßstab dargestellt. Spuren der farbigen Fassung haben sich erhalten und sind auf der Tafel deutlicher wiedergegeben, als sie am Original erhalten sind.

CROSSERON D'ÉVÊQUE « CURVA »

France, milieu du XIVᵉ siècle. Ivoire, hauteur 19,5 cm

AUTREFOIS CONSERVÉ À L'ABBAYE BÉNÉDICTINE D'ALTAICH (?)

MUNICH, BAYERISCHES NATIONALMUSEUM

Le crosseron représente, à l'intérieur d'un sarment richement orné de feuillages gothiques et soutenu par un ange assis, le couronnement de la Vierge. Un ange pose la couronne sur la mère de Dieu, alors que celle-ci reçoit la bénédiction de Dieu le Père. La face postérieure du crosseron figure ici à une échelle plus petite. Des traces du revêtement de couleur sont conservées ; sur la planche, elles sont reproduites avec plus de netteté qu'elles n'apparaissent sur l'original.

1300 — 1350.

Lith. HEFNER-ALTENECK.

C. REGNIER.

PAIR OF SAINTS
Master of Ottobeuren, South German, 1510–20. Lime, h. 176 cm / 69 ¼ in.
NUREMBERG, GERMANISCHES NATIONALMUSEUM
The figures of St Martin and St Barbara adorn one of the two side pieces of a carved altarpiece.
Together with the saints reproduced on plate 53 (ill. p. 349), who appear on the opposite side,
they flank the main scene in the central panel. The original still retains its polychrome decoration,
although its colours have suffered some damage by comparison with the plate.

HEILIGENPAAR
Meister von Ottobeuren, süddeutsch, 1510–1520. Lindenholz, 176 cm hoch
NÜRNBERG, GERMANISCHES NATIONALMUSEUM
Die Heiligen Martin und Barbara zieren eines der beiden Seitenstücke eines Schnitzaltars.
Gemeinsam mit dem anderen Seitenelement, das die auf Tafel 53 abgebildeten Heiligen zeigt (Abb. S. 349),
flankiert das Heiligenpaar die zentrale Darstellung im Mittelfeld des Altars. Die alte farbige Fassung hat
sich am Original erhalten, ist jedoch im Gegensatz zur Darstellung auf der Tafel nicht unbeschädigt.

COUPLE DE SAINTS
Maître d'Ottobeuren, Allemagne du Sud, 1510-1520. Bois de tilleul, hauteur 176 cm
NUREMBERG, GERMANISCHES NATIONALMUSEUM
Saint Martin et sainte Barbara ornent l'un des deux volets latéraux d'un retable sculpté.
La scène centrale du polyptyque est flanquée, de l'autre côté, des saints figurant en planche 53 (ill. p. 349).
Des traces de couleur sont conservées sur l'original. Cependant, contrairement à ce que montre
l'illustration reproduite sur la planche, cette peinture n'est pas intacte.

1510 — 1530.

PAIR OF SAINTS

Master of Ottobeuren, South German, 1510–20. Lime, h. 157 cm / 61 ¾ in.
NUREMBERG, GERMANISCHES NATIONALMUSEUM
The plate shows St Margaret and St George.

HEILIGENPAAR

Meister von Ottobeuren, süddeutsch, 1510–1520. Lindenholz, 157 cm hoch
NÜRNBERG, GERMANISCHES NATIONALMUSEUM
Die Tafel zeigt die Heiligen Margaret und Georg.

COUPLE DE SAINTS

Maître d'Ottobeuren, Allemagne du Sud, 1510–1520. Bois de tilleul, hauteur 157 cm
NUREMBERG, GERMANISCHES NATIONALMUSEUM
La planche montre sainte Marguerite et saint Georges.

1510 — 1530.

LECTERN
Bavarian, 2nd half of the 15th century. Pearwood, partly painted, d. 24 cm / 9 ½ in.
MUNICH, BAYERISCHES NATIONALMUSEUM
The slanting bookrest, designed to support a missal, originates from a village church in Upper Bavaria.

LESEPULT
Bayerisch, 2. Hälfte 15. Jahrhundert. Birnbaum, teilweise bemalt, 24 cm tief
MÜNCHEN, BAYERISCHES NATIONALMUSEUM
Das Pult für ein Messbuch stammt aus einer oberbayerischen Dorfkirche.

PUPITRE
Bavière, 2ᵉ moitié du XVᵉ siècle. Poirier, partiellement peint, profondeur 24 cm
MUNICH, BAYERISCHES NATIONALMUSEUM
Ce porte-missel provient de l'église d'un village de Haute-Bavière.





COVER OF A LECTIONARY
Weser region, 2nd quarter of the 13th century; Limoges, early 13th century
Wood, copper gilt, enamel, gems, h. 32 cm / 12 ⅝ in.
PADERBORN, ERZBISCHÖFLICHES DIÖZESANMUSEUM
The cover consists of an inner core of wood, 3.5 cm (1 ⅜ in.) thick, encased in copper gilt. It was probably assembled from older elements after the abbey of St Aegidius in Braunschweig burned down in 1278, and adorns a lectionary – a collection of the readings and sermons for all the Sundays and feast days in the Church year. The Virgin with the Christ Child in her lap, both with their right hand raised in blessing, and the Evangelist symbols in the corners were cast in different workshops in the Weser region in the 2nd quarter of the 13th century, but were chased by the same master. The round medallions each show an allegorical scene of a man vanquishing a beast. They were made in Limoges in the opening years of the 13th century as part of the mounts for a box or chest.

EINBANDDECKEL EINES LEKTIONARS
Weserraum, 2. Viertel 13. Jahrhundert; Limoges, Anfang 13. Jahrhundert
Holz, Kupfer, vergoldet, Email, Edelsteine, 32 cm hoch
PADERBORN, ERZBISCHÖFLICHES DIÖZESANMUSEUM
Der Einbanddeckel besteht aus vergoldetem Kupferblech, das einen 3,5 cm starken Holzkern überzieht. Der Einband ist vermutlich nach dem Brand des Ägidienklosters in Braunschweig 1278 aus älteren Teilen zusammengesetzt worden und schmückt ein Lektionar, eine Textsammlung der Lesungen und Predigten sämtlicher Sonn-, Fest- und Gedenktage des Kirchenjahres. Die segnende Muttergottes mit segnendem Christuskind auf dem Schoß und die Evangelistensymbole in den Ecken wurden in unterschiedlichen Werkstätten des Weserraumes im 2. Viertel des 13. Jahrhunderts gegossen, aber von einem einzigen Meister ziseliert. Die Rundmedaillons mit den allegorischen Tierbezwingern stammen aus Limoges. Sie wurden zu Beginn des 13. Jahrhunderts als Teile von Beschlägen für einen Koffer oder Kasten gefertigt.

COUVERTURE D'UN LECTIONNAIRE
Vallée de la Weser, 2ᵉ quart du XIIIᵉ siècle ; Limoges, début du XIIIᵉ siècle
Bois, cuivre, doré, émail, pierres précieuses, hauteur 32 cm
PADERBORN, ERZBISCHÖFLICHES DIÖZESANMUSEUM
La couverture est constituée d'un noyau en bois d'une épaisseur de 3,5 cm recouvert d'une lame de cuivre dorée. Probablement assemblée à partir d'éléments plus anciens après l'incendie de l'abbaye Saint-Gilles à Brunswick en 1278, elle orne un lectionnaire – un recueil des lectures et sermons pour l'ensemble des dimanches, fêtes et commémorations de l'année liturgique. Les figures de la Vierge et de l'Enfant Jésus, qu'elle tient sur ses genoux, tous deux faisant un geste de bénédiction, ainsi que les symboles des évangélistes ont été fondus dans la vallée de la Weser pendant le deuxième quart du XIIIᵉ siècle. Issus de différents ateliers, ils ont néanmoins été ciselés par le même maître. Les *tondi*, qui représentent les figures allégoriques de vainqueurs d'animaux, proviennent de Limoges. Ils ont été exécutés au début du XIIIᵉ siècle en tant qu'éléments de ferrures destinés à une malle ou à un coffre.

3. Par Zoll.

1280 — 1320.

COVERED BEAKER
South German, late 15th century. Silver, partly gilded, enamelled, h. 31.6 cm / 12 ½ in.
PURCHASED IN THE MID-19TH CENTURY FOR A BRITISH PRIVATE COLLECTION
WHEREABOUTS UNKNOWN
The covered beaker formerly belonged to the Ingolstadt Shooting Association. Its three feet bear the Ingolstadt coat of arms and two shields showing gold crossbows on a blue ground. The cover is crowned by the figure of St Sebastian, the association's patron saint. A masterpiece of virtuoso goldsmithery, the beaker features a "tree-stump" or "knob" decoration, in which tree branches – studded with low knobs that resemble the stumps of sawn-off branches – alternate with gilt bands that trace a slight curve as they rise.

DECKELBECHER
Süddeutsch, Ende 15. Jahrhundert. Silber, teilweise vergoldet, emailliert, 31,6 cm hoch
MITTE DES 19. JAHRHUNDERTS IN BRITISCHEN PRIVATBESITZ VERKAUFT
AUFBEWAHRUNGSORT UNBEKANNT
Bei dem Deckelbecher handelt es sich um einen Pokal der Schützengesellschaft in Ingolstadt. Die drei Füße tragen das Ingolstädter Stadtwappen und zwei Wappenschilde mit goldenen Armbrüsten auf blauem Grund. Den Deckel des Bechers bekrönt der Schutzpatron der Schützengesellschaft, der heilige Sebastian. Das goldschmiedekünstlerische Virtuosenstück ist ein Pokal des Typus „knorrichter Becher", wobei der Korpus alternierend mit schräg laufenden Bändern und Ästen mit Ansätzen von Knorren abgehauener Zweige geschmückt ist.

GOBELET À COUVERCLE
Allemagne du Sud, fin du XVe siècle. Argent, partiellement doré, émaillé, hauteur 31,6 cm
VENDU À UN PARTICULIER BRITANNIQUE AU MILIEU DU XIXe SIÈCLE
LOCALISATION INCONNUE
Il s'agit d'une coupe de la société de tir d'Ingolstadt. Ses trois pieds arborent le blason de la ville et deux écus portant des arbalètes dorées sur fond bleu. Le couvercle de la coupe est surmonté d'une statuette du saint patron de la société de tir, saint Sébastien. Exécutée par un orfèvre virtuoso, la pièce appartient aux coupes du type « gobelets noueux » : son corps est orné de rubans inclinés alternant avec des troncs d'arbres parsemés de naissances de branches coupées.

1480 — — 1500.

3 Par. Zoll

J. KLIFFHAHN. SC.

MUSIC STAND
Venice, 2nd half of the 15th century
Wood, bronze, h. c. 225 cm / 88 ½ in., plinth: w. 97 cm / 38 ⅛ in.
VERONA, S. ZENO
The stand is lavishly decorated with geometrically patterned intarsia that juxtaposes pale and
dark natural woods to achieve contrasting effects. The protruding nails are made of green bronze.
The chest-like plinth was used to store choir books.

SINGEPULT
Venedig, 2. Hälfte 15. Jahrhundert. Holz, Bronze, ca. 225 cm hoch, Sockel 97 cm breit
VERONA, S. ZENO
Das Singepult ist aufwendig mit abstraktem Intarsienschmuck verziert, wobei immer
dunkle Naturhölzer kontrastierend gegen helle gesetzt sind. Die vorstehenden Nägel bestehen
aus grüner Bronze. Der Kastensockel dient zur Aufbewahrung der Chorbücher.

PUPITRE DE CHANT
Venise, 2ᵉ moitié du XVᵉ siècle. Bois, bronze, hauteur env. 225 cm, socle: largeur 97 cm
VÉRONE, BASILIQUE SAINT-ZÉNON
Le pupitre de chant est richement décoré d'ornements abstraits en marqueterie, où bois
sombre et bois clair ne cessent de contraster l'un avec l'autre. Les clous saillants sont en bronze vert.
Le socle rectangulaire sert à recueillir les antiphonaires.

CEREMONIAL CHAIN

Munich, mid-15th century. Silver, cast, chased, enamelled

MUNICH, STADTMUSEUM

The Münchner Armbrust- und Stachelschützenbruderschaft (Munich Fraternity of Crossbowmen and Arbalestiers), whose members were drawn from the nobility and upper bourgeoisie, existed from the 15th century right up to 1659. The ceremonial chain of the association illustrated here later passed into the possession of Munich's municipal treasury and is today housed in the Stadtmuseum. The chain comprises a total of 36 shields (cf. also ills. pp. 361, 363) and a pendant. The chain is fastened to a pectoral (not shown) in the form of a circular shield commemorating a celebratory shoot in 1577. The sculpturally modelled falcon reproduced on the plate hangs from this pectoral. The plate also shows four shields from the years 1510 and 1550.

SCHÜTZENKETTE

München, Mitte 15. Jahrhundert. Silber, gegossen, ziseliert, emailliert

STADTMUSEUM MÜNCHEN

Die Münchner Armbrust- und Stachelschützenbruderschaft bestand als Vereinigung von Adeligen und vornehmen Bürgern vom 15. Jahrhundert bis zum Jahr 1659. Die Schützenkette der Bruderschaft kam später in den Besitz der Stadtkammer und wird heute im Stadtmuseum aufbewahrt. Das Stück besteht aus einem Anhänger und insgesamt 36 Schilden (siehe auch Abb. S. 361, 363). Geschlossen wird die Schützenkette an einem hier nicht gezeigten Brustteil, einem Rundschild zur Erinnerung an das Festschießen von 1577. An diesem Brustteil hängt der abgebildete plastisch gearbeitete Falke. Die Tafel zeigt außerdem vier Schilde aus den Jahren 1510 und 1550.

CHAÎNE D'UNE CONFRÉRIE DE TIREURS

Munich, milieu du XVᵉ siècle. Argent, fondu, ciselé, émaillé

MUNICH, STADTMUSEUM

Fondée au XVᵉ siècle, la confrérie munichoise des tireurs à l'arbalète et à l'arc d'acier (Armbrust- und Stachelschützenbruderschaft) a existé, jusqu'en 1659, en tant qu'assemblée de nobles et de bourgeois distingués. La chaîne, qui entra plus tard en la possession du trésor de la ville, est aujourd'hui conservée au Stadtmuseum (musée de la ville). Elle est constituée, au total, de 36 blasons (cf. aussi ill. pp. 361, 363) et d'un pendentif. Le fermoir se situe au niveau d'un élément pectoral ne figurant pas sur la planche, un bouclier rond commémorant le tir festif de l'année 1577. À cet élément pectoral est accroché le faucon exécuté en relief et reproduit sur la planche. Celle-ci montre, en outre, quatre blasons datant des années 1510 et 1550.

I. H. v. Hefner-A.

I. Klietmann sc.

1460 — 1550.

CEREMONIAL CHAIN
Munich, mid-15th century. Silver, cast, chased, enamelled
MUNICH, STADTMUSEUM

The 36 shields on the ceremonial chain (cf. also ills. pp. 359, 363) date from the period of the association's existence, namely from the 15th century until 1659, and from the 19th century, when they were added to the chain on the occasion of the Oktoberfest. The oldest shield on the chain (A) was presented by Duke Hans of Bavaria in 1463. The second-oldest shield (B), dating from 1486, was presented by the Munich patrician Heinrich Bart (spelled "part" by Hefner-Alteneck). The most recent shield, not illustrated here, dates from 1832.

SCHÜTZENKETTE
München, Mitte 15. Jahrhundert. Silber, gegossen, ziseliert, emailliert
STADTMUSEUM MÜNCHEN

Alle 36 Schilde der Schützenkette (siehe auch abb. S. 359, 363) stammen aus der Zeit, in der die Schützenbruderschaft existierte (vom 15. Jahrhundert bis zum Jahr 1659) und aus dem 19. Jahrhundert, als sie der Kette anlässlich des Oktoberfestes hinzugefügt wurden. Der älteste Schild (A) der Schützenkette wurde 1463 von Herzog Hans von Bayern gestiftet. Den zweitältesten Schild (B) von 1486 stiftete der Münchner Patrizier Heinrich Bart (bei Hefner-Alteneck „part" geschrieben). Der jüngste, nicht abgebildete Schild stammt aus dem Jahr 1832.

CHAÎNE D'UNE CONFRÉRIE DE TIREURS
Munich, milieu du XVᵉ siècle. Argent, fondu, ciselé, émaillé
MUNICH, STADTMUSEUM

Les 36 blasons de la chaîne (cf. aussi ill. pp. 359, 363) datent de la période durant laquelle la confrérie de tireurs a existé (du XVᵉ siècle jusqu'en 1659) et du XIXᵉ siècle où ils furent ajoutés à la chaîne à l'occasion de la Fête de la bière. Le plus ancien d'entre eux a été offert en 1463 par le duc Jean de Bavière (A). Le deuxième blason par rang d'âge (B), datant de 1486, est un don du patricien munichois Heinrich Bart (orthographié « part » chez Hefner-Alteneck). Le blason le plus récent, ne figurant pas sur la planche, date de 1832.

B.

C.

A.

D.

E.

J. H. v. HEFNER-ALTENECK.

L. KLIPPHAHN. SC.

CEREMONIAL CHAIN
Munich, mid-15th century. Silver, cast, chased, enamelled
MUNICH, STADTMUSEUM
The plate shows two shields presented by Bavarian dukes in 1511 and 1550 (cf. also ills. pp. 359, 361).

SCHÜTZENKETTE
München, Mitte 15. Jahrhundert. Silber, gegossen, ziseliert, emailliert
STADTMUSEUM MÜNCHEN
Die Tafel zeigt zwei von bayerischen Herzögen gestiftete Schilde von 1511 und 1550 (siehe auch Abb. S. 359, 361).

CHAÎNE D'UNE CONFRÉRIE DE TIREURS
Munich, milieu du XV^e siècle. Argent, fondu, ciselé, émaillé
MUNICH, STADTMUSEUM
La planche présente deux blasons datant de 1511 et 1550 et constituant des dons de ducs bavarois (cf. aussi ill. pp. 359, 361).

ᒍAL.BRECHTᒍHERᒍ INᒍBAIGERN ᒍ1550ᒍ

WILHELMᒍ HERZOGᒍINᒍPAIRNᒍ1511ᒍ

TARGE, CEREMONIAL SHIELD
Lower Rhenish, c. 1500. Silver, partly gilded, h. 12 cm / 4 ¾ in.
PARIS, MUSÉE DE CLUNY
The ceremonial silver shield was forged for the Konfraternitas sancti Hermetis martyr (Confraternity of St Hermetus the Martyr), an association based in the Lower Rhenish village of Warbeyen, near Kleve. According to his legend, Hermetus (more accurately, Hermes) was a Roman soldier in the 3rd century AD. He became prefect of Rome, where he was persecuted and beheaded. According to the inscription, the shield is dedicated to Jesus, Mary and St Hermetus as patron saints of the association. The figures of the Virgin and Hermetus are cast. Hanging beneath the shield are a bird perched on a branch and a crossbow (not visible). The shield itself is suspended from a crown.

TARTSCHE, SCHÜTZENSCHILD
Niederrheinisch, um 1500. Silber, teilweise vergoldet, 12 cm hoch
PARIS, MUSÉE DE CLUNY
Der Schild der Schützengilde Confraternitas Sancti Hermetis martyr (Bruderschaft des heiligen Märtyrers Hermetus) des Dorfes Warbeyen bei Kleve am Niederrhein ist geschmiedet. Der Soldatenheilige Hermetus von Rom (eigentlich: Hermes) war der Legende nach im 3. Jahrhundert n. Chr. Präfekt von Rom und wurde enthauptet. Der Schild ist laut Inschrift Jesus, Maria und dem heiligen Hermetus als Schutzpatronen gewidmet. Die Figuren der Madonna und des Schutzheiligen Hermetus sind gegossen. Unten am Schild hängen ein auf einem Ast sitzender Vogel und eine Armbrust. Der Schild selbst hängt an einer Krone.

RONDACHE, BOUCLIER DE TIREUR
Basse-Rhénanie, vers 1500. Argent, partiellement doré, hauteur 12 cm
PARIS, MUSÉE DE CLUNY
Le bouclier de la société de tireurs « Confraternitas Sancti Hermetis » (confrérie du saint martyr Hermès) du village de Warbeyen près de Clèves, sur les bords du Rhin inférieur, est forgé. D'après la légende, le saint soldat Hermès, préfet de Rome au III^e siècle apr. J.-C., aurait été décapité. Le bouclier, comme l'atteste l'inscription, est dédié à Jésus, à Marie et à saint Hermès en leur qualité de saints patrons. Les sculptures de la Vierge à l'Enfant et de Hermès sont fondues. Un oiseau assis sur une branche ainsi qu'une arbalète sont suspendus au bouclier, lui-même suspendu à une couronne.

1470 — 1490.

ASCHAFFENBURG BOARD GAME

Rhenish (?), c. 1300. Wood, silver, jasper, earthenware, enamel, rock crystal, 46 x 34.5 cm / 18 ⅛ x 13 ⅝ in.
ASCHAFFENBURG, STIFTMUSEUM, STIFTSCHATZ ST. PETER UND ALEXANDER
The sumptuous Aschaffenburg Board Game is the oldest chequerboard in Germany (cf. also ill. p. 34).
It was discovered in 1854 during restoration work on the St Valentine altarpiece in Aschaffenburg's
collegiate church. Relics were housed in the compartments at the side of the board. According to an entry
in the *Würzburger Register*, an appendix to *Das Hallesche Heiltum* (cf. ill. p.87), the reliquary formed
part of the famous collection of relics assembled by Cardinal Albrecht of Brandenburg in Halle and
accompanied the latter when he moved to Aschaffenburg. One side of the board contains a chequerboard
(ills. pp. 367–71) and the other a tric-trac board (ills. pp. 373, 375).
Plate 62 shows one half of the chequerboard.

„ASCHAFFENBURGER BRETTSPIEL"

Rheinländisch (?), um 1300. Holz, Silber, Jaspis, Ton, Email, Bergkristall , 46 x 34,5 cm
ASCHAFFENBURG, STIFTMUSEUM, STIFTSCHATZ ST. PETER UND ALEXANDER
Bei dem kostbaren „Aschaffenburger Brettspiel" handelt es sich um das älteste Schachbrett in Deutschland
(siehe auch Abb. S. 34). Es wurde 1854 bei Restaurierungsarbeiten am Valentins-Altar in der
Aschaffenburger Stiftskirche entdeckt. In den Kästchen des Spiels befanden sich Reliquien.
Einer Beschreibung im *Würzburger Register* zufolge, bei dem es sich um einer Ergänzung zum *Halleschen
Heiltum* (siehe Abb. S. 87) handelt, gehörte das Reliquiar Kardinal Albrecht von Brandenburg
und kam mit diesem nach Aschaffenburg. Auf der einen Seite des Brettspiels befindet sich ein Schachspiel
(Abb. S. 367–371), auf der anderen Seite ein Tric-Trac-Spiel (Abb. S. 373, 375).
Tafel 62 zeigt eine Hälfte der Schachspielseite.

« JEU DE SOCIÉTÉ D'ASCHAFFENBOURG »

Rhénanie (?), vers 1300. Bois, argent, jaspe, argile, émail, cristal de roche, 46 x 34,5 cm
ASCHAFFENBOURG, STIFTMUSEUM, STIFTSCHATZ ST. PETER UND ALEXANDER
Le précieux « jeu de société d'Aschaffenbourg » est l'échiquier le plus ancien d'Allemagne (cf. aussi ill. p. 34).
Il fut découvert en 1854 lors de la restauration, dans la collégiale d'Aschaffenbourg, de l'autel dédié à saint
Valentin. Les coffrets du jeu renfermaient des reliques. D'après une description contenue dans le
Würzburger Register, lequel complète le *Hallesches Heiltum* (trésor sacré de Halle, cf. ill. p. 87), le reliquaire
appartenait au cardinal Albrecht de Brandebourg et parvint avec ce dernier jusqu'à Aschaffenbourg.
Une face de la tablette présente un jeu d'échecs (ill. pp. 367–371), l'autre un trictrac (ill. pp. 373, 375).
La planche 62 montre une moitié du jeu d'échecs.

4 Par Zoll

1270 — 1300

I. KLIPPHAHN. del e XX

ASCHAFFENBURG BOARD GAME

Rhenish (?), c. 1300. Wood, silver, jasper, earthenware, enamel, rock crystal, 46 x 34.5 cm / 18 ⅛ x 13 ⅝ in.
ASCHAFFENBURG, STIFTMUSEUM, STIFTSCHATZ ST. PETER UND ALEXANDER

Plate 63 shows the second half of the chequerboard. Compartments for storing the pieces are set back along the outer edges of the board. The "black" squares are inlaid with jasper, while the "white" squares are hollowed out and contain the figures of fabulous beasts, fashioned from cold-painted and gilded earthenware (cf. also ill. pp. 368/69). Each recess is sealed beneath a polished plate of rock crystal. The individual squares are separated by bands of embossed silver gilt decorated with enamel.

„ASCHAFFENBURGER BRETTSPIEL"

Rheinländisch (?), um 1300. Holz, Silber, Jaspis, Ton, Email, Bergkristall, 46 x 34,5 cm
ASCHAFFENBURG, STIFTMUSEUM, STIFTSCHATZ ST. PETER UND ALEXANDER

Tafel 63 zeigt die zweite Hälfte der Schachspielseite. Am Rand des Brettes sind versetzt Kästchen zur Aufbewahrung der Spielsteine angebracht. Die „schwarzen" Felder sind mit Jaspis eingelegt, die „weißen" Felder vertieft gearbeitet und mit geschliffenen Bergkristallplatten verschlossen; darin gemodelte Tonfiguren, kalt bemalt und vergoldet (siehe auch Abb. S. 368/369). Getrennt werden die Felder von Stegen aus getriebenem Silber, das vergoldet und mit Email verziert ist. Die Figuren der weißen Felder sind als Fabelwesen ausgebildet.

« JEU DE SOCIÉTÉ D'ASCHAFFENBOURG »

Rhénanie (?), vers 1300. Bois, argent, jaspe, argile, émail, cristal de roche, 46 x 34,5 cm
ASCHAFFENBOURG, STIFTMUSEUM, STIFTSCHATZ ST. PETER UND ALEXANDER

La planche 63 montre l'autre moitié du jeu d'échecs. De part et d'autre de l'échiquier sont placés, en sens opposé l'un par rapport à l'autre, des coffrets destinés à la conservation des pièces. Les cases « noires » sont incrustées de jaspe ; les cases « blanches » sont travaillées en creux et fermées par des plaques de cristal de roche polies ; à l'intérieur se trouvent des créatures fabuleuses modelées dans de l'argile, peintes à froid et dorées (cf. aussi ill. pp. 368/369). Les cases sont séparées les unes des autres par des bandes d'argent repoussé ; celui-ci est doré puis décoré d'émail.

1270 — 1300.

ASCHAFFENBURG BOARD GAME
Rhenish (?), c. 1300, Wood, silver, jasper, earthenware, enamel, rock crystal, 46 x 34.5 cm / 18 ⅛ x 13 ⅓ in.
ASCHAFFENBURG, STIFTMUSEUM, STIFTSCHATZ ST. PETER UND ALEXANDER
Plate 64 shows one half of the tric-trac board.

„ASCHAFFENBURGER BRETTSPIEL"
Rheinländisch (?), um 1300. Holz, Silber, Jaspis, Ton, Email, Bergkristall, 46 x 34,5 cm
ASCHAFFENBURG, STIFTMUSEUM, STIFTSCHATZ ST. PETER UND ALEXANDER
Tafel 64 zeigt eine Hälfte der Tric-Trac-Spielseite.

« JEU DE SOCIÉTÉ D'ASCHAFFENBOURG »
Rhénanie (?), vers 1300. Bois, argent, jaspe, argile, émail, cristal de roche, 46 x 34,5 cm
ASCHAFFENBOURG, STIFTMUSEUM, STIFTSCHATZ ST. PETER UND ALEXANDER
La planche 64 montre une moitié du jeu de trictrac.

4 Par:Zoll.

1270 — 1300.

J. KLIFFHAHN

ASCHAFFENBURG BOARD GAME
Rhenish (?), c. 1300. Wood, silver, jasper, earthenware, enamel, rock crystal, 46 x 34.5 cm / 18 ⅛ x 13 ⅓ in.
ASCHAFFENBURG, STIFTMUSEUM, STIFTSCHATZ ST. PETER UND ALEXANDER
Plate 65 reproduces a detail of the decoration of the tric-trac board, in which two figural scenes are shown in life size (A). The ornamental border (B) runs along the outside edges and can be seen when the board is folded up.

„ASCHAFFENBURGER BRETTSPIEL"
Rheinländisch (?), um 1300. Holz, Silber, Jaspis, Ton, Email, Bergkristall, 46 x 34,5 cm
ASCHAFFENBURG, STIFTMUSEUM, STIFTSCHATZ ST. PETER UND ALEXANDER
Auf Tafel 65 sind Details des Tric-Trac-Spielbretts mit figürlichen Szenen in Originalgröße wiedergegeben (A). Das ornamentale Dekorband (B) ziert die Kanten des Brettspiels, wenn es geschlossen ist.

« JEU DE SOCIÉTÉ D'ASCHAFFENBOURG »
Rhénanie (?), vers 1300. Bois, argent, jaspe, argile, émail, cristal de roche, 46 x 34,5 cm
ASCHAFFENBOURG, STIFTMUSEUM, STIFTSCHATZ ST. PETER UND ALEXANDER
La planche 65 restitue, grandeur nature, un détail de cette moitié du tablier. On y aperçoit des scènes pourvues de figures (A). Un bandeau ornemental (B) se déroule sur les bords du jeu lorsque celui-ci est en position fermée.

B

A

Original - Groesse.

1270 - 1300.

A–C. CANDLESTICK

Limoges, late 12th/early 13th century. Copper gilt, enamelled, h. 22.5 cm / 8 ⅞ in.

<small>FORMERLY MUNICH, PRIVATE COLLECTION – WHEREABOUTS UNKNOWN</small>

The copper candlestick is decorated with leafy ornament (B) and fabulous beasts (C).

D & E. DRIP TRAY

Rhenish, 12th century. Copper, partly gilded, engraved, ⌀ 12.4 cm / 4 ⅞ in.

<small>FORMERLY COLOGNE, ERZBISCHÖFLICHES DIÖZESANMUSEUM – WARTIME LOSS (?)</small>

Part of a candleholder, the drip tray (D and E) catches the melted candle wax and thus eliminates a danger. The decoration of the tray with dragon ornament correspondingly symbolizes the vanquishing of Evil.

A–C. LEUCHTER

Limoges, Ende 12./Anfang 13. Jahrhundert. Kupfer, vergoldet, emailliert, 22,5 cm hoch

<small>EHEMALS IN MÜNCHNER PRIVATBESITZ – AUFBEWAHRUNGSORT UNBEKANNT</small>

Der Kupferleuchter ist mit Ranken (B) und Fabelwesen (C) geschmückt.

D & E. TROPFSCHALE

Rheinisch, 12. Jahrhundert. Kupfer, teilvergoldet, graviert, ⌀ 12,4 cm

<small>EHEMALS ERZBISCHÖFLICHES DIÖZESANMUSEUM, KÖLN – KRIEGSVERLUST (?)</small>

Die Tropfschale eines Leuchters (D und E) verhindert das Herabtropfen des Wachses, bannt also eine Gefahr. Dementsprechend symbolisiert die Verzierung der Schale mit Drachenornamenten die Überwindung des Bösen.

A–C. CHANDELIER

Limoges, fin du XII^e/début du XIII^e siècle. Cuivre doré, émaillé, hauteur 22,5 cm

<small>AUTREFOIS EN LA POSSESSION D'UN PARTICULIER MUNICHOIS – LOCALISATION INCONNUE</small>

Le chandelier en cuivre est décoré de rinceaux (B) et de créatures fabuleuses (C).

D & E. BOBÈCHE

Rhénanie, XII^e siècle. Cuivre, partiellement doré, gravé, ⌀ 12,4 cm

<small>AUTREFOIS CONSERVÉE AU ERZBISCHÖFLICHES DIÖZESANMUSEUM, COLOGNE – PERTE DE GUERRE (?)</small>

Empêchant la cire de goutter, la bobèche d'un chandelier (D et E) conjure un danger. Aussi les ornements en forme de dragons ornant la coupelle symbolisent-ils le triomphe sur le Mal.

II.

66.

2 P. Z.

C

E

B

D

1150.

1200.

A

LIТн. HEFNER-ALTENECK. del.

C.R. sc.

3 Par. Zoll

(pp. 378–81)
TARGE
German, 15th century. Steel, etched, h. 47.8 cm / 18 ¾ in.

FORMERLY MEININGEN, THURINGIA , BURG LANDSBERG – WHEREABOUTS UNKNOWN
The centre of the targe bears an etched representation of the Roman Mucius Scaevola, holding his right hand in the fire (ill. p. 381). A procession of Tritons and Nereids is portrayed beneath the buckler.

(S. 378–381)
TARTSCHE
Deutsch, 15. Jahrhundert. Stahl, geätzt, 47,8 cm hoch

EHEMALS BURG LANDSBERG THÜRINGEN – AUFBEWAHRUNGSORT UNBEKANNT
Im Zentrum des Schildes befindet sich die eingeätzte Darstellung des Römers Mutius Scaevola, der seine Hand im Feuer verbrennt (Abb. S. 381). Unter dem Armschutz ist ein Zug von Tritonen und Nereiden dargestellt.

(pp. 378–381)
RONDACHE
Allemagne, XVe siècle. Acier, déroché, hauteur 47,8 cm

AUTREFOIS CONSERVÉE DANS LE CHÂTEAU DE LANDSBERG/THURINGE – LOCALISATION INCONNUE
Au centre du bouclier figure la représentation gravée à l'eau-forte du Romain Mucius Scaevola, qui fait brûler sa main dans le feu (ill. p. 381). Sous le brassard défile un cortège de Tritons et de Néréides.

RELIQUARY CROSS

Bavarian, early 15th century

Copper, gilded and silvered; gems, diamonds, pearls, 57.2 x 32 x 17.5 cm / 22 ½ x 12 ⅝ x 6 ⅞ in.

INGOLSTADT, CATHOLIC MINSTER OF OUR LADY, TREASURY

The front (A) has at its centre a number of slivers from the True Cross that have been fashioned into the shape of a crucifix (C). The arms of the reliquary cross are studded with gems and its edges with twenty-five pearls. Four diamonds surround the actual relic. The back (B) reveals an Ecce Homo scene at the centre and the symbols of the Evangelists at the four ends of the cross. The Bavarian heraldic lozenges in the decoration refer to the donor, Duke Stephan III of Bavaria. His son, Louis the Bearded of Bavaria-Ingolstadt, added a shaft and a pedestal in the shape of Calvary Hill to the reliquary cross, and in 1432 donated it to the new minster in Ingolstadt.

KREUZRELIQUIAR

Bayerisch, Anfang 15. Jahrhundert

Kupfer, vergoldet und versilbert, Edelsteine, Diamanten, Perlen, 57,2 x 32 x 17,5 cm

INGOLSTADT, KATHOLISCHE STADTPFARRKIRCHE ZUR SCHÖNEN UNSERER LIEBEN FRAU, SCHATZKAMMER

Im Zentrum der Vorderseite (A) befinden sich zu einem Kreuz gefügte Partikel vom Kreuz Christi (C). Die Kreuzarme sind mit Edelsteinen, die Ränder des Kreuzes mit 25 Perlen besetzt. Zu Seiten der Reliquie befinden sich vier Diamanten. Die Rückseite (B) zeigt im Zentrum des Kreuzes eine Darstellung der Ecce-Homo-Szene und an den Kreuz-Enden die Evangelistensymbole. Die Verzierung mit bayerischen Wappenrauten verweist auf den Stifter Herzog Stephan den Kneißel. Sein Sohn, Herzog Ludwig der Gebartete von Bayern-Ingolstadt, ergänzte das Kreuz durch einen Schaft und ein Postament in Form eines Kalvarienberges und schenkte es 1432 der neuen oberen Pfarrkirche.

RELIQUAIRE DE LA SAINTE CROIX

Bavière, début du XVᵉ siècle

Cuivre, doré et argenté, pierres précieuses, diamants, perles, 57,2 x 32 x 17,5 cm

INGOLSTADT, TRÉSOR DE LA CATHÉDRALE DE NOTRE-DAME

Au centre de la face avant (A) se trouvent des fragments de la croix du Christ rassemblés en une croix (C). Les branches de la croix-reliquaire sont garnies de pierres précieuses, ses bords, de 25 perles. La relique est flanquée de quatre diamants. Sur la face arrière (B) du reliquaire on distingue, au centre, une représentation de l'Ecce Homo et, aux extrémités, les symboles des évangélistes. L'ornementation héraldique en forme de losanges bavarois renvoie au donateur, le duc Étienne III de Bavière. Son fils, le duc Louis VII de Bavière-Ingolstadt, dit le Barbu, compléta la croix par une hampe et une terrasse en forme de Calvaire, puis en fit présent à la cathédrale en 1432.

A

B

C.

D

2 PARISER ZOLL .

MIRROR CASE

Paris, mid-14th century. Ivory, 12.3 x 12.2 cm / 4 ⅞ x 4 ¾ in.
Darmstadt, Hessisches Landesmuseum

The mirror case shows an episode from the story of the Château d'Amour, or Castle of Love, a standard decorative theme of cosmetic and toiletry items in the Middle Ages (cf. ills. pp. 229, 317). Venus, wearing a crown as queen of the castle, stands on top of the battlements, where two lovers approach her beseechingly. Two female attendants stand to one side, ready to assist the goddess of Love. In the foreground, three further attendants, carrying the key to the fortress and a spray of roses, are leading three knights up the steps to the castle gate. Two mouldings carved into the back of the ivory plaque are designed to hold the mirror. The original shows damage to the leaf decoration in the top left and bottom right-hand corners (cf. ill. p. 14).

SPIEGELKAPSEL

Paris, Mitte 14. Jahrhundert. Elfenbein, 12,3 x 12,2 cm
Darmstadt, Hessisches Landesmuseum

Die Spiegelkapsel zeigt eine Episode aus der Geschichte des Château d'Amour, der Burg der Liebe, einem Standardthema zur Zierde mittelalterlicher Gegenstände der Schönheitspflege (vgl. Abb. S. 229, 317). Hinter den Burgzinnen erhebt sich Venus als gekrönte Herrscherin der Burg, der sich bittend zwei Liebende nähern. Zwei Dienerinnen der Liebesgöttin stehen helfend zur Seite. Im Vordergrund der Darstellung führen drei weitere Dienerinnen, mit dem Burgschlüssel und einem Rosenzweig in Händen, drei Ritter die Treppe hinauf und zum Tor der Burg. Die Elfenbeinscheibe ist rückwärtig in zwei Profilierungen ausgedreht, die zur Aufnahme des Spiegels dienen. Das Original ist an dem Blattwerk links oben und rechts unten beschädigt (siehe Abb. S. 14).

VALVE DE MIROIR

Paris, milieu du XIVᵉ siècle. Ivoire, 12,3 x 12,2 cm
Darmstadt, Hessisches Landesmuseum

La valve de miroir montre un épisode emprunté à l'histoire du Château d'Amour, thème récurrent dans le décor des objets médiévaux dévolus aux soins de beauté (cf. ill. pp. 229, 317). Derrière les créneaux s'élève Vénus ; souveraine du château, elle porte une couronne. Deux amants s'approchent d'elle et l'implorent, aidés par deux servantes de la déesse de l'amour, lesquelles se tiennent à leurs côtés. Au premier plan de la scène, trois autres servantes, tenant dans leurs mains la clé du château et une branche de roses, conduisent trois chevaliers en haut de l'escalier menant à la porte de l'édifice. La valve en ivoire est pourvue, de l'autre côté, d'un dispositif d'accrochage servant à accueillir le miroir. Sur l'original, le feuillage est endommagé en haut à gauche et en bas à droite (cf. ill. p. 14).

1280 — 1320

A–D. CANDLESTICK
Limoges, late 13th century. Bronze with sunk enamel, 26 x 11 cm / 10 ¼ x 4 ⅜ in.
STAATLICHE MUSEEN ZU BERLIN, KUNSTGEWERBEMUSEUM
The candlestick foot is decorated with four enamelled coats of arms, namely twice with the arms of England with the three golden leopards (detail, B) and twice with the arms of Castile and León with castles and lions (A). The circular illustration (D) reproduces the underside of the footplate.

E. CANDLESTICK WITH ORNAMENTAL PATTERN
German, 13th century. Copper, h. 26 cm / 10 ¼ in.
NUREMBERG, GERMANISCHES NATIONALMUSEUM

F. CANDLESTICK
Saxon, c. 1200. Copper, h. 11.9 cm / 4 ⅝ in.
FORMERLY LEIPZIG, COLLECTION OF THE HISTORISCHER VEREIN – WHEREABOUTS UNKNOWN

A–D. LEUCHTER
Limoges, Ende 13. Jahrhundert. Bronze mit Grubenschmelz, 26 cm hoch, 11 cm breit
STAATLICHE MUSEEN ZU BERLIN, KUNSTGEWERBEMUSEUM
Auf der Fußplatte des Leuchters befinden sich vier emaillierte Wappenschilde. Zweimal wird das englische Wappen mit drei goldenen Leoparden (B) und zweimal das Wappen von Kastilien mit Burgen und von León mit Löwen (A) gezeigt. Die kreisrunde Abbildung (D) gibt die Oberfläche des Leuchterfußes wieder.

E. LEUCHTER MIT ORNAMENTALEM MUSTER
Deutsch, 13. Jahrhundert. Kupfer, 26 cm hoch
NÜRNBERG, GERMANISCHES NATIONALMUSEUM

F. LEUCHTER
Sächsisch, um 1200. Kupfer, 11,9 cm hoch
EHEMALS IM BESITZ DES HISTORISCHEN VEREINS LEIPZIG – AUFBEWAHRUNGSORT UNBEKANNT

A–D. CHANDELIER
Limoges, fin du XIIIᵉ siècle. Bronze avec émail champlevé, hauteur 26 cm, largeur 11 cm
STAATLICHE MUSEEN ZU BERLIN, KUNSTGEWERBEMUSEUM
Sur le dessus du pied se trouvent quatre blasons émaillés. Le blason anglais, avec ses trois léopards dorés (B), et celui de la Castille et de León, avec ses châteaux et ses lions (A), apparaissent respectivement deux fois. L'illustration circulaire (D) restitue la face supérieure du pied du chandelier.

E. CHANDELIER À MOTIF ORNEMENTAL
Allemagne, XIIIᵉ siècle. Cuivre, hauteur 26 cm
NUREMBERG, GERMANISCHES NATIONALMUSEUM

F. CHANDELIER
Saxe, vers 1200. Cuivre, hauteur 11,9 cm
AUTREFOIS EN LA POSSESSION DE LA SOCIÉTÉ D'HISTOIRE DE LEIPZIG – LOCALISATION INCONNUE

D

E

5 P. Z.

F

2 P. Z.

B

C

1160 -

- 1220.

A

J.H.v.H.A. Sc.

SACRISTY CUPBOARD

South German, 2nd half of the 15th century. Lime, partly painted, h. 3.7 m / 12 ft 1 ⅝ in.
FROM THE PROTESTANT CHAPEL OF EASE (FORMERLY SS SIXTUS UND LORENZ) IN WILMERSREUTH
KULMBACH, STIFTUNG LANDSCHAFTSMUSEUM OBERMAIN AUF DER PLASSENBURG
The sacristy cupboard is decorated with Late Gothic ornament, carved in relief and highlighted in bright colours against a blackened ground. The feet of the cupboard carry coats of arms.

SAKRISTEISCHRANK

Süddeutsch, 2. Hälfte 15. Jahrhundert. Lindenholz, teilweise bemalt, 370 cm hoch, 97 cm tief
AUS DER EVANGELISCHEN FILIALKIRCHE EHEMALS SS. SIXTUS UND LORENZ WILMERSREUTH
KULMBACH, STIFTUNG LANDSCHAFTSMUSEUM OBERMAIN AUF DER PLASSENBURG
Den Sakristeischrank zieren erhaben herausgearbeitete spätgotische Ornamente, deren bunte Farbfassung sich vom geschwärzten Grund abhebt. Auf den Füßen des Schranks befinden sich Wappen.

ARMOIRE DE SACRISTIE

Allemagne du Sud, 2ᵉ moitié du XVᵉ siècle. Bois de tilleul, partiellement peint, hauteur 370 cm
PROVENANT DE L'ÉGLISE FILIALE PROTESTANTE ANCIENNEMENT
SAINT-SIXTE ET SAINT-LAURENT WILMERSREUTH
KULMBACH, STIFTUNG LANDSCHAFTSMUSEUM OBERMAIN AUF DER PLASSENBURG
L'armoire de sacristie est décorée d'ornements du gothique tardif travaillés en relief et dont les couleurs vives contrastent avec la noirceur du fond. Sur les pieds de l'armoire, on distingue des blasons.

(S. 390–93)

BOOK COVER

Italian, c. 1300. Copper, partly gilded and silvered, parchment, painted, 37 x 25 cm / 14 ½ x 10 in.

FORMERLY MUNICH, PETERSKIRCHE

AUCTIONED IN 1904 FROM THE ESTATE OF THE EDITOR HEFNER-ALTENECK

WHEREABOUTS UNKNOWN

The Italian book cover adorns a copy of the *Novum Missale Romanum* (a revised version of the Roman missal) published in Augsburg in 1739. Formerly the property of the Peterskirche in Munich, it was purchased by Hefner-Alteneck and subsequently auctioned in 1904 as part of his estate. The beardless figure of Christ in Blessing is seated at the centre of the cover, on a throne of Gothic tracery set against a silvered background (cf. ill. pp. 390/91). Arranged around the cover's wide, chamfered edges are twenty portrait medallions of saints, painted on parchment in the manner of miniatures. Protected by thin leaves of horn, they appear within a Gothic tracery surround that is held in place by rivets in the four corners. The framing elements and the Saviour's nimbus are gilded.

(S. 390–393)

BUCHDECKEL

Italienisch, um 1300. Kupfer, teilvergoldet und versilbert, Pergament, bemalt, 37 x 25 cm

EHEMALS AUS DER PETERSKIRCHE IN MÜNCHEN

AUS DEM NACHLASS DES HERAUSGEBERS HEFNER-ALTENECK 1904 VERSTEIGERT

AUFBEWAHRUNGSORT UNBEKANNT

Der italienische Buchdeckel ziert den Einband eines Augsburger *Novum missale Romanum* (überarbeitete Form des römischen Messbuchs) aus dem Jahr 1739, das aus der Peterskirche in München stammt. Jakob von Hefner-Alteneck erwarb das Stück, und 1904 wurde es aus seinem Nachlass versteigert. In der Mitte der Darstellung sitzt der bartlose, segnende Christus auf einem gotischen Maßwerksthron, der sich vom versilberten Grund abhebt (siehe Abb. S. 390/391). Auf dem breiten abgeschrägten Rand des Buchdeckels befinden sich 20 Medaillonbildnisse von Heiligen, die miniaturartig auf Pergament gemalt sind. Von Hornblättchen überdeckt, werden die Miniaturen durch gotisches Maßwerk, das an vier Vorsprüngen angenietet ist, fixiert. Die Rahmenelemente und der Nimbus des Heilands sind vergoldet.

(pp. 390–393)

COUVERTURE DE LIVRE

Italie, vers 1300. Cuivre, partiellement doré et argenté, parchemin, peint, 37 x 25 cm

AUTREFOIS CONSERVÉE DANS L'ÉGLISE SAINT-PIERRE DE MUNICH

PROVENANT DE LA SUCCESSION DE HEFNER-ALTENECK ET MISE AUX ENCHÈRES EN 1904

LOCALISATION INCONNUE

La couverture italienne orne la reliure d'un exemplaire augsbourgeois du *Novum missale Romanum* (version remaniée du Missel romain) datant de 1739 et provenant de l'église Saint-Pierre de Munich. Jakob von Hefner-Alteneck fit l'acquisition de l'objet ; lors de sa succession en 1904, ce dernier fut vendu aux enchères. Assis sur un trône à remplage gothique se détachant sur le fond argenté, le Christ imberbe et bénissant occupe le centre de la représentation (cf. ill. pp. 390/391). Sur le large bord chanfreiné de la couverture se succèdent 20 portraits de saints en médaillon, peints à la manière de miniatures sur du parchemin. Recouverts de lamelles de corne, les portraits sont respectivement fixés par un remplage gothique riveté à quatre saillies. Les éléments constituant le cadre ainsi que l'auréole du Sauveur sont dorés.

E T Z.

CROOK OF A CROSIER, "CURVA"

Limoges, late 12th/early 13th century. Copper, gilded and enamelled, h. 30.2 cm / 11 ⅞ in.

BRUGES, CATHEDRAL OF ST SALVATOR

The crook of the crosier contains a scene from the legend of St Valerie of Limoges. After being baptized by St Martial, the young Valerie took a vow of Christian chastity and refused to get married, upon which her betrothed ordered her decapitation. St Valerie is said to have carried her head in her hands to the altar where St Martial was celebrating Mass. The outside of the crook is decorated with leafy ornament in the Romanesque style. The lizards symbolize the Evil that must yield to the saint. The crook is enamelled in azure blue patterned with gold lozenges. The knob and the backs of the lizards are studded with turquoise in the shape of pearls.

BISCHOFSSTAB „CURVA"

Limoges, Ende 12./Anfang 13. Jahrhundert. Kupfer, vergoldet und emailliert, 30,2 cm hoch

BRÜGGE, KATHEDRALE ST. SALVATOR

In der Rundung des Bischofsstabs wird eine Szene aus der Legende der heiligen Valeria gezeigt. Nachdem sie vom heiligen Martial getauft worden war, strebte die junge Valeria nach christlicher Vollkommenheit und weigerte sich zu heiraten. Ihr Verlobter ließ sie köpfen. Valeria nahm ihr Haupt in die Hände und brachte es Martial, der in der Kirche von Limoges die Messe feierte. Die Krümme ist mit romanischem Blattwerk verziert. Die Eidechsen symbolisieren das Böse, das dem Heiligen weichen muss. Der Rundstab ist azurblau emailliert und mit goldenen Rauten versehen. Perlförmige Türkise befinden sich am Knauf und auf dem Rücken der Eidechsen.

CROSSE ÉPISCOPALE « CURVA »

Limoges, fin du XIIᵉ/début du XIIIᵉ siècle. Cuivre, doré et émaillé, hauteur 30,2 cm

BRUGES, CATHÉDRALE SAINT-SAUVEUR

Dans la volute de la crosse épiscopale figure une scène empruntée à la légende de sainte Valérie, laquelle aspirait à la perfection chrétienne depuis que le saint évêque Martial de Limoges l'avait baptisée. Comme elle refusait de se marier, son fiancé la fit exécuter. Valérie prit sa tête dans les mains et la porta à Martial, tandis que ce dernier célébrait la messe à Limoges. Le crosseron est orné de feuillages romans. Les lézards symbolisent le Mal, lequel doit céder devant le sacré. Le bâton est émaillé de bleu azuré et constellé de losanges d'or. La pomme de la crosse et le dos des lézards sont ornés de turquoises en forme de perles.

2 par.Zoll.

1150 – 1250.

CUPBOARD
South German, 2nd half of the 15th century. Wood, 259 x 194 cm / 102 x 76 ⅜ in.
NUREMBERG, GERMANISCHES NATIONALMUSEUM
The cupboard's lavishly carved decoration originally appeared against a coloured ground. Represented on the edges of the cupboard, on either side of the upper doors, are the figures of St Sebastian (left) and St George (right). The eagle and the lion appearing beneath the two lower doors represent the symbols of the Evangelists St John and St Mark.

SCHRANK
Süddeutsch, 2. Hälfte 15. Jahrhundert. Holz, 259 x 194 cm
NÜRNBERG, GERMANISCHES NATIONALMUSEUM
Die reichen Verzierungen des Schrankes waren ursprünglich farbig unterlegt. An den Rändern zu Seiten der oberen Türen sind der heilige Sebastian und der heilige Georg dargestellt. Unterhalb der beiden unteren Türen sind Adler und Löwe, die Symbole der Evangelisten Johannes und Markus, gezeigt.

ARMOIRE
Allemagne du Sud, 2ᵉ moitié du XVᵉ siècle. Bois, 259 x 194 cm
NUREMBERG, GERMANISCHES NATIONALMUSEUM
À l'origine, les riches ornements de l'armoire étaient posés sur un fond coloré. Sur les côtés, de part et d'autre des portes supérieures, on distingue saint Sébastien et saint Georges. Au-dessous des deux portes inférieures figurent l'aigle et le lion, symboles des évangélistes Jean et Marc.

(pp. 398–402)

TAPESTRY

Middle Rhenish, c. 1415. Wool and pale silk, partly embroidered, partly painted, 0.80 x 6.5 m / 2 ft 7 ½ x 21 ft 3 ⅞ in.

FRANKFURT AM MAIN, MUSEUM FÜR KUNSTHANDWERK

The narrative tapestry was acquired by the museum in 1929 at the auction of the Hohenzollern-Sigmaringen collection. It shows scenes from "Willehalm von Orlens", a poem composed around 1240 by Rudolf von Ems, written in Middle High German and based on an Old French epic. The tale is that of the childhood romance of Willehalm and Amelie, one of the medieval era's most famous pairs of lovers. Banderoles provide information about the scenes portrayed. The story unfolds from upper left to lower right as follows: Willehalm von Orlens and Amelie, daughter of the King of England, are playing chess; Willehalm declares his love to Amelie as she exits the church; the King and Queen visit Willehalm, who is lying lovesick in bed (ill. p. 401); Amelie visits Willehalm (A); Willehalm, cured, takes his leave of Amelie, who gives him a ring; Willehalm takes his leave of Amelie's parents (ill. pp. 398/99); he arrives at the court of the Duke of Brabant (B). The scenes that follow are shown on plate 4 (ills. pp. 403–07).

(S. 398–402)

BILDTEPPICH

Mittelrheinisch, um 1415. Wolle und helle Seidenfäden, teils bestickt, teils bemalt, 80 x 650 cm

FRANKFURT AM MAIN, MUSEUM FÜR KUNSTHANDWERK

Das Museum erwarb den Teppich 1929 bei der Versteigerung der Sammlung Hohenzollern-Sigmaringen. Das Stück zeigt Szenen aus dem altfränzösischen Epos Willehalm von Orlens nach der um 1240 verfassten deutschen Bearbeitung des Rudolf von Ems. Erzählt wird die Geschichte der Kinderminne zwischen Wilhelm (Willehalm) und Amelie, die zu den berühmtesten Liebespaaren des Mittelalters gehören. Spruchbänder erläutern die auf dem Teppich dargestellten Szenen. Die Geschichte beginnt oben links mit dem Schachspiel von Wilhelm von Orlens und Amelie, der Königstochter von England. Dann folgen: Wilhelms Liebeserklärung an die aus der Kirche kommende Amelie; König und Königin besuchen den liebeskrank im Bett liegenden Wilhelm; der Besuch Amelies am Krankenbett (A; Abb. S. 401); der genesene Wilhelm verabschiedet sich von Amelie, die ihm einen Ring schenkt; Wilhelm verabschiedet sich von Amelies Eltern (Abb. S. 398/399); er kommt an den Hof des Herzogs von Brabant (B). Die folgenden Szenen des Epos sind auf Tafel 4 dargestellt (Abb. S. 403–407).

(pp. 398–402)

TAPISSERIE

Vallée du Haut-Rhin moyen, vers 1415. Laine et fils de soie clairs, en partie brodée, en partie peinte, 80 x 650 cm

FRANCFORT-SUR-LE-MAIN, MUSEUM FÜR KUNSTHANDWERK

Le musée fit l'acquisition de la tapisserie en 1929, lors de la vente aux enchères de la collection Hohenzollern-Sigmaringen. Les scènes qui s'y déroulent sont empruntées au *Willehalm von Orlens* (Guillaume d'Orléans) de Rudolf von Ems, une version allemande, écrite vers 1240, de l'épopée médiévale française. Celle-ci raconte l'histoire d'amour de deux enfants, Guillaume et Amélie, qui figuraient, au Moyen Âge, parmi les plus célèbres couples d'amoureux. Des cartouches commentent les scènes représentées sur la tapisserie. Le début de l'histoire montre, en haut à gauche, Guillaume et Amélie, la fille du roi d'Angleterre, jouant aux échecs. Suivent différents épisodes : Guillaume déclare son amour à Amélie, laquelle sort de l'église ; le roi et la reine rendent visite à Guillaume, malade d'amour et alité ; Amélie se rend au chevet du malade (A ; ill. p. 401) ; Guillaume, guéri, fait ses adieux à Amélie, qui lui offre une bague ; Guillaume prend congé des parents d'Amélie (ill. pp. 398/399) ; il arrive enfin à la cour du duc de Brabant (B). Les scènes suivantes de l'épopée figurent sur la planche 4 (ill. pp. 403–407).

A

B

1390 — 1420.

(pp. 403–07)

TAPESTRY

Middle Rhenish, c. 1415
Wool and pale silk, the facial features partly embroidered, partly painted, 0.80 x 6.5 m / 2 ft 7 ½ x 21 ft 3 ⅞ in.

FRANKFURT AM MAIN, MUSEUM FÜR KUNSTHANDWERK

Plate 4 continues on from the scenes shown in plate 3 (ills. pp. 398–402). Willehalm von Orlens is dubbed a knight by the Duke of Brabant (ill. p. 405); Willehalm takes part in a tournament; he receives a letter from Amelie, telling him that her father is going to marry her to the King of Spain; Willehalm secretly returns to Amelie's garden and they elope (ill. pp. 406/07). In the final scene, the lovers are seen riding away with two armed companions.

(S. 403–407)

BILDTEPPICH

Mittelrheinisch, um 1415
Wolle und helle Seidenfäden, Gesichtszüge teils gestickt, teils gemalt, 80 x 650 cm

FRANKFURT AM MAIN, MUSEUM FÜR KUNSTHANDWERK

Tafel 4 zeigt die Fortsetzung der auf Tafel 3 gezeigten Szenen (Abb. S. 398–402). Wilhelm von Orlens wird durch den Herzog von Brabant zum Ritter geschlagen (Abb. S. 405); Wilhelm nimmt an einem Turnier teil; er erhält einen Brief von Amelie, in dem sie schreibt, dass ihr Vater sie mit dem König von Spanien verloben wird; Wilhelm kommt heimlich in den Garten Amelies und entführt sie (Abb. S. 406/407). In der Schlussszene reitet das Liebespaar mit zwei bewaffneten Begleitern davon.

(pp. 403–407)

TAPISSERIE

Vallée du Haut-Rhin moyen, vers 1415
Laine et fils de soie clairs, visages en partie brodés, en partie peints, 80 x 650 cm

FRANCFORT-SUR-LE-MAIN, MUSEUM FÜR KUNSTHANDWERK

La planche 4 présente la suite des scènes figurant sur la planche 3 (ill. pp. 398–402). Guillaume d'Orléans est fait chevalier par le duc de Brabant (ill. p. 405) ; Guillaume participe à un tournoi ; il reçoit une lettre d'Amélie lui apprenant que son père va le fiancer au roi d'Espagne ; Guillaume arrive en cachette dans le jardin d'Amélie et enlève la jeune fille (ill. pp. 406/407). Dans la scène finale, le couple d'amoureux s'enfuit à cheval, accompagné de deux hommes armés.

BOOK COVER
Ulm, early 16th century. Wood, velvet, silver, 26.5 x 20 cm / 10 ¼ x 7 ⅞ in.
Nuremberg, Germanisches Nationalmuseum, Sign. Hs 3155B
The book cover adorns the manuscript of an Augsburg epistolary that once belonged to the Ulm minster treasury. The silver frame in the style of openwork Gothic tracery was originally backed by red velvet, which concealed the wooden core. Medallions depicting the four Evangelists are situated in the four outer corners. An inner frame contains a representation of the Madonna of the Crescent Moon, in which the Virgin and Child are seen beneath an elaborate canopy. Two angels are lowering a crown onto the Virgin's head. The back of the book cover (not illustrated) is decorated in a similar manner, whereby the Evangelists are replaced in the medallions by the four Church Fathers, and the Virgin and Child by saints. The two silver clasps bear the coats of arms of the Kraft family from Ulm on the outside and an inscription and the date 1506 on the inside, the latter possibly indicating when the cover was made.

BUCHDECKEL
Ulm, Anfang 16. Jahrhundert. Holz, Samt, Silber, 26,5 x 20 cm
Nürnberg, Germanisches Nationalmuseum, Sign. Hs 3155B
Der Buchdeckel ziert die Handschrift eines Augsburger Festepistolars, das zum Ulmer Münsterschatz gehörte. Der Holzkern des Deckels war ursprünglich mit rotem Samt überzogen und ist mit einem silbernen, durchbrochen gearbeiteten gotischen Maßwerksrahmen verziert, in dessen Ecken sich Medaillons mit Darstellungen der vier Evangelisten befinden. Ein innerer Rahmen zeigt unter aufwendigem Baldachin zwischen Fialen die Mondsichelmadonna mit dem Jesuskind, die von zwei Engeln gekrönt wird. Die Rückseite des Bucheinbandes, die nicht gezeigt wird, ist in gleicher Weise verziert. Sie zeigt statt der Evangelisten in den Medaillons die vier Kirchenväter und anstelle Marias Heiligenfiguren. Die beiden Silberschließen tragen auf ihren Außenseiten das Wappen der Ulmer Familie Kraft, auf der Innenseite ein Spruchband und die Datierung 1506, die möglicherweise das Herstellungsdatum des Einbandes angibt.

COUVERTURE DE LIVRE
Ulm, début du XVIᵉ siècle. Bois, velours, argent, 26,5 x 20 cm
Nuremberg, Germanisches Nationalmuseum, Cod. Hs 3155B
La couverture de livre orne le manuscrit d'un Epistolarium augsbourgeois qui appartenait au trésor de la cathédrale d'Ulm. À l'origine recouvert de velours rouge, le fond en bois de la couverture est orné d'un cadre d'argent en remplage gothique travaillé en ajouré. Dans les coins de celui-ci se trouvent des médaillons contenant les représentations des quatre évangélistes. Un cadre intérieur montre, sous un précieux baldaquin flanqué de pinacles, la Vierge au croissant de lune portant l'Enfant Jésus et couronnée par deux anges. Le plat arrière de la reliure, lequel ne figure pas sur la planche, est pareillement décoré. Il montre, à la place des évangélistes dans les médaillons, les quatre Pères de l'Église et, au lieu de la Vierge Marie, des figures de saints. Les deux fermoirs en argent portent, sur leur face externe, les armoiries de la famille Kraft, originaire d'Ulm ; sur leur face interne, un cartouche ainsi que la date de 1506, à laquelle la reliure a peut-être été fabriquée.

C. BRONER del.

1460 — 1500.

CARVING CROWNING THE END OF A CHOIR STALL
German, 15th century. Wood, 9 x 15 cm / 3 ½ x 5 ⅞ in.
FORMERLY BERLIN, KUNSTGEWERBEMUSEUM – UNTRACED
The carving, untraced since 1945, shows a man being grabbed by the Devil. The representation thereby falls into the tradition of medieval drolleries, which were frequent elements in the decoration of choir stalls, and in particular of misericords. These small wooden shelves were attached to the underside of the hinged seats in the choir stalls, and could be leant against when standing for prolonged periods during a church service. The figures seen here are carved in freehand. By 1945, the carving was severely damaged.

BEKRÖNUNG DER WANGE EINES CHORSTUHLES
Deutsch, 15. Jahrhundert. Holz, 9 x 15 cm
EHEMALS KUNSTGEWERBEMUSEUM, BERLIN –VERSCHOLLEN
Das 1945 verschollene Stück zeigt einen Mann, den der Teufel packt. Die Darstellung steht in der Tradition mittelalterlicher Drolerien, die häufig das Chorgestühl zierten, und zwar insbesondere die Misericordien. Diese Stützbretter waren im Chorgestühl unterhalb der Klappsitze als Stütze für lange Stehzeiten angebracht. Die Figuren der gezeigten Wangenbekrönung sind frei geschnitzt. Das Objekt war 1945 bereits zerbrochen.

CORNICHE DE LA JOUÉE D'UNE STALLE DE CHŒUR
Allemagne, XV^e siècle. Bois, 9 x 15 cm
AUTREFOIS CONSERVÉE AU KUNSTGEWERBEMUSEUM BERLIN – DISPARUE
La pièce, disparue en 1945, montre un homme empoigné par le diable. La représentation s'inscrit dans la tradition des drôleries médiévales, qui ornaient souvent les stalles de chœur et, en particulier, les miséricordes. Ces consoles fixées sous l'abattant des stalles permettaient aux membres du clergé de s'appuyer lorsqu'ils devaient rester longtemps debout. Les personnages occupant la corniche de jouée reproduite sur la planche sont librement sculptés. En 1945, l'objet était déjà détérioré.

6.

6 par. Zoll.

1400 — 1450.

AQUAMANILE

Lorraine, 2nd half of the 12th century. Bronze gilt, 14 x 13.5 cm / 5 ½ x 5 ⅜ in.

MUNICH, BAYERISCHES NATIONALMUSEUM

The jug-like vessel illustrated on the plate is a reconstruction, as the original is in a fragmentary condition and is today missing the entire front half of the head, with the spout. An aquamanile is a ritual ewer for the liturgical washing of hands. The Munich example ranks amongst the earliest examples in the shape of a dragon. Traces of silver inlay were formerly visible in the wing feathers and appear in colour in the plate.

AQUAMANILE

Lothringisch, 2. Hälfte 12. Jahrhundert. Bronze, vergoldet, 14 x 13,5 cm

MÜNCHEN, BAYERISCHES NATIONALMUSEUM

Die Tafel zeigt eine Rekonstruktion des nur fragmentarisch erhaltenen Gießgefäßes, bei dem heute der ganze vordere Teil des Kopfes mit dem Ausguss fehlt. Es handelt sich um ein Gießgefäß, das Wasser zur liturgischen Handwaschung aufnahm. Das Münchner Exemplar gehört zu den frühesten Aquamanilen in Drachengestalt. In den Schwungfedern ließen sich früher Reste von Silbereinlagen feststellen, die auf der Tafel farbig gekennzeichnet sind.

AQUAMANILE

Lorraine, 2ᵉ moitié du XIIᵉ siècle Bronze, doré, 14 x 13,5 cm

MUNICH, BAYERISCHES NATIONALMUSEUM

La planche montre la reconstitution de l'aiguière, dont seuls des fragments ont été conservés. La partie antérieure de la tête, comprenant le bec, fait aujourd'hui intégralement défaut. Il s'agit d'un récipient verseur qui contenait l'eau destinée au rite du lavement des mains. Cet exemplaire munichois compte parmi les premiers aquamaniles en forme de dragon. Dans les rémiges, on distinguait autrefois les restes d'une garniture d'argent, indiquée en couleur sur la planche.

TILED STOVE

South German, early 16th century. Ceramic, polychrome glazing, h. 1.84 m / 6 ft

NUREMBERG, GERMANISCHES NATIONALMUSEUM

This tiled stove from the chapterhouse at Ortenburg ranks amongst the most magnificent examples of its day. The upper cornice is decorated with the coats of arms of Lorenz of Bibra, Prince-Bishop of Würzburg (r. 1495–1519), and of members of the cathedral chapter, whose family arms are repeated several times on the tiled walls, interspersed with figures of the apostles. Landsknecht mercenaries are shown in reclining poses in the concave moulding around the bottom of the stove.

KACHELOFEN

Süddeutsch, Anfang 16. Jahrhundert. Keramik, bunt glasiert, 184 cm hoch

NÜRNBERG, GERMANISCHES NATIONALMUSEUM

Der Kachelofen aus dem Kapitelhaus zu Ortenburg gehört zu den prächtigsten Exemplaren seiner Zeit. Das obere Gesims des Ofens zieren die Wappen des Würzburger Bischofs Lorenz von Bibra (reg. 1495–1519) und der Mitglieder des Domkapitels, deren Familienwappen sich an den Seitenwänden mehrmals wiederholen. Dazu treten alternierend Darstellungen der Apostel. In der unteren Hohlkehle des Ofens sind liegend Landsknechte dargestellt.

POÊLE DE FAÏENCE

Allemagne du Sud, début du XVIᵉ siècle. Céramique, vernis teinté, hauteur 184 cm

NUREMBERG, GERMANISCHES NATIONALMUSEUM

Le poêle de faïence issu de la salle capitulaire d'Ortenburg figure parmi les exemples les plus somptueux de son époque. La corniche du poêle est ornée des blasons de Lorenz von Bibra (prince-évêque wurtzbourgeois de 1495 à 1519) et des membres du chapitre, dont les armoiries familiales, entremêlées de représentations des apôtres, se répètent plusieurs fois sur les parois latérales. Dans la moulure creuse, en bas du poêle, figurent des lansquenets allongés.

1490 - 1510.

"ST HENRY'S CUP"

Fatimid, c. 1000; German, 12th century
Rock crystal, silver gilt, gems, h. 13 cm / 5 in.; footplate ø 11 cm / 4 ⅜ in.

MUNICH, RESIDENZ, TREASURY

The cup passed from Bamberg cathedral to the Reiche Kapelle ("Ornate Chapel") in the Munich Residenz and from there into the palace treasury (cf. also ill. p. 27). According to legend, the cup was presented to Bamberg cathedral by its founder, Emperor Henry II (r. 1014–24). This is contradicted, however, by the fact that the originally one-handled crystal cup – fashioned in a Fatimid stone-cutting technique from the period around AD 1000 – was not set into its silver-gilt housing until the 12th century, at which point it was transformed into a double-handled cup.

„ST.-HEINRICHS-KELCH"

Fatimidisch, um 1000; Deutsch, 12. Jahrhundert
Bergkristall; Silber, vergoldet, Edelsteine, 13 cm hoch, ø Fußplatte 11 cm

MÜNCHEN, SCHATZKAMMER DER RESIDENZ

Der Kelch kam aus dem Bamberger Dom in die Reiche Kapelle zu München und von dort in die Schatzkammer der Residenz (siehe auch Abb. S. 27). Der Legende nach stiftete Kaiser Heinrich II. (reg. 1014–1024) den Kelch der von ihm gegründeten Bamberger Bischofskirche. Gegen diese Annahme spricht, dass der ursprünglich einhenklige Kristallnapf in fatimidischer Steinschnitttechnik aus der Zeit um 1000 erst im 12. Jahrhundert eine Goldschmiedefassung erhielt, wodurch ein Doppelhenkelkelch entstand.

« CALICE DE SAINT HENRI »

Fatimide, vers 1000 ; Allemagne, XIIᵉ siècle
Cristal de roche, argent, doré, pierres précieuses, hauteur 13 cm, ø du pied 11 cm

MUNICH, TRÉSOR DE LA RÉSIDENCE

Le calice fut transféré de la cathédrale de Bamberg dans la riche chapelle de Munich et, de là, dans le trésor de la Résidence (cf. aussi ill. p. 27). D'après la légende, Henri II (empereur de 1014 à 1024) fit don du calice à l'église épiscopale de Bamberg fondée par lui. Or, le vase de cristal à une anse, exécuté selon la technique fatimide du cristal de roche taillé vers l'an 1000, ne reçut une monture d'orfèvrerie et, dans le même temps, une seconde anse, qu'au XIIᵉ siècle.

.003.

1024.

IH v H v A sc.

(pp. 419–23)
PORTABLE ALTAR
English, c. 1350. Gold, enamelled in translucent colours, 8.3 x 7.2 cm / 3 ¼ x 2 ¾ in.

The tiny portable altar came into the possession of the Reiche Kapelle ("Ornate Chapel") in the Munich Residenz under Duke Maximilian I of Bavaria (r. 1597–1651). The Elector had received it from the Jesuit General Claudio Aquaviva, who had in turn obtained it – according to an engraved inscription dating from the 17th century – from Elizabeth Vaux, lady-in-waiting to Mary Stuart, the executed Catholic Queen of Scots. In 1931, the object was sold by the House of Wittelsbach. Its present owner is the Master of Campion Hall in Oxford, but the work is on permanent loan to the Victoria and Albert Museum in London. In the upper illustration of the plate (ill. p. 419) the travelling altar appears in the open position and features episodes from life of Christ beneath the Holy Trinity at the top. The central panel shows scenes from the Passion (ill. p. 421), flanked on the wings by the Annunciation (left) and the Adoration of the Magi (right). The back of the travelling altar in the open position (seen in the lower illustration) shows the Virgin and saints as intercessors between God and humankind. The Coronation of the Virgin appears at the top, with St Christopher on the left wing and the Miracle of Pentecost on the right. The six fields in the centre show St Anne and Mary as a young girl, the Visitation and SS John the Baptist, James, Canute and Giles (ill. p. 423). To close the altar, the wings were folded inwards and the top folded downwards, whereby the hinges allowed movement in both directions. In the closed position, therefore, the altarpiece could show either the central panel with the Passion of Christ (upper illustration) or the central panel with the saints as Christ's followers (lower illustration). On the altarpiece today, the scenes appear in a different sequence.

Orig. Gr.

1340 – 1380.

J.Hv. HEFNER=ALTENECK del. C.REGNIER sc.

(S. 419–423)

WANDELALTÄRCHEN

Englisch, um 1350. Gold, transluzid emailliert, 8,3 x 7,2 cm
LONDON, VICTORIA AND ALBERT MUSEUM

Das als „Reisealtärchen der Maria Stuart" bekannte Stück kam unter Herzog Maximilian I. von Bayern (reg. 1597–1651) in den Besitz der Reichen Kapelle der Münchner Residenz. Der Kurfürst erhielt den kleinen Altar vom Jesuitengeneral Aquaviva, der ihn – laut einer im 17. Jahrhundert eingravierten Inschrift – von Elizabeth Vaux, einer Dienerin der hingerichteten katholischen schottischen Königin Maria Stuart, erhalten hatte. 1931 wurde das Objekt vom Haus Wittelsbach verkauft. Eigentümer ist heute The Master of Campion Hall in Oxford. Das Werk befindet sich jedoch als Dauerleihgabe im Londoner Museum. Die obere Abbildung der Tafel (Abb. S. 419) gibt den geöffneten Wandelaltar wieder und zeigt das Erlösungswerk Christi, das in der Trinität gipfelt. Auf den Seitenflügeln sind links die Verkündigung und rechts die Anbetung der Heiligen Drei Könige dargestellt. Die Mitteltafel zeigt Szenen aus der Passion Christi (Abb. S. 421). Die Rückseite des geöffneten Zustands (in der Abbildung unten) zeigt Maria und die Heiligen als Vermittler zwischen Gott und den Menschen. Oben ist die Marienkrönung dargestellt und auf den Flügeln links der heilige Christophorus und rechts das Pfingstfest. Die sechs Felder in der Mitte zeigen Anna und Maria als Kind, die Heimsuchung und die Heiligen Johannes d. T., Jakobus, Canut und Egidius (Abb. S. 423). Im geschlossenen Zustand wurden die Seitentafeln und der Aufsatz des Altars nach hinten weggeklappt. Die Schauseite des geschlossenen Altärchens bildete so entweder die obere Mitteltafel mit der Passion Christi oder die untere Mitteltafel mit den Heiligen als Nachfolger Christi.

Heute ist die Abfolge der Szenen verändert.

(pp. 419–423)

PETIT POLYPTYQUE

Angleterre, vers 1350. Or, émail translucide, 8,3 x 7,2 cm

LONDRES, VICTORIA AND ALBERT MUSEUM

Connue sous le nom de « petit retable de voyage de Marie Stuart », la pièce devint, sous le duc Maximilien I^{er} de Bavière (règne 1597–1651), la propriété de la riche chapelle de la Résidence munichoise. Le prince électeur reçut l'objet de Claudio Acquaviva, Général des jésuites, lequel l'avait reçu – d'après une inscription gravée au XVII^e siècle – d'Élisabeth Vaux, une servante de la reine catholique écossaise exécutée Maria Stuart. En 1931, le petit polyptyque fut vendu par la maison des Wittelsbach.

Le propriétaire en est aujourd'hui le Maître de Campion Hall à Oxford. L'œuvre se trouve toutefois, en prêt permanent, au musée londonien. L'illustration supérieure de la olanche (ill. p. 419) restitue l'intérieur du polyptyque ouvert et montre, en haut, Dieu le Père. Sur les volets latéraux apparaissent, à gauche, l'Annonciation et, à droite, l'Adoration des Mages. Le panneau central présente des scènes de la Passion du Christ (ill. p. 421). En position ouverte (dans l'illustration inférieure), le dos du polyptyque montre Marie et les saints en tant qu'intermédiaires entre Dieu et les hommes. En haut est représenté le Couronnement de la Vierge. Sur les volets latéraux figurent, à gauche, saint Christophe, à droite, la Pentecôte. Les six surfaces médianes contiennent des représentations d'Anne et de Marie enfant, de la Visitation ainsi que des saints Jean Baptiste, Jacques, Canut et Gilles (ill. p. 423).

En position fermée, les panneaux latéraux et l'élément supérieur étaient repliés vers l'arrière. La surface visible du polyptyque fermé était ainsi constituée soit du panneau central supérieur avec la Passion du Christ soit du panneau central inférieur avec les saints suivant le Christ.

Aujourd'hui, la succcession des scènes est modifiée sur l'original.

LIDDED POT

German, end of the 13th century. Silver, partly gilded, embossed, h. 38 cm / 15 in.

BRAUNFELS, BRAUNFELS CASTLE, FÜRSTLICH VON SOLM'SCHE SAMMLUNGEN, ALTENBERGER RÄUME

The pot exhibits a shape typical of the High Middle Ages. It is made up of three parts, whose soldered seams are hidden behind gilt rings. The underside of the lid features a quatrefoil plaque showing Christ surrounded by the symbols of the four Evangelists (B). The pot was originally part of the furnishings of Altenberg abbey, which passed into the possession of the Princes of Solms in the wake of secularization. According to legend, St Elizabeth used the pot to serve wine to the sick. The 17th-century inscription on the lid (A) makes reference to this charitable deed, as does a second inscription on the foot, added in 1803 at the instigation of Prince William of Solms. It cannot be proved, however, that the pot truly belonged to the saint. The legend is based on the fact that Elizabeth's four-year-old daughter Gertrude entered the Altenberg convent after her mother's death and later became its abbess.

SCHENKKANNE

Deutsch, Ende 13. Jahrhundert. Silber, getrieben, teilweise vergoldet, 38 cm hoch

SCHLOSS BRAUNFELS, FÜRSTLICH VON SOLM'SCHE SAMMLUNGEN, ALTENBERGER RÄUME

Die Schenkkanne besitzt eine für das Hochmittelalter typische Form. Sie ist aus drei Teilen zusammengesetzt, wobei die Lötnähte mit vergoldeten Reifen kaschiert sind. In den Deckel ist von unten eine vierpassförmige Platte mit der Darstellung Christi, der von den Symbolen der Evangelisten umgeben ist, eingesetzt (B). Die Kanne gehörte ursprünglich zum Inventar des Klosters Altenberg, das mit der Säkularisation in den Besitz der Fürsten von Solms überging. Der Überlieferung nach spendete die heilige Elisabeth den Kranken aus dieser Kanne Wein. Auf diese mildtätige Handlung beziehen sich die Inschrift auf dem Deckel aus dem 17. Jahrhundert (A) und diejenige, die 1803 auf Veranlassung des Fürsten Wilhelm von Solms am Fuß angebracht wurde. Es lässt sich jedoch nicht nachweisen, dass die Kanne wirklich der Heiligen gehörte. Die Legende stützt sich auf die Tatsache, dass Elisabeths vierjährige Tochter Gertrud nach dem Tod der Mutter in das Kloster Altenberg kam und dort später Äbtissin wurde.

PICHET

Allemagne, fin du XIIIe siècle. Argent, repoussé, partiellement doré, hauteur 38 cm

CHÂTEAU DE BRAUNFELS, FÜRSTLICH VON SOLM'SCHE SAMMLUNGEN, ALTENBERGER RÄUME

Le pichet possède une forme caractéristique du haut Moyen Âge. Il se compose de trois parties liées entre elles par des cercles dorés sous lesquels disparaissent les jointures. Dans le couvercle est insérée, d'en bas, une plaque de forme quadrilobée contenant la représentation du Christ entouré des symboles des évangélistes (B). À l'origine, le pichet appartenait à l'inventaire de l'abbaye d'Altenberg qui, à la faveur de la sécularisation, devint la propriété des princes de Solms. La légende rapporte que sainte Élisabeth utilisait le broc pour servir du vin aux malades, un geste charitable auquel renvoient l'inscription du XVIIe siècle figurant sur le couvercle (A) et celle qui, à l'initiative du prince Guillaume de Solms, fut gravée sur le pied en 1803. Cependant, il n'est guère possible de prouver que le pichet a véritablement appartenu à la sainte. La légende s'appuie sur le fait que Gertrude, la fille d'Élisabeth, fut accueillie à l'abbaye d'Altenberg lorsqu'elle perdit sa mère, à l'âge de quatre ans, et qu'elle y devint plus tard abbesse.

B

A

C

6. Par. Zoll.

1226 — 1231.

RELIQUARY

German, c. 1160–80. Bronze, 24.3 x 27.5 x 13.8 cm / 9 ½ x 10 ¾ x 5 ½ in.

MUNICH, BAYERISCHES NATIONALMUSEUM

The reliquary in the shape of a casket is supported by the seated figures of the Evangelists.
On the front, Christ in Blessing appears in a mandorla, surrounded by the symbols of the four Evangelists
and flanked on one side by SS Peter and Paul and on the other by the Virgin and St John the Baptist.
The back of the reliquary depicts the Baptism in the River Jordan and the Nativity, whereas the side walls
show the Miracle at Cana and the Annunciation. The lid, shaped like a low-pitched hipped roof, is
surmounted by a square tube, to which something could be attached. All four sides of the lid are also
decorated with biblical scenes and show the Four Women at the Tomb on the front and the Resurrection
on the back, with the Ascension and the Temptation of Christ in the Desert on the sides.

RELIQUIENBEHÄLTER

Deutsch, um 1160–1180. Bronze, 24,3 x 27,5 x 13,8 cm

MÜNCHEN, BAYERISCHES NATIONALMUSEUM

Der kastenförmige Reliquienbehälter wird von den Sitzfiguren der Evangelisten getragen.
Auf der Vorderseite des Kastens ist der segnende Christus in der Mandorla dargestellt, umgeben
von den Symbolen der vier Evangelisten und seitlich flankiert von Petrus und Paulus sowie Maria und
Johannes dem Täufer. Die Rückseite zeigt die Taufe im Jordan und die Geburt Christi.
Auf den Seitenflächen wird die Verwandlung des Wassers in Wein und die Verkündigung wiedergegeben.
Auf dem abgeplatteten, dachförmigen Deckel des Reliquienbehälters befindet sich eine viereckige Röhre,
auf der etwas befestigt werden konnte. Die Dachflächen zeigen auf der Vorderseite die vier Frauen am
Grabe, auf der Rückseite die Auferstehung und an den Seiten die Himmelfahrt Christi und
die Versuchung Christi in der Wüste.

RELIQUAIRE

Allemagne, vers 1160–1180. Bronze, 24,3 x 27,5 x 13,8 cm

MUNICH, BAYERISCHES NATIONALMUSEUM

Le coffre-reliquaire est porté par les sculptures assises des évangélistes. Sur la face antérieure apparaît,
dans une mandorle, le Christ bénissant, entouré des symboles des quatre évangélistes et flanqué,
sur les côtés, de Pierre et de Paul ainsi que de la Vierge Marie et de saint Jean Baptiste.
La face postérieure montre le baptême dans le Jourdain et la naissance du Christ. Les surfaces latérales,
quant à elles, restituent la transformation de l'eau en vin et l'Annonciation. Le couvercle en forme de toit
est surmonté d'une pièce quadrangulaire sur laquelle on pouvait fixer quelque chose. Ses surfaces planes
montrent, sur la face avant, les quatre femmes au tombeau, sur la face arrière, la Résurrection,
sur les côtés, l'Ascension et la Tentation au désert.

6 Par. Zoll.

950 - 1000.

COMB

French, 1st half of the 15th century. Boxwood, waxed, 19.9 x 19.9 x 0.7 cm / 7 ¾ x 7 ¾ x ¼ in.

BAMBERG, HISTORISCHES MUSEUM

This magnificent comb was originally created as a love token, that is a gift exchanged between a bridal couple or a pair of lovers. It was later adopted as a ceremonial comb by a Bamberg guild of craftsmen, from whose *Zunftlade*, or "guild chest" (a chest in which a guild's most important documents, ritual objects and cash box were kept under lock and key), it passed into the possession of the Bamberg Historical Society. The comb is today on loan to the Historisches Museum in Bamberg. The front of the comb shows Tristan and Iseult meeting at a fountain, in whose waters Iseult espies the reflection of her husband, King Mark, who is hiding in a tree overhead. The back of the comb shows a joust. The fields on the four lateral tongues contain hybrid beings that combine a human head with an animal body. The words spoken by Iseult, Tristan and King Mark in the banderoles on the front of the comb are written in a French dialect from the Picardy region. The knights' crests on the reverse bear similarly French mottos, which can be translated as "For the sake of our love" (left) and "Beautiful lady friend" (right).

KAMM

Französisch, 1. Hälfte 15. Jahrhundert. Buchsbaum, gewachst, 19,9 x 19,9 x 0,7 cm

BAMBERG, HISTORISCHES MUSEUM

Bei dem Prunkkamm handelte es sich ursprünglich um eine Minnegabe, das heißt ein Geschenk unter Braut- oder Liebesleuten. Später wurde er als Zunftkamm benutzt und gelangte aus der Zunftlade einer Bamberger Handwerkerzunft in den Besitz des Historischen Vereins Bamberg. Heute ist der Kamm als Leihgabe im Bamberger Museum ausgestellt. Auf der Vorderseite ist die sogenannte Brunnenszene dargestellt, das Treffen von Tristan und Isolde an einer Quelle, wo Isolde im Spiegel des Wassers ihren Gatten, König Marke, im Wipfel eines Baumes erspäht. Die Rückseite des Kamms zeigt ein Turnier. Auf den jeweils vier Zungenfeldern befinden sich Mischwesen mit Tierleibern und Menschenköpfen. Die Spruchbänder der Vorderseite geben Aussagen von Isolde, Tristan und König Marke in einem französischen Dialekt aus der Picardie wieder. Die Helmzier der Ritter auf der Rückseite trägt ebenfalls solche Devisensprüche. Links steht laut Hefner-Alteneck „Por amor de nos" (Um unserer Liebe willen) und rechts „Schöne Freundin".

PEIGNE

France, 1ère moitié du XVe siècle. Buis, ciré, 19,9 x 19,9 x 0,7 cm

BAMBERG, HISTORISCHES MUSEUM

À l'origine, le peigne d'apparat était un présent de courtoisie, un cadeau échangé entre fiancés ou amoureux. Plus tard, il fut utilisé par une corporation d'artisans de Bamberg, avant de devenir la propriété de la société d'Histoire de la ville bavaroise. Aujourd'hui, le peigne est exposé en tant que prêt au musée de Bamberg. La face antérieure de l'objet montre la célèbre scène de la fontaine, où se rencontrent Tristan et Iseult et où celle-ci aperçoit, dans le reflet de l'eau, son époux le roi Marc, tapi au sommet de l'arbre. Au dos du peigne figure un tournoi. Des deux côtés, les rangées de dents sont respectivement flanquées de deux créatures hybrides aux corps d'animaux et aux têtes d'hommes. Les cartouches de la face antérieure restituent, dans le dialecte picard, les déclarations d'Iseult, de Tristan et du roi Marc. Au dos, les casques des chevaliers présentent des ornements portant, eux aussi, de telles devises. À gauche on lit, d'après Hefner-Alteneck, « Por amor de nos » (Au nom de notre amour) ; à droite, « Belle amie ».

2.P.Z.

1400 — 1450

"WOLKENSTEIN HARP"

Tyrol, late 14th/early 15th century. Wood, ivory, bronze, h. c. 1 m / 3 ft 3 ⅜ in.

EISENACH, WARTBURG

This Gothic "Wolkenstein harp" is one of just four of such Celtic type instruments – also known as the Irish or Gaelic harp – to have survived from the medieval period; the other three are housed in Trinity College, Dublin (the *Trinity College Harp*), and the Museum of Scotland, Edinburgh (the *Queen Mary Harp* and the *Lamont Harp*). The bronze-stringed harp is said to have belonged to the medieval composer and singer Oswald von Wolkenstein (c. 1377–1445). The front of the pillar is decorated with inlay in white and green-dyed ivory (details on p. 433).

„WOLKENSTEIN-HARFE"

Tirol, Ende 14./Anfang 15. Jahrhundert. Holz, Elfenbein, Bronze, ca. 1 m hoch

EISENACH, WARTBURG

Die gotische *Wolkenstein-Harfe*, die der Legende nach dem mittelalterlichen Dichter und Sänger Oswald von Wolkenstein (um 1377–1445) gehört haben soll, ist eine von vier heute noch erhaltenen mittelalterlichen Harfen des keltischen Typs, auch als irisch oder schottisch bezeichnet. Die anderen drei erhaltenen Harfen werden im Trinity-College in Dublin (*Trinity College Harp*) und im Museum of Scotland in Edinburgh (*Queen Mary Harp* und *Lamont Harp*) aufbewahrt. Die *Wolkenstein-Harfe* ist mit Bronzesaiten bespannt. Die Front der Säule zieren Einlegearbeiten aus weißem und grün gefärbtem Elfenbein (Details auf S. 433).

« HARPE DE WOLKENSTEIN »

Tyrol, fin du XIVᵉ/début du XVᵉ siècle. Bois, ivoire, bronze, hauteur env. 1 mètre

EISENACH, WARTBURG

La harpe gothique de Wolkenstein, qui d'après la légende aurait appartenu au poète et chanteur médiéval Oswald von Wolkenstein (vers 1377–1445), est l'une des quatre harpes médiévales de type celte, également qualifiées d'irlandaises ou d'écossaises, ayant été conservées jusqu'à aujourd'hui. Les trois autres pièces se trouvent au Trinity College de Dublin (harpe du Trinity College) et au Museum of Scotland à Édimbourg (harpe de la Reine Marie et harpe de Lamont). La harpe de Wolkenstein est garnie de cordes en bronze. La face antérieure de la colonne est marquetée d'ivoire teinté de blanc et de vert (détails sur la page 433).

B

A

D

C

3 Par. Zoll.

1350 — 1400

"WOLKENSTEIN HARP"

Tyrol, late 14th/early 15th century. Wood, ivory, bronze, h. approx. 1 m / 3 ft 3 ⅜ in.

EISENACH, WARTBURG

The plate shows details of the ivory inlay on the "Wolkenstein Harp" (ill. p. 431).

„WOLKENSTEIN-HARFE"

Tirol, Ende 14./Anfang 15. Jahrhundert. Holz, Elfenbein, Bronze, ca. 1 m hoch

EISENACH, WARTBURG

Die Tafel zeigt Details der Elfenbein-Einlegearbeiten der *Wolkenstein-Harf* (Abb. S. 431).

« HARPE DE WOLKENSTEIN »

Tyrol, fin du XIVᵉ/début du XVᵉ siècle. Bois, ivoire, bronze, hauteur env. 1 mètre

EISENACH, WARTBURG

La planche montre des détails de la marqueterie d'ivoire ornant la harpe de Wolkenstein (ill. p. 431).

WANN

1350 — 1400.

TH. v. HEFNER-ALTENECK del. C. REGNIER

RELIEF MEDALLIONS
German, 19th century. Mother-of-pearl, ø 11 cm / 4 ⅜ in.
<small>FORMERLY WITHIN THE ART TRADE – WHEREABOUTS UNKNOWN</small>
The two relief medallions represent historicist copies after the representations of Christ Enthroned and the Crucifixion that are found on the base of the eight small towers adorning the Romanesque Barbarossa chandelier in Aachen cathedral.

RELIEFMEDAILLONS
Deutsch, 19. Jahrhundert. Perlmutt, ø 11 cm
<small>EHEMALS IM KUNSTHANDEL – AUFBEWAHRUNGSORT UNBEKANNT</small>
Bei den Reliefmedaillons handelt es sich um historistische Kopien nach Darstellungen der Kreuzigung und des thronenden Christus an der Basis der acht Türmchen des romanischen Barbarossaleuchters im Aachener Dom.

MÉDAILLONS EN RELIEF
Allemagne, XIXᵉ siècle. Nacre ; ø 11 cm
<small>AUTREFOIS DANS LE COMMERCE D'OBJETS D'ART – LOCALISATION INCONNUE</small>
Les médaillons sont des copies historiques exécutées d'après la Crucifixion et le Christ trônant représentés sur la partie inférieure des huit petites tours du lustre roman de Frédéric Barberousse, installé dans la cathédrale d'Aix-la-Chapelle.

(pp. 436–39)
JEWEL BOX
German, c. 1500
Wood, painted, partly silvered; copper, gilded and engraved, 6.8 x 14.4 x 8.8 cm / 2 ⅝ x 5 ⅝ x 3 ½ in.
NUREMBERG, GERMANISCHES NATIONALMUSEUM
The jewel box in the tradition of the medieval *Minnekästchen*, or "love box" (cf. also ills. pp. 337, 449),
was made as a bridal gift. On the lid, a man is presenting his beloved with a playing card bearing
three hearts (ill. pp. 70/71). The front of the box, by contrast, is decorated with a mythological scene:
Venus victorious over Mars (ill. pp. 436/37).

(S. 436–439)
SCHMUCKKÄSTCHEN
Deutsch, um 1500
Holz, bemalt, teilweise versilbert. Kupfer, vergoldet und graviert, 6,8 x 14,4 x 8,8 cm
NÜRNBERG, GERMANISCHES NATIONALMUSEUM
Das Schmuckkästchen wurde in der Tradition mittelalterlicher Minnekästchen als Brautgeschenk
gefertigt (siehe auch Abb. S. 337, 449). Die Darstellung auf dem Deckel zeigt, wie ein Herr seiner Dame
eine Spielkarte mit drei Herzen überreicht (Abb. S. 70/71). Die Vorderseite hingegen schmückt eine
mythologische Darstellung: Venus überwindet Mars (Abb. S. 436/437).

(pp. 436–439)
COFFRET À BIJOUX
Allemagne, vers 1500. Bois, peint, partiellement argenté, cuivre, doré et gravé, 6,8 x 14,4 x 8,8 cm
NUREMBERG, GERMANISCHES NATIONALMUSEUM
Le coffret à bijoux a été fabriqué dans la tradition médiévale des coffrets de courtoisie conçus comme
cadeaux de mariage (cf. aussi ill. pp. 337, 449). La représentation occupant la surface du couvercle montre
un seigneur offrant à sa dame une carte à jouer pourvue de trois cœurs (ill. pp. 70/71).
La face antérieure du coffret, quant à elle, est ornée d'une scène mythologique :
Vénus triomphant de Mars (ill. pp. 436/437).

NECK JEWELLERY
German, 2nd half of the 16th century. Gold, silver gilt, gems, pearls, painted enamel
FORMERLY IN A PRIVATE COLLECTION WITHIN THE NOBILITY – WHEREABOUTS UNKNOWN
As was conventional in their day, some of the pendants and necklaces are furnished with religious motifs.
One pendant shows the Crucifixion (A) and another St Andrew (B).

HALSSCHMUCK
Deutsch, 2. Hälfte 16. Jahrhundert. Gold, Silber, vergoldet, Edelsteine, Perlen, Maleremail
EHEMALS IN ADELIGEM PRIVATBESITZ – AUFBEWAHRUNGSORT UNBEKANNT
Den Halsschmuck zieren – wie zur Entstehungszeit üblich – teils sakrale Motive.
Ein Anhänger zeigt die Kreuzigung (A) und ein weiterer den heiligen Andreas (B).

COLLIERS
Allemagne, 2ᵉ moitié du XVIᵉ siècle. Or, argent, doré, pierres précieuses, perles, émail peint
AUTREFOIS EN LA POSSESSION D'UN PARTICULIER NOBLE – LOCALISATION INCONNUE
Comme il était d'usage à l'époque où ils ont vu le jour, les colliers sont en partie ornés de motifs sacrés.
Un pendentif montre la Crucifixion (A), un autre, saint André (B).

A

C

B

D

1550 — 1600.

VIRGIN AND CHILD

French, 2nd half of the 14th century; Nuremberg, 15th century
Ivory and bronze gilt, statuette: h. 17.4 cm / 6 ⅞ in., plinth: h. 11.9 cm / 4 ⅝ in.
MUNICH, BAYERISCHES NATIONALMUSEUM

The ivory statuette sits on top of a bronze reliquary that, according to its inscription, belonged to husband and wife Berthold and Osanna Stromer, members of the Nuremberg patriciate. The figure retains traces of polychrome decoration and gilding, which is seen more clearly on the plate than in real life.

MADONNA MIT DEM KINDE

Französisch, 2. Hälfte 14. Jahrhundert; Nürnberg 15. Jahrhundert
Elfenbein und Bronze, vergoldet, Figur: 17.4 cm hoch, Sockel: 11,9 cm hoch
MÜNCHEN, BAYERISCHES NATIONALMUSEUM

Die Elfenbein-Statuette aus der 2. Hälfte des 14. Jahrhunderts wurde auf ein metallenes Reliquiar gesetzt, das laut Inschrift dem Nürnberger Patrizierehepaar Berthold und Osanna Stromer gehörte. An der Figur befinden sich Reste einer farbigen Fassung und einer Vergoldung, die auf der Tafel deutlicher wiedergegeben sind als am Original.

VIERGE À L'ENFANT

France, 2ᵉ moitié du XIVᵉ siècle; Nuremberg, XVᵉ siècle
Ivoire et bronze, doré, statuette: hauteur 17.4 cm, socle: hauteur 11,9 cm
MUNICH, BAYERISCHES NATIONALMUSEUM

La statuette d'ivoire a été placée sur un reliquaire en métal qui, d'après l'inscription, appartenait à Berthold et Osanna Stromer, un couple de patriciens nurembergeois. La sculpture présente des restes de couleur et de dorure plus nettement visibles sur la planche que sur l'original.

bertholdus stromair

osanna uror

1340 – 1380

LADY'S BELT
Rhenish (?), 2nd half of the 15th century
Silk damask, brass, iron, copper, translucent pastes, 70 x 8.4 cm / 27 ½ x 3 ¼ in.
NUREMBERG, GERMANISCHES NATIONALMUSEUM
The belt buckle, of the tongue design, shows the Annunciation. The other end of the silk damask belt bears on one side a depiction of the Visitation and on the other an image of St Joseph. Belts of this kind were part of the dress worn by Netherlandish and French noblewomen.

FRAUENGÜRTEL
Rheinisch (?), 2. Hälfte 15. Jahrhundert
Seidendamast, Messing, Eisen, Kupfer, Transluzide Glasflüsse, 70 x 8.4 cm
NÜRNBERG, GERMANISCHES NATIONALMUSEUM
Die Metallschließe des Dorngürtels zeigt die Verkündigung. Das Ende des Seidendamastgürtels ziert auf der einen Seite die Heimsuchung und auf der anderen Seite der heilige Josef. Derartige Gürtel gehörten in den Niederlanden und Frankreich zur Tracht vornehmer Frauen.

CEINTURE DE FEMME
Rhénanie (?), 2ᵉ moitié du XVᵉ siècle
Damas de soie, laiton, fer, cuivre, pâtes de verre translucides, 70 x 8.4 cm
NUREMBERG, GERMANISCHES NATIONALMUSEUM
Le fermoir métallique de la ceinture à ardillon montre l'Annonciation. L'extrémité de l'accessoire en damas de soie est ornée, sur une face, de la Visitation, sur l'autre, de saint Joseph. Ce type de ceinture faisait alors partie, aux Pays-Bas et en France, du costume des femmes de haut rang.

III.

20.

1450 - 1490.

P. Walther sc.

RELIQUARY

German, 1st half of the 15th century. Silver gilt, rock crystal, h. 44 cm / 17 ⅜ in.

FORMERLY WITHIN THE ART TRADE – WHEREABOUTS UNKNOWN

The reliquary comprises a cylindrical rock-crystal container mounted within a Gothic architectural housing, supported on a foot made up of six trefoils and a stem with a nodus. Representations of St Peter and the Virgin within an architectural surround appear at either end of the cylinder, whereby the Virgin (not visible in the main illustration) is the subject of a separate outline drawing. On a pedestal on top of the cylinder stands a bishop saint wearing a crown; above his head is a baldachin, supported by buttresses and carrying a Crucifixion at its pinnacle.

RELIQUIAR

Deutsch, 1. Hälfte 15. Jahrhundert. Silber, vergoldet, Bergkristall, 44 cm hoch

EHEMALS IM KUNSTHANDEL – AUFBEWAHRUNGSORT UNBEKANNT

Auf einem aus sechs Dreipässen zusammengesetzten Fuß und Ständer mit Nodus ruht das aus einem quer gelagerten Bergkristallzylinder bestehende Reliquiengefäß in architektonischer gotischer Einfassung. An den Seiten des Zylinders befinden sich im architektonischen Rahmenwerk Darstellungen von Petrus und Maria. Letztere ist auf der Tafel zusätzlich in einer Umrissdarstellung wiedergegeben. Über dem Bergkristall erhebt sich auf einem Postament ein heiliger gekrönter Bischof unter einem Fialenbaldachin, dessen Spitze den Gekreuzigten trägt.

RELIQUAIRE

Allemagne, 1ère moitié du XVe siècle. Argent, doré, cristal de roche, hauteur 44 cm

AUTREFOIS DANS LE COMMERCE D'OBJETS D'ART – LOCALISATION INCONNUE

Sur un pied composé de six trilobes et une tige pourvue d'un nœud repose un reliquaire constitué d'un cylindre en cristal de roche. Posé transversalement, celui-ci est enchâssé dans un cadre architectural gothique. De part et d'autre du cristal se trouvent, dans la structure l'encadrant, des représentations de Pierre et de la Vierge Marie, laquelle est par ailleurs restituée par un croquis figurant sur la planche. Au-dessus du cylindre se dresse un saint évêque couronné, soutenu par un socle et surmonté d'un baldaquin à pinacles, au sommet duquel se tient le Crucifié.

1400 — 1450

BOX

Franconian, 2nd half of the 15th century. Leather, wood, 9.5 x 17.7 x 10.2 cm / 3 ¾ x 7 x 4 in.

NUREMBERG, GERMANISCHES NATIONALMUSEUM

The leather encasing the box's wooden core is embossed and carved with a wealth of decoration. In the tradition of *Minnekästchen,* or "love boxes" (cf. also ills. pp. 337, 439), the lid shows a man and woman surrounded by leafy tendrils and symbolic beasts. A virgin and a unicorn appear on the front of the box, whereas on one of the end walls, a bear lies in wait for a cockerel and a hen.

KÄSTCHEN

Fränkisch, 2. Hälfte 15. Jahrhundert. Leder über Holzkern, 9,5 x 17,7 x 10,2 cm

NÜRNBERG, GERMANISCHES NATIONALMUSEUM

Die Verzierungen des Kästchens sind in das Leder gepresst oder geschnitten. In der Tradition der Minnekästchen stehend (siehe auch Abb. S. 337, 439), schmückt den Deckel ein Paar, das von Rankenwerk mit Symboltieren umgeben ist. Die Vorderseite zeigt eine Jungfrau und ein Einhorn. Auf einer Seitenwand stellt ein Bär Hahn und Henne nach.

COFFRET

Franconie, 2ᵉ moitié du XVᵉ siècle. Cuir sur fond de bois, 9,5 x 17,7 x 10,2 cm

NUREMBERG, GERMANISCHES NATIONALMUSEUM

Les décors du coffret ont été obtenus par repoussage ou taillés dans le cuir. Conformément à la tradition des coffrets de courtoisie (cf. aussi ill. pp. 337, 439), le couvercle est orné d'un couple entouré de rinceaux peuplés d'animaux symboliques. La face antérieure montre une vierge et une licorne. Sur une paroi latérale, un ours poursuit un coq et une poule.

P. Walther sc.

6 Par. Zoll.

1470 – 1500

SITULA
Cologne or Meuse region, final third of the 12th century
Bronze, h. 12.4 cm / 4 ⅞ in., top ⌀ 12.8 cm / 5 in., bottom ⌀ 8.5 cm / 3 ⅜ in.
MAINZ, BISCHÖFLICHES DOM- UND DIÖZESANMUSEUM

The *situla* (Lat., "bucket"), is one of just a few such holy-water containers to survive from the Romanesque period. First mentioned in an inventory of 1786, it entered the Diözesanmuseum of the parish church of St Stephen in Mainz. Depicted between pilasters around the outer wall are the figures of Christ, the Virgin and St Heribert, Archbishop of Cologne. A fourth figure is identified by his inscription as Abbot Hardmann and in all probability represents the reigning abbot of Heribert monastery in Deutz in 1185.

SITULA
Kölnisch oder maasländisch, letztes Drittel 12. Jahrhundert
Bronze, 12,4 cm hoch, ⌀ oben 12,8 cm, ⌀ unten 8,5 cm
MAINZ, BISCHÖFLICHES DOM- UND DIÖZESANMUSEUM

Die dargestellte Situla (lat. für Eimer) gehört zu den wenigen aus romanischer Zeit erhaltenen Weihwasserkesseln. Sie wurde 1786 erstmals in einem Inventarverzeichnis erwähnt. Aus der Pfarrkirche St. Stephan in Mainz kam sie in das Museum. Dargestellt sind auf der Wandung zwischen Pilastern Christus, Maria und der heilige Heribert, der Erzbischof von Köln. Laut Inschrift wird außerdem Abt Hardmann gezeigt. Bei ihm handelt es sich sehr wahrscheinlich um den 1185 regierenden Abt des Heribert-Klosters in Köln-Deutz.

SITULA
Cologne ou Maasland, dernier tiers du XIIᵉ siècle
Bronze, hauteur 12,4 cm, ⌀ supérieur 12,8 cm, ⌀ inférieur 8,5 cm
MAYENCE, BISCHÖFLICHES DOM- UND DIÖZESANMUSEUM

Le seau représenté (« situla » en latin) compte au nombre des rares bénitiers de l'époque romane ayant été conservés. Mentionné pour la première fois dans un inventaire en 1786, il a été transféré de l'église paroissiale Saint-Étienne de Mayence au musée épiscopal de la cathédrale et du diocèse. Sur les parois comprises entre les pilastres sont représentés le Christ, la Vierge Marie et saint Héribert, archevêque de Cologne. D'après l'inscription y figure également l'abbé Hardmann qui très probablement dirigeait, en 1185, l'abbaye d'Héribert à Cologne-Deutz.

4 Par : Fuss

1050 — 1100.

TWO SPANDRELS

Nicholas of Verdun, 1st quarter of the 13th century
Copper gilt, enamelled, 11.3 x 11.4 cm / 4 ⅜ x 4 ½ in. (left). 11.4 x 11.3 cm / 4 ½ x 4 ⅜ in. (right)
DARMSTADT, HESSISCHES LANDESMUSEUM

The two spandrels originally formed part of the decoration of the famous Shrine of the Magi in Cologne cathedral. The copper plates reveal drill holes, via which they were affixed to the oak core of the shrine. The corners of the originals are today damaged and in some places have lost their enamel.

NAVICULA

Rhenish, c. 1200. Copper gilt, enamelled
FORMERLY IN THE POSSESSION OF THE PRINCES OF HOHENZOLLERN-SIGMARINGEN; AUCTIONED IN 1928
WHEREABOUTS UNKNOWN

The small censer is illustrated as seen from above as well as from the side. Its lid is decorated with two bosses and bears a dragon motif.

ZWEI ECKZWICKEL

Nikolaus von Verdun, 1. Viertel 13. Jahrhundert
Kupfer, vergoldet, emailliert, 11,3 x 11,4 cm (links). 11,4 x 11,3 (rechts)
DARMSTADT, HESSISCHES LANDESMUSEUM

Die beiden Zierstücke gehörten ursprünglich zum Schmuck des berühmten Schreines der Heiligen Drei Könige im Kölner Dom. Die Eckzwickel weisen Durchbohrungen auf, die zur Befestigung der Kupferplatten am Eichenholzkern des Schreins dienten. Die Originale sind in den Ecken beschädigt und weisen Fehlstellen im Email auf.

WEIHRAUCHSCHIFFCHEN

Rheinisch, um 1200. Kupfer, vergoldet, emailliert
AUS DEM BESITZ DER FÜRSTEN VON HOHENZOLLERN-SIGMARINGEN; 1928 VERSTEIGERT
AUFBEWAHRUNGSORT UNBEKANNT

Den Deckel des Weihrauchschiffchens, das in Aufsicht und Seitenansicht wiedergegeben ist, zieren zwei Knäufe mit Drachenmotiv.

DEUX PENDENTIFS

Nicolas de Verdun, 1ᵉʳ quart du XIIIᵉ siècle
Cuivre, doré, émaillé, 11,3 x 11,4 cm (à gauche). 11,4 x 11,3 cm (à droite)
DARMSTADT, HESSISCHES LANDESMUSEUM

À l'origine, les deux pièces ornementales appartenaient au décor de la célèbre châsse des Rois mages conservée dans la cathédrale de Cologne. Les pendentifs présentent des perforations qui servaient à fixer les plaques de cuivre sur le fond en chêne du reliquaire. Les originaux sont endommagés dans les angles ; l'émail a par endroits disparu.

NAVETTE À ENCENS

Rhénanie, vers 1200. Cuivre, doré, émaillé
PROVENANT DE LA COLLECTION DES PRINCES DE HOHENZOLLERN-SIGMARINGEN ;
VENDUE AUX ENCHÈRES EN 1928 – LOCALISATION INCONNUE

Le couvercle de la navette à encens, qui est restituée vue d'en haut et de côté, est orné de deux poignées en forme de dragon.

5 Par. Zoll

L. Hoch=A : del

L. Ritter.

RELIQUARY BUST

German, late 15th century. Boxwood, painted, bronze, fire-gilded, gems, h. 13.5 cm / 5 ⅜ in.

FORMERLY FRANKFURT AM MAIN, PRIVATE COLLECTION

This so-called speaking reliquary announces its content through its form, as its outer shape is based on the body part whose relics it houses. The present bust reliquary, carved out of boxwood and painted, preserves the remains of the head of a female saint. Her bust rises from a plinth supported by three lions and fashioned – like the crown on the saint's head – in fire-gilded bronze studded with gems.

BÜSTENRELIQUIAR

Deutsch, Ende 15. Jahrhundert. Buchsbaum, farbig gefasst, Bronze, feuervergoldet, Edelsteine, 13,5 cm hoch

EHEMALS IN FRANKFURTER PRIVATBESITZ

Das sogenannte sprechende Reliquiar verweist durch seine Form auf seinen Inhalt. Die äußere Form des Gefäßes wurde dem Körperteil nachempfunden, dessen Reliquien sich darin befinden. Das aus Buchsbaumholz geschnitzte und farbig gefasste Büstenreliquiar bewahrt die Überreste vom Kopf einer Heiligen. Die Büste erhebt sich auf einem bronzenen, von drei Löwen getragenen, feuervergoldeten und mit Edelsteinen besetzen Sockel. Eine ebenso gestaltete Krone trägt die Heilige auf dem Haupt.

BUSTE-RELIQUAIRE

Allemagne, fin du XVᵉ siècle. Buis, coloré, bronze, doré au feu, pierres précieuses, hauteur 13,5 cm

AUTREFOIS EN LA POSSESSION D'UN PARTICULIER DE FRANCFORT

Le reliquaire « parlant » renvoie par sa forme à son contenu. L'aspect de l'objet correspond à la partie du corps dont les reliques y sont conservées. Sculpté dans du buis et coloré, le buste-reliquaire contient les restes de la tête d'une sainte. Le buste s'élève sur un socle de bronze porté par trois lions, doré au feu puis serti de pierres précieuses. La sainte est coiffée d'une couronne pareillement conçue.

1380—1420

III.

HP sc :

26.

I H vH A del :

(pp. 456–59)

RELIQUARY

Cologne (?). 2nd half of the 12th century. Oak, copper, enamelled. 35.2 x 14.8 cm / 13 ⅞ x 5 ⅞ in.

MUNICH, BAYERISCHES NATIONALMUSEUM

Formerly housed in the palace chapel of Schloss Tüssling in the district of Altötting, Upper Bavaria,
the reliquary passed into the collection of the Bayerisches Nationalmuseum in 1864.
It consists of an oak core encased by enamelled copper plaques. The front of the reliquary shows an
engraved Crucifixion with the Virgin and St John the Evangelist, whereby all three heads are modelled out
of copper and mounted in high relief onto the bodies. The decoration on the side walls is illustrated
on the plate in separate outline drawings: on the left, the Virgin and Child on a rainbow, and on the right,
Christ on a rainbow with the symbols of the Evangelists in the four spandrels (cf. also ill. p. 459).
On the back of the reliquary, a representation of St Peter as Gatekeeper is a later addition.
Each of the four sides of the roof is decorated with an angel holding a Gospel Book.

(S. 456–459)

RELIQUIAR

Köln (?). 2. Hälfte 12. Jahrhundert. Eichenholz, Kupfer, emailliert, 35,2 cm hoch, 14,8 cm breit

MÜNCHEN, BAYERISCHES NATIONALMUSEUM

Das Reliquiar gelangte 1864 aus der Kapelle von Schloss Tüßling im Landkreis Altötting (Oberbayern)
in Museumsbesitz. Es besteht aus einem Eichenholzkern, der mit emaillierten Kupferplatten belegt ist.
Die Vorderseite des Reliquiars zeigt die gravierten Figuren des Gekreuzigten mit Maria und Johannes,
deren Köpfe aus Kupfer modelliert und plastisch aufgesetzt sind. Die Darstellungen der Seitenwände
sind auf der Tafel in gesonderten Umrisszeichnungen wiedergegeben. Auf der linken Seite ist
Maria mit dem Jesuskind auf einem Regenbogen dargestellt, auf der rechten Seite Christus
auf dem Regenbogen mit Evangelistensymbolen in den Zwickeln (siehe auch Abb. S. 459).
Auf der Rückseite des Reliquiars befindet sich eine später hinzugefügte Darstellung des heiligen Petrus
als Pförtner. Jede der vier Dachflächen ziert ein Engel mit Evangeliar.

(pp. 456–459)

RELIQUAIRE

Cologne (?). 2ᵉ moitié du XIIᵉ siècle. Chêne, cuivre, émaillé, hauteur 35,2 cm, largeur 14,8 cm

MUNICH, BAYERISCHES NATIONALMUSEUM

Issu de la chapelle du château de Tüssling, dans l'arrondissement d'Altötting (Haute-Bavière),
le reliquaire devint en 1864 la propriété du musée. Il est constitué d'un fond en chêne recouvert de plaques
de cuivre. La face antérieure du reliquaire montre les figures gravées du Crucifié avec Marie et Jean dont
les têtes en cuivre ont été exécutées en relief puis posées. Les représentations des parois latérales
apparaissent sur la planche sous forme de croquis distincts. À gauche, la Vierge à l'Enfant sur un
arc-en-ciel ; à droite, le Christ sur l'arc-en-ciel avec, dans les angles, les symboles des évangélistes
(cf. aussi ill. p. 459) ; enfin, la figure de saint Pierre en portier du paradis, ajoutée ultérieurement
sur la face postérieure. Chacune des quatre surfaces du couvercle en forme de toit arbore
un ange tenant un évangéliaire.

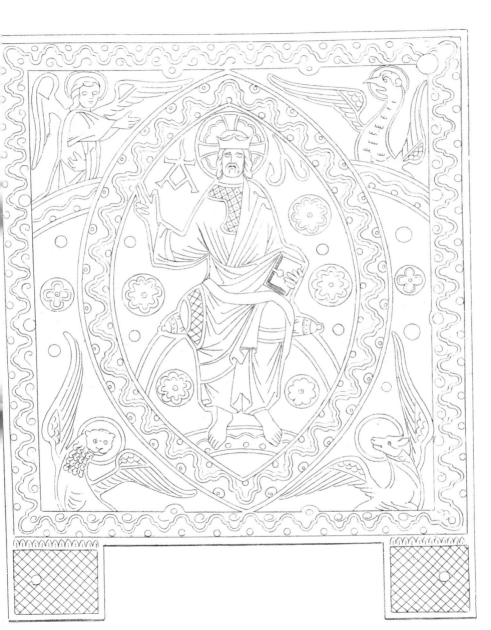

RELIQUARY CROSS

German, 2nd half of the 15th century. Silver gilt, gems, 33.7 x 14.5 cm / 13 ¼ x 5 ⅝ in.

FREISING, DOMMUSEUM

The centre of the cross is occupied by a statuette of St George, whose relics are preserved in an interior cavity. The ends of the cross are decorated with rosettes studded with coloured stones (no longer the originals). To allow the relics to be viewed, a cruciform opening was cut into the back of the reliquary, whereby a high-quality engraving of the Crucified Christ with the symbols of the Evangelists was destroyed. The reliquary cross is today housed in the cathedral museum in Freising, on loan from the parish of Massenhausen in Upper Bavaria.

RELIQUIENKREUZ

Deutsch, 2. Hälfte 15. Jahrhundert. Silber, vergoldet, Edelsteine, 33.7 x 14.5 cm

FREISING, DOMMUSEUM

Im Zentrum des Werkes befindet sich die Statuette des heiligen Georg, dessen Reliquien im Hohlraum des Kreuzes aufbewahrt werden. Die Kreuz-Enden zieren Rosetten mit farbigen Steinen, die allerdings nicht die Originalsteine sind. Zur Betrachtung der Reliquien wurde in die Rückseite des Reliquiars eine kreuzförmige Öffnung geschnitten, wodurch eine qualitätvolle Gravur des Gekreuzigten mit den Evangelistensymbolen zerstört wurde. Das Reliquienkreuz befindet sich als Leihgabe der Pfarrei Massenhausen in Oberbayern im Dommuseum Freising.

CROIX-RELIQUAIRE

Allemagne, 2ᵉ moitié du XVᵉ siècle. Argent, doré, pierres précieuses, 33.7 x 14.5 cm

FREISING, DOMMUSEUM

Au centre de l'œuvre se trouve la statuette de saint Georges, dont les reliques sont conservées dans la cavité de la croix. Les extrémités de celle-ci sont ornées de rosettes garnies de pierres colorées qui, toutefois, ne sont pas d'origine. Pour permettre la contemplation des reliques, une ouverture cruciforme a été découpée dans la face postérieure du reliquaire, entraînant la destruction d'une gravure de grande qualité qui représentait le Christ crucifié et les symboles des évangélistes. La croix-reliquaire, qui constitue un prêt de la paroisse de Massenhausen en Haute-Bavière, est conservée au musée de la cathédrale de Freising.

1460 — 1490.

J.H.v.H.del. L.P. sc.

BOX

Lake Constance region, c. 1340. Leather, iron, 7 x 22 x 16 cm / 2 ¾ x 8 ½ x 6 ¼ in.

STAATLICHE MUSEEN ZU BERLIN, KUNSTGEWERBEMUSEUM

This rectangular box is made of carved and embossed leather and furnished with iron fittings and an iron lock. The side walls are decorated with embossed leafy ornament. On the lid, embossed scrolling tendrils and foliage surround a man and a woman with a falcon.

KÄSTCHEN

Bodenseegebiet, um 1340. Leder, Eisen, 7 x 22 x 16 cm

STAATLICHE MUSEEN ZU BERLIN, KUNSTGEWERBEMUSEUM

Das viereckige Kästchen ist aus geritztem und gepunztem Leder hergestellt und mit Eisenbeschlägen und einem Eisenschloss versehen. Die Seitenwände ziert gepresstes Blattwerk. Auf dem Deckel mit ebenfalls gepressten Darstellungen sind ein Mann und eine Frau mit Falken von Blattwerk umgeben.

COFFRET

Région du lac de Constance, vers 1340. Cuir, fer, 7 x 22 x 16 cm

STAATLICHE MUSEEN ZU BERLIN, KUNSTGEWERBEMUSEUM

Exécuté en cuir gravé et poinçonné, le coffret rectangulaire est garni de ferrures et d'une serrure en fer. Les parois latérales sont ornées de feuillages pressés dans le cuir. Sur le couvercle apparaissent les figures, également pressées, d'un homme et d'une femme avec un faucon, entourés de feuillages.

4 Par Fuss.

1300 — 1350.

CROOK OF A CROSIER, "CURVA"

German, 2nd half of the 13th century. Copper, fire-gilded; gems, h. 28.3 cm / 11 ⅛ in.

FORMERLY WITHIN THE ART TRADE –WHEREABOUTS UNKNOWN

The crook, or *curva*, of this crosier contains a representation of the Annunciation.
The shaft and spiral are studded with blue and green gems in alternating sequence.

BOOK MOUNTS

German, mid-13th century. Bronze; each 7.3 x 7.3 cm / 2 ⅞ x 2 ⅞ in.

WÜRZBURG, UNIVERSITÄTSBIBLIOTHEK

The book mounts are found on the cover of a Bible codex from the 13th century. The upper design adorns
the centre of the front and back cover, whereas the lower mount features on all the corners,
i.e. eight times in total.

BISCHOFSSTAB, „CURVA"

Deutsch, 2. Hälfte 13. Jahrhundert. Kupfer, feuervergoldet, Edelsteine. 28.3 cm hoch

EHEMALS IM KUNSTHANDEL –AUFBEWAHRUNGSORT UNBEKANNT

In der Krümme, „Curva", des Bischofsstabes befindet sich eine Darstellung der Verkündigung.
Auf Schaft und Spirale sind im Wechsel Edelsteine in den Farben Blau und Grün aufgesetzt.

BUCHBESCHLÄGE

Deutsch, Mitte 13. Jahrhundert. Bronze, je 7.3 x 7.3 cm

WÜRZBURG, UNIVERSITÄTSBIBLIOTHEK

Die Buchbeschläge zieren den Einband eines Bibelcodex aus dem 13. Jahrhundert. Der obere Beschlag
schmückt die Mitte des vorderen und hinteren Buchdeckels. Der untere Beschlag wurde an allen Ecken
der Buchdeckel verwendet, das heißt insgesamt acht Mal.

CROSSE ÉPISCOPALE, « CURVA »

Allemagne, 2ᵉ moitié du XIIIᵉ siècle. Cuivre, doré à l'amalgame, pierres précieuses, hauteur 28.3 cm

AUTREFOIS DANS LE COMMERCE D'OBJETS D'ART – LOCALISATION INCONNUE

Dans le crosseron, la « curva », de la crosse épiscopale, est représentée l'Annonciation.
La hampe et la volute sont garnies de pierres précieuses faisant alterner le bleu et le vert.

FERRURES DE LIVRE

Allemagne, milieu du XIIIᵉ siècle, Bronze, 7.3 x 7.3 cm chacune

WURTZBOURG, UNIVERSITÄTSBIBLIOTHEK

Les ferrures ornent la reliure d'un codex de la Bible datant du XIIIᵉ siècle. La ferrure du haut décore
le centre du plat avant et du plat arrière. Celle du bas a été utilisée pour décorer tous les angles des plats,
c'est-à-dire huit fois au total.

3 Par. Zoll.

CENSER
German, c. 1100. Bronze, 25.6 x 12.1 cm / 10 x 4 ¾ in.
FREISING, DOMMUSEUM
The censer, whose design invokes the forms of secular Romanesque architecture,
is identical on every side. The foot is today missing from the original and the censer
is furnished instead with a chain.

WEIHRAUCHFASS
Deutsch, um 1100. Bronze, 25,6 x 12,1 cm
FREISING, DOMMUSEUM
Das aus profanen romanischen Architekturformen aufgebaute Rauchfass
ist an allen Seiten gleichartig gestaltet. Am Original fehlt heutzutage der Fuß.
Das Rauchfass ist stattdessen mit einer Kette versehen.

ENCENSOIR
Allemagne, vers 1100. Bronze, 25,6 x 12,1 cm
FREISING, DOMMUSEUM
Tous les côtés de l'encensoir, construit à partir de formes architecturales profanes d'époque
romane, sont conçus de manière identique. Aujourd'hui, l'original ne comporte plus le pied.
Au lieu de cela, l'encensoir est pourvu d'une chaînette.

1050 — 1150.

Left / links / à gauche

CANDLESTICK

German, 2nd half of the 15th century. Brass, cast, 13.8 x 9.7 cm / 5 ½ x 3 ¾ in.

MUNICH, BAYERISCHES NATIONALMUSEUM

The candlestick stands on three feet, which describe the outline of an ogee arch and which
end at the bottom in dragon heads. Above this construction is a circular bowl, from which
the cylindrical candleholder rises on a ring.

LEUCHTER

Deutsch, 2. Hälfte 15. Jahrhundert. Messing, gegossen, 13.8 x 9.7 cm

MÜNCHEN, BAYERISCHES NATIONALMUSEUM

Die Standkonstruktion des Leuchters besteht aus drei nach unten in Drachenköpfen auslaufenden Füßen
in Form eines sogenannten Eselsrückens. Über dieser Konstruktion befindet sich eine vertiefte Schale,
in die auf einem Ring die Befestigung für das Aufstecken des Lichtes eingelassen ist.

CHANDELIER

Allemagne, 2ᵉ moitié du XVᵉ siècle. Laiton, fondu; 13,8 x 9,7 cm

MUNICH, BAYERISCHES NATIONALMUSEUM

Le support du chandelier est constitué de trois pieds en forme de doucine, se terminant en bas par
des têtes de dragon. Au-dessus de cette construction se trouve une coupe creuse dans laquelle est
enchâssée, sur un anneau, la fixation destinée à recevoir le cierge.

Right / rechts / à droite

HOLY-WATER CONTAINER

German, 2nd half of the 15th century. Brass, cast, 25.9 x 10.8 cm / 10 ⅛ x 4 ¼ in.

FORMERLY IN A PRIVATE COLLECTION - WHEREABOUTS UNKNOWN

The container for holy water can be suspended from its handle or stood on a surface. Cast in bronze,
it has been ornamented with simple horizontal lines and slight convex mouldings,
created by turning the vessel on the lathe.

WEIHWASSERKESSEL

Deutsch, 2. Hälfte 15. Jahrhundert. Messing, gegossen, 25,9 x 10,8 cm

EHEMALS IN PRIVATBESITZ - AUFBEWAHRUNGSORT UNBEKANNT

Der Weihwasserkessel, der sowohl hingestellt als auch aufgehängt werden kann, wurde gegossen und
anschließend auf der Drehbank mit einfachen horizontalen Linien und leichten Vorsprüngen verziert.

VASE À EAU BÉNITE

Allemagne, 2ᵉ moitié du XVᵉ siècle. Laiton, fondu, 25,9 x 10,8 cm

AUTREFOIS EN LA POSSESSION D'UN PARTICULIER – LOCALISATION INCONNUE

Ce vase à eau bénite, pouvant être posé ou suspendu, a été fondu puis décoré, sur le tour,
de simples lignes horizontales et de moulures peu saillantes.

3 Par Zoll

4 Par Zoll

1440 — 1480.

PORTABLE ALTAR, "SECOND ARNULF CIBORIUM"
South German, Regensburg (?), c. 1240
Oak, silver gilt, porphyry, 24 x 16 cm / 9 ½ x 6 ¼ in.
MUNICH, RESIDENZ, TREASURY

The portable altar is made of oak encased in silver gilt and incorporates a framed slab of porphyry, as seen on the plate. The altar housed relics of all the saints engraved and individually named in the border, together with a splinter of the True Cross and other sacred objects. The Crucifixion with the Virgin and St John the Evangelist is depicted at the centre of the upper border, and the Virgin and Child in the lower border. The altar carries an inscription – separately reproduced at the top of the plate – that makes reference to its nature as a reliquary.

TRAGBARER ALTAR „ZWEITES ARNULF-ZIBORIUM"
Süddeutsch, Regensburg (?), um 1240
Eichenholz, Silber, vergoldet, Porphyr, 24 x 16 cm
MÜNCHEN, SCHATZKAMMER DER RESIDENZ

Der tragbare Altar aus Eichenholz ist mit vergoldetem Silber beschlagen und trägt eine gerahmte Porphyrplatte, die auf der Tafel abgebildet ist. Der Altar enthielt die Reliquien aller im Rahmen in Gravur dargestellten und namentlich bezeichneten Heiligen sowie ein Kreuzpartikel und andere Heiltümer. Oben im Zentrum des Rahmens ist der Gekreuzigte mit Maria und dem Evangelisten Johannes dargestellt und unten auf dem Rahmen die Muttergottes mit dem Kind. Am oberen Rand der Tafel ist die Inschrift des Altars, die auf die Reliquiareigenschaft des Objekts verweist, separat wiedergegeben.

AUTEL PORTATIF, « DEUXIÈME CIBOIRE D'ARNULF »
Allemagne du Sud, Ratisbonne (?), vers 1240
Chêne, argent, doré, porphyre, 24 x 16 cm
MUNICH, TRÉSOR DE LA RÉSIDENCE

L'autel portatif en chêne est garni d'argent doré et surmonté d'un plateau de porphyre encadré, lequel figure sur la planche. Il contenait les reliques de tous les saints gravés et nommément désignés dans le cadre, ainsi qu'un fragment de la Croix et d'autres trésors sacrés. En haut, au centre du cadre, on aperçoit le Christ crucifié accompagné de Marie et de saint Jean l'évangéliste et, en bas, la Vierge à l'Enfant. L'inscription figurant sur l'autel et indiquant qu'il s'agit d'un reliquaire, est reproduite séparément, sur le bord supérieur de la planche.

OMNES·ISTI·SANCTI·QVI·SVNT·HIC·IN
SCRIPTI·ILLÓR·SACTVARIVM·EST·HIC

1150–1200.

COMB

North Italian, c. 1400. Ivory, 13.7 x 15.7 cm / 5 ⅜ x 6 ⅛ in.

STAATLICHE MUSEEN ZU BERLIN, KUNSTGEWERBEMUSEUM

Between its two rows of teeth, the comb offers room in the centre for reliefs of religious scenes.
The front of the comb, illustrated in the upper half of the plate, shows the Annunciation: Mary is kneeling
in front of a prie-dieu while the dove of the Holy Spirit flies towards her from out of a cloud.
Separated from her by a vase containing a lily, the Archangel Gabriel appears with a long scroll.
The reverse of the comb shows the Adoration of the Magi: Mary and the Infant Christ are sitting up
in bed, the manger with the ox and ass visible above them and Joseph, dressed as a pilgrim, standing
at the head of the bed behind them. One of the Kings is kneeling at the foot of the bed, and a second,
standing behind him, is pointing to the star, which is not visible. The carved scenes are bordered
on both sides by rose stems.

KAMM

Norditalienisch, um 1400. Elfenbein, 13,7 x 15,7 cm

STAATLICHE MUSEEN ZU BERLIN, KUNSTGEWERBEMUSEUM

Der Kamm mit zwei Zahnreihen bietet auf dem Mittelstück Platz für Reliefs mit sakralen Darstellungen.
Auf der oben abgebildeten Vorderseite ist die Verkündigung dargestellt. Maria kniet vor einem Betpult,
während die Taube aus einer Wolke auf sie zufliegt. Abgetrennt durch eine Vase mit Lilie
erscheint gegenüber der Erzengel mit einer langen Schriftrolle. Auf der Rückseite des Kammes ist der
Besuch der Heiligen Drei Könige zu sehen. Maria liegt mit dem Jesuskind im Bett, an dessen Kopfende
Joseph in Pilgerkleidung steht. Oberhalb ist die Krippe mit Ochs und Esel dargestellt. Am Fußende kniet
einer der Könige, ein weiterer steht hinter ihm und weist auf den nicht sichtbaren Stern.
Gerahmt werden die Darstellungen der Vorder- und Rückseite von Rosenzweigen.

PEIGNE

Italie du Nord, vers 1400. Ivoire, 13,7 x 15,7 cm

STAATLICHE MUSEEN ZU BERLIN, KUNSTGEWERBEMUSEUM

Le peigne à deux rangées de dents offre, dans sa partie médiane, un espace accueillant des reliefs de figures
saintes. L'Annonciation apparaît sur la face antérieure, illustrée en haut de la planche. Marie est agenouillée
devant un prie-dieu tandis que la colombe, sortant d'un nuage, vole vers elle. En face, séparé par un vase
contenant un lys, se tient l'archange, portant un long volumen. La face postérieure du peigne représente
la visite des Rois mages. Marie est allongée avec l'Enfant Jésus ; Joseph, en tenue de pèlerin, se tient
à son chevet. Au-dessus de la Vierge on aperçoit la crèche, avec l'âne et le bœuf. L'un des Rois mages
est agenouillé au pied du lit, un autre se tient derrière lui et montre l'étoile, laquelle n'est pas visible.
Sur les deux faces du peigne, les reliefs sont encadrés de branches de rosiers.

I.H.v.H.A.del.

1380 – 1420

P. Walther sc.

3 P. Zoll

B

3 P Zoll

C

(pp. 474/75)

A. GUILD JUG, "SCHLEIFKANNE"

Hans Boeler, Hof, 1568. Tin, cast, h. 40.6 cm / 16 in.; ø 16.2 cm / 6 ⅜ in.

NUREMBERG, GERMANISCHES NATIONALMUSEUM

The plate shows the guild jug, or *Schleifkanne*, of the Nuremberg guild of tailors, whose coat of arms appears above the engraved representation of the Resurrection. This type of jug was known as a *Schleifkanne*, or "drag jug," because its size made it very heavy when full of beer and it had to be dragged back to the guild after being filled at the nearest inn. The present example was made by Master Hans Boeler and bears the date 1568.

B. JUG, "SCHNELLE"

Siegburg, 1559. Stoneware, h. 29 cm / 11 ⅜ in.

NUREMBERG, GERMANISCHES NATIONALMUSEUM

The German term *Schnelle* designates a particular jug design from the 16th and 17th century, characterized by its tall, slender form that tapers at the top.

C. JUG

Waldenburg, last quarter of the 16th century. Stoneware, tin mount, h. 26 cm / 10 ¼ in., ø 10.8 cm / 4 ¼ in.

NUREMBERG, GERMANISCHES NATIONALMUSEUM

(S. 474/475)

A. ZUNFTKANNE, „SCHLEIFKANNE"

Hans Boeler, Hof, 1568. Zinn, gegossen; 40,6 cm hoch, ø 16,2 cm

NÜRNBERG, GERMANISCHES NATIONALMUSEUM

Die Tafel zeigt die „Schleifkanne" (Zunftkanne) der Nürnberger Schneider, deren Wappenschild sich oberhalb der gravierten Darstellung der Auferstehung Christi befindet. Das Stück wurde von Meister Hans Boeler angefertigt und trägt die Datierung 1568. Das Gefäß wurde als Schleifkanne bezeichnet, da man es in einem nahegelegenen Gasthaus mit Bier füllte und es dann aufgrund des hohen Gewichts zur Zunft- oder Gildenzusammenkunft „heranschleifen" musste.

B. SCHNELLE

Siegburg, 1559. Steinzeug, 29 cm hoch

NÜRNBERG, GERMANISCHES NATIONALMUSEUM

Schnelle ist die Bezeichnung für sehr hohe, schlanke, nach oben schmaler werdende Gefäße, die von der Mitte des 16. bis Anfang des 17. Jahrhunderts hergestellt wurden.

C. KRUG

Waldenburg, letztes Viertel 16. Jahrhundert. Steinzeug, Zinnmontierung, 26 cm hoch, ø 10,8 cm

NÜRNBERG, GERMANISCHES NATIONALMUSEUM

(p. 474/475)

A. CRUCHE DE CORPORATION, « SCHLEIFKANNE »

Hans Boeler, Hof, 1568. Étain, fondu, hauteur 40,6 cm, ø 16,2 cm
NUREMBERG, GERMANISCHES NATIONALMUSEUM

La planche montre la cruche de corporation des tailleurs nurembergeois, dont le blason se trouve
au-dessus d'une gravure représentant la Résurrection. La pièce a été exécutée par le maître Hans Boeler
et porte la date de 1568. Ce récipient était appelé «Schleifkanne» (broc à traîner) car, après l'avoir rempli
de bière dans une auberge voisine, il fallait – à cause de son poids considérable – le « traîner »
jusqu'au lieu de rencontre de la corporation ou de la guilde.

B. « SCHNELLE » (CHOPE)

Siegburg, 1559. Grès, hauteur 29 cm
NUREMBERG, GERMANISCHES NATIONALMUSEUM

« Schnelle » est le terme désignant des récipients très grands, élancés et se rétrécissant vers le haut,
qui furent fabriqués du milieu du XVIe au début du XVIIe siècle.

C. CHOPE

Waldenburg, dernier quart du XVIe siècle. Grès, monture d'étain, hauteur 26 cm, ø 10,8 cm
NUREMBERG, GERMANISCHES NATIONALMUSEUM

A. HOUSING OF ST ULRICH'S CROSS (FRONT VIEW)
Nikolaus Seld, Augsburg, 1494. Silver gilt, gems, h. 12.5 cm / 5 in.

B. ST ULRICH'S CROSS (FRONT)
Augsburg, 1320/30. Gold, h. 6.5 cm / 2 ½ in.
Both : Augsburg, parish church of SS Ulrich and Afra

According to legend, the little Gothic St Ulrich's Cross (B, ills. pp. 479 and 481 bottom) contains a splinter of the cross that Bishop Ulrich is said to have brandished in front of the Hungarian enemy at the victorious Battle of Lechfeld in AD 955. The front carries a depiction of Christ crucified on a raguly cross, accompanied on either side by the heads of the Virgin and St John the Evangelist. The magnificent housing (A, ills. pp. 479 and 481 top) in which the St Ulrich's cross is kept was commissioned by Abbot Johann of Giltlingen, who is named as the donor in the inscription. The goldsmith's signature is found on the inside of the lid. At the centre of the display face is a rosette of table diamonds, of which smaller examples decorate the ends of the cross. The arms of the cross are studded with four sapphires, together with rubies and pearls.

A. GEHÄUSE DES ULRICHSKREUZES (VORDERSEITE)
Nikolaus Seld, Augsburg, 1494. Silber, vergoldet, Edelsteine, 12,5 cm hoch

B. ULRICHSKREUZ (VORDERSEITE)
Augsburg, 1320/30. Gold, 6,5 cm hoch
Beide: Augsburg, Stadtpfarrkirche St. Ulrich und Afra

Im Inneren des Gehäuses befindet sich das kleine gotische Ulrichskreuz (B, Abb. S. 479 und 481 unten), das der Legende nach ein Holzpartikel jenes Kreuzes bergen soll, das der heilige Bischof Ulrich im Jahre 955 während der siegreichen Schlacht auf dem Lechfeld den ungarischen Feinden entgegengehalten haben soll. Auf der Vorderseite des Ulrichskreuzes ist Christus an einem Astkreuz dargestellt, daneben die Köpfe von Maria und Johannes.Das prunkvolle Gehäuse (A, Abb. S. 479 und 481 oben) ließ Abt Johann von Giltlingen anfertigen, der in der Inschrift als Stifter genannt wird. Der Gehäusedeckel trägt innen die Signatur des Goldschmiedes. Auf der Schauseite des Gehäuses befindet sich im Zentrum eine Rosette aus Tafeldiamanten, von denen kleinere Exemplare die Kreuz-Enden zieren. Die Kreuzarme schmücken vier Saphire und zusätzlich Perlen und Rubine.

A. BOÎTIER DE LA CROIX DE SAINT ULRICH (FACE ANTÉRIEURE)
Nikolaus Seld, Augsbourg, 1494. Argent, doré, pierres précieuses, hauteur 12,5 cm

B. CROIX DE SAINT ULRICH (FACE ANTÉRIEURE)
Augsbourg, 1320/30. Or, hauteur 6,5 cm
Les deux : Augsbourg, basilique Saint-Ulrich-et-Sainte-Afre

À l'intérieur du boîtier se trouve la petite croix gothique de saint Ulrich (B, ill. pp. 479 et 481 en bas), laquelle, selon la légende, recèle un fragment de bois issu de la croix que l'évêque saint Ulrich aurait brandie face aux ennemis hongrois lors de la bataille victorieuse du Lechfeld, en l'an 955. Sur la face antérieure de la croix, le Christ est représenté sur une croix écotée, flanqué des têtes de Marie et de saint Jean. Le somptueux boîtier (A, ill. pp. 479 et 481 en haut) a été commandé par l'abbé Johann von Giltlingen, mentionné par l'inscription en tant que donateur. Le couvercle du boîtier porte à l'intérieur la signature de l'orfèvre. La face tournée vers le spectateur est garnie, au centre, d'une rosette de diamants taillés en biseau, dont des exemplaires plus petits ornent les extrémités de la croix. Quatre saphirs agrémentés de perles et de rubis en décorent les branches.

A — 1494.

B. 1280-1320.

B

A. HOUSING OF ST ULRICH'S CROSS (BACK VIEW)
Nikolaus Seld, Augsburg, 1494. Silver gilt, gems, h. 12.5 cm / 5 in.

B. ST ULRICH'S CROSS (BACK)
Augsburg, 1320/30, Gold, h. 6.5 cm / 2 ½ in.
BOTH: AUGSBURG, PARISH CHURCH OF SS ULRICH AND AFRA

The back of the housing is engraved with a representation of the Battle of Lechfeld (A). The figure of
St Ulrich is seen at the centre, receiving the cross of victory from an angel. The inscription of the back
of the small cross (B) describes the object as the victory cross of Bishop Ulrich.

A. GEHÄUSE DES ULRICHSKREUZES (RÜCKSEITE)
Nikolaus Seld, Augsburg, 1494. Silber, vergoldet, Edelsteine, 12,5 cm hoch

B. ULRICHSKREUZ (RÜCKSEITE)
Augsburg, 1320/30. Gold, 6,5 cm hoch
BEIDE: AUGSBURG, STADTPFARRKIRCHE ST. ULRICH UND AFRA

Auf der Rückseite des Gehäuses befindet sich eine gravierte Darstellung der Schlacht auf dem Lechfeld,
in deren Zentrum der heilige Ulrich von einem Engel das Siegeskreuz empfängt.
Die Inschrift auf der Rückseite bezeichnet das Werk als Siegeskreuz des Bischofs Ulrich.

A. BOÎTIER DE LA CROIX DE SAINT ULRICH (FACE POSTÉRIEURE)
Nikolaus Seld, Augsbourg, 1494. Argent, doré, pierres précieuses, hauteur 12,5 cm

B. CROIX DE SAINT ULRICH (FACE POSTÉRIEURE)
Augsbourg, 1320/30. Or, hauteur 6,5 cm
LES DEUX : AUGSBOURG, BASILIQUE SAINT-ULRICH-ET-SAINTE-AFRE

Sur la face arrière du boîtier est gravée une représentation de la bataille du Lechfeld, au centre de laquelle
saint Ulrich reçoit des mains d'un ange la croix du triomphe. L'inscription au dos de la croix indique
qu'il s'agit de la croix du triomphe de l'évêque Ulrich.

A — 1494. B. 1280-1320.

B

(pp. 483–85)

A & B. RELIQUARY MONSTRANCE "ST CUNEGUND'S LAMP"

Egyptian, 10th–12th century; South German, 13th–14th century
Rock crystal, copper gilt, h. 29.4 cm / 11 ½ in.
BAMBERG, CATHEDRAL TREASURY

The foot consists of three crouching lions, carved out of rock crystal and mounted in copper gilt.
The octagonal stem is also made of crystal and features four bosses and a double nodus, above which rise
three arms that formerly all held oval capsules containing relics. Only one of these capsules is still in situ.
Hefner-Alteneck shows a second capsule in his illustration in order to convey an impression of the original
appearance of the whole. The dowel centrally positioned between the capsules carried a fourth reliquary
in the shape of a cylinder. The object is first documented as a monstrance for relics in 1444.
It contained, amongst other things, remains of the Virgin's girdle and robes, Aaron's staff and the rod
with which Christ was beaten. After the monstrance was damaged in the 17th century,
these relics were subsequently transferred to other housings. Due to its similarity with an oil lamp,
the monstrance in its surviving form became known as "St Cunegund's lamp,"
a name inspired sooner by legend than historical fact.

C. FLASK

Arabic, 10th–12th century. Rock crystal
BAMBERG, CATHEDRAL TREASURY

B.

C.

2 Par. Zoll.

1000 — 1050.

A.

I.H. v H = A. del :

HP. sc:

(S. 483–485)

A & B. RELIQUIENMONSTRANZ
„LAMPE DER HL. KUNIGUNDE"

Ägyptisch, 10.–12. Jahrhundert; Süddeutsch, 13.–14. Jahrhundert
Bergkristall, Kupfer, vergoldet, 29,4 cm hoch

BAMBERG, DOMSCHATZ

Der Fuß besteht aus drei in vergoldetem Kupfer montierten kauernden Löwen, die in Bergkristall (ägyptisch, 10.–12. Jahrhundert) geschnitten sind. Der ebenfalls kristallene Schaft ist achtkantig und besitzt vier Köpfe und einen Doppelnodus, von dem drei Arme abgehen, die früher ovale Kapseln für Reliquien trugen. Von den Kapseln hat sich am Original nur eine erhalten. Auf der Tafel zeigt Hefner-Alteneck eine zweite, um einen Eindruck vom ursprünglichen Zustand zu vermitteln. In der Mitte der Kapseln befindet sich ein Dübel für einen Zylinder als vierte Reliquienfassung. Das Objekt ist seit 1444 als Monstranz für Reliquien bezeugt und wurde im 17. Jahrhundert beschädigt. Es enthielt unter anderem Überreste vom Gürtel und Kleid Marias, vom Stabe Aarons und vom Stab, mit dem Christus geschlagen wurde. Diese Reliquien wurden in andere Fassungen verbracht. Aufgrund der Ähnlichkeit der Reste der Monstranz mit einer Öllampe entstand die neue, legendarisch anmutende Bezeichnung „Lampe der Kunigunde".

C. BERGKRISTALLFLÄSCHCHEN

Arabisch, 10.–12. Jahrhundert. Bergkristall

BAMBERG, DOMSCHATZ

(pp. 483–485)

A & B. OSTENSOIR,
« LAMPE DE SAINTE CUNÉGONDE »

Égypte, Xᵉ–XIIᵉ siècle; Allemagne du Sud, XIIIᵉ–XIVᵉ siècle,
Cristal de roche, cuivre doré, hauteur 29,4 cm

BAMBERG, TRÉSOR DE LA CATHÉDRALE

Le pied est constitué de trois lions accroupis taillés dans le cristal de roche et enchâssés dans du cuivre doré (Égypte, Xᵉ–XIIᵉ siècle). La tige, également en cristal de roche, et de section octogonale, possède quatre têtes et un nœud double d'où partent trois bras, qui portaient autrefois des capsules ovales destinées à contenir des reliques. Une seule de ces capsules est conservée sur l'original. Hefner-Alteneck en présente une deuxième sur la planche, afin de donner un aperçu de l'état initial. Au centre des capsules est installée une cheville destinée à accueillir un cylindre faisant office de quatrième contenant de reliques. Attesté en tant qu'ostensoir pour reliques depuis 1444, l'objet a été détérioré au XVIIᵉ siècle. Jusque-là, il contenait, entre autres, les vestiges de la ceinture et de la robe de la Vierge, du bâton d'Aaron et du bâton avec lequel on frappa Jésus. Ces reliques ont été transférées dans d'autres contenants. En raison de la ressemblance de ce qui reste de l'ostensoir avec une lampe à huile, on inventa la désignation récente, à consonance légendaire, « lampe de sainte Cunégonde ».

C. FIOLE EN CRISTAL DE ROCHE

Arabie, Xᵉ–XIIᵉ siècle. Cristal de roche

BAMBERG, TRÉSOR DE LA CATHÉDRALE

WINE JUG

Cuncz Has, Regensburg, 1453. Tin, h. 58 cm / 22 ⅞ in.

FORMERLY MUNICH, KIRSCH COLLECTION – WHEREABOUTS UNKNOWN

The wine jug by Cuncz Has represents the earliest German example of a "footed jug" made from tin. In central, eastern and southern Germany, jugs of this type were one of the set objects that craftsmen wishing to qualify as a master had to produce, and were frequently owned and used by municipal councils. The present wine jug bears the master's mark of Cuncz Has, the Regensburg city mark and the date 1453.

WEINKANNE

Cuncz Has, Regensburg, 1453. Zinn, 58 cm hoch

EHEMALS SAMMLUNG KIRSCH, MÜNCHEN – AUFBEWAHRUNGSORT UNBEKANNT

Bei der Weinkanne des Cuncz Has handelt es sich um das früheste Exemplar einer „gefußten Kanne". Kannen dieses Typus waren in zahlreichen Zinngießerordnungen in Mittel-, Ost- und Süddeutschland als Meisterprobe vorgeschrieben und wurden vielfach als Ratskannen verwendet. Die Weinkanne trägt das Meisterzeichen des Cuncz Has, die Stadtmarke von Regensburg und das Datum 1453.

PICHET À VIN

Cuncz Has, Ratisbonne, 1453. Étain, hauteur 58 cm

AUTREFOIS CONSERVÉ DANS LA COLLECTION KIRSCH À MUNICH – LOCALISATION INCONNUE

Le pichet à vin de Cuncz Has est l'exemplaire le plus ancien d'une « cruche sur pied ». De nombreux règlements de fondeurs d'étain du centre, de l'est et du sud de l'Allemagne imposaient l'exécution de ce type de pichet – très souvent destiné aux hôtels de ville – pour l'obtention du titre de maître. Le pichet à vin porte le poinçon de maître de Cuncz Has, le poinçon de la ville de Ratisbonne et la date de 1453.

A.

B.

1450

1490

COVERED BEAKER
Hall in Tirol, late 16th century
Glass, polychrome enamel, h. 25 cm / 10 in., cover: ø 8.6 cm / 3 ⅜ in., foot: ø 9.6 cm / 3 ¾ in.
NUREMBERG, GERMANISCHES NATIONALMUSEUM
It is highly probable that the covered beaker was created as a wedding gift. It bears the coat of arms of the Löffelholz family on the side facing the viewer and those of the Volckamer family on the side we cannot see.

DECKELPOKAL
Hall in Tirol, Ende 16. Jahrhundert
Glas, Emailfarben, 25 cm hoch, ø Deckel 8,6 cm, ø Fuß 9,6 cm
NÜRNBERG, GERMANISCHES NATIONALMUSEUM
Bei dem Deckelglas handelt es sich sehr wahrscheinlich um ein Hochzeitsgeschenk. Auf der dem Betrachter zugewandten Seite trägt es das Wappen der Familie Löffelholz und auf der abgewandten Seite das der Familie Volckamer.

COUPE À COUVERCLE
Hall-en-Tyrol, fin du XVIᵉ siècle
Verre, couleurs d'émail, hauteur 25 cm, ø du couvercle 8,6 cm, ø du pied 9,6 cm
NUREMBERG, GERMANISCHES NATIONALMUSEUM
Ce verre à couvercle fut très probablement conçu comme un cadeau de mariage. Sur la face tournée vers le spectateur, il porte le blason de la famille Löffelholz, sur l'envers, celui de la famille Volckamer.

1560 —

DRINKING GLASS
South German, late 16th century. Glass, painted, h. 58.3 cm / 23 in.
FORMERLY NUREMBERG, GERMANISCHES NATIONALMUSEUM
The unusually tall lidded glass shows scenes from peasant life, with people eating, playing games and fighting. The decoration is only painted on, not baked. The drinking glass broke while the museum's exhibits were being installed.

TRINKGLAS
Süddeutsch, Ende 16. Jahrhundert. Glas, bemalt, 58,3 cm hoch
EHEMALS GERMANISCHES NATIONALMUSEUM, NÜRNBERG
Das ungewöhnlich große Deckelglas zeigt Darstellungen aus dem bäuerlichen Leben wie Gastmahle, Spiele und Schlägereien. Die Szenen wurden nur aufgemalt und nicht eingebrannt. Das Trinkglas zerbrach bereits bei der Einrichtung des Museums.

VERRE
Allemagne du Sud, fin du XVIe siècle. Verre, peint, hauteur 58,3 cm
AUTREFOIS CONSERVÉ AU GERMANISCHES NATIONALMUSEUM, NUREMBERG
Des scènes de la vie paysanne telles que des banquets, des jeux et des bagarres figurent sur ce verre à couvercle, de taille exceptionnelle. Elles sont seulement peintes et non cuites. Le verre se brisa dès l'installation du musée.

6 Par: Zoll

STEM GLASS

South German, 1566. Glass, polychrome enamel, h. 21.7 cm / 8 ½ in.
NUREMBERG, GERMANISCHES NATIONALMUSEUM
The stem glass was made as a wedding gift. According to its inscription, it was dedicated
to Michael Ludwig von Freiberg zu Jostingen and his wife Felicitas von Freiberg, née Landschaden
von und zu Steinach, whose coats of arms are portrayed, along with the date 1566.

STENGELGLAS

Süddeutsch, 1566. Glas, Emailfarben, 21,7 cm hoch
NÜRNBERG, GERMANISCHES NATIONALMUSEUM
Das Stengelglas wurde als Hochzeitsgeschenk angefertigt. Es wurde laut Inschrift 1566
Michael Ludwig von Freiberg zu Jostingen und seiner Gemahlin Felicitas von Freiberg, geborene
Landschaden von und zu Steinach, gewidmet, deren Wappen dargestellt sind.

VERRE À PIED

Allemagne du Sud, 1566. Verre, couleurs d'émail, hauteur 21,7 cm
NUREMBERG, GERMANISCHES NATIONALMUSEUM
Ce verre à tige a été conçu comme cadeau de mariage. Selon l'inscription, il a été dédié
en 1566 à Michael Ludwig von Freiberg zu Jostingen et à son épouse Felicitas von Freiberg,
née Landschaden von und zu Steinach, dont les blasons figurent sur le verre.

1600

MIRROR

Italian, Venice (?), c. 1400. Metal, bone, 40 x 27 cm / 15 ¾ x 10 ⅝ in.

FORMERLY IN A PRIVATE COLLECTION WITHIN THE NOBILITY – WHEREABOUTS UNKNOWN

The mirror, which was intended as a bridal gift for a noblewoman, is the product of an art industry that flourished in northern Italy, chiefly in Venice, in the Late Middle Ages. The reflective surface is made of metal. The carved bone frame with two hearts at the top is crowned by Lady Love, flanked by decorative shrubs in tubs. The frame is decorated with winged female genii in a setting of leaves interspersed with occasional fruits.

SPIEGEL

Italienisch, Venedig (?), um 1400. Metall, Bein, 40 x 27 cm

EHEMALS IN ADELIGEM PRIVATBESITZ – AUFBEWAHRUNGSORT UNBEKANNT

Der Spiegel ist das Erzeugnis einer im Spätmittelalter in Norditalien, vorzugsweise in Venedig, etablierten Kunstindustrie und war als vornehmes Brautgeschenk gedacht. Die Spiegelfläche besteht aus Metall. Den Rahmen aus geschnitzten Knochen bekrönt über zwei Herzen Frau Minne, die seitlich von Ziersträuchern in Kübeln begleitet wird. Den Rahmen zieren geflügelte weibliche Genien auf Laubwerk mit einigen Früchten.

MIROIR

Italie, Venise (?), vers 1400. Métal, os, 40 x 27 cm

AUTREFOIS EN LA POSSESSION DE NOBLES – LOCALISATION INCONNUE

Conçu comme un présent raffiné à l'intention de la mariée, le miroir provient d'une industrie d'art établie, au Moyen Âge tardif, en Italie du Nord, probablement à Venise. La surface du miroir est en étain. Le cadre, en os sculpté, est surplombé par la déesse de l'amour se tenant au-dessus de deux cœurs. Celle-ci est flanquée de buissons ornementaux installés dans des jardinières. Le cadre est également orné, sur un fond de feuillages garnis de quelques fruits, de génies féminins ailés.

1440 -

1490.

4 PAR. ZOLL.

BOWL

Nuremberg, 15th century. Brass, beaten, above ∅ 40.6 cm / 16 in., below ∅ 37.8 cm / 14 ¾ in.

NUREMBERG, GERMANISCHES NATIONALMUSEUM

Plate 41 shows two examples of the widely sold items of domestic brassware issuing from Nuremberg in the 15th century and commemorated even today in the city's Beckenschlägergasse, "Bowl-beaters Alley." The upper dish is decorated with a shield in the centre, surrounded by a wreath of leaves interlaced with banderoles. The lower dish is adorned with lions and unicorns on leafy decoration.

BECKEN

Nürnberg, 15. Jahrhundert. Messing, geschlagen, ∅ oben 40,6 cm, ∅ unten 37,8 cm

NÜRNBERG, GERMANISCHES NATIONALMUSEUM

Tafel 41 zeigt zwei Exemplare einer im 15. Jahrhundert weit verbreiteten Nürnberger Haushaltsgeräteproduktion, an die in der Stadt heute noch die Beckenschlägergasse erinnert. Das obere Becken ziert im Zentrum ein Schild, umgeben von einem Blattkranz mit Schriftbändern. Das untere Becken schmücken Löwen und Einhörner auf Blattdekor.

VASQUES

Nuremberg, XVᵉ siècle. Laiton, martelé, en haut ∅ 40,6 cm, en bas ∅ 37, 8 cm

NUREMBERG, GERMANISCHES NATIONALMUSEUM

La planche 41 présente deux exemplaires d'une production d'ustensiles ménagers très répandue à Nuremberg au XVᵉ siècle, évoquée aujourd'hui encore par la « Beckenschlägergasse » (Ruelle des marteleurs de vasques). La vasque du haut est ornée, au centre, d'un blason entouré d'une couronne de feuilles aux rubans portant des inscriptions ; celle du bas est décorée de feuillages peuplés de lions et de licornes.

1480 – 1500

3 P. Zoll

CRUCIFIX

German, c. 1150. Oak, copper, fire-gilded, enamelled, 36.2 x 21.6 cm / 14 ¼ x 8 ½ in.
FORMERLY WITHIN THE ART TRADE – WHEREABOUTS UNKNOWN
Individual copper plaques are mounted onto the wooden core of the crucifix. In the centre of the work is the cast figure of the crucified Christ. The quatrefoil ends of the cross contain enamel images of the Evangelists, each identified by name.

KRUZIFIX

Deutsch, um 1150. Eichenholz, Kupfer, feuervergoldet, emailliert, 36,2 x 21,6 cm
EHEMALS IM KUNSTHANDEL – AUFBEWAHRUNGSORT UNBEKANNT
Auf den Holzkern des Kruzifixes sind einzelne Kupferplatten aufgebracht. Im Zentrum des Werkes befindet sich die gegossene Figur des Gekreuzigten. Die vierpassigen Kreuz-Enden zeigen die Emaildarstellungen der Evangelisten, deren Namen die Inschriften angeben.

CRUCIFIX

Allemagne, vers 1150. Chêne, cuivre, doré à l'amalgame, émaillé, 36,2 x 21,6 cm
AUTREFOIS DANS LE COMMERCE D'OBJETS D'ART – LOCALISATION INCONNUE
Des plaques de cuivre sont appliquées sur le corps en bois du crucifix. La statuette fondue du Crucifié occupe le centre de l'œuvre. Sur les extrémités quadrilobées de la croix figurent les représentations émaillées des évangélistes, lesquels sont désignés par des inscriptions.

2 Par Zoll.

J.H.v. HEFNER-ALTENECK C.REGNIER del.

1100 — 1150.

EUCHARISTIC CHALICE
Regensburg, c. 1260. Silver gilt, sunk enamel, h. 17.9 cm / 7 in.
REGENSBURG, CATHEDRAL TREASURY

The Eucharistic chalice in the Regensburg cathedral treasury was formerly believed to have belonged to St Wolfgang and has been preserved through the centuries for this reason. Medallions containing the half-length figures of Peter, Paul, David, Solomon and two prophets are mounted on top of the foot, whose surface has been finely textured with hammer and punch. Heraldic lilies descend between the medallions, while the foot rim is ringed with carved rosettes. The nodus comprises six circular bosses bearing half-length figures of angels and saints in sunk enamel, and is one of the very earliest known examples of its kind.

EUCHARISTISCHER KELCH
Regensburg, um 1260. Silber, vergoldet, Grubenschmelz, 17.9 cm hoch
REGENSBURG, DOMSCHATZ

Der eucharistische Kelch galt früher als Kelch des heiligen Wolfgang und ist aus diesem Grund bis heute erhalten. Auf den mittels Punzen aufgerauten Fuß sind Medaillons aufgelegt, die Halbfiguren von Petrus, Paulus, David, Salomon und zwei Propheten zeigen. Zwischen den Figuren befinden sich aufgelegte heraldische Lilien und Rosetten, die aus der Zarge ausgeschnitten sind. Der Knauf mit sechs runden Zapfen, auf denen in Grubenschmelz Halbfiguren von Engeln und Heiligen dargestellt sind, ist einer der ältesten dieses Knauf-Typus überhaupt.

CALICE EUCHARISTIQUE
Ratisbonne, vers 1260. Argent, doré, émail champlevé, hauteur 17,9 cm
RATISBONNE, TRÉSOR DE LA CATHÉDRALE

Considéré jadis comme étant le calice de saint Wolfgang, l'objet a été, pour cette raison, conservé jusqu'à aujourd'hui. Saint Pierre, saint Paul, David, Salomon et deux prophètes apparaissent en demi-figures dans des médaillons appliqués sur le pied, gratté au poinçon. Des fleurs de lys et des rosettes, découpées dans le socle, sont apposées entre ces personnages. Le nœud à six boutons, sur lesquels figurent des bustes d'anges et de saints en émail champlevé, est l'un des plus anciens de ce type.

á Par. Zoll.

1220 - 1260

COVERED BEAKER

Hans Greiff (?), Ingolstadt, c. 1480. Silver, partly gilded, sunk enamel, h. 32.5 cm / 12 ¾ in.

ORIGINALLY PART OF THE INGOLSTADT MUNICIPAL TREASURY

MUNICH, BAYERISCHES NATIONALMUSEUM

The beaker, with its decoration of seven rows of gadroons, is attributed to Hans Greiff. Inside the cover, it carries the Ingolstadt punch mark together with the enamelled coat of arms of the Glätzl family. The cup can thus be linked to Hans Glätzl, a member of Ingolstadt's Inner Council from 1453. The band of tracery around the edge of the cover corresponds closely to that of the beaker on plate 52 (ill. p. 533). The cover is crowned by a finial fashioned as a bouquet of flowers. The body of the beaker is supported by three figures of St George slaying the dragon.

DECKELPOKAL

Hans Greiff (?), Ingolstadt, um 1480. Silber, teilvergoldet, Grubenschmelz, 32,5 cm hoch

URSPRÜNGLICH TEIL DES INGOLSTÄDTER RATSSILBERS

MÜNCHEN, BAYERISCHES NATIONALMUSEUM

Das als Buckelpokal mit sieben Buckelreihen gestaltete Trinkgefäß, das Hans Greiff zugeschrieben wird, trägt innen im Deckel das Ingolstädter Beschauzeichen und das emaillierte Wappen der Familie Glätzl. Es kann auf Hans Glätzl bezogen werden, der seit 1453 Mitglied des inneren Rates war. Das Maßwerkband am Deckelrand stimmt mit demjenigen des Pokals auf Tafel 52 überein (Abb. S. 533). Eine Blütenkrone ziert als sogenannter Schmeck den Deckel. Über drei Figuren des drachentötenden heiligen Georg erhebt sich der Pokalkorpus.

COUPE À COUVERCLE

Hans Greiff (?), Ingolstadt, vers 1480. Argent, partiellement doré, émail champlevé, hauteur 32,5 cm

PROVENANT DE L'ARGENTERIE DU CONSEIL D'INGOLSTADT

MUNICH, BAYERISCHES NATIONALMUSEUM

Conçu comme une coupe bosselée à sept rangées de bosses, le récipient à boire est attribué à Hans Greiff. À l'intérieur du couvercle, il porte le poinçon de contrôle de la ville d'Ingolstadt et le blason émaillé de la famille Glätzl, lequel peut être associé à Hans Glätzl, membre du Conseil interne à partir de 1453. La frise de remplages ornant le bord du couvercle est identique à celle de la coupe figurant sur la planche 52 (ill. p. 533). Le couvercle est décoré d'une couronne de fleurs appelée « Schmeck ». La coupe s'élève au-dessus de trois figurines de saint Georges terrassant le dragon.

1460 — 1490

3 Par.　　Zoll.

A. WHISTLE AMULET
Spanish, 18th century. Silver, partly gilded, 17 x 7.6 cm / 6 ¾ x 3 in.
NUREMBERG, GERMANISCHES NATIONALMUSEUM
The whistle is the small pipe borne by a siren, through which air is blown into the mouth of the sphere opposite. The siren's mirror and the five teardrop pendants are today missing from the original.

B & C. WHISTLE AMULETS
Spanish, 18th century. Gold, silver, partly gilded, gems
FORMERLY MUNICH, PRIVATE COLLECTION WITHIN THE NOBILITY – WHEREABOUTS UNKNOWN
The whistle on the left (B), whose setting is studded with a sapphire and a ruby, is designed in the same manner as the siren whistle (A). In the case of the golden crocodile (C), which is adorned with rubies and turquoise, you blow into the open jaws.

A. PFEIFENAMULETT
Spanisch, 18. Jahrhundert. Silber, teilvergoldet, 17 cm hoch, 7.6 cm breit
NÜRNBERG, GERMANISCHES NATIONALMUSEUM
Das von einer Sirene getragene Röhrchen ist die eigentliche Pfeife, durch die man in die Öffnung der gegenüber angebrachten Kugel bläst. Der Spiegel der Sirene und die fünf tropfenförmigen Anhänger sind am Original verloren.

B & C. PFEIFENAMULETTE
Spanisch, 18. Jahrhundert. Gold, Silber, teilvergoldet, Edelsteine
EHEMALS IN ADELIGEM PRIVATBESITZ IN MÜNCHEN – AUFBEWAHRUNGSORT UNBEKANNT
Die Pfeife, deren Fassung ein Saphir und ein Rubin ziert (B), ist genauso konstruiert wie die Sirenenpfeife (A). Beim goldenen Krokodil (C), das mit Rubinen und Türkisen besetzt ist, bläst man in den geöffneten Rachen.

A. AMULETTE-SIFFLET
Espagne, XVIIIᵉ siècle. Argent, partiellement doré, hauteur 17 cm, largeur 7.6 cm
NUREMBERG, GERMANISCHES NATIONALMUSEUM
Le petit tube porté par une sirène constitue le sifflet à proprement parler, dans lequel on souffle par l'ouverture de la boule installée en face. Le miroir de la sirène ainsi que les cinq pendentifs en forme de gouttes ont disparu de l'original.

B & C. AMULETTES-SIFFLETS
Espagne, XVIIIᵉ siècle. Or, argent, partiellement doré, pierres précieuses
AUTREFOIS EN LA POSSESSION DE NOBLES MUNICHOIS – LOCALISATION INCONNUE
Le sifflet dont la monture est ornée d'un saphir et d'un rubis (B) possède exactement la même structure que celui représentant une sirène (A). Le sifflet en forme de crocodile (C), garni de rubis et de turquoises, s'utilise en soufflant dans la gueule entr'ouverte de l'animal.

A.

B.

C.

1550 — 1600

I.H.vH=A. del.

IP. sc.

BOOK COVER
Nuremberg, c. 1476–80. Wood, calf leather
NUREMBERG, GERMANISCHES NATIONALMUSEUM

The book cover accompanies the folio *German Bible* printed in 1475/76 by Günter Zainer in Augsburg and was crafted by the Nuremberg bookbinder Heinrich Eyring (active 1462–85; d. 1487). It consists of a wooden board covered in calf leather and patterned with blind-tooled lines and stamped decoration. The mounts with the symbols of the evangelists have all survived intact. It is possible, however, that they are in fact 19th-century copies.

BUCHDECKEL
Nürnberg, um 1476–1480. Holz, Kalbsleder
NÜRNBERG, GERMANISCHES NATIONALMUSEUM

Der Buchdeckel des Foliobandes der *Biblia, deutsch* von 1475/76 der Augsburger Offizin Günter Zainer besteht aus einer Holztafel, die mit Kalbsleder überzogen und mit Streicheisenlinien und Stempelprägungen verziert ist. Angefertigt wurde der Deckel von dem Nürnberger Buchbinder Heinrich Eyring, der zwischen 1462 und 1485 tätig war und 1487 starb. Die Beschläge mit den Evangelistensymbolen sind vollständig erhalten. Es handelt sich bei ihnen aber möglicherweise um Kopien des 19. Jahrhunderts.

COUVERTURE DE LIVRE
Nuremberg, vers 1476–1480. Bois, cuir de veau
NUREMBERG, GERMANISCHES NATIONALMUSEUM

La couverture du volume en format in-folio de la *Biblia, deutsch* (Bible, allemand), de 1475/76, livre issu de l'imprimerie augsbourgeoise de Günter Zainer, est constituée d'une planche de bois recouverte de cuir de veau, orné de lignes appliquées au fer à polir et gravé au poinçon. L'œuvre a été exécutée par le relieur nurembergeois Heinrich Eyring, en activité de 1462 à 1485, décédé en 1487. Les ferrures où apparaissent les symboles des évangélistes sont entièrement conservées, mais il s'agit peut-être de copies datant du XIX^e siècle.

III.

46.

6 Par. Zoll

1473 — 1475.

HP sc.

CENSER
German, early 13th century. Bronze, 15.5 cm x 9.5 cm / 6 ⅛ x 3 ¾ in.
PADERBORN, ERZBISCHÖFLICHES DIÖZESANMUSEUM
The four-sided censer features an indented openwork upper section, similar to a lantern, above the bowl for the charcoal. Lion's heads at the corners of the bowl provide fastening points for chains. The cover is crowned by a lizard. The ring and hanger date from a later period. The censer is the property of the Catholic filial church of St Anthony of Padua in Warburg-Menne and is on loan to the museum.

RAUCHFASS
Deutsch, Anfang 13. Jahrhundert. Bronze, 15.5 x 9.5 cm
PADERBORN, ERZBISCHÖFLICHES DIÖZESANMUSEUM
Das vierseitige, im oberen Teil durchbrochen und mit Ausbuchtungen gearbeitete Rauchfass hat einen laternenartigen Aufsatz. An den Ecken des unteren Kohlebeckens befinden sich Löwenköpfe als Kettenhalter. Auf dem Deckel thront eine Eidechse. Der Deckelhalter aus Ring und Schlaufe stammt aus späterer Zeit. Das Rauchfass ist Eigentum der katholischen Filialkirche St. Antonius von Padua in Warburg-Menne und befindet sich jetzt als Leihgabe im Museum.

ENCENSOIR
Allemagne, début du XIII^e siècle. Bronze, 15.5 x 9.5 cm
PADERBORN, ERZBISCHÖFLICHES DIÖZESANMUSEUM
L'encensoir à quatre côtés, ajouré dans sa partie supérieure et pourvu d'échancrures, possède un couvercle pareil à une lanterne. Sur les coins, en bas du brasero, des têtes de lion servent de fixations aux chaînettes. Sur le couvercle trône un lézard. La platine, constituée d'un anneau et d'une boucle, date d'une époque plus tardive. L'encensoir est la propriété de l'église Saint-Antoine-de-Padoue à Warburg-Menne et se trouve maintenant au musée de Paderborn, en tant que prêt.

HP. sc.

GUILD ROD
South German, 16th century. Wood, sheet iron, glass, partly gilded and painted, h. 146 cm/ 57 ½ in.
The staff, with its raguly arms, is crowned by St Philip, patron of the guild. He is accompanied by two lanterns, one on each side. The place of origin, "Deckendorf," given by Hefner-Alteneck in his accompanying text, does not exist.

ZUNFTSTANGE
Süddeutsch, 16. Jahrhundert. Holz, Eisenblech, Glas, teilvergoldet und bemalt, 146 cm hoch
Auf der astförmig gebildeten Stange erhebt sich der heilige Philippus als Schutzpatron der Zunft. Seitlich begleiten ihn zwei Laternen. Der Herkunftsort „Deckendorf ", den Hefner-Alteneck in seinem erläuternden Text angibt, existiert nicht.

BÂTON DE CORPORATION
Allemagne du Sud, XVIᵉ siècle. Bois, tôle de fer, verre, partiellement doré et peint, hauteur 146 cm
Au-dessus du bâton, qui revêt la forme d'une branche, se dresse saint Philippe, le patron de la corporation. Il est flanqué de deux lampes. Le lieu d'origine « Deckendorf », que Hefner-Alteneck indique dans son texte explicatif, n'existe pas.

1 Par. Fuss.

1500 — 1520.

J. H. v H. A. del.

(pp. 512–27)

TAPESTRY IN TWO PARTS

*Alsatian, mid-15th century. Wool, woven, first part: 0.40 x 3.06 m / 1 ft 3 ¾ x 10 ft ½ in.,
second part: 0.40 x 3.03 m / 1 ft 3 ¾ x 9 ft 11 ¼ in.*

WHEREABOUTS UNKNOWN (FIRST PART) / LONDON, VICTORIA AND ALBERT MUSEUM (SECOND PART)
The two tapestry fragments illustrated in the upper half of the plate originally formed a single frieze, whose whereabouts is today unknown. The two lower sections make up a second frieze, today housed in the Victoria and Albert Museum (cf. ill. pp. 66/67). The two friezes were conceived as a single whole and illustrate, like a calendar of the year, the labours of the months. The first half shows the activities typical of the months February (*hornung*) to June (*browot*), and the second half those typical of July (*howmonet*) to December (*volrot*). The names of the months are thereby given in Alsatian dialect. The labours and scenes unfold from top left as follows: tree-pruning, ploughing, tree-grafting, a pair of lovers and bathing, hoeing, hay-making, grain harvest, harrowing and sowing, grape harvest and wine pressing, slaughtering and finally eating.

(S. 512–527)

ZWEITEILIGER BILDTEPPICH, „RÜCKLAKEN"

Elsässisch, Mitte 15. Jahrhundert. Wolle, gewirkt, 40 x 306 cm (erster Teil), 40 x 303 cm (zweiter Teil)
UNBEKANNTER AUFBEWAHRUNGSORT (ERSTER TEIL)
LONDON, VICTORIA AND ALBERT MUSEUM (ZWEITER TEIL)
Die beiden oberen auf der Tafel abgebildeten Segmente bildeten ursprünglich einen fortlaufenden Teppich, dessen Verbleib unbekannt ist. Die beiden unteren Segmente geben einen weiteren fortlaufenden Teppich wieder, der sich heute im Victoria and Albert Museum befindet (siehe Abb. S. 66/67). Zusammen bildeten die beiden Teppiche eine inhaltliche Einheit und zeigen wie ein Jahreskalender die in jedem Monat anfallenden Arbeiten. Auf dem ersten Teppich sind die typischen Tätigkeiten von Februar („hornung") bis Juni („browot") und auf dem zweiten diejenigen von Juli („howmonet") bis Dezember („volrot") dargestellt und jeweils mit den Bezeichnungen in elsässischer Mundart versehen. Zu sehen sind die folgenden Arbeiten und Szenen: Beschneiden der Bäume, Pflügen, Pfropfen der Bäume, Liebespaar und Bad, Umgraben des Gartens, Heuernte, Getreideernte, Eggen und Säen, Weinlese und -kelter, Schlachten, Speisen.

(pp. 512–527)

TAPISSERIE EN DEUX PARTIES « RÜCKLAKEN » (DRAP DE DOS)

Alsace, milieu du XVᵉ siècle. Laine, tissée, 40 x 306 cm (première partie), 40 x 303 cm (deuxième partie)
LOCALISATION INCONNUE (PREMIÈRE PARTIE)
LONDRES, VICTORIA AND ALBERT MUSEUM (DEUXIÈME PARTIE)
Les deux segments représentés en haut de la planche formaient à l'origine une tapisserie continue, aujourd'hui disparue. Les deux segments du bas reproduisent une autre tapisserie constituant une seule pièce, qui se trouve aujourd'hui au Victoria and Albert Museum (cf. ill. p. 66/67). Ensemble, les deux ouvrages formaient une unité narrative montrant pour chaque mois, à la manière d'un calendrier, les travaux devant être effectués. La première tapisserie illustre les activités caractéristiques des mois de février (« hornung ») à juin (« browot ») ; la deuxième, celles des mois de juillet (« howmonet ») à décembre (« volrot »). Chaque représentation porte des désignations dans le dialecte alsacien. On y voit les travaux et les scènes suivantes : la taille des arbres, le labour, la greffe des arbres, un couple d'amoureux et une scène de bain, le bêchage du jardin, la récolte du foin, la récolte des céréales, le hersage et les semis, les vendanges et le pressurage du vin, l'abattage, une scène de repas.

1 Par. Fuff.

BOX

Middle Rhenish (?), 2nd half of the 15th century
Wood, paper, painted, papier mâché, painted, h. 8.8 cm / 3 ½ in., ø 20.3 cm / 8 in.
NUREMBERG, GERMANISCHES NATIONALMUSEUM

The box, which was undoubtedly intended as a bridal gift, is made of wood covered with paper.
This latter serves as the ground for the painting on the cover, which shows the Judgement of Paris:
Mercury arouses Paris from his dreams and gives him the golden apple, the victory prize that Paris must
award to the most beautiful of the three waiting goddesses. The representation is still entirely indebted
to the medieval style and all the figures are identified in banderoles. The colours of the box today are
substantially paler than those reproduced in the plate.

SCHACHTEL

Mittelrheinisch (?), 2. Hälfte 15. Jahrhundert
Spanholz, Papier, bemalt, Pappmaché, bemalt, 8,8 cm hoch, ø 20,3 cm
NÜRNBERG, GERMANISCHES NATIONALMUSEUM

Die Schachtel, die sicherlich als Brautgeschenk gedacht war, besteht aus Holz und ist mit Papier
verkleidet, das als Malgrund für die Darstellung auf dem Deckel diente. Gezeigt wird in noch gänzlich
mittelalterlicher Auffassung die Szene des Parisurteils, wobei alle Figuren auf dem Spruchband
benannt werden. Merkur erweckt Paris aus seinen Träumen und gibt ihm den goldenen Apfel, den Paris
der schönsten der drei wartenden Göttinnen als Siegespreis überreichen soll. Die Schachtel
weist im Original wesentlich blassere Farben auf als die Wiedergabe auf der Tafel.

BOÎTE

Vallée du Haut-Rhin moyen (?), 2ᵉ moitié du XVᵉ siècle
Bois aggloméré, papier, peint, papier mâché, peint, hauteur 8,8 cm, ø 20,3 cm
NUREMBERG, GERMANISCHES NATIONALMUSEUM

La boîte, qui était sûrement destinée à être offerte en cadeau de mariage, est constituée de bois
et recouverte d'un papier servant de fond à l'image peinte sur le couvercle. Celle-ci représente, dans une
conception encore toute médiévale, la scène du jugement de Pâris, dont tous les personnages sont
désignés sur un cartouche. Mercure éveille Pâris de ses songes et lui donne une pomme d'or,
que le jeune homme doit remettre en guise de récompense à la plus belle des trois déesses qui l'attendent.
La boîte, dans sa version originale, présente des couleurs beaucoup plus ternes que celles
de la reproduction figurant sur la planche.

6 Par: Zoll.

1480 – 1500.

RELIQUARY "ST EMMERAM'S CIBORIUM"

Cologne, between 1200 and 1250. Wood with bone plaques, h. 19 cm / 7 ½ in., ø 13.6 cm / 5 ⅜ in.

REGENSBURG, DIÖZESANMUSEUM ST. ULRICH

The reliquary, traditionally known as "St Emmeram's ciborium," is now believed to be that of St Wolfgang. It comprises a wooden casket faced with bone plaques. The eight sides of the casket are decorated with apostles, identified by inscriptions, who appear standing beneath an arcade. The half-length figures appearing within the eight triangular fields on the pyramidal cover probably represent prophets.

RELIQUIAR „ZIBORIUM DES HL. EMMERAM"

Köln, zwischen 1200 und 1250. Holzkasten mit Knochenplatten, 19 cm hoch, ø 13,6 cm

REGENSBURG, DIÖZESANMUSEUM ST. ULRICH

Das unter dem Namen „Ziborium des heiligen Emmeram" bekannte Reliquiar gilt als Ziborium des heiligen Wolfgang. An den acht Seiten des Kastens befinden sich unter Pfeilerarkaden Apostel, die inschriftlich bezeichnet sind. Bei den Halbfiguren auf den acht Dreiecksflächen des pyramidenförmigen Deckels handelt es sich wahrscheinlich um Propheten.

RELIQUAIRE, « CIBOIRE DE SAINT EMMERAN »

Cologne, entre 1200 et 1250. Coffret de bois et plaques en os, hauteur 19 cm, ø 13,6 cm

RATISBONNE, DIÖZESANMUSEUM ST. ULRICH

Connu sous le nom de « ciboire de saint Emmeran », le reliquaire est considéré comme le ciboire de saint Wolfgang. Sur les huit côtés du coffret sont représentés des apôtres, installés sous une arcade sur piliers et désignés par des inscriptions. Les demi-figures apparaissant sur les huit surfaces triangulaires du couvercle pyramidal sont vraisemblablement des prophètes.

1000 — 1040.

COVERED BEAKER

Hans Greiff (?), Ingolstadt, 1470. Silver, partly gilded, h. 36.5 cm / 14 ⅜ in.
ORIGINALLY PART OF THE INGOLSTADT MUNICIPAL TREASURY
NEW YORK, THE METROPOLITAN MUSEUM OF ART

Supported at the base by three so-called Wild Men, each carrying a heraldic shield, this magnificent beaker
is divided by means of applied tracery arcades and leafy ornament in the Gothic style into three main
fields. The engraving on the beaker wall is of outstanding quality: within an elaborate leafy surround,
it shows various animals together with a hunter blowing a horn and shooting with a crossbow.
The cover is crowned with a finial comprising a knot of leaves and an acorn. The enamelled Ingolstadt
coat of arms and the Ingolstadt punch mark are found on the inside of the cover (cf. also ill. p. 503).

DECKELPOKAL

Hans Greiff (?), Ingolstadt, 1470. Silber, teilvergoldet, 36,5 cm hoch
URSPRÜNGLICH TEIL DES INGOLSTÄDTER RATSSILBERS
NEW YORK, THE METROPOLITAN MUSEUM OF ART

Getragen von drei sogenannten Wilden Männern, die Wappenschilde halten, erhebt sich der dreifach
gegliederte prächtige Pokal, auf den gotische Maßwerkarkaden und Laubwerk appliziert sind.
Die hervorragenden Gravierungen an der Wandung des Pokals zeigt, umgeben von reichem Blattwerk,
Tiere sowie einen Jäger, der in ein Hifthorn bläst und mit einer Armbrust schießt.
Den Deckel bekrönt ein Laubwerkknoten mit einer Eichel, ein sogenannter Schmeck.
Im Inneren des Deckels befindet sich das emaillierte Wappen von Ingolstadt und das Ingolstädter
Beschauzeichen (siehe auch Abb. S. 503).

COUPE À COUVERCLE

Hans Greiff (?), Ingolstadt, 1470. Argent, partiellement doré, hauteur 36,5 cm
PROVENANT DE L'ARGENTERIE DU CONSEIL D'INGOLSTADT
NEW YORK, THE METROPOLITAN MUSEUM OF ART

La somptueuse coupe, sur laquelle sont appliqués des arcades en remplage gothique et des rinceaux,
est divisée en trois parties. Elle est portée par trois personnages, appelés « hommes sauvages »,
qui tiennent des boucliers. Les remarquables gravures sur la paroi représentent, parmi une abondante
frondaison, des animaux et un chasseur, lequel souffle dans un huchet et tire avec une arbalète.
Le couvercle est couronné d'un entrelacement de feuillages, appelé « Schmeck » auquel s'ajoute un gland.
À l'intérieur du couvercle se trouve le blason émaillé de la ville d'Ingolstadt ainsi que le poinçon
de contrôle correspondant (cf. aussi ill. p. 503).

1450 — 1500 .

HP. sc.

3 Par Zoll

SMALL DOMESTIC ALTAR (FRONT VIEW)

German, final third of the 15th century. Wood, partly gilded and painted

FORMERLY MUNICH PRIVATE COLLECTION WITHIN THE NOBILITY – WHEREABOUTS UNKNOWN

In a niche beneath openwork tracery and a roof with gilded flowers stands the statuette of St Maurice. The soldier-saint, whose name appears on his shield, is dressed in contemporary 15th-century armour, parts of which are gilded (cf. also ill. p. 2). The predella of the small domestic altar shows St Ursula and her companions. The exterior sides of the small altar are shown on plate 54 (ill. pp. 536/37)

HAUSALTÄRCHEN (SCHAUSEITE)

Deutsch, 3. Drittel 15. Jahrhundert. Holz, teilvergoldet und bemalt

EHEMALS IN ADELIGEM PRIVATBESITZ IN MÜNCHEN – AUFBEWAHRUNGSORT UNBEKANNT

In einer Nische des Hausaltärchens steht unter durch-brochenem Maßwerk und einem Dach mit vergoldeten Blumen die Statuette des heiligen Mauritius. Teile seiner zeitgenössischen Rüstung sind vergoldet, und auf seinem Schild steht der Name des Ritterheiligen (siehe auch Abb. S. 2). Die Predella des Altärchens zeigt die heilige Ursula mit ihrem Gefolge. Die Außenseiten des Altärchens werden auf Tafel 54 gezeigt (Abb. S. 536/537)

PETIT RETABLE DOMESTIQUE (FACE INTERNE)

Allemagne, 3ᵉ tiers du XVᵉ siècle. Bois, partiellement doré et peint

AUTREFOIS EN LA POSSESSION DE NOBLES MUNICHOIS – LOCALISATION INCONNUE

Dans une niche du petit retable, sous des remplages ajourés et sous un toit orné de fleurs dorées, se tient la statuette de saint Maurice. Certaines parties de son armure d'époque sont dorées. Le nom de ce saint chevalier est inscrit sur son bouclier (cf. aussi ill. p. 2). La prédelle du retable représente sainte Ursule, accompagnée de sa suite. Les faces extérieures du retable sont représentées à la planche 54 (ill. pp. 536/537)

I.H. v H=A. del:

C. R. sc.

490

HP. sc:

(pp. 536/37)

SMALL DOMESTIC ALTAR (EXTERIOR SIDES)

German, final third of the 15th century. Wood, partly gilded and painted

FORMERLY MUNICH PRIVATE COLLECTION WITHIN THE NOBILITY – WHEREABOUTS UNKNOWN

The panel shows the vegetal ornament on the exterior sides of the altar, whose front view
is reproduced on plate 53 (ill. p. 535).

(S. 536/537)

HAUSALTÄRCHEN (AUSSENSEITEN)

Deutsch, 3. Drittel 15. Jahrhundert. Holz, teilvergoldet und bemalt

EHEMALS IN ADELIGEM PRIVATBESITZ IN MÜNCHEN – AUFBEWAHRUNGSORT UNBEKANNT

Die Tafel zeigt die vegetabile Ornamentik der Außenseiten des Altars, dessen Schauseite
auf Tafel 53 wiedergegeben ist (Abb. S. 535).

(pp. 536/537)

PETIT RETABLE DOMESTIQUE (FACES EXTÉRIEURES)

Allemagne, 3ᵉ tiers du XVᵉ siècle. Bois, partiellement doré et peint

AUTREFOIS EN LA POSSESSION DE NOBLES MUNICHOIS – LOCALISATION INCONNUE

La planche présente les ornements végétaux des faces extérieures du retable dont la face interne,
destinée à être exposée à la vue, est reproduite en planche 53 (ill. p. 535).

(pp. 540/41)

BRIDAL CHEST

Italian, last third of the 15th century. Wood, iron, 62 x 183 x 57 cm / 24 ½ x 76 x 22 ½ in.

FORMERLY BERLIN, KUNSTGEWERBEMUSEUM – UNTRACED

The hinged chest made of stained wood and standing on four bun feet was stored in Schloss Sophienhof during the Second World War and has been missing since 1945. Only the key to the chest is preserved in the museum. The decoration on the front of the bridal chest is executed in low relief on an embossed ground and shows a Garden of Love. Queen Love appears beneath the arch of a canopy on the far left, with figures standing and kneeling before her. On the far right, also beneath a canopy, is a royal couple, the king with a sceptre and the queen with an apple. In the centre, several figures are grouped around a fountain: on the left, a woman with a goose, on the right a woman with a jug and, beside her, a man with a hunting hawk. A hunter with hounds and game can be seen along the upper edge of the picture. Beneath and on both sides of the scene are borders of leafy ornament and animals. The side walls of the chest featured iron handles.

(S. 540/541)

BRAUTTRUHE

Italienisch, 3. Drittel 15. Jahrhundert. Holz, Eisen, 62 x 183 x 57 cm

EHEMALS KUNSTGEWERBEMUSEUM, BERLIN – VERSCHOLLEN

Die aus gebeiztem Holz hergestellte Falzkiste auf vier Knopffüßen war im 2. Weltkrieg in Schloss Sophienhof ausgelagert und ist seit 1945 verschollen. Nur der Schlüssel des Stücks hat sich im Museum erhalten. Die Vorderseite der Brauttruhe zeigt in flachem Relief auf gepunztem Grund einen Liebesgarten. Unter dem Bogen eines Thronhimmels ist auf der linken Seite die Königin Minne dargestellt; vor ihr knien und stehen Figuren. Gegenüber auf der rechten Seite ist – ebenfalls unter einem Thronhimmel – ein Königspaar wiedergegeben: der König mit Szepter und die Königin mit einem Apfel. In der Bildmitte gruppieren sich mehrere Figuren um einen Brunnen: zur Linken eine Frau mit Gans, zur Rechten eine Frau mit Kanne und daneben ein Mann mit einem Jagdfalken. Am oberen Bildrand ist ein Jäger mit Hunden und Wild zu sehen. Borten mit Tieren in Rankenwerk befinden sich unterhalb und seitlich der Darstellung. An den Seitenwänden der Truhe befanden sich eiserne Griffe mit Beschlägen, die nicht abgebildet sind.

(pp. 540/541)

COFFRE DE MARIÉE

Italie, 3ᵉ tiers du XVᵉ siècle. Bois, fer, 62 x 183 x 57 cm

AUTREFOIS CONSERVÉ AU KUNSTGEWERBEMUSEUM BERLIN – DISPARU

Pendant la Seconde Guerre mondiale, le coffre à rainures, en bois teinté et monté sur quatre pieds en forme de boutons, fut mis en lieu sûr au château Sophienhof. Il disparut en 1945 ; seule la clé est aujourd'hui conservée au musée. La face antérieure du coffre représente en bas-relief, sur un fond poinçonné, un jardin de l'amour. À gauche, sous l'arc formé par un baldaquin, figure la déesse de l'amour, devant laquelle se tiennent des personnages, agenouillés ou debout. En face, sur le côté droit, est représenté – également sous un baldaquin – un couple royal : le roi tenant un sceptre, la reine, une pomme. Au centre de l'image, plusieurs figures sont groupées autour d'une fontaine : à gauche, une femme portant une oie, à droite, une autre femme, tenant une cruche et, à côté d'elle, un homme portant un faucon de chasse. Près du bord supérieur de l'image, on aperçoit un chasseur parmi des chiens et des animaux sauvages. Des bordures d'entrelacs peuplés d'animaux décorent le bord inférieur et les bords latéraux de l'image. Les parois latérales du coffre étaient pourvues de poignées en fer ornées de ferrures, qui n'apparaissent pas sur la planche.

I.H. v HEFNER=ALTENECK . *del :*

90

H. PETERSEN . *sculpsit*

CRUETS

Venetian (?) and Rhenish (?), mid-14th century
Rock crystal, silver gilt, engraved and chased, amethyst, h. 19 cm / 7 ½ in. (left), h. 18 cm / 7 in. (right)
DÜSSELDORF, BASILICA OF ST LAMBERT, TREASURY

The cruet on the left contains relics of St Willeikus. The stepped foot consists of a star-shaped, six-lobed base followed by a raised rim with an openwork quatrefoil frieze. This gives way, in turn, to a circular section overlaid with openwork decoration. The polygonal rock-crystal body is secured at the top by a frieze of arches and foliage beneath a smooth rim. The cover is divided by arms into fields with trefoils and is ringed by a quatrefoil mesh and a dentate frieze. The handle takes the form of a dragon, who is grasping his ears with his front feet. The cruet on the right contains relics of St Mary Magdalene. Its twelve-sided, pear-shaped rock-crystal body is held by slender vertical clasps and stands on a smooth, circular foot that widens towards the base. The rim of the foot, the clasps of the mounting, the upper rim of the pot and the rim of the cover are decorated with friezes of small crosses. The vaulted cover, with its vertical ribs, is crowned by an amethyst. The handle is decorated with engraved tracery and rosettes.

MESSKÄNNCHEN, „POLLEN"

Venezianisch (?) und rheinländisch (?), Mitte 14. Jahrhundert
Bergkristall, Silber, vergoldet, graviert, ziseliert, Amethyst, 19 cm hoch (links), 18 cm hoch (rechts)
DÜSSELDORF, KIRCHENSCHATZ DER ST. LAMBERTUS-BASILIKA

Das linke Kännchen bewahrt Reliquien des heiligen Willeikus. Es besitzt einen sternförmigen, sechspassigen Fuß mit Stehrand und durchbrochen gearbeitetem Vierpassfries auf der Zarge sowie eine runde Fläche mit durchbrochenem Netz. Der polygonal geschliffene Bergkristallkörper wird oben von einem Bogen-Blattfries unter glattem Rand gehalten. Am Deckel, der mittels Stegen in Felder mit Dreiblatt geteilt ist, befinden sich ein Vierpassgitter und ein Zackenfries. Als Henkel fungiert ein Drache, der sich mit den Vorderfüßen an die Ohren greift. Das rechte Kännchen bewahrt Reliquien der heiligen Maria Magdalena. Es besitzt einen birnen-förmigen, zwölfkantigen, abgerundeten Bergkristall-körper, der von vertikalen Spangen gehalten wird und auf einem trompenförmig ausschwingenden glatten Fuß steht. Die Zarge des Fusses, die Spangen der Montierung, die obere Kannenöffnung und der Deckel sind mit Kreuzchenfriesen verziert. Den leicht gewölbten, vertikal gerippten Deckel bekrönt ein Amethyst. Den Henkel zieren graviertes Maßwerk und Rosetten.

BURETTES

Venise (?) et Rhénanie (?), milieu du XIV^e siècle
Cristal de roche, argent, doré, gravé, ciselé, améthyste, hauteur 19 cm (à gauche), 18 cm (à droite)
DÜSSELDORF, TRÉSOR DE LA BASILIQUE SAINT-LAMBERT

La burette de gauche conserve les reliques de saint Willeikus. Son pied hexalobé, en forme d'étoile, possède une base surmontée d'un socle orné d'une frise de quadrilobes ajourés, ainsi que d'une surface ronde décorée d'une toile, elle aussi ajourée. Le corps, en cristal de roche taillé en polygone, est maintenu en sa partie supérieure par une frise d'arcs et de feuillages, au-dessous d'un bord lisse. Le couvercle, compartimenté par des traverses en champs ornés d'un trèfle, est agrémenté d'une frise dentée et d'un grillage constitué de quadrilobes. L'anse prend la forme d'un dragon attrapant ses oreilles de ses pattes avant. La burette de droite conserve les reliques de sainte Marie-Madeleine. Son corps piriforme et arrondi, à douze côtés, est maintenu par des agrafes verticales. Son pied, lisse, est évasé en trompe. Le socle, les agrafes de la monture, l'ouverture supérieure ainsi que le couvercle sont ornés de frises de croix découssées. Le couvercle, légèrement bombé, à nervures verticales, est couronné d'une améthyste. L'anse est ornée de remplages gravés et de rosettes.

3 Par Zoll.

1480 — 1520.

H. sc.

SMALL DOMESTIC ALTAR
French, 1st third of the 14th century
Ivory, central panel 27 x 10.5 cm / 10 ⅝ x 4 ⅛ in., outer wings 27 x 5.25 cm / 10 ⅝ x 2 in.
FORMERLY CRACOW, PRIVATE COLLECTION WITHIN THE NOBILITY – WHEREABOUTS UNKNOWN
The winged altar, which takes the form of a triptych, presents the Coronation of the Virgin carved in high
relief at its centre. The two wings are carved in shallower relief and show the Annunciation and the Magi
on the left-hand wing and the Visitation and the Presentation in the Temple on the right. In line with
medieval convention, the scenes are designed to be read in registers, in other words, as continuous
horizontal zones. Thus the Annunciation and the Visitation form one register and the two lower scenes
a second. Traces of the altarpiece's original painting are reproduced in the plate. Another strikingly similar
small altar, today housed in the Kunsthistorisches Museum in Vienna and identical to the present
example in all but a few details, retains more of its original painting.

HAUSALTÄRCHEN
Französisch, 1. Drittel 14. Jahrhundert
Elfenbein, Mitteltafel 27 x 10,5 cm, Außenflügel 27 x 5,25 cm
EHEMALS IN ADELIGEM PRIVATBESITZ IN KRAKAU – AUFBEWAHRUNGSORT UNBEKANNT
In der Mitte des in Triptychonform aufgebauten Flügelaltars ist im Hochrelief die Marienkrönung
dargestellt. Die Seitenflügel zeigen in flacherem Relief links die Verkündigung und die Heiligen
Drei Könige und rechts die Heimsuchung und die Darbringung im Tempel. Die Szenen sind entsprechend
mittelalterlicher Konvention als Register, das heißt, als durchlaufende Höhenzonen zu lesen. So bilden
die Verkündigung und die Heimsuchung ein gemeinsames Register und die beiden unteren Darstellungen
ebenfalls. Auf der Tafel sind am Altar Reste ursprünglicher Bemalung wiedergegeben. Ein frappierend
ähnliches Altärchen, das nur in kleinsten Details abweicht und mehr Bemalung aufweist,
befindet sich im Wiener Kunsthistorischen Museum.

PETIT RETABLE DOMESTIQUE
France, 1ᵉʳ tiers du XIVᵉ siècle
Ivoire, panneau central 27 x 10,5 cm, volets extérieurs 27 x 5,25 cm
AUTREFOIS EN LA POSSESSION DE NOBLES À CRACOVIE – LOCALISATION INCONNUE
Au centre du retable à volets, articulé en triptyque, figure en haut-relief le couronnement de la Vierge.
Sur les volets latéraux sont sculptés, en un relief moins saillant, l'Annonciation et les Rois mages (volet de
gauche), puis la Visitation de la Vierge et la Présentation de Jésus au Temple (volet de droite). Les scènes,
conformément à la convention médiévale du registre, doivent être lues selon une narration linéaire. Ainsi,
l'Annonciation et la Visitation forment un même registre, et il en est de même pour les deux scènes du
niveau inférieur. Des restes de la peinture d'origine du retable sont restitués sur la planche. Un autre petit
retable, d'une ressemblance frappante, ne se distinguant que par d'infimes détails et par une peinture
plus abondante, est conservé au Kunsthistorisches Museum de Vienne.

4 Par.Zall .

I.H.v H=A.del. 1 3 0 0 — 1 3 5 0 . H.P.sc.

DOOR KNOCKER

Wendel Dietrich (?), Augsburg, 1585. Bronze, 27.5 x 23.5 cm / 10 ¾ x 9 ¼ in.

KIRCHHEIM, SWABIA, FUGGER CASTLE

The knocker adorns one of the stately doors in the Cedar Hall in the east wing of Fugger palace. It was probably conceived by Wendel Dietrich, who was responsible for the design of the doors as a whole, and made in an Augsburg workshop. Court sculptors Hubert Gerhard and Carlo di Cesare del Palagio are unlikely to have addressed themselves to small details of this kind; there is nothing in surviving records, at least, to indicate that they did so. The door knocker exhibits the symbolic, grotesque style of ornament typical of its day. Its reclining figures are based on Michelangelo's sculptures of *Dawn* (Aurora) and *Dusk* (Crepuscolo) from the tomb of Lorenzo de' Medici in Florence. In the present case, the female figure embodies Ceres (fertility) and the male figure Bacchus (well-being). Their respective attributes of an ear of corn and a bunch of grapes are held by the genius in the middle, albeit on the side furthest away from each of the figures.

TÜRKLOPFER

Wendel Dietrich (?), Augsburg, 1585. Bronze, 27.5 x 23.5 cm

KIRCHHEIM/SCHWABEN, FUGGERSCHLOSS

Der Türklopfer ziert ein Prunkportal des Cedernsaals im Ostflügels des Fuggerschlosses. Vermutlich hat Wendel Dietrich, der für die Gestaltung der Portale verantwortlich war, auch diesen Entwurf geschaffen, der dann in einer Augsburger Werkstätte ausgeführt wurde. Die Hofbildhauer Hubert Gerhard und Carlo di Cesare del Palagio kümmerten sich vermutlich nicht um derartige Details, zumindest existieren dafür keine urkundlichen Belege. Der Türklopfer weist die für seine Zeit typische symbolische Groteskornamentik auf. Vorbilder für seine lagernden Figuren sind die Michelangelo-Skulpturen *Der Morgen* (Aurora) und *Der Abend* (Crepuscolo) von den Medici-Gräbern in Florenz. Am Türklopfer verkörpert die weibliche Figur Ceres die Fruchtbarkeit und die männliche Bacchus die Wohlfahrt. Der Genius in der Mitte hält ihre Attribute Kornähre und Weintraube, allerdings jeweils auf der gegenüberliegenden Seite der Figuren.

HEURTOIR

Wendel Dietrich (?), Augsbourg, 1585. Bronze, 27.5 x 23.5 cm

KIRCHHEIM (SOUABE), CHÂTEAU DES FUGGER

Le heurtoir orne un portail d'apparat du « Cedernsaal » (salle des cèdres) dans l'aile orientale du château. Il est probable que Wendel Dietrich, qui était responsable de la conception des portails, dessina également le projet de ce heurtoir, ensuite exécuté dans un atelier augsbourgeois. Les sculpteurs de la cour, Hubert Gerhard et Carlo di Cesare del Palagio, ne s'occupaient sans doute pas de détails de ce genre – du moins aucun document ne l'atteste-t-il. L'objet présente des ornements grotesques symboliques caractéristiques de son époque. *L'Aube* (Aurora) et le *Crépuscule* (Crepuscolo), sculptures de Michel-Ange ornant les tombeaux des Médicis à Florence, servirent de modèles aux figures allongées. La figure féminine représente Cérès (la fécondité) et la figure masculine, Bacchus (la prospérité). Au centre, un génie tient leurs attributs, l'épi de blé et la grappe de raisin, mais en les présentant chacun sur le côté opposé de la figure à laquelle ils se rapportent.

3 Par. Zoll.

Martin del.

1560 — 1600.

IP sc

MORTAR

German, c. 1400. Bronze, h. 10.5 cm / 4 ⅛ in.

Formerly Augsburg, private collection – Whereabouts unknown

The mortar is decorated with a wealth of drolleries taken from the border miniatures
of medieval manuscripts.

MÖRSER

Deutsch, um 1400. Bronze, 10,5 cm hoch

Ehemals in Augsburger Privatbesitz – Aufbewahrungsort unbekannt

Der Mörser ist reich mit Droleriefiguren verziert, die aus den Randleistenminiaturen
mittelalterlicher Codices entlehnt sind.

MORTIER

Allemagne, vers 1400. Bronze, hauteur 10,5 cm

Autrefois en la possession d'un particulier à Augsbourg – Localisation inconnue

L'objet est richement décoré de drôleries empruntées aux miniatures
en marge de codices médiévaux.

1250 — 1300.

I.H.v H=A.del:

HP sc:

CANDLESTICK

Lorraine, c. 1160–80. Bronze, h. 17.3 cm / 6 ¾ in.

FORMERLY HARBURG, FÜRSTLICH OETTINGEN-WALLERSTEIN'SCHE SAMMLUNGEN

SOLD IN LONDON IN 1995

The candlestick recalls the monumental Trivulzio candelabrum in Milan cathedral in its zoomorphic
design. Like the Milan piece and a whole group of similar dragon candlesticks, the present work
is therefore also thought to have been produced in the Lorraine region (cf. ill. p. 341).

LEUCHTER

Lothringisch, um 1160–1180. Bronze, 17.3 cm hoch

EHEMALS FÜRSTLICH OETTINGEN-WALLERSTEIN'SCHE SAMMLUNGEN, HARBURG

1995 IN LONDON VERKAUFT

In seiner zoomorphen Gestaltung erinnert das Stück an den monumentalen Trivulzio-Leuchter des
Mailänder Domes. Der auf der Tafel gezeigte Leuchter gilt daher – wie das Mailänder Stück – zusammen
mit einer ganzen Gruppe ähnlicher Drachenleuchter als Arbeit aus Lothringen (siehe Abb. S. 341).

CHANDELIER

Lorraine, vers 1160–1180. Bronze, hauteur 17.3 cm

AUTREFOIS CONSERVÉ DANS LA COLLECTION PRINCIÈRE D'OETTINGEN-WALLERSTEIN, HARBURG

VENDU À LONDRES EN 1995

Par sa conception zoomorphe, la pièce rappelle le monumental candélabre Trivulzio de la cathédrale
de Milan. L'objet présenté sur la planche est donc considéré, à l'instar de l'œuvre milanaise et de tout un
ensemble de chandeliers similaires en forme de dragon, comme un travail lorrain (cf. ill. p. 341).

A.

B.

1120 — 1180.

ALTAR CROSS (REAR VIEW)
Limoges, c. 1180. Copper, engraved, gilded and enamelled, h. 17.2 cm / 6 ¾ in.
FREISING, DOMMUSEUM

As the Tree of Life, the altar cross – here seen in rear view (cf. ill. p. 555 for the front view) – is densely decorated with gilded leafy ornament, which on the back takes the form of palmettes. Behind the round, convex crystal at the centre lay a splinter of the True Cross, making the Crucifix a reliquary cross. Both crystal and relic are today lost. The cross is mounted on a Limoges-manufactured candleholder base by means of a spike (cf.ill. p. 555).

ALTARKREUZ (RÜCKSEITE)
Limoges, um 1180. Kupfer, graviert, vergoldet und emailliert, 17,2 cm hoch
FREISING, DOMMUSEUM

Das Altarkreuz ist als Lebensbaum mit vergoldetem Rankenwerk verziert (siehe Vorderseite Abb. S. 555) und auf der Rückseite, die auf dieser Tafel zu sehen ist, dicht mit Palmetten verziert. Im Zentrum der Palmetten befand sich hinter einem runden, stark erhabenen Kristall ein Kreuzpartikel, wodurch das Kruzifix zum Reliquienkreuz wurde. Kristall und Reliquie sind heute beide verloren. Mit einem spitzen Sporn (siehe Abb. S. 555) ist das Kreuz in einen in Limoges hergestellten Leuchterfuß montiert worden.

CROIX D'AUTEL (FACE ARRIÈRE)
Limoges, vers 1180. Cuivre, gravé, doré et émaillé, hauteur 17,2 cm
FREISING, DOMMUSEUM

En tant qu'arbre de vie, la croix d'autel est ornée de rinceaux dorés (cf. ill. p. 555 pour la face antérieure). La face arrière, montrée sur cette planche, présente un décor dense de palmettes. Au centre de ces dernières se trouvait, derrière un cristal rond formant un haut relief, une particule de la Sainte Croix, laquelle faisait du crucifix une croix-reliquaire. Ni le cristal ni la relique n'ont été conservés. À l'aide d'un éperon pointu (cf. ill. p. 555), la croix a été montée sur un pied de chandelier fabriqué à Limoges.

1100 — 1150.

I.H.vH·A. del: HP. sc:

ALTAR CROSS (FRONT VIEW)
Limoges, c. 1180. Copper, engraved, gilded and enamelled, h. 17.2 cm / 6 ¾ in.
FREISING, DOMMUSEUM

On the front of the altar cross, the enamel-painted figure of Christ is portrayed crucified with four nails, his arms extended horizontally (A, cf. also ills. pp. 179, 201). He wears a knee-length loincloth, and a rayed nimbus appears behind his sculpturally modelled head. With this representation, the altar cross marks the transition from a richly decorated work of art destined for a cathedral treasury to a crucifix that illustrates aspects of Christ's Passion. Above the inscription in Latin and Greek, the hand of God descends in blessing. Details of the decoration on the candleholder base are shown in separate illustrations (B–G, cf. ill. p. 553).

ALTARKREUZ (VORDERSEITE)
Limoges, um 1180. Kupfer, graviert, vergoldet und emailliert, 17,2 cm hoch
FREISING, DOMMUSEUM

Auf der Vorderseite des Altarkreuzes wird der Gekreuzigte im „Viernageltypus" mit waagerecht ausgebreiteten Armen, knielangem Rock und Kreuznimbus in Emailmalerei gezeigt (A, siehe auch Abb. S. 179, 201); der Kopf ist plastisch ausgearbeitet. Das Werk markiert mit dieser Darstellung den Übergang von einem reich verzierten Schatzkreuz zu einem Kruzifix, das Züge des Leidens Christi zeigt. Über der Inschrift in lateinischen und griechischen Buchstaben ist die segnende Hand Gottes zu sehen. Detailabbildungen zeigen die Ornamentik des Leuchterfußes (B–G, siehe Abb. S. 553).

CROIX D'AUTEL (FACE ANTÉRIEURE)
Limoges, vers 1180. Cuivre, gravé, doré et émaillé, hauteur 17,2 cm
FREISING, DOMMUSEUM

Sur la face antérieure de la croix d'autel, le Christ à quatre clous, peint sur émail, tend les bras à l'horizontale et porte une tunique descendant jusqu'aux genoux ; auréolée du nimbe crucifère (A, cf. aussi ill. pp. 179, 201), sa tête est exécutée en haut-relief – une représentation qui transforme la croix précieuse et richement décorée en crucifix montrant les traits du Christ souffrant. Au-dessus de l'inscription en lettres latines et grecques, on aperçoit la main bénissante de Dieu. Des reproductions de détails montrent les motifs ornant le pied du chandelier (B–G, cf. ill. p. 553).

1100 — 1150 .

IH v H-A del.

HP. sc.

RELIQUARY STATUETTE OF ST SEBASTIAN
Regensburg, before 1496. Silver gilt, h. 34.6 cm / 13 ⅝ in.
REGENSBURG, CATHEDRAL TREASURY
The statuette, which was originally only partly gilded, is listed in the 1496 *Verzeichnis der Regensburger Heiltümer*, an inventory of the relics that were ceremonially presented in public once a year in Regensburg. In 1505, Bishop Rupert II donated the statuette to the cathedral, in whose treasury it is today housed. The figurine carries in its left hand one of St Sebastian's bones, mounted at the top and bottom in gold and studded with rubies. The hollow arrow in his right hand may have been used as a suction tube for drinking the "Sebastian wine" believed to offer protection from the plague.

RELIQUIENSTATUETTE DES HL. SEBASTIAN
Regensburg, vor 1496. Silber, vergoldet, 34,6 cm hoch
REGENSBURG, DOMSCHATZ
Die Statuette, die ursprünglich nur teilvergoldet war, wird im *Verzeichnis der Regensburger Heiltümer* von 1496 erwähnt. In dem Verzeichnis sind die Reliquien aufgeführt, die in Regensburg bei der sogenannten Weisung des Heiltums einmal jährlich öffentlich präsentiert wurden. Bischof Rupert II. schenkte die Statuette 1505 dem Dom. Die Figur hält einen oben und unten in Gold gefassten und mit Rubinen besetzten Knochen des Heiligen in der linken Hand. Der hohle Pfeil in der Rechten des Heiligen wurde möglicherweise als Saugröhrchen zum Trinken des Sebastianweins benutzt, von dem man annahm, dass er vor der Pest schütze.

STATUETTE RELIQUAIRE DE SAINT SÉBASTIEN
Ratisbonne, avant 1496. Argent, doré, hauteur 34,6 cm
RATISBONNE, TRÉSOR DE LA CATHÉDRALE
La statuette, qui n'était à l'origine que partiellement dorée, est mentionnée dans le *Verzeichnis der Regensburger Heiltümer* (inventaire des reliques de Ratisbonne) de 1496. L'inventaire énumère les reliques qui, à Ratisbonne, étaient présentées au public une fois par an. En 1505, l'évêque Rupert II offrit la statuette à la cathédrale. Dans sa main gauche, la figure tient un os du saint, dont les parties supérieure et inférieure sont enchâssées dans de l'or et garnies de rubis. La flèche creuse que le saint tient dans sa main droite était peut-être utilisée comme pipette pour boire le vin de Sébastien, dont on supposait qu'il protégeait de la peste.

(pp. 559–63)

A. GOBLET

Augsburg, 1549. Silver gilt, h. 33.7 cm / 13 ¼ in.

The goblet, resembling a cluster of grapes, rises above a stem fashioned as a tree trunk on which a woodcutter is working (ill. p. 561). From the engraving "15+N.I.+49" on the edge of the cup, the goblet can be dated to 1549; the master's mark N.I. has yet to be deciphered, however. The goblet also bears the Augsburg punch mark.

B. BEAKER

Hans Baur (?), Ulm, c. 1610. Silver gilt, embossed, cast, chased, h. 8.8 cm / 3 ½ in.
NUREMBERG, GERMANISCHES NATIONALMUSEUM

The wine beaker, embossed with gadroons in the shape of grapes, bears the Ulm punch mark and a master's mark that was probably used by Hans Baur. The gadroon decoration is typical of the period around 1500, but the beaker in fact represents a fine example of the neo-Gothic stylistic tendencies in evidence at the beginning of the 17th century.

C. BEAKER

South German, 1st half of the 16th century. Silver, partly gilded, h. 9.5 cm / 3 ¾ in.
FORMERLY WITHIN THE MUNICH ART TRADE – WHEREABOUTS UNKNOWN

D–G. PENDANTS

German, 17th century. Silver gilt, h. 2.5–3.5 cm / 1–1 ⅜ in.

D.

A.

F.

E.

G.

B.

C.

1540 — 1560.

I.H.v.H.A. del.

H. sc.

(S. 559–563)

A. POKAL

Augsburg, 1549. Silber, vergoldet, 33,7 cm hoch

Aus dem Nachlass des Herausgebers Hefner-Alteneck 1904 versteigert

Aufbewahrungsort unbekannt

Über einem Baumstamm, an dem ein Holzfäller arbeitet (Abb. S. 561), erhebt sich in Traubenform die Kuppa, deren Rand die Gravur „15+N.I.+49" trägt. Das Meisterzeichen N.I. ist ungedeutet. Der datierte Pokal ist mit der Augsburger Beschau gemarkt.

B. BECHER

Hans Baur (?), Ulm, um 1610. Silber, vergoldet, getrieben, gegossen, ziseliert, 8,8 cm hoch

Nürnberg, Germanisches Nationalmuseum

Der mit traubenförmigen Buckeln getriebene Weinbecher ist mit Ulmer Beschau gemarkt und trägt ein Meisterzeichen, das vermutlich von Hans Baur verwendet wurde. Die Buckelung ist typisch für die Zeit um 1500. Bei dem Becher handelt es sich jedoch um ein schönes Zeugnis der Stilströmung der Neogotik zu Beginn des 17. Jahrhunderts.

C. BECHER

Süddeutsch, 1. Hälfte 16. Jahrhundert. Silber, teilvergoldet, 9,5 cm hoch

Ehemals im Münchner Kunsthandel – Aufbewahrungsort unbekannt

D–G. ANHÄNGER

Deutsch, 17. Jahrhundert. Silber, vergoldet, 2,5–3,5 cm hoch

Aus dem Nachlass des Herausgebers – Hefner-Alteneck 1904 versteigert

(pp. 559–563)

A. COUPE

Augsbourg, 1549. Argent, doré, hauteur 33,7 cm

PROVENANT DE LA SUCCESSION DE L'ÉDITEUR HEFNER-ALTENECK, VENDUE AUX ENCHÈRES EN 1904
LOCALISATION INCONNUE

Au-dessus d'un tronc d'arbre auprès duquel travaille un bûcheron (ill. p. 561), s'élève la coupe en forme
de grappe de raisins, dont le bord porte l'inscription gravée « 15+N.I.+49». Le poinçon de maître N. I. n'est
pas identifié. La coupe datée est frappée du poinçon de la ville d'Augsbourg.

B. GOBELET

Hans Baur (?), Ulm, vers 1610. Argent, doré, repoussé, fondu, ciselé, hauteur 8,8 cm

NUREMBERG, GERMANISCHES NATIONALMUSEUM

Pourvu de bosses en forme de raisins exécutées au repoussé, le gobelet à vin est marqué du poinçon
de la ville d'Ulm et porte un poinçon de maître qui était probablement utilisé par Hans Baur.
Si le bosselage est caractéristique de l'époque aux alentours de 1500, le gobelet témoigne superbement
du courant stylistique néogothique qui marqua le début du XVIIᵉ siècle.

C. GOBELET

Allemagne du Sud, 1ʳᵉ moitié du XVIᵉ siècle. Argent, partiellement doré, hauteur 9,5 cm

AUTREFOIS DANS LE COMMERCE MUNICHOIS D'OBJETS D'ART – LOCALISATION INCONNUE

D–G. PENDENTIFS

Allemagne, XVIIᵉ siècle. Argent, doré, hauteur 2,5–3,5 cm

PROVENANT DE LA SUCCESSION DE L'ÉDITEUR HEFNER-ALTENECK, VENDUS AUX ENCHÈRES EN 1904

A .

A. LEATHER BAG

German, c. 1500. Leather, book
AUCTIONED IN 1904 FROM THE ESTATE OF THE EDITOR HEFNER-ALTENECK
The plate illustrates the medieval custom of carrying small books around
in leather bags.

B & C. BOOK BOX

French, c. 1480. Wood, leather, iron, 6 x 12 x 9 cm / 2 ⅜ x 4 ¾ x 3 ½ in.
STAATLICHE MUSEEN ZU BERLIN, KUNSTGEWERBEMUSEUM
The rectangular book box, whose interior is lined with red leather, is covered on the outside with carved
leather and furnished with iron mounts and a lock. It could be carried by means of the strap fastened to the
longer sides. Boxes of this type were used for transporting valuable parchment prayer books.

A. GEBETBUCH IM BUCHSACK

Deutsch, um 1500. Leder, Buchblock
AUS DEM NACHLASS DES HERAUSGEBERS HEFNER-ALTENECK 1904 VERSTEIGERT
Die Tafel zeigt ein Beispiel für den mittelalterlichen Brauch, kleinere Bücher in Ledersäckchen
mit sich zu führen.

B & C. BUCHKASTEN

Französisch, um 1480. Holz, Leder, Eisen, 6 x 12 x 9 cm
STAATLICHE MUSEEN ZU BERLIN, KUNSTGEWERBEMUSEUM
Der viereckige, mit geritztem Leder bezogene Buchkasten mit Deckel ist mit Eisenbeschlägen und Schloss
versehen. An den Seiten befinden sich Zügel zum Umhängen des Behältnisses, das im Inneren mit rotem
Leder bezogen ist. Derartige Kästen dienten zum Transport kostbarer Pergament-Gebetbücher.

A. LIVRE DE PRIÈRES DANS UN SAC

Allemagne, vers 1500. Cuir, bloc livre
PROVENANT DE LA SUCCESSION DE L'ÉDITEUR HEFNER-ALTENECK, VENDU AUX ENCHÈRES EN 1904
La planche présente un exemple de la coutume médiévale qui consistait à porter sur soi
de petits livres dans des sacs de cuir.

B & C. COFFRE À LIVRES

France, vers 1480. Bois, cuir, fer, 6 x 12 x 9 cm
STAATLICHE MUSEEN ZU BERLIN, KUNSTGEWERBEMUSEUM
Recouvert de cuir fendillé, le coffre à livres rectangulaire est pourvu de ferrures et d'une serrure.
Sur les côtés se trouvent des lanières servant à porter sur l'épaule le contenant, recouvert à l'intérieur
de cuir rouge. Ce type de coffre servait à transporter les précieux livres de prière sur parchemin.

III.

65.

B.

A.

2 Par. Zoll.

C.

I.H.vH-A. del.

1400 — 1460.

IP. sc.

14th century

A. CENSER
German, c. 1350. Bronze, h. 31 cm / 12 ⅛ in.
FORMERLY AUGSBURG, PRIVATE COLLECTION – WHEREABOUTS UNKNOWN
The censer's uncluttered design and architectural motifs are typical of the Gothic style.

B & C. BOOK MOUNTS
German, c. 1300. Bronze, ø 13.5 cm / 5 ⅜ in.
FORMERLY BERGISCH GLADBACH, CATHOLIC PARISH CHURCH OF ST CLEMENT

D & E. BOOK MOUNTS
German, 1st half of the 14th century. Bronze, ø 10.3 cm / 4 in. (D), ø 11.7 cm / 4 ⅝ in. (E)
MUNICH, BAYERISCHES NATIONALMUSEUM

A. RAUCHFASS
Deutsch, um 1350. Bronze, 31 cm hoch
EHEMALS IN AUGSBURGER PRIVATBESITZ – AUFBEWAHRUNGSORT UNBEKANNT
Das Rauchfass ist in typisch gotischer Weise schlicht und mit architektonischen Motiven gestaltet.

B & C. BUCHBESCHLÄGE
Deutsch, um 1300. Bronze, ø 13,5 cm (B, C)
EHEMALS KATHOLISCHE PFARRKIRCHE ST. KLEMENS IN BERGISCH GLADBACH

D & E. BUCHBESCHLÄGE
Deutsch, 1. Hälfte 14. Jahrhundert. Bronze, ø 10,3 cm (D), ø 11,7 cm (E)
MÜNCHEN, BAYERISCHES NATIONALMUSEUM

A. ENCENSOIR
Allemagne, vers 1350. Bronze, hauteur 31 cm
AUTREFOIS EN LA POSSESSION D'UN PARTICULIER AUGSBOURGEOIS – LOCALISATION INCONNUE
L'encensoir est décoré de motifs architecturaux dont la sobriété est caractéristique du style gothique.

B & C. FERRURES DE LIVRE
Allemagne, vers 1300. Bronze, ø 13, 5 cm (B, C)
AUTREFOIS CONSERVÉES DANS L'ÉGLISE PAROISSIALE CATHOLIQUE SAINT-CLÉMENT
À BERGISCH GLADBACH

D & E. FERRURES DE LIVRE
Allemagne, 1ère moitié du XIVe siècle. Bronze, ø 10,3 cm (D), 11,7 cm (E)
MUNICH, BAYERISCHES NATIONALMUSEUM

B.

D.

A.

2 Par Zoll.

2 Par Zoll.

C.

E.

2 Par Zoll.

2 Par Zoll.

1300 —

1350.

2 Par Zoll.

(pp. 569–73)

A, C, E. MAIOLICA BOWL AND PLATES

Italian, 15th and 16th century. Earthenware, painted and glazed, ø 20–25 cm / 7 ⅞ –10 in.
FORMERLY BERLIN, KUNSTGEWERBEMUSEUM – WARTIME LOSS
The bowl by master Giorgio da Gubbio (A) from 1519 is decorated with early examples of grotesque ornament (cf. also ill. 571). Two shallow plates show a representation of St Margaret (C) after a composition by Raphael, and a pair of lovers (E, ill. p. 573) accompanied by the words "Per amore."

D. FAIENCE PLATE

Faenza, c. 1500. Earthenware, painted and glazed, h. 4.1 cm / 1 ⅝ in.; ø 27 cm / 10 ⅝ in.
STAATLICHE MUSEEN ZU BERLIN, KUNSTGEWERBEMUSEUM
The central field of the dish whose flat well and gently rising sides are shown in cross-section in a second outline drawing depicts the bust of a young girl in contemporary dress facing towards the right. The portrait appears against a blackish-blue ground and is accompanied by the inscription "Landrea be" (in Italian "L'Andrea bella," or "The beautiful Andrea"), scraped out of the paint. The plate is covered by a glassy, transparent *coperta* glaze.

F. PLATE

WHEREABOUTS UNKNOWN
The central medallion containing a head seen in profile
is surrounded by slender boughs of oak leaves and acorns.

G. FAIENCE PLATE

French, early 17th century. Earthenware, painted and glazed, ø 24.6 cm / 9 ⅝ in.
FORMERLY IN A PRIVATE COLLECTION WITHIN THE NOBILITY – WHEREABOUTS UNKNOWN
The rim of the plate is painted with floral decoration.
The well shows Venus and Cupid after an engraving by Crispin de Passe.

III. A. c. 67.

4 Par. Zell. 2 Par. Zell.

B.

D. E.

4 Par. Zell. 4 Par. Zell.

SLAND REABE PER MORE

F. G.

4 Par. Zell. 4 Par. Zell.

J.H. & H.A. del. 1510 — 1580 H.P. sc.

(S. 569–573)

A, C, E. MAJOLIKA-SCHÜSSEL UND -TELLER

Italienisch, 15. und 16. Jahrhundert. Ton, bemalt gebrannt, ø 20–25 cm

EHEMALS KUNSTGEWERBEMUSEUM, BERLIN - KRIEGSVERLUST

Die Schüssel des Meisters Giorgio da Gubbio (A) aus dem Jahr 1519 zieren frühe Groteskornamente (siehe auch Abb. S. 571). Zwei flache Teller zeigen die Darstellung der heiligen Margarete nach Raffael (C) und ein Liebespaar (E, Abb. S. 573) mit der Beischrift „Per amore".

D. FAYENCE-TELLER

Faenza, um 1500. Ton, bemalt und gebrannt, 4,1 cm hoch, ø 27 cm

STAATLICHE MUSEEN ZU BERLIN, KUNSTGEWERBEMUSEUM

Der Teller mit flacher Mitte und aufsteigendem Rand, dessen Querschnitt schematisch dargestellt ist, zeigt im Rundfeld das nach rechts gewendete Brustbild eines jungen Mädchens in zeittypischer Tracht. Das Bildnis ist aus dem schwarzblauen Grund ausgespart. Die Beischrift „Landrea be", auf Italienisch „L'Andrea bella" und in der Übersetzung „Die schöne Andrea", ist aus dem Hintergrund ausgeschabt. Bedeckt ist die Darstellung mit glänzender, durchsichtiger Coperta-Glasur.

F. TELLER

AUFBEWAHRUNGSORT UNBEKANNT

Medaillon mit Profilkopf, umrahmt von Eichenzweigen mit Früchten.

G. FAYENCE-TELLER

Französisch, Anfang 17. Jahrhundert. Ton, bemalt gebrannt, ø 24,6 cm

EHEMALS IN ADELIGEM PRIVATBESITZ – AUFBEWAHRUNGSORT UNBEKANNT

Die Fahne des Tellers schmückt Blumendekor. Der Spiegel des Tellers zeigt Venus und Amor nach einem Stich von Crispin de Passe.

(pp. 569–573)

A, C, E. PLAT ET ASSIETTES EN MAJOLIQUE

Italie, XV^e et XVI^e siècles. Argile, peint, cuit, ø 20–25 cm

AUTREFOIS CONSERVÉS AU KUNSTGEWERBEMUSEUM BERLIN – PERTE DE GUERRE

Le plat du maître Giorgio da Gubbio (A) datant de 1519 est orné de motifs de l'art grotesque primitif (cf. aussi ill. p. 571). Deux assiettes plates montrent la représentation de sainte Marguerite d'après Raphaël (C) et un couple d'amoureux (E, ill. p. 573) accompagné de l'inscription « Per amore ».

D. ASSIETTE DE FAÏENCE

Faenza, vers 1500. Argile, peint et cuit, hauteur 4,1 cm, ø 27 cm

STAATLICHE MUSEEN ZU BERLIN, KUNSTGEWERBEMUSEUM

L'assiette au centre plat et au bord ascendant, dont la vue en coupe est représentée par un schéma, montre le buste tourné vers la droite d'une jeune fille en habits d'époque. Le portrait se détache sur un fond bleu sombre ; l'inscription « Landrea be », « La belle Andrea », est obtenue par grattage de ce dernier. La représentation est recouverte d'un vernis brillant et transparent.

F. ASSIETTE

LOCALISATION INCONNUE

Le médaillon contenant une tête vue de profil est entouré de branches de chêne parsemées de fruits.

G. ASSIETTE DE FAÏENCE

France, début du XVII^e siècle. Argile, peint, cuit, ø 24,6 cm

AUTREFOIS EN LA POSSESSION DE NOBLES – LOCALISATION INCONNUE

Le marli présente un décor floral ; l'ombilic montre Vénus et l'Amour d'après une gravure de Crispin de Passe.

MONSTRANCE

Caspar Naiser (or Naysar), Worms, 1523. Copper gilt, h. 72 cm / 28 ⅜ in.

GROSSOSTHEIM, PARISH CHURCH OF SS PETER AND PAUL

The monstrance, which is dated and signed by the artist in an inscription, represents a late example of a type predominant in the Late Gothic era. Details of its decoration are reproduced in additional outline drawings (A and B). Above the six-lobed foot, decorated with engraved tracery, the three-section stem supports an octagonal plate. This, in turn, carries the lavish architectural superstructure that formerly surrounded a cylindrical rock-crystal housing, as correctly reconstructed on the plate. The original today has a Baroque heart-shaped construction in place of the cylinder. The Virgin and St John the Evangelist appear between two pairs of columns at the height of the cylinder, whereas in the centre overhead, surrounded by finials, stands the figure of Christ displaying his wounds. Six small bells complete the overall picture. The remaining two outline drawings on the plate (C and D) show other monstrances.

MONSTRANZ

Caspar Naiser (oder Naysar), Worms, 1523. Kupfer, vergoldet, 72 cm hoch

GROSSOSTHEIM, PFARRKIRCHE ST. PETER UND PAUL

Die Monstranz, die inschriftlich vom Künstler bezeichnet und datiert ist, gehört zu den späten Werken eines am Ausgang der Gotik vorherrschenden Typus, dessen Detailformen (A, B) hier umgezeichnet wiedergegeben sind. Auf dem sechspassigen, mit graviertem Maßwerk verzierten Fuß erhebt sich ein dreifach untergliederter Ständer, der die achteckige Standplatte trägt. Auf der Platte erhebt sich der reiche architektonische Aufbau, der das kristallene zylindrische Schaugefäß umgab, das auf der Tafel richtig rekonstruiert wurde. Das Original besitzt anstelle des Zylinders heute eine barocke herzförmige Konstruktion. Zwischen den vier Pfeilern befinden sich unten Maria und Johannes, während in der Mitte über dem Zylinder, umgeben von Fialen, Christus steht, der seine Wundmale vorzeigt. Sechs Glöckchen vervollständigen das Gesamtbild. Die beiden weiteren Umzeichnungen (C, D) geben andere Monstranzen wieder.

OSTENSOIR

Caspar Naiser (ou Naysar), Worms, 1523. Cuivre, doré, hauteur 72 cm

GROSSOSTHEIM, ÉGLISE PAROISSIALE SAINT-PIERRE-ET-SAINT-PAUL

Signé et daté par l'artiste, l'ostensoir appartient aux œuvres tardives d'un style dominant à la fin de l'époque gothique et dont la planche restitue les détails formels (A, B). Sur le pied hexalobé orné de remplages gravés s'élève une tige subdivisée en trois parties et portant le plateau octogonal. Sur celui-ci se déploie la riche structure architecturale qui entourait jadis le cylindre en cristal faisant office d'ostensoir. Ce dernier a été fidèlement reconstitué sur la planche. Aujourd'hui, l'original possède, à la place du cylindre, une construction baroque en forme de cœur. Entre les quatre piliers se trouvent, en bas, la Vierge Marie et saint Jean tandis qu'au centre, placé au-dessus du cylindre et entouré de pinacles, Jésus montre ses stigmates. Six petites cloches complètent le tableau d'ensemble. Deux autres ostensoirs sont dessinés sur la planche (C, D).

C.

D.

A.

3 Par.Zoll

1523.

B.

I.H.v.H-A. del

H.P. sc.

(pp. 577–79)

CONFECTIONERY BOWL FROM THE TUCHER SERVICE

Pierre Reymond, Limoges, 1561. Copper, enamel, h. 9.5 cm / 3 ¾ in., ⌀ 20.5 cm / 8 in.

NUREMBERG, MUSEUM TUCHERSCHLOSS, HANS-CHRISTOPH VON TUCHER FOUNDATION

The footed serving bowl is part of the Tucher Service, the most important ensemble of Limoges enamel-painted tableware surviving in German collections today. The service was commissioned in 1561 by the Nuremberg mayor and merchant Linhart Tucher via his son Herdegen Tucher IV, who ran the Lyons branch of the family firm. Its decoration was based on that of existing Limoges tableware designs. The service was acquired in 1833 at auction for the King of Bavaria and in 1873 it passed into the Bayerisches Nationalmuseum. In 1929, it was placed under the control of the Wittelsbach equalization fund and was later offered for sale, at which point it was reacquired by the Tucher family. Since 1967, the service has been on display in the Tucher palace museum in Nuremberg. The Tucher Service today consists of five components: a lavabo set comprising a ewer and basin (for washing the hands at the dining table), two tall covered dishes and two different-sized pairs of serving bowls. The present confectionery bowl belongs to these last. Its representation of the Chastisement of Psyche is taken from the story of Cupid and Psyche as narrated within *The Golden Ass*, the famous novel by the antique author Apuleius. The Tucher coat of arms appears beneath the scene. The outline drawing at the top reproduces the decoration on the underside of the bowl.

3 Par Zoll.

1558.

I H JH A del.

Hl Sc

(S. 577–579)

KREDENZ, „TUCHER'SCHE KONFEKTSCHALE"

Pierre Reymond, Limoges, 1561. Kupfer, Email, 9,5 cm hoch, ø 20,5 cm

NÜRNBERG, MUSEUM TUCHERSCHLOSS, HANS-CHRISTOPH-VON-TUCHER-STIFTUNG

Die Kredenz ist Teil des Tucher-Service, eines mehrteiligen Geschirrs, bei dem es sich um das bedeutendste in deutschen Sammlungen erhaltene Ensemble in der Technik des Limousiner Maleremails handelt. Das Service wurde 1561 von dem Nürnberger Bürgermeister und Handelsherrn Linhart Tucher über seinen Sohn Herdegen Tucher IV., der die Lyoner Niederlassung der Familienfirma leitete, in Auftrag gegeben, wobei bereits vorhandene Stücke das Dekor vorgaben. 1833 kam das Service durch Versteigerung in den Besitz des bayerischen Königs, gelangte 1873 in das Bayerische Nationalmuseum, wurde 1929 an den Wittelsbacher Ausgleichsfonds abgegeben und kam anschließend durch Verkauf wieder in den Tucher'schen Besitz. Seit 1967 ist das Service im Nürnberger Tucherschloss, einem Teil des Stadtmuseums, ausgestellt. Es besteht heute aus fünf Teilen, einem Lavabo mit Kanne und Becken (Gerät zur Handwaschung bei Tisch), zwei hohen Deckelschalen und zwei Paaren unterschiedlich großer Kredenzen. Zu diesen gehört das hier abgebildete Stück mit einer Darstellung der Züchtigung der Psyche nach der Geschichte von Amor und Psyche in dem berühmten Roman *Der goldene Esel* des antiken Dichters Apuleius. Unter der Szene ist das Tucher'sche Wappen abgebildet. Die obere Abbildung gibt den Schmuck der Schalenunterseite in einer Umzeichnung wieder.

(pp. 577–579)

« COUPE SUR PIED DE TUCHER »

Pierre Reymond, Limoges, 1561. Cuivre, émail, hauteur 9,5 cm, ø 20,5 cm

NUREMBERG, MUSEUM TUCHERSCHLOSS, FONDATION HANS-CHRISTOPH VON TUCHER

La coupe appartient au service de Tucher, un service de vaisselle fabriqué selon la technique limousine des émaux peints. Il s'agit, en la matière, de l'ensemble le plus important ayant été conservé dans les collections allemandes. Le service fut commandé en 1561 par Linhart Tucher, maire de Nuremberg et négociant, dont le fils, Herdegen Tucher IV, qui dirigeait la filiale lyonnaise de l'entreprise familiale, fut chargé de passer la commande. Des pièces déjà existantes déterminèrent le décor des récipients. Lors d'une vente aux enchères, en 1833, le service passa aux mains du roi de Bavière ; en 1873, il parvint au Bayerisches Nationalmuseum ; en 1929, il fut transmis au fonds de compensation des Wittelsbach avant de redevenir enfin, lors d'une vente, la propriété des Tucher. Depuis 1967, le service est exposé au château Tucher à Nuremberg, une aile du musée de la ville. Il se compose aujourd'hui de cinq pièces : un lavabo avec broc et vasque (ustensile permettant aux convives de se laver les mains à table), deux hautes coupes à couvercle et deux paires de coupes de différentes tailles. À ces dernières appartient la pièce reproduite ici et ornée d'une représentation du châtiment de Psyché d'après l'histoire d' « Amour et Psyché » empruntée au roman *Les Métamorphoses d'Apulée*. Sous la scène figure le blason de la famille Tucher. L'illustration située en haut de la planche restitue le décor de la face inférieure de la coupe.

NECK JEWELLERY
German, late 15th century. Silver gilt, gems, pearls
WITHIN THE ART TRADE IN 1837 – WHEREABOUTS UNKNOWN
The various items of neck jewellery illustrated on the plate are characterized by Late Gothic vegetal decoration. One pendant shows St George (A).

HALSSCHMUCK
Deutsch, Ende 15. Jahrhundert. Silber, vergoldet, Edelsteine, Perlen
1837 IM KUNSTHANDEL – AUFBEWAHRUNGSORT UNBEKANNT
Den Halsschmuck ziert spätgotisches vegetabiles Dekor. Ein Anhänger zeigt die Darstellung des heiligen Georg (A).

COLLIERS
Allemagne, fin du XVe siècle. Argent, doré, pierres précieuses, perles
DANS LE COMMERCE D'OBJETS D'ART EN 1837 – LOCALISATION INCONNUE
Les colliers sont ornés d'un décor végétal caractéristique du gothique tardif. Un pendentif offre une représentation de saint Georges (A).

A.

B.

C.

D.

E.

14th/15th century

A–D. CANDLESTICK AND CANDELABRA
German, 2nd half of the 15th century
Brass, cast, h. 43.7 cm / 12 ¼ in. (A), h. 24 cm / 9 ½ in. (C), H. 21 cm / 8 ¼ in. (D)
Formerly in a private collection in South Germany – Whereabouts unknown
The objects bear witness to the variety of secular candlestick designs in the Late Middle Ages.

E. DRAGON CANDLEHOLDER
German, 14th–15th century. Brass, cast, 11.8 x 15.8 cm / 4 ⅝ x 6 ¼ in.
Nuremberg, Germanisches Nationalmuseum
Dragon candleholders were a widespread type of candlestick design. In the variation seen here,
a bracket extending from the dragon's mouth serves to support the socket for the candle.

F & G. POTS
German, 2nd half of the 15th century. H. 22.2 cm / 8 ¾ in. (F), h. 23 cm / 9 in. (G)
Formerly within the Munich art trade (F); formerly Nuremberg,
private collection (G)– Whereabouts unknown

A–D. LEUCHTER
Deutsch, 2. Hälfte 15. Jahrhundert. Messing, gegossen, 43,7 cm hoch (A), 24 cm hoch (C), 21 cm hoch (D)
Ehemals im süddeutschen Privatbesitz – Aufbewahrungsort unbekannt
Die Stücke zeigen die Gestaltungsvielfalt profaner Leuchter des Spätmittelalters.

E. LEUCHTER
Deutsch, 14.–15. Jahrhundert. Messing, gegossen, 11,8 x 15,8 cm
Nürnberg, Germanisches Nationalmuseum
Der weit verbreitete Typus des Drachenleuchters wird hier in einer Variante präsentiert,
bei der ein Tragstück im Maul des Drachen zum Einsetzen einer Kerzentülle dient.

F & G. KANNEN
Deutsch, 2. Hälfte 15. Jahrhundert. 22,2 cm hoch (F), 23 cm hoch (G)
Ehemals im Münchner Kunsthandel (F); ehemals in Nürnberger Privatbesitz (G)
Aufbewahrungsort unbekannt

A–D. CHANDELIERS
Allemagne, 2ᵉ moitié du XVᵉ siècle. Laiton, fondu, hauteur 43,7 (A), 24 (C), 21 (D) cm
Autrefois en la possession d'un particulier d'Allemagne du Sud – Localisation inconnue
Les pièces témoignent de la diversité plastique des chandeliers profanes du Moyen Âge tardif.

E. CHANDELIER
Allemagne, XIVᵉ/XVᵉ siècle. Laiton, fondu, 11,8 cm x 15,8 cm
Nuremberg, Germanisches Nationalmuseum
Figure ici une variante du chandelier en forme de dragon, alors très répandu :
une pièce porteuse placée dans la gueule du dragon sert à installer un cache-bougie.

F & G. CRUCHES
Allemagne, 2ᵉ moitié du XVᵉ siècle. Hauteur 22,2 cm (F) et 23 cm (G)
Autrefois dans le commerce munichois d'objets d'art (F) ; autrefois en la possession
d'un particulier de Nuremberg (G) – Localisation inconnue

DESIGN DRAWING FOR A CHALICE
Mathias Hauch, Weimar, 1571. Pen, gouache
STAATLICHE KUNSTSAMMLUNGEN ZU WEIMAR, GRAPHISCHE SAMMLUNG

The design drawing stems from the hand of an otherwise entirely unknown artist. It is the property of the
Thuringian state archives in Weimar and has been on loan to Weimar's Graphische Sammlung (Collection
of Prints and Drawings) since 1923. The drawing is very interesting from the point of view of the sociology
of art, since it is the subject of a detailed correspondence. From the letters exchanged over a period of
several months between Mathias Hauch and Duke John William of Saxony, it emerges that the artist had
submitted a design for a silver-gilt goblet with enamel decoration and wished to have the object crafted for
the Duke by Augsburg goldsmiths. The project was evidently never realized, however, not least because the
Duke continuously requested improvements and alterations, also regarding the price. Discussing the
subject in his book, Hefner-Alteneck writes: "We cannot tell from these letters whether the chalice was
actually produced, but the mistrust and punctiliousness of the Duke vis-à-vis the artists, who emerge as
simple and modest craftsmen, shows us the obstacles against which art, however skilled,
no doubt often had to struggle, even in those days."

ENTWURFSZEICHNUNG FÜR EINEN KELCH
Mathias Hauch, Weimar, 1571. Feder, Gouache
STAATLICHE KUNSTSAMMLUNGEN ZU WEIMAR, GRAPHISCHE SAMMLUNG

Die Zeichnung stammt von der Hand eines sonst gänzlich unbekannten Künstlers. Sie ist Eigentum des
Thüringischen Hauptstaatsarchivs Weimar und befindet sich seit 1923 als Leihgabe in der Weimarer
Graphischen Sammlung. Die Entwurfszeichnung ist kunstsoziologisch betrachtet sehr interessant, weil
dazu ein ausführlicher Briefwechsel existiert. Aus der sich über Monate hinziehenden Korrespondenz von
Mathias Hauch mit Herzog Johann Wilhelm von Sachsen geht hervor, dass der Künstler den Entwurf für
einen vergoldeten Silberpokal mit Emaildekor vorgelegt hatte und das Werk von Augsburger
Goldschmieden für den Herzog ausführen lassen wollte. Offenbar ist es nicht zu einer Realisierung
gekommen, nicht zuletzt, weil der Herzog ständig Verbesserungen und Änderungen, auch in der
Preisgestaltung, wünschte. Hefner-Alteneck schreibt dazu im Text seiner Publikation: „Aus diesen Briefen
ersehen wir nun nicht, ob dieser Kelch wirklich zur Ausführung gekommen, aber das Mißtrauen und die
große Genauigkeit des Herzogs den Künstlern gegenüber, welche als schlichte Handwerker bescheiden
auftraten, zeigt uns, mit welchen Hindernissen auch damals die Kunst bei aller Tüchtigkeit
wohl oft zu kämpfen hatte."

DESSIN DE PROJET POUR UN CALICE
Mathias Hauch, Weimar, 1571. Plume, gouache
STAATLICHE KUNSTSAMMLUNGEN ZU WEIMAR, GRAPHISCHE SAMMLUNG

Le dessin est l'œuvre d'un artiste par ailleurs totalement inconnu. Propriété des archives de Thuringe à
Weimar, il est conservé en prêt, depuis 1923, dans la collection des arts graphiques de la ville. Accompagné
d'un échange épistolaire circonstancié, il présente un grand intérêt pour la sociologie de l'art. D'après la
correspondance qu'entretinrent pendant les mois Mathias Hauch et le duc Jean-Guillaume de Saxe-
Weimar, l'artiste avait présenté le dessin en vue de la fabrication d'une coupe en argent doré pourvue d'un
décor en émail et voulait faire exécuter l'œuvre par des orfèvres d'Augsbourg. Le projet, manifestement, ne
vit jamais le jour, en raison, notamment, des améliorations et modifications, y compris dans l'établissement
du prix, que le duc n'avait de cesse de réclamer. Dans le texte de sa publication, Hefner-Alteneck écrivit à
ce propos : « Si ces lettres ne nous permettent pas d'affirmer avec certitude que le calice a bien été exécuté,
la méfiance et l'exigence pointilleuse dont le duc faisait montre à l'égard des artistes, qui se présentaient
avec la modestie de simples artisans, témoignent des obstacles que la création artistique, en dépit de la
valeur de ceux qui s'y adonnaient, devait, à cette époque déjà, affronter. »

Index of locations / Standortverzeichnis / Index des localisations

BIBLIOGRAPHY / BIBLIOGRAFIE / BIBLIOGRAPHIE

Literature on the objects in this book.
The relevant references for illustrations appear in **bold** in brackets.
Literatur zu den im Buch abgebildeten Werken.
Die Abbildungsverweise sind **fett** in Klammern angegeben.
Écrits relatifs aux œuvres reproduites dans ce livre.
Les références aux illustrations sont indiqués **en gras** entre parenthèses.

Ars Sacra: Kunst des frühen Mittelalters, Munich 1950, no. 295 (**ill. p. 453**).

Friedrich Back, *Führer durch die Kunst- und Historischen Sammlungen: Grossherzoglich Hessisches Landesmuseum in Darmstadt*, Darmstadt 1908, p. 47 (**ills. pp. 95, 97**), p. 86 (**ill. p. 113**).

Ernst Bassermann-Jordan and Wolfgang Schmid, *Der Bamberger Domschatz*, Munich 1914, no. 20 (**ills. pp. 483–85**).

Lothar Bauer, "Der französische Prunkkamm," in *Historischer Verein Bamberg*, report 136, Bamberg 2000, no. 5 (**ill. p. 429**).

Michael Baxandall, *The Limewood Sculptors of Renaissance Germany*, New Haven, CT, and London 1980, p. 306, pl. 86 and 87 (**ills. pp. 347, 349**).

Carl Becker, *Leben und Werke des Bildhauers Tilmann [!] Riemenschneider, eines fast unbekannten aber vortrefflichen Künstlers, am Ende des 15. und Anfang des 16. Jahrhunderts*, Leipzig 1849, no. 20 (**ills. pp. 17, 177**).

Joseph Braun, *Das christliche Altargerät in seinem Sein und in seiner Entwicklung*, Munich 1932, p. 639 (**ill. p. 453**).

Herbert Brunner, *Die Kunstschätze der Münchner Residenz*, Munich 1977, p. 132, no. 124 (**ill. p. 315**), p. 152, no. 146 (**ills. pp. 27, 417**), p. 131f. (**ills. pp. 419–23**).

Theodor Demmler (ed.), *Staatliche Museen zu Berlin: Die Bildwerke des Deutschen Museums*, vol. 1: Wolfgang Fritz Volbach, *Die Elfenbeinbildwerke*, Berlin and Leipzig 1923, no. 666 (**ills. pp. 54, 207**), no. 678 (**ills. pp. 55, 235–37**), no. 617–619 (**ill. p. 277**).

Theodor Demmler (ed.), *Staatliche Museen zu Berlin: Die Bildwerke des Deutschen Museums*, vol. 4: E. F. Bange, *Die Bildwerke in Holz, Stein und Ton: Kleinplastik*, Berlin and Leipzig 1930, p. 10f., no. 5943 (**ills. pp. 11, 143**).

Deutsche Kunst und Kultur im Germanischen National-Museum, Nuremberg 1952, p. 45 (**ill. p. 337**), p. 101 (**ill. p. 415**).

Barbara Dienst, *Der Kosmos des Peter Flötner: Eine Bildwelt der Renaissance in Deutschland*, Munich and Berlin 2002, p. 509, ill. 244 (**ills. pp. 21, 205**), p. 569, ill. 288 (**ills. pp. 19, 211**).

Renate Eikelmann (ed.), *Bayerisches Nationalmuseum: Handbuch*, Munich 2000, p. 76 (**ill. p. 503**).

Renate Eikelmann (ed.), *Der Mohrenkopfpokal von Christoph Jamnitzer*, Munich 2002, nos. 59 and 60 (**ills. pp. 577–79**).

Gerhard Ermischer and Andreas Tacke (eds.), *Cranach im Exil: Aschaffenburg um 1540*. Regensburg 2007, no. 92 (**ills. pp. 34, 367–75**), no. 95 (**ills. pp. 79–81 and 127 B and C**).

Otto von Falke and Max J. Friedländer (eds.), *Die Sammlung Dr. Albert Figdor*, vol. 2: *Möbel*, Vienna 1930, p. 547 (**ills. pp. 263, 265**).

Otto von Falke and Erich Meyer, *Romanische Leuchter und Gefäße: Gießgefäße der Gotik*. Berlin 1935, p. 29, ill. 170 (**ill. p. 551**), p. 40, ill. 231 (**ill. p. 413**), p. 54, ill. 311 (**ill. p. 199**).

Max. H. von Freeden, *Aus den Schätzen des Mainfränkischen Museums Würzburg*, Würzburg 1972, p. 22 (**ill. p. 77**), p. 113 (**ill. p. 219**), p. 116 (**ill. p. 161**), p. 119 (**ill. p. 133**).

Johann Michael Fritz, *Gestochene Bilder: Gravierungen auf deutschen Goldschmiedearbeiten der Spätgotik*, Cologne and Graz 1966, no. 203 (**ill. p. 189**).

Johann Michael Fritz, *Goldschmiedekunst der Gotik in Mitteleuropa*, Munich 1982, pl. XIV (**ills. pp. 479, 481**), nos. 67 and 68 (**ill. p. 501**), no. 73 (**ill. p. 425**), no. 358 (**ill. p. 543**), no. 406 (**ill. p. 287**), no. 517 (**ill. p. 241**), no. 630 (**ill. p. 503**), no. 631 (**ill. p. 533**),

no. 641 (ill. p. 145), no. 644 (ill. p. 77), no. 645 (ill. p. 107), no. 746 (ill. p. 355), no. 750 (ill. p. 557), no. 878 (ills. pp. 31, 227), no. 961 (ill. p. 365), pp. 339 and 345 (ill. p. 575).

Führer des Hessischen Landesmuseums Darmstadt: Frühmittelalterliches Kunsthandwerk, no. 2, Darmstadt 1955, p. 35, ill. 31 (ill. p. 453), p. 36 (ill. p. 97).

Danielle Gaborit-Chopin, *Elfenbeinkunst im Mittelalter,* Berlin 1978, no. 69 (ill. p. 91).

Hubert Glaser (ed.), *Wittelsbach und Bayern,* vol. 2, part II: *Um Glauben und Reich: Kurfürst Maximilian I,* Munich 1980, no. 335 (ills. pp. 419–23).

Adolph Goldschmidt, *Die Elfenbeinskulpturen aus der Zeit der karolingischen und sächsischen Kaiser,* repr. Berlin 1972, vol. 1: p. 83, no. 169, pl. LXXX (ill. p. 91), vol. 2: p. 10f. and 45, no. 149, pl. XLII (ills. pp. 73, 135), p. 45, no. 148, pl. XLII (ills. pp. 22, 103).

Adolph Goldschmidt, *Die byzantinischen Elfenbeinskulpturen,* vols. 1 and 2, repr. Berlin 1979, p. 42, pl. XXIII (ill. p. 137).

Sylvia Hahn, *Kreuz und Kruzifix: Zeichen und Bild,* exh. cat., Lindenberg im Allgäu 2005, no. IV, 12 (ills. pp. 553, 555).

Philipp Maria Halm and Rudolf Berliner, *Das Hallesche Heiltum,* Berlin 1931, p. 36, no. 108 (ill. p. 87).

J. F. Hayward, *Virtuoso Goldsmiths and the Triumph of Mannerism, 1540–1620,* London 1976, pl. 328 (ill. p. 151).

Jakob Heinrich von Hefner-Alteneck, *Trachten, Kunstwerke und Geräthschaften vom frühen Mittelalter bis Ende des Achtzehnten Jahrhunderts,* 10 vols., Frankfurt am Main 1879–89.

Jakob Heinrich von Hefner-Alteneck, *Lebens-Erinnerungen,* Munich 1899.

Barbara Helwig, *Inkunabelkatalog des Germanischen Nationalmuseums Nürnberg,* Wiesbaden 1970, no. 203 (ill. p. 507).

Harald Hilg, *Germanisches Nationalmuseum: Die lateinischen mittelalterlichen Handschriften,* Wiesbaden 1983, p. 34 (ill. p. 409).

Hans Holländer, "Schachfiguren im Bode-Museum," in Tobias Kunz, *"Nicht die Bibliothek, sondern das Auge": Westeuropäische Skulptur und Malerei an der Wende zur Neuzeit,* contributions in honour of Hartmut Krohm, Petersberg 2008, pp. 15–21 (ills. pp. 54, 55, 207, 235–37).

Achim Hubel and Manfred Schuller, *Der Dom zu Regensburg,* Regensburg 1995, p. 9, ill. 5 (ill. p. 501), p. 148, ill. 135 (ill. p. 557).

Wolfgang Jahn, Margot Hamm and Evamaria Brockhoff (eds.), *Adel in Bayern: Ritter, Grafen, Industriebarone,* Stuttgart 2008, no. I.49 (ills. pp. 157–59).

Theo Jülich, *Die mittelalterlichen Elfenbeinarbeiten des Hessischen Landesmuseums Darmstadt,* Regensburg 2007, no. 15 (ill. p. 171), no. 38 (ills. pp. 14, 385).

Michael Kamp, "Das Bayerische Nationalmuseum unter Jakob Heinrich von Hefner-Alteneck 1868–1885," in Renate Eikelmann and Ingolf Bauer (eds.), *Das Bayerische Nationalmuseum 1855–2005: 150 Jahre Sammeln, Forschen, Ausstellen,* Munich 2006, pp. 84–94.

Heinrich Kohlhaussen, *Nürnberger Goldschmiedekunst des Mittelalters und der Dürerzeit 1240 bis 1540,* Berlin 1968, cat. no. 357 (ills. pp. 41, 225).

Dietrich Kötzsche, *Der Quedlinburger Schatz wieder vereint,* Berlin 1992, no. 3 (ills. pp. 51, 203), no. 10 (ills. pp. 59, 215).

Heinrich Kreisel, *Die Kunst des deutschen Möbels,* vol. 1, Munich 1968, p. 57, ill. 71 (ill. p. 161), p. 55, ill. 142 (ill. p. 267).

Kunstgewerbemuseum Berlin: Führer durch die Sammlungen, (East) Berlin 1988, no. 12 (ill. p. 463).

Betty Kurth, *Die deutschen Bildteppiche des Mittelalters,* 3 vols., Vienna 1926, p. 128, pl. 127–130 (ills. pp. 66/67, 512–27), p. 145, pl. 170 (ills. pp. 398–407).

Kurzes Verzeichnis der im Städelschen Kunstinstitut ausgestellten Sigmaringer Sammlungen, Frankfurt am Main 1928, no. 824 (ill. p. 503).

A. Ludorff, *Die Bau- und Kunstdenkmäler von Westfalen: Die Bau- und Kunstdenkmäler des Kreises Paderborn,* Münster 1899, p. 22 (ill. p. 287).

Felix Mader, *Die Kunstdenkmäler des Königreichs Bayern,* vol. 3: Regierungsbezirk Unterfranken und Aschaffenburg, no. XII: Stadt Würzburg, Munich 1915, pp. 56–57 (ill. p. 109), p. 90 (ill. p. 199), p. 91f. (ills. pp. 183, 223), p. 304, fig. 246 (ills. pp. 318–21).

Felix Mader, *Die Kunstdenkmäler von Bayern, Regierungsbezirk Oberpfalz,* no. XXII: Stadt Regensburg I, Munich 1933, p. 141f., pl. XVIII (**ill. p. 501**), p. 152f., pl. XXI (**ill. p. 557**), p. 322, ill. 217 (**ills. pp. 318–21**).

Michael Maek-Gérard, *Liebieghaus - Museum Alter Plastik, Frankfurt am Main, Wissenschaftliche Kataloge,* vol. III: *Nachantike grossplastische Bildwerke,* Melsungen 1985, no. 103 (**ills. pp. 17, 177**).

Ute and Hermann Maué, "Ein Lektionar in St. Nikolai zu Höxter aus dem Ägidienkloster zu Braunschweig," in *Westfälische Zeitschrift* 128 (1978), pp. 217–228 (**ill. p. 353**).

Klaus Maurice, *Die deutsche Räderuhr,* vol. II, Munich 1976, no. 538 (**ills. pp. 119–21**).

Hanns-Ulrich Mette, *Der Nautiluspokal,* Munich and Berlin 1995, no. 161 (**ill. p. 221**).

Eva Mühlbacher, *Europäische Lederarbeiten vom 14. bis 19. Jahrhundert aus den Sammlungen des Berliner Kunstgewerbemuseums,* Berlin 1988, no. 9 (**ill. p. 565 B and C**).

Eva Mühlbacher, *Europäische Stickereien vom Mittelalter bis zum Jugendstil aus der Textilsammlung des Berliner Kunstgewerbemuseums,* Berlin 1995, p. 77f., no. 81 (**ill. p. 299**).

Das Oktoberfest, exh. cat., Münchner Stadtmuseum, Munich 1985, no. 327 (**ills. pp. 359, 361, 363**).

Klaus Pechstein et al., *Wenzel Jamnitzer und die Nürnberger Goldschmiedekunst 1500–1700,* Munich 1985, no. 55 (**ills. pp. 38, 269–71**).

Klaus Pechstein et al., *Deutsche Goldschmiedekunst vom 15. bis zum 20. Jahrhundert aus dem Germanischen Nationalmuseum,* Berlin 1987, p. 39, ill. 40 (**ill. p. 409**), no. 56 (**ills. pp. 559–63**).

Gerhard Pfeiffer, *Bau- und Kunstdenkmäler von Westfalen,* vol. 44: *Kreis Warburg,* Münster 1939, pp. 406 and 408 (**ill. p. 301**).

Robert Piloty, *Kunstsammlungen des verewigten Herrn Geheimrats Dr. Jakob von Hefner-Alteneck: Versteigerungskatalog,* Munich 1904, no. 216 (**ill. p. 593**), no. 229 (**ill. p. 373**), no. 238 (**ill. p. 257**), no. 247 (**ill. p. 373**), no. 308 (**ill. p. 229**), no. 397 and 403 (**ill. pp. 172/73**), no. 2209 (**ill. p. 565**).

Lieselotte E. Saurma-Jeltsch, *Die Miniaturen im "Liber Scivias" der Hildegard von Bingen: Die Wucht der Visionen und die Ordnung der Bilder,* Wiesbaden 1998, p. 3f. (**ill. p. 195**).

Schatzkammer der Deutschen: Aus den Sammlungen des Germanischen Nationalmuseums Nürnberg, Nuremberg 1982, no. 58 (**ill. p. 337**).

Werner Schiedermaier, *Die Alte Kapelle in Regensburg,* Regensburg 2002, p. 84, ill. 41 (**ill. p. 471**).

Lorenz Seelig, "Kunstwerke aus den Wittelbacher Sammlungen im Bayerischen Nationalmuseum," in Renate Eikelmann and Ingolf Bauer (eds.), *Das Bayerische Nationalmuseum 1855–2005: 150 Jahre Sammeln, Forschen, Ausstellen,* Munich 2006, pp. 45 and 405 (**ills. pp. 577–79**).

Peter Springer, *Kreuzfüße: Ikonographie und Typologie eines hochmittelalterlichen Gerätes,* Berlin 1981, p. 141, ill. 221 (**ill. p. 427**).

Frauke Steenbock, *Der kirchliche Prachteinband im frühen Mittelalter von den Anfängen bis zum Beginn der Gotik,* Berlin 1963, no. 721, ill. 98 and 99 (**ills. pp. 73, 175**).

Christoph Stiegemann, *Erzbischöfliches Diözesanmuseum und Domschatzkammer Paderborn, Geschichte-Architektur-Sammlung,* Paderborn 2003, p. 7 (**ill. p. 301**), p. 8 (**ill. p. 353**), p. 51, no. 74 (**ill. p. 509**).

Anna-Elisabeth Theuerkauff-Liederwald, *Mittelalterliche Bronze- und Messinggefäße: Eimer – Kannen – Lavabokessel,* Berlin 1988, p. 51, no. 11, ill. 11 and 11a (**ill. p. 451**).

Hans Thurn, *Die Handschriften der Universitätsbibliothek Würzburg,* vol. 3/1: *Die Pergamenthandschriften der ehemaligen Dombibliothek,* Wiesbaden 1984, pp. 54–56 (**ills. pp. 73, 135**), pp. 52–54 (**ill. p. 91**), p. 51f. (**ill. p. 137**), p. 85f. (**ills. pp. 22, 103**).

Hans and Siegfried Wichmann, *Schach: Ursprung und Wandlung der Spielfigur in zwölf Jahrhunderten,* Munich 1960, no. 67 (**ills. pp. 54, 203**).

Gottfried Zedler, *Die Handschriften der Nassauischen Landesbibliothek zu Wiesbaden,* Leipzig 1931, pp. 1–17 (**ill. p. 195**).

Acknowledgements / Danksagung / Remerciements

I wish to thank the following people for the information and suggestions they kindly provided:
Für freundliche Auskünfte und Hinweise danke ich:
Mes remerciements vont à ceux qui ont eu l'amabilité de fournir renseignements et indications:

Dr Uta-Christiane Bergemann, Bochum/Göttingen; Dagmar Blaha, senior archivist, Thüringisches Hauptstaatsarchiv Weimar; Dr Emanuel Braun, Domschatz und Diözesanmuseum, Eichstätt; Dr Julian Chapuis, Skulpturensammlung und Museum für Byzantinische Kunst, Staaatliche Museen zu Berlin; Ulrike Dura, Stadtgeschichtliches Museum, Kunsthistorische Sammlungen, Leipzig; Linda Eggers, Göttingen; Dr Thomas Foerster, Hessisches Landesmuseum, Darmstadt; Lucie Friedrich, Evangelisch-lutherisches Pfarramt Schwarzach, St. Johannis; Dr Angela Graf, Museum für Kunst und Gewerbe, Hamburg; Peter Groh, senior archivist, Gräfliche Sammlungen Schloss Erbach; Dr Sylvia Hahn, Dommuseum, Freising; Dr Widar Halén, Kunstindustriemuseet, Nasjonalmuseet, Oslo; Dr Sabine Heym, Museumsabteilung, Bayerische Verwaltung der staatlichen Schlösser, Gärten und Seen; Jutta Hofmann-Beck, Münchner Stadtmuseum; Pastor Bernhard Jakobs, katholische Kirchengemeinde Liebfrauen und St. Martin, Oberwesel; Dr Norbert Jopek, Victoria and Albert Museum, London; Dr Frank Matthias Kammel, Germanisches Nationalmuseum, Nuremberg; Michael Koller, Bau- und Kunstreferat, Bischöfliches Ordinariat Würzburg; Dr Hans-Jürgen Kotzur, Bischöfliches Dom- und Diözesanmuseum, Mainz; Lothar Lambacher, chief curator, Kunstgewerbemuseum, Staatliche Museen zu Berlin; Andreas von Majewski, Wittelsbacher Ausgleichsfonds, Munich; Hermann Müller, Kulturabteilung, Stadt Kulmbach; Dr Susanne Netzer, Kunstgewerbemuseum, Staatliche Museen zu Berlin; Stefanie Gräfin von Pfuel, Marktgemeinde Tüssling; Dr Johannes Pommeranz, Germanisches Nationalmuseum, Nuremberg; Hermann J. Richartz, Basilika St. Lambertus, Düsseldorf; Dr Thomas Richter, Museen der Stadt Aschaffenburg; Dr Achim Riether, Staatliche Graphische Sammlung, Munich; Dr Thomas Rudi, Grassi Museum, Leipzig; Dr Christiane Ruhmann, Erzbischöfliches Diözesanmuseum, Paderborn; Dr Thomas Schauerte, Stadtmuseum, Nuremberg; Prof. Ulrich Schneider, Museum für Angewandte Kunst, Frankfurt am Main; Dr Ralf Schürer, Germanisches Nationalmuseum, Nuremberg; Dr Eva Schurr, Museen der Stadt Bamberg; Dr Lorenz Seelig, Gräfelfing; Dr Achim Stiegel, Kunstgewerbemuseum, Staatliche Museen zu Berlin; Dr Ulrike Surmann, Kolumba, Kunstmuseum des Erzbistums Köln, Cologne; Prof. Brigitte Tietzel, Deutsches Textilmuseum, Krefeld; Dr Gert-Dieter Ulferts, Kunstsammlungen, Klassik Stiftung Weimar, Museen, Weimar; Dr Frauke van der Wall, Mainfränkisches Museum, Würzburg; and Dr Heidrun Zinkann, Museum für Angewandte Kunst, Frankfurt am Main.

This reprint of Jakob Heinrich von Hefner-Alteneck and Carl Becker's *Kunstwerke und Geräthschaften des Mittelalters und der Renaissance* (Artworks and Artefacts of the Middle Ages and the Renaissance) is based on a copy owned by the Württembergische Landesbibliothek Stuttgart and has been made possible through the kind permission of the library's deputy director, Martina Lüll. We are particularly grateful to Dr Eberhard Zwink, director of the Historische Sammlungen Division, for supporting the project unstintingly from the outset.
The original was digitally reproduced by the Göttingen Digitization Center (GDZ) of the Staats- und Universitätsbibliothek Göttingen. We wish to thank Martin Liebetruth of the GDZ for being so cooperative during all stages of this undertaking.

Der vorliegende Nachdruck der *Kunstwerke und Geräthschaften des Mittelalters und der Renaissance* von Jakob Heinrich von Hefner-Alteneck und Carl Becker erfolgte auf der Grundlage des Exemplars der Württembergischen Landesbibliothek Stuttgart und wurde dank der freundlichen Genehmigung der stellvertretenden Direktorin Martina Lüll ermöglicht. Dem Leiter der Abteilung „Historische Sammlungen", Dr. Eberhard Zwink, der das Projekt von Anfang an unterstützt hat, gilt unser besonderer Dank.
Die digitale Reproduktion des Originals führte das Göttinger Digitalisierungszentrum der Staats- und Universitätsbibliothek Göttingen durch. Für die gute Zusammenarbeit danken wir Herrn Martin Liebetruth vom GDZ.

La présente réimpression de l'ouvrage de Jakob Heinrich von Hefner-Alteneck et Carl Becker *Kunstwerke und Geräthschaften des Mittelalters und der Renaissance* (Œuvres d'art et Ustensiles du Moyen Âge et de la Renaissance) a été réalisée à partir de l'exemplaire de la Württembergische Landesbibliothek Stuttgart et avec l'aimable autorisation de la directrice adjointe, Martina Lüll. Nous remercions tout particulièrement le directeur de la section des imprimés anciens, le Dr Eberhard Zwink, qui a soutenu le projet dès son origine. La numérisation du volume a été effectuée par le Digitalisierungszentrum de la Bibliothèque universitaire de Göttingen, où nous remercions chaleureusement Martin Liebetruth pour l'excellente qualité de sa collaboration.

Photo credits / Bildquellenverzeichnis / Crédits photographiques

Alchemy & Mysticism

Hieronymus Bosch.
Complete Works

Caravaggio.
Complete Works

Dalí. The Paintings

Hiroshige

Impressionist Art

Leonardo da Vinci.
Complete Paintings

Leonardo da Vinci.
The Graphic Work

Michelangelo.
The Graphic Work

Michelangelo.
Life and Work

Modern Art

Bookworm's delight:
never bore, always excite!

TASCHEN
Bibliotheca Universalis

What Paintings Say

Monet

Van Gogh

Becker. Medieval &
Renaissance Art

The Book of Bibles

Bodoni. Manual of
Typography

Bourgery. Atlas of
Anatomy & Surgery

Braun/Hogenberg.
Cities of the World

D'Hancarville.
Antiquities

Encyclopaedia
Anatomica

Six Books of Euclid

Basilius Besler's
Florilegium

A Garden Eden

Mamerot. A Chronicle
of the Crusades

Martius.
The Book of Palms

Piranesi.
Complete Etchings

Prisse d'Avennes.
Oriental Art

Seba. Cabinet of
Natural Curiosities

The World
of Ornament

Racinet.
The Costume History

Type. A Visual History

Eugène Atget. Paris

Karl Blossfeldt

Curtis. The North
American Indian

Eadweard Muybridge

A History of
Photography

New Deal
Photography

20th Century
Photography

Stieglitz.
Camera Work

Architectural Theory

The Grand Tour

Photographers A–Z

Modern
Architecture A–Z

Industrial Design A–Z

Design of the
20th Century

Fashion. A History from
18th–20th Century

Monuments and marvels

A defining record of Islamic art and architecture

Through Syria, Arabia, Persia, and Palestine, Émile Prisse d'Avennes voyaged with a rapturous love for the Orient and a keen eye for the symmetry, opulence, and complexity of visual culture. This TASCHEN edition revives Prisse d'Avennes' 1869–1877 survey *L'Art arabe d'après les monuments du Kaire* in all its attention to detail, as well as to historical, social, and religious contexts. The result is a precious record of Arabic, Persian, and Ottoman heritage as well as of the history of thought and imagination between Europe and the Middle East.

"This publication of Prisse d'Avennes' magisterial chromolithographs is truly a fabulous thing."
—*World of Interiors*, London

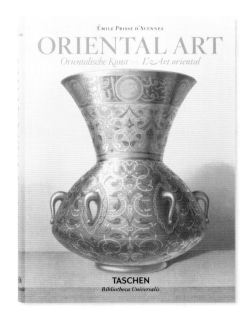

Émile Prisse d'Avennes. Oriental Art
Sheila S. Blair, Jonathan M. Bloom
Hardcover, 14 x 19.5 cm (5.5 x 7.7 in.),
520 pages
US$ 19.99 | £ 12.99 | € 14.99

TRILINGUAL EDITION IN:
ENGLISH / DEUTSCH / FRANÇAIS

Turbans, togas, and tailcoats

The evolution of style from antiquity to 1888

Originally published in France between 1876 and 1888, Auguste Racinet's *Le Costume historique* was in its day the most wide-ranging and incisive study of clothing ever attempted. This TASCHEN reprint presents Racinet's exquisitely precise color illustrations, as well as his delightful descriptions and often witty commentary. Spanning everything from ancient Etruscan attire to French women's couture, material is arranged by culture and subject according to Racinet's original plan. As expansive in its reach as it is passionate in its research and attention to detail, Racinet's *Costume History* is an invaluable reference for students, designers, artists, illustrators, and historians.

> "Some books just scream out to be bought; this is one of them."
> — *Vogue*, Sydney

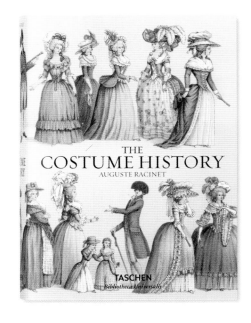

Auguste Racinet.
The Costume History
Françoise Tétart-Vittu
Hardcover, 14 x 19.5 cm (5.5 x 7.7 in.),
752 pages
US$ 19.99 | £ 12.99 | € 14.99

EDITIONS IN: ENGLISH / DEUTSCH / FRANÇAIS

Spectacular specimens

Albertus Seba's unrivaled catalogue of animals, insects and plants

Albertus Seba's *Cabinet of Natural Curiosities* is one of the 18th century's greatest natural history achievements and remains one of the most prized natural history books of all time. Though scientists of his era often collected natural specimens for research purposes, Amsterdam-based pharmacist Seba (1665–1736) was unrivaled in his passion. His amazing collection of animals, plants and insects from all around the world gained international fame during his lifetime.

This reproduction is taken from a rare, hand-coloured original. The introduction supplies background information about the fascinating tradition of natural collections to which Seba's curiosities belonged.

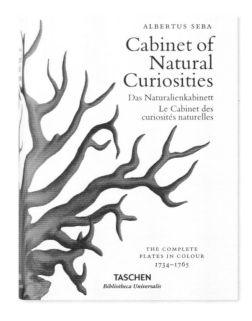

ALBERTUS SEBA

Cabinet of Natural Curiosities

Das Naturalienkabinett
Le Cabinet des
curiosités naturelles

1734–1765

THE COMPLETE
PLATES IN COLOUR
1734–1765

TASCHEN
Bibliotheca Universalis

"A powerful testament to nature's beauty and diversity."
—*Chicago Tribune*

Albertus Seba.
Cabinet of Natural Curiosities
Irmgard Müsch, Jes Rust, Rainer Willmann
Hardcover, 14 x 19.5 cm (5.5 x 7.7 in.),
752 pages
US$ 19.99 | £ 12.99 | € 14.99

TRILINGUAL EDITIONS IN:
ENGLISH / DEUTSCH / FRANÇAIS &
ESPAÑOL / ITALIANO / PORTUGUÊS

Epic exploits

The intrepid voyages, bloody battles and heroic burials of the French crusades

Completed circa 1474, Sébastien Mamerot's lavishly illustrated manuscript is the only contemporary document to describe several centuries of French crusades, when successive kings tried to seize the Holy Land. Jean Colombe, the medieval illuminator best known for his work on the *Très Riches Heures du Duc de Berry*, is the principal artist of its 66 exquisite miniatures. *Les Passages d'Outremer* (*The Expeditions to Outremer*) comprises 277 parchment folios, illustrated by Colombe and the finest calligraphers of the medieval era, and now resides in the French national library. This new hardcover edition includes a complete translation of the manuscript text, illustrated with Jean Colombe's 66 colourful miniatures, and their explanations. The battles, burials, coronations and processions depicted in the illustrations come to life before our eyes and create a forceful image, as well as a compelling read, of this centuries-long campaign of religious fervour and epic journey.

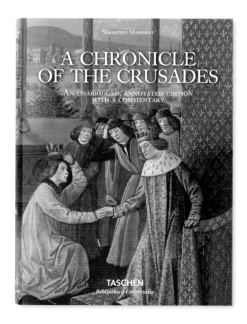

"One doesn't need to be a history professor to enjoy this book."
— *San Francisco Book Review*

Sébastien Mamerot.
A Chronicle of the Crusades
Thierry Delcourt, Fabrice Masanès,
Danielle Quéruel
Hardcover, 14 x 19.5 cm (5.5 x 7.7 in.),
760 pages
US$ 19.99 | £ 12.99 | € 14.99

EDITIONS IN: ENGLISH / DEUTSCH / FRANÇAIS

Endpaper
Casket (detail), cf. p. 141
Lower Rhenish or Westphalian, c. 1500

Page 2
Small Domestic Altar (Front view, detail), cf. p. 535
German, final third of the 15th century

Page 4
Small Domestic Altar (Exterior Side, detail), cf. pp. 536/37
German, final third of the 15th century

Page 586
Cupboard (detail), cf. p. 289
German, 2nd half of the 15th century

© 2017 TASCHEN GmbH
Hohenzollernring 53, D–50 672 Köln
www.taschen.com

Original edition: © 2011 TASCHEN GmbH

Editing and coordination: Ute Kieseyer, Cologne
English translation: Karen Williams, Rennes-le-Château
French translation: Caroline Jouannic, Paris (introduction, plate commentary: pp. 72–293); Guénolée Khoshbakht, Nantes (plate commentary: pp. 294–585)
Design: Sense/Net Art Direction, Andy Disl, www.sense-net.net and Birgit Eichwede, Cologne
Production: Tina Ciborowius, Cologne

Printed in China
ISBN 978-3-8365-2026-3